D1175709

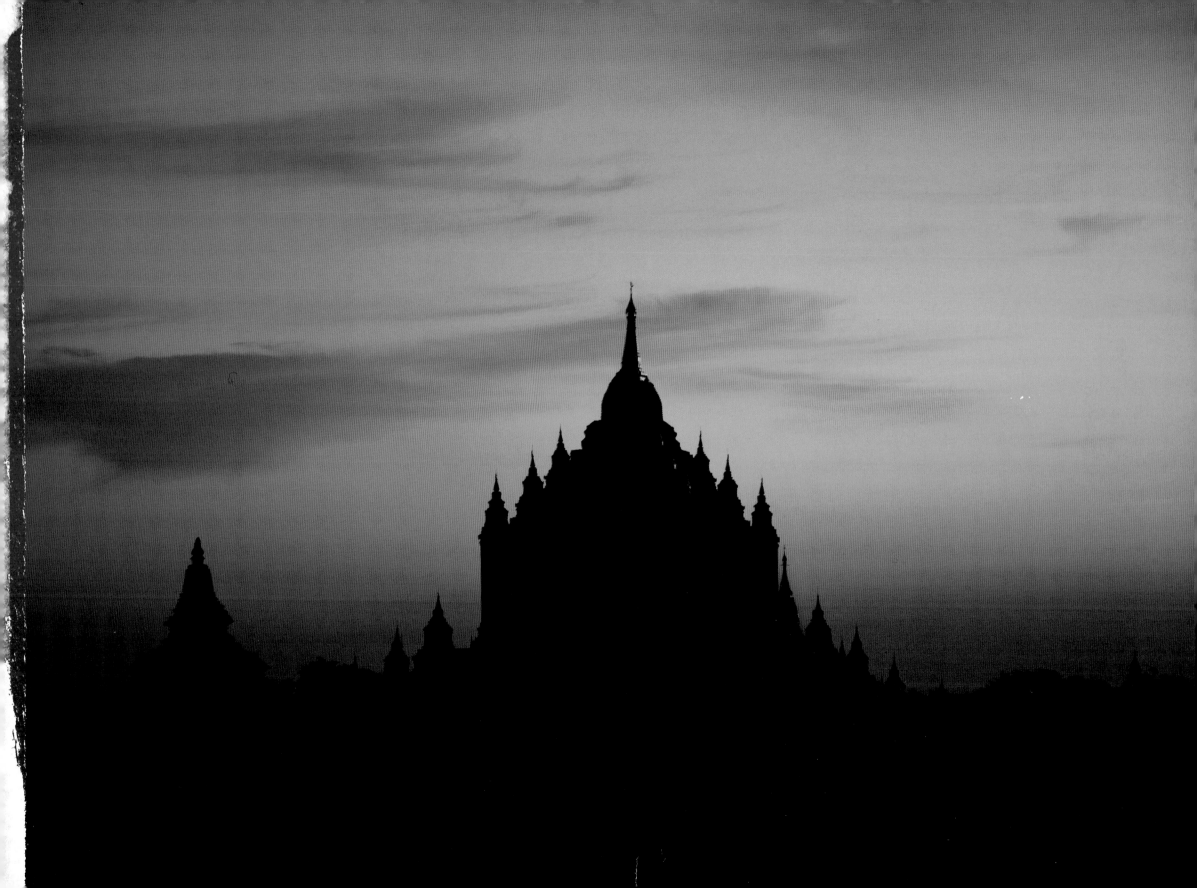

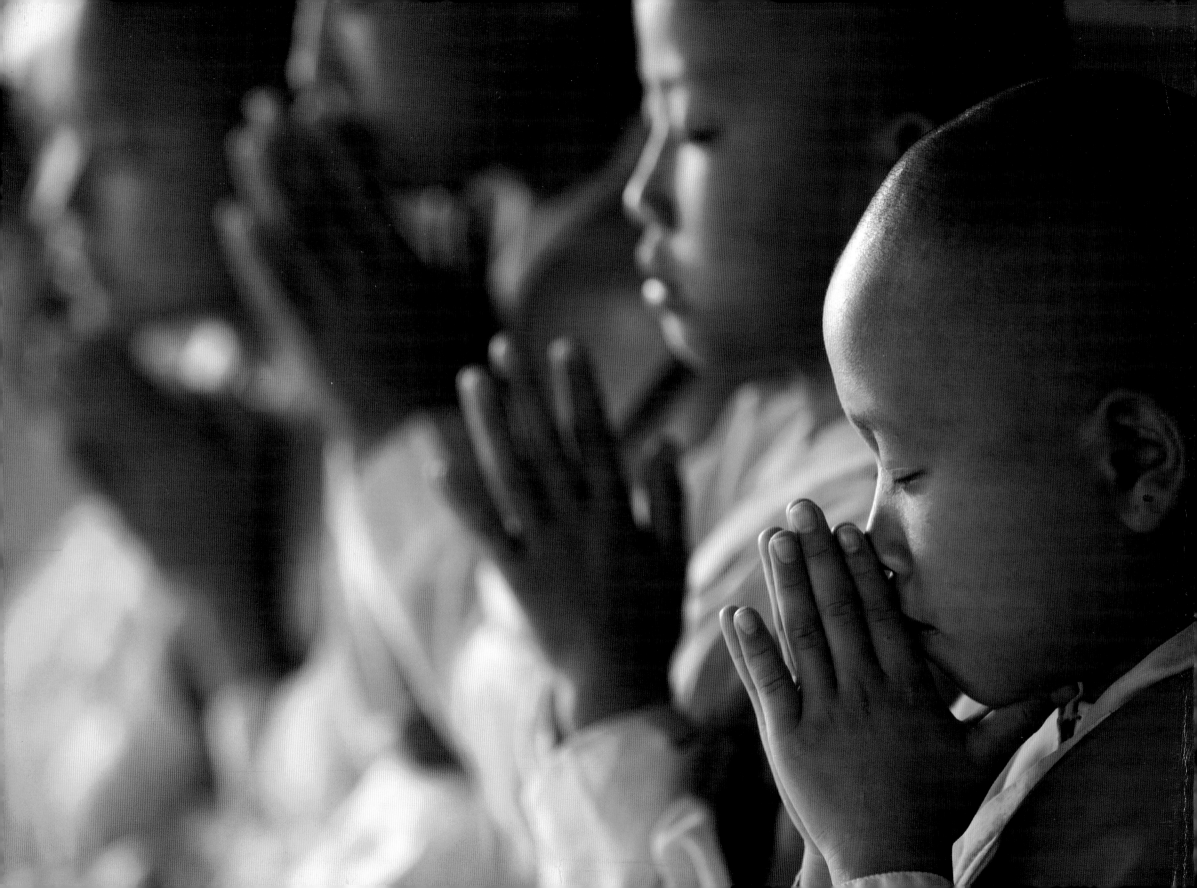

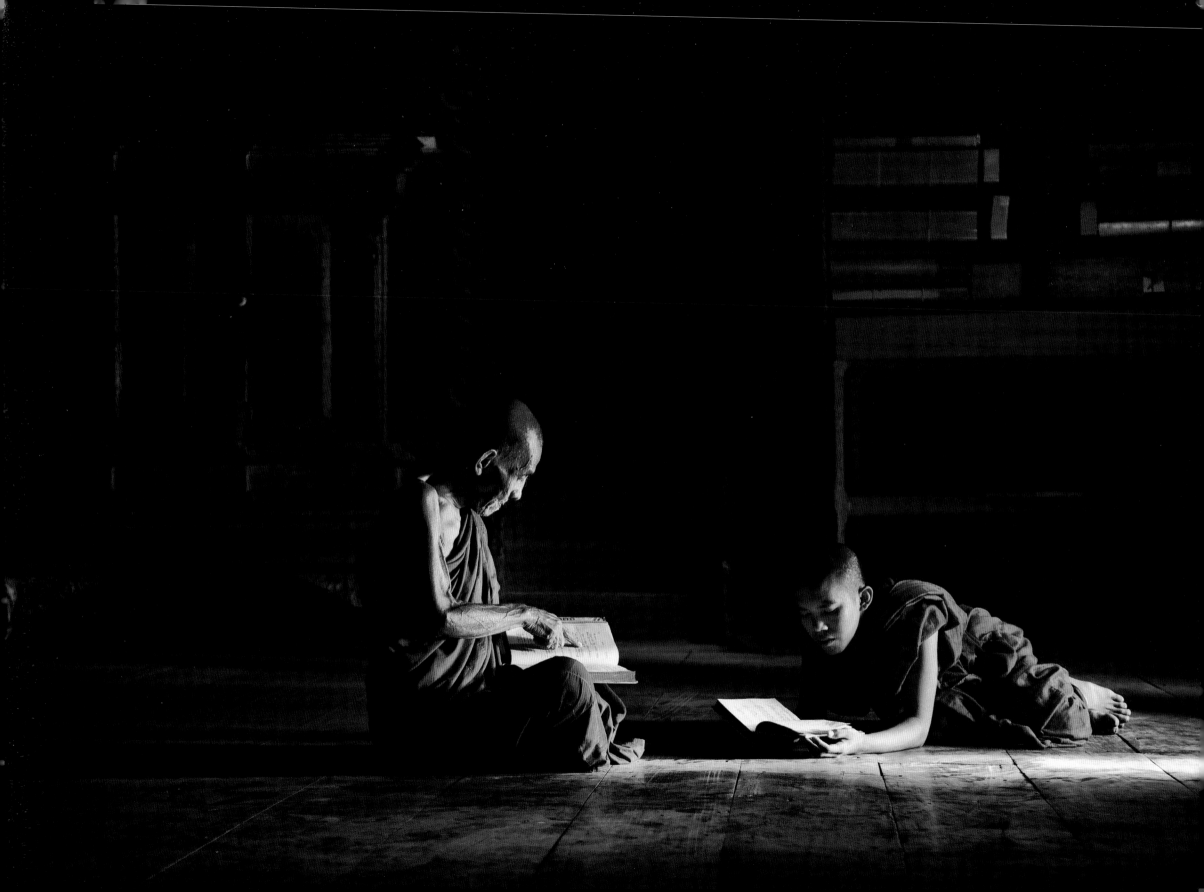

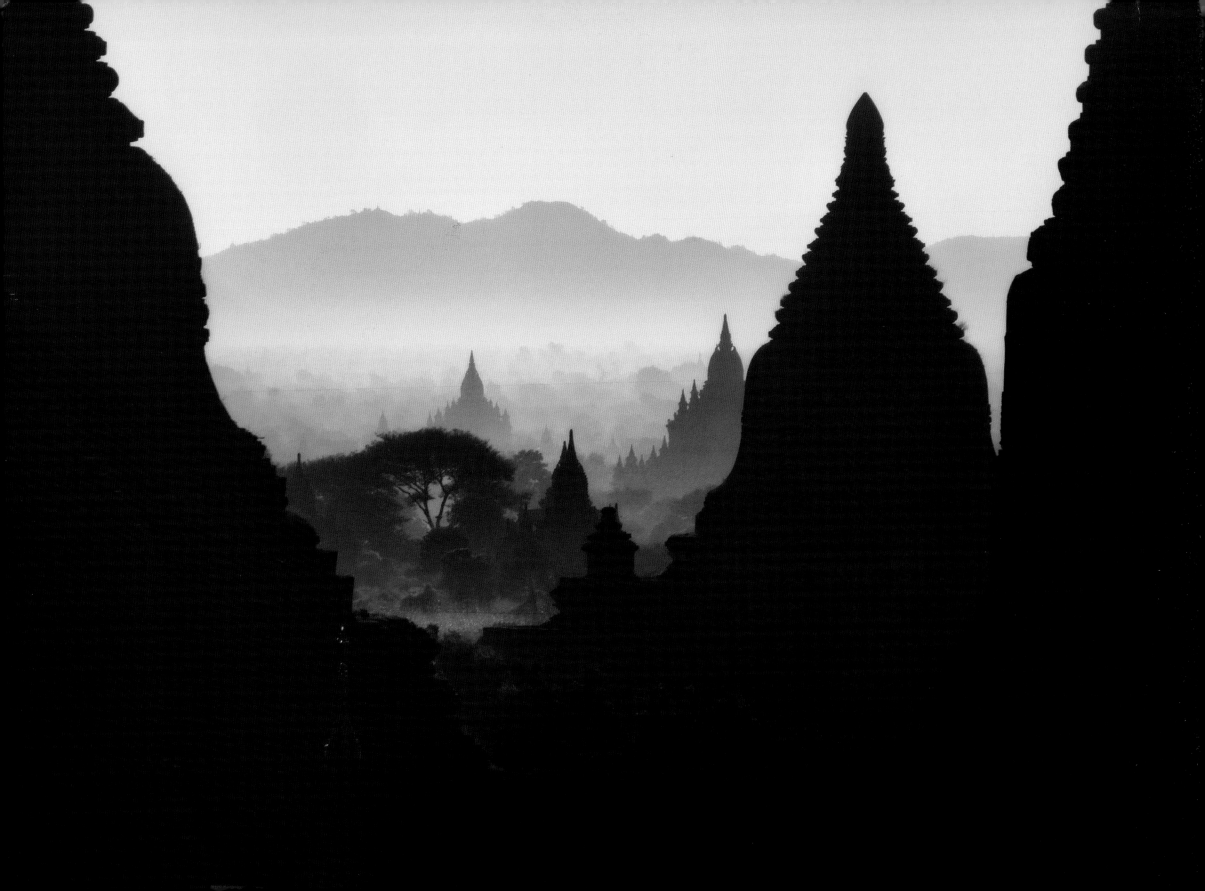

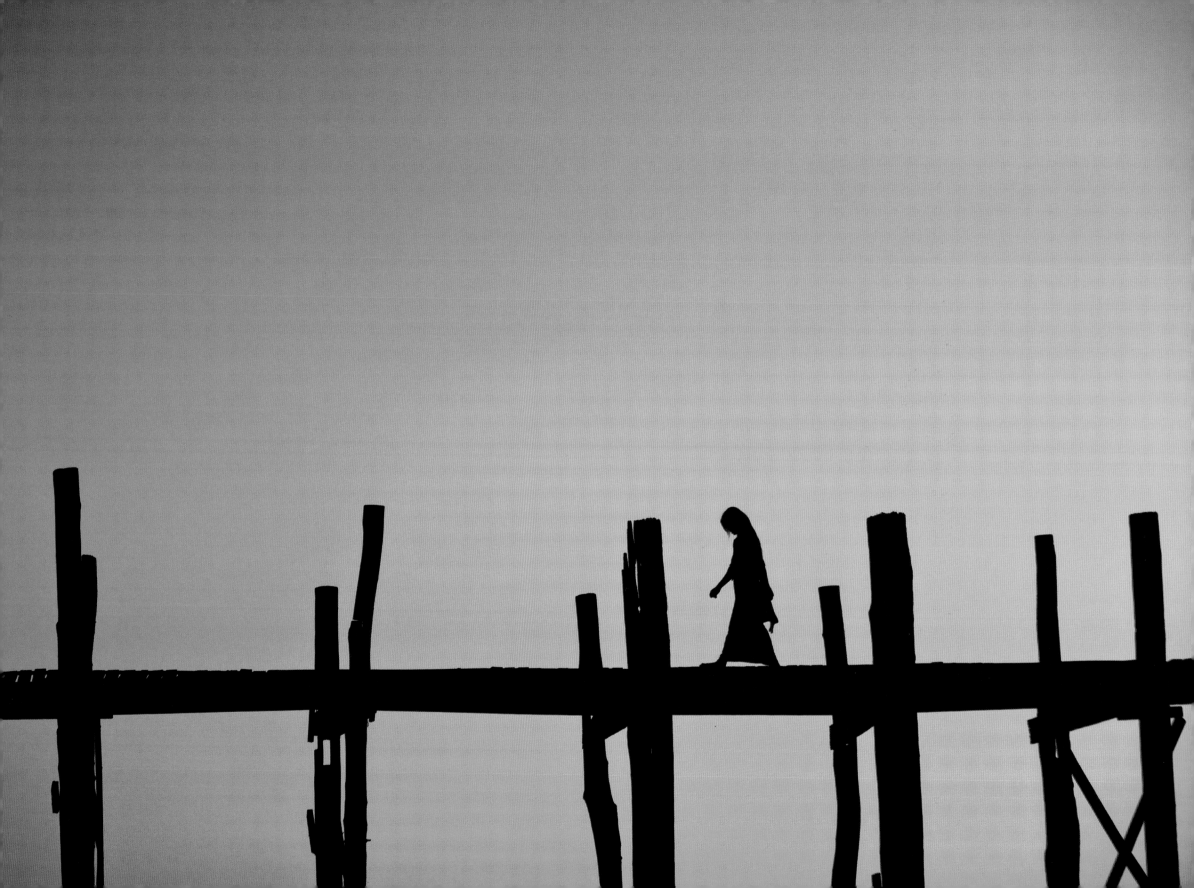

Passage

to Burma

Scott Stulberg

Skyhorse Publishing

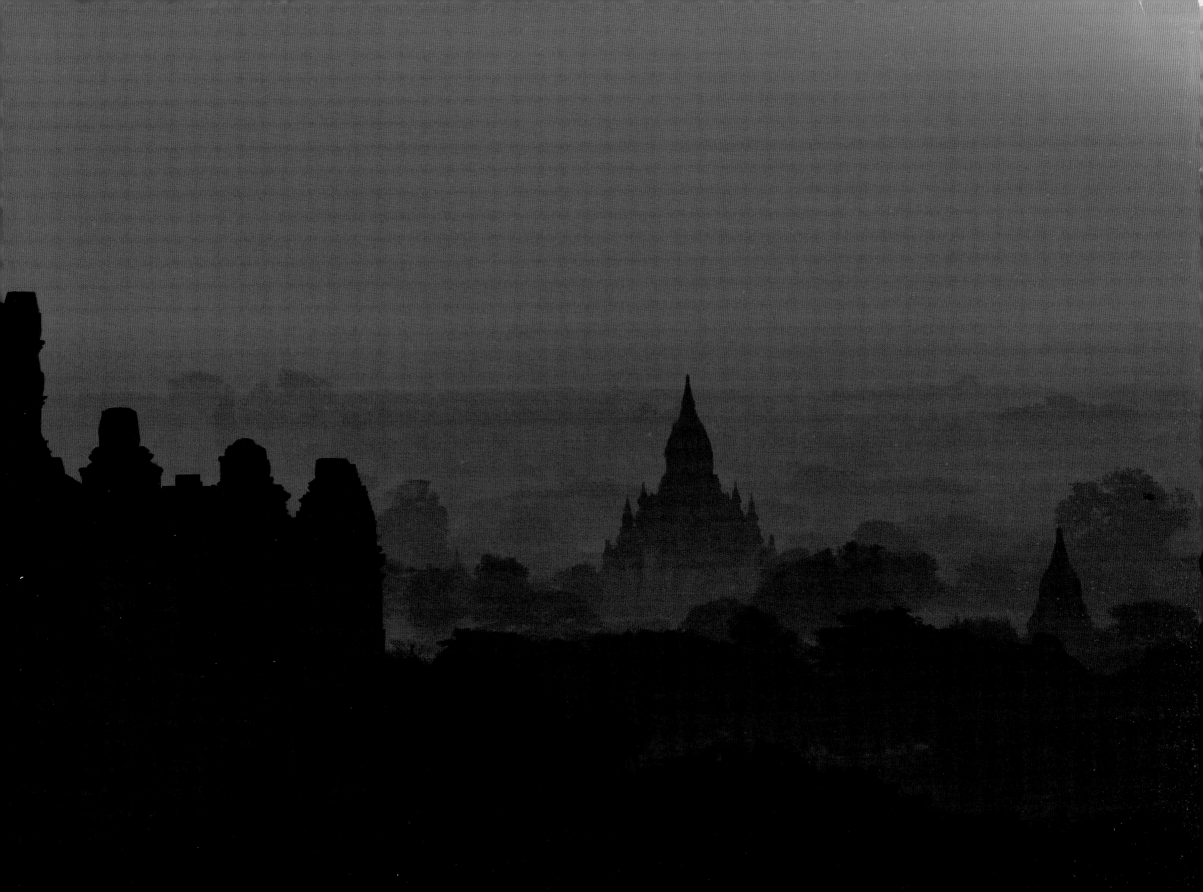

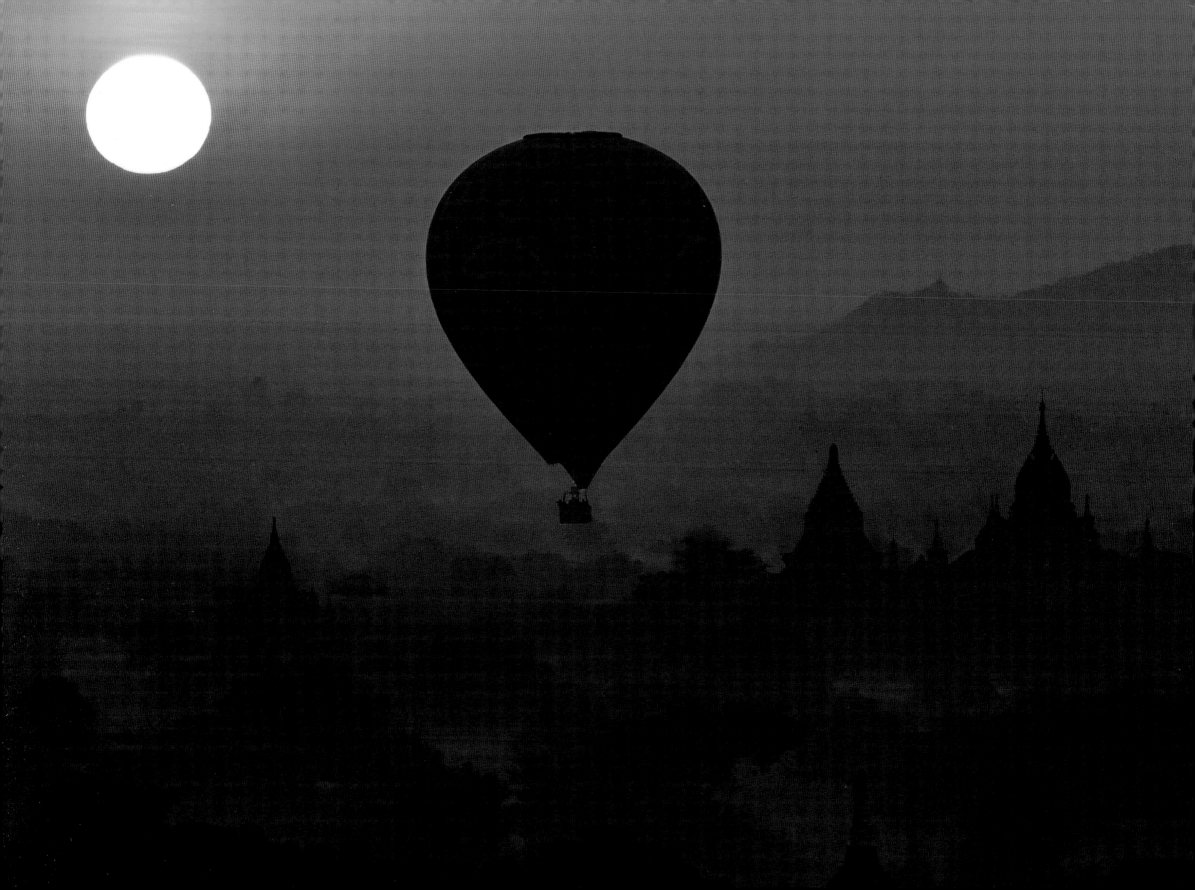

For my baby

Years ago in a basic photography class in Los Angeles, one of my students was a shy young girl who had no idea she would change my life forever. She has been the wings of my inspiration and has shown me what true love can really be like.

Holly, you are the love of my life and I am so lucky that you found me that day long ago and forever changed our destiny.

With you at my side, anything is possible . . .

Acknowledgments

I want to thank two individuals without whom this project would not have been possible.

The first is my good friend Dr. Steven Shepard, whose true friendship and expertise on so much about this world we live in have shown me what wisdom is all about. My travels on this planet pale in comparison to his, and his guidance and forethought have helped me understand how to explain life's experiences in words. You helped me find my voice for this book, and your friendship I consider one of the great gifts of my life and will forever be in debt. Thank you, Steven.

And to my Burmese guide Win, one of my favorite people alive. You opened my eyes to really see inside my favorite country and over the years have shown me what Burma is all about. You realized from our first trip together long ago what I was seeking and helped me find my artistic vision inside your amazing country. You knew what I wanted to capture before I did half the time, and the two of us are always magical together. You've called me your favorite photographer, which is such an honor coming from you, but you are without a doubt the secret to my success in one-of-a kind Burma. I'm not sure if I can ever thank you enough, but always know that this book is because of you. We pushed each other to get powerful images of your country, but if not for you . . . I know this book would be a distant dream.

And last, to my mom and dad, who long ago gave me my first camera at the age of ten and never stopped encouraging me to keep my eyes open and try new things.

I miss you both so much . . .

Copyright © 2013 by Scott Stulberg

All Rights Reserved. No part of this book may be reproduced in any manner without the express written consent of the publisher, except in the case of brief excerpts in critical reviews or articles. All inquiries should be addressed to Skyhorse Publishing, 307 West 36th Street, 11th Floor, New York, NY 10018.

Skyhorse Publishing books may be purchased in bulk at special discounts for sales promotion, corporate gifts, fund-raising, or educational purposes. Special editions can also be created to specifications. For details, contact the Special Sales Department, Skyhorse Publishing, 307 West 36th Street, 11th Floor, New York, NY 10018 or info@skyhorsepublishing.com.

Skyhorse® and Skyhorse Publishing® are registered trademarks of Skyhorse Publishing, Inc.®, a Delaware corporation.

Visit our website at www.skyhorsepublishing.com.

10 9 8 7 6 5 4 3 2 1

Library of Congress Cataloging-in-Publication Data is available on file

ISBN: 978-1-62636-141-6

Printed in China

Contents

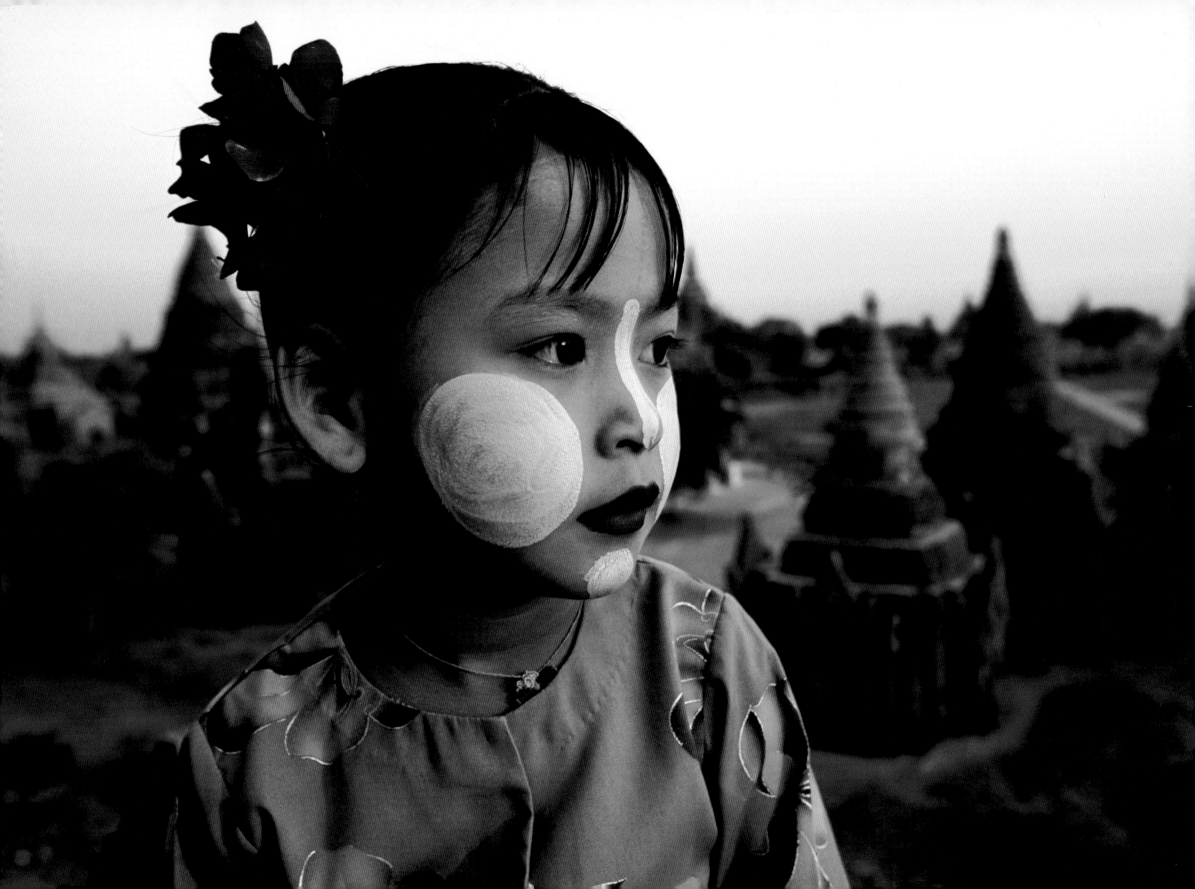

San-San, her angelic face glowing in the setting sun
near Bagan, will forever represent Burma to me.
My friend for life, San San is indeed an angel.

Introduction

The names here evoke thoughts of intrigue, of quiet voices in smoky bars with slowly spinning fans overhead: Burma, Myanmar, Mandalay, Rangoon, Bagan. The country lies in the sweltering belt between the equator and the Tropic of Cancer, and monsoons are an ever-present reality. When the monsoons come, entire landscapes disappear. When they leave, shifting mists envelop the teak and ironwood and bamboo forests and the timeless temples that dot the landscape of this magical place. And when the sun sets, a new dance of beauty begins: a quiet string of lanterns crossing a teak footbridge in Mandalay, carried by monks in red and saffron robes. A gaggle of children, playing in the street as the sun burns itself out in the treetops of the tropical forest. An ancient temple, shining in the afterglow of another day's end.

For over ten years, I have traveled to Burma (Myanmar) as a photographer, a chronicler of events, and a documentarian of social change. I first came here in 2001 and stepped into a time warp that transported me to a place of mystery wrapped in intrigue and swaddled in the kindness of Buddhism, cloaked in the historical mists of a country that began almost 2,000 years ago. This is a place that gently sinks its cultural talons into one's psyche, and by the time a person realizes it happened, it's too late to escape the country's powerful magnetism.

Why does one call it Burma and another call it Myanmar? Depends on who you ask. Burma was changed to Myanmar and Rangoon to Yangon after a huge suppression by the military of a popular uprising. The change was recognized by the United Nations, and by countries such as France and Japan, but not by the United States and the United Kingdom. So the use of Burma can indicate non-recognition for the military junta, and the use of Myanmar can indicate a distaste for the colonial powers of the past who called the country Burma. For me and my friends, it will forever be Burma.

Burma is a country of incomprehensible contrast, a place ruled by a brutal and ironfisted military junta for the better part of five decades, imprisoning those who dissented, or worse. On the other end of the cultural scale are Burma's Buddhist monks, the most open, charming, friendly, accepting, non-judgmental people on earth. Those qualities alone have caused them to be targets of the government, yet they remain open and accepting in spite of the brutal treatment they have endured. How two such radically different views of life—one based on fear and oppression, the other on acceptance, forgiveness, and kindness—can co-exist in the same country is one of the questions that draws me back, year after year.

The names in this place conjure up fleeting glimpses of Somerset Maugham, whose nineteenth-century writings about Burma captured the essence of Burma ("In these countries of the East, the most impressive, the most awe-inspiring monument of antiquity is neither temple, nor citadel, nor great wall, but man."); of Rudyard Kipling, whose acerbic wit failed to hide his admiration; and of John Le Carré, whose Asia-based novels seemingly took place in every dark, mysterious corner of this country. These are not the unpronounceable names of China, or Thailand, or Cambodia—they are the soft, idyllic, mysterious names of a very different place. Mandalay. Rangoon. Irrawaddy. Tavoy. These names don't challenge; they seduce.

Burma lies on the east side of the Bay of Bengal, snuggled against a gaggle of exotic neighbors—India to the west, China, Laos, and Thailand to the east. It is the geographic barrier between the Indian and Chinese superpowers, a less-than-envious role for any country. On the other hand, Burma has held its own for nearly twenty centuries, including three wars against colonial Britain, each time inflicting massive casualties on the United Kingdom's armies. Kipling himself wrote about it in Letter II, the 1889 journal of his wandering voyage to Rangoon (collected in *From Sea to Sea*). His account of the journey up the Irrawaddy River captures his feelings about the place:

"As we gave the staggering rice-boats the go-by, I reflected that I was looking upon the River of the Lost Footsteps—the road that so many, many men of my acquaintance had travelled, never to return . . . They had gone up the river in the very steamers that were nosing the yellow flood and they had died since 1885. At my elbow stood one of the workers in New Burma . . . and he told tales of . . . deaths in the wilderness as noble as they were sad. Then, a golden mystery upheaved itself on the horizon . . . a shape that was neither Muslim dome nor Hindu temple spire . . . the golden dome said: 'This is Burma, and it will be quite unlike any land you know about.'"

Kipling was right. Burma is politically, culturally, economically, and spiritually unique, a country of puzzling contrasts. Politically, the right-wing military junta that runs the country is pitted against an army of gentle, pacific monks. Culturally, Burma is a "country of countries," a gaggle of ethnic groups that live harmoniously in vastly different geographies. Economically, the country is among the poorest on earth, yet is in the midst of a tourism renaissance. And spiritually, Burma is the heart of Buddhism. How to reconcile these vastly different perspectives?

Some would conclude that I, in my many visits to Burma, seek answers to something, but the very questions to ask elude me. What I do know is this: When imagination, knowledge, and camera collide here, seduction is the ultimate result. This book is a journal of my journey through the seductive space and time of a place called Myanmar—or Burma, to its friends.

"This is Burma and it will be quite unlike any land you know about."

–Rudyard Kipling

Letters from the East

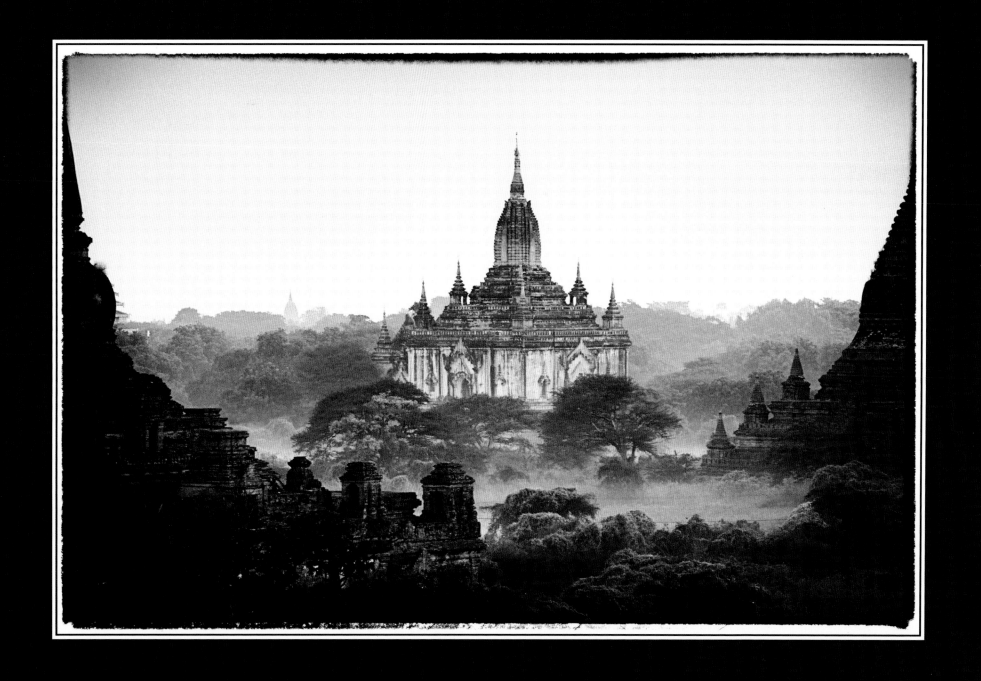

Bagan

In *The Gentleman in the Parlour: A Record of a Journey from Rangoon to Haiphong,* W. Somerset Maugham pondered the intellectual challenge before him: How to put into words a description of the grandeur and grace that confronted him every day of the voyage up the Irrawaddy River:

"In the distance I saw the pagodas for which it is renowned. They loomed, huge, remote and mysterious out of the mist of the early morning like the vague recollections of a fantastic dream."

This is my favorite place in the world to photograph. I have tried many times to understand why, but like W. Somerset Maugham, I have difficulty finding the words. Perhaps it is the fact that, looking down on the temples and pagodas that pepper and shape the area, I feel that the world is bigger than the world I was born into. Or that I feel irreversibly changed every time I come to this place. Or that, no matter where I point my camera, there is a unique, powerful, and heart-stopping image that jolts my senses to life and makes me want to relish every moment that I am in Bagan.

This place is the place of dreams. And as Marco Polo wrote: "Bagan is a gilded city alive with tinkling bells and the swishing sounds of monks' robes." Founded almost 1,200 years ago, Bagan served as the first royal capital between 1044 and 1287. It was the center of Theravada Buddhism, the religion practiced in Burma and promoted by King Anawrahta in the eleventh century. This is Buddhism writ large. Scattered along the banks of the Ayeyarwady (also called Irrawaddy) River, two thousand pagodas occupy an area one-sixth the size of Washington, DC. and they are so ever-present, so imposing, that they change the landscape. They terraform. And like Cambodia's Angkor Wat or Indonesia's Borobudur, Bagan is a cultural time warp, a place where time slows and becomes syrupy to match the stately pace of a country formed in the distant mists of another age.

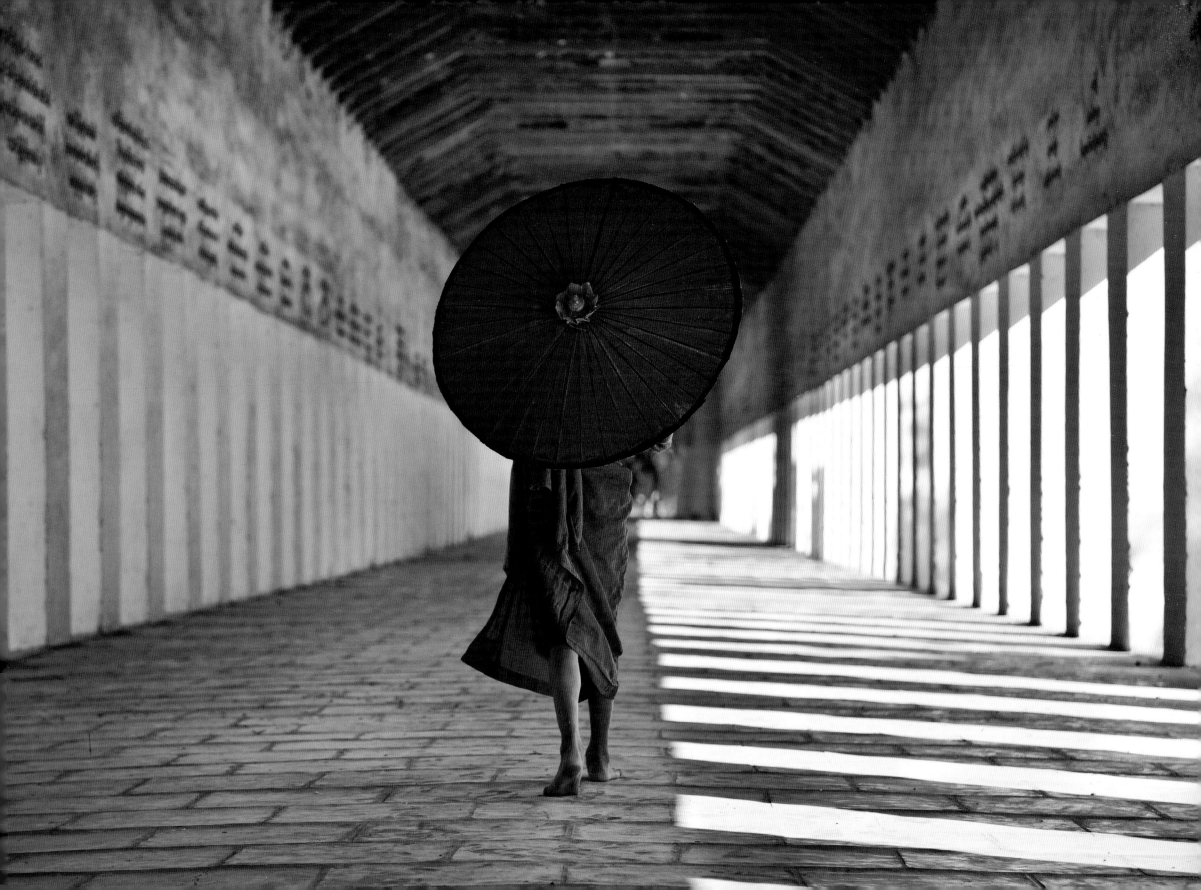

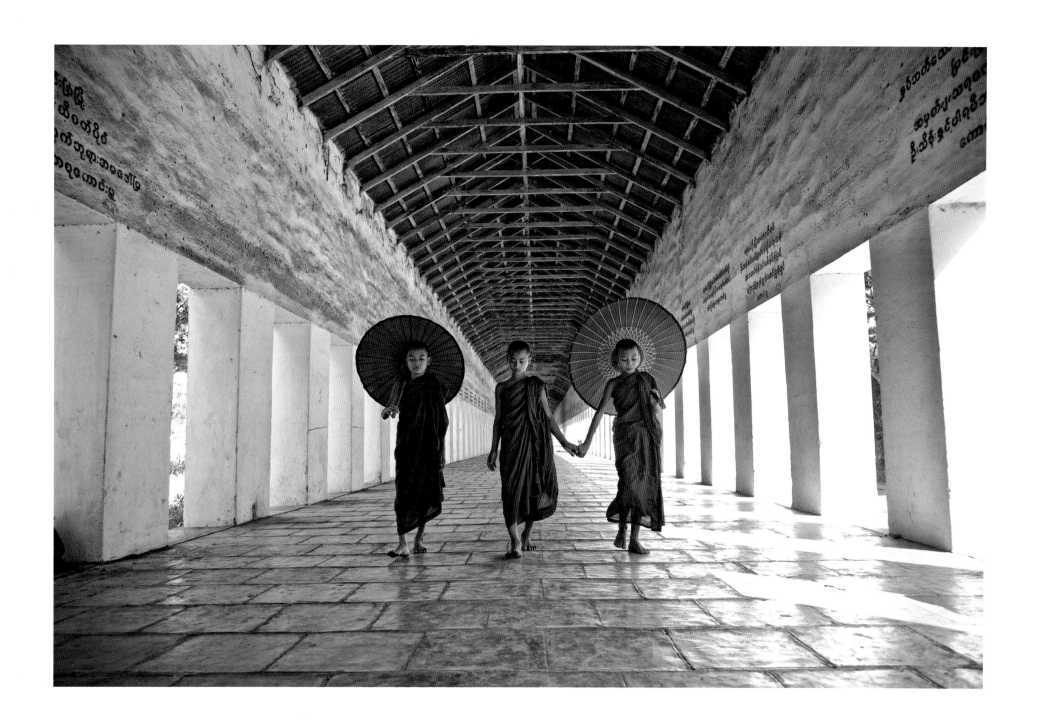

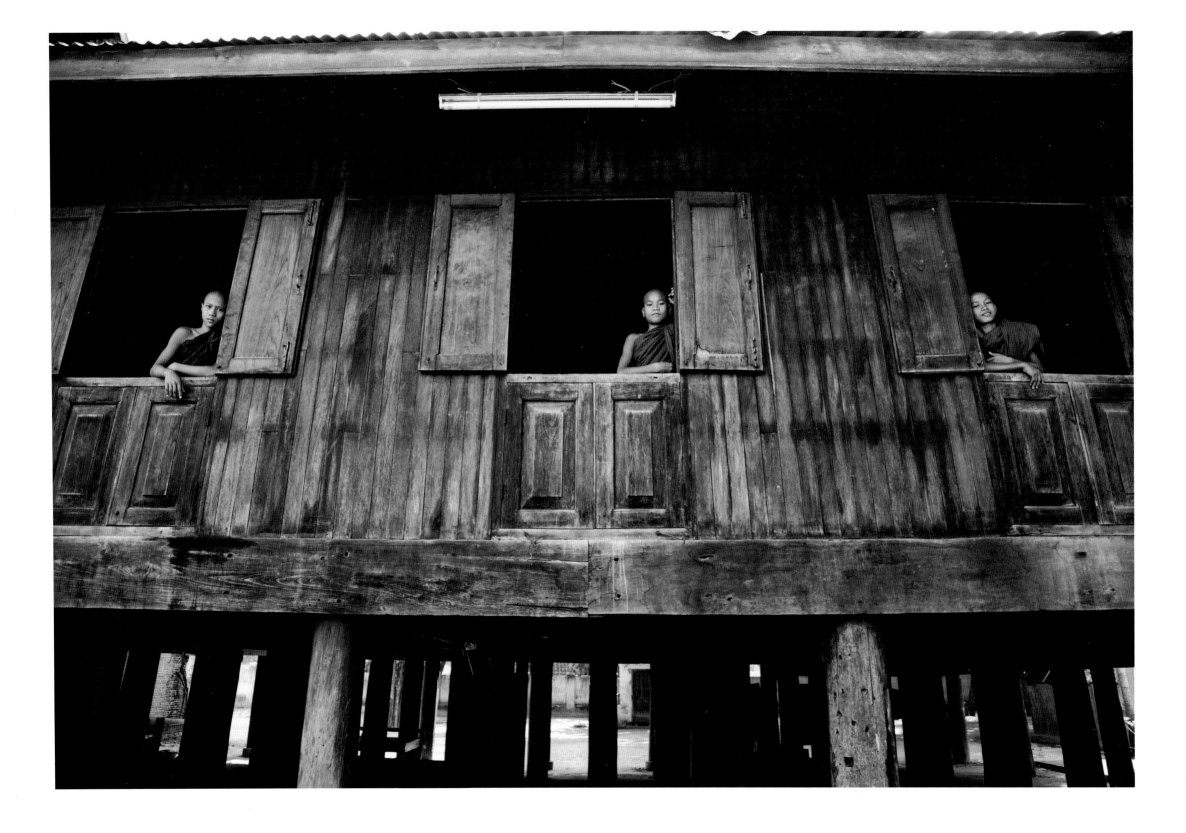

Thinking back to my first trip to Burma, it was really my special friends in the red robes that kept me curious. Their culture was so vastly different from what I had been used to, and they forever changed me and my ideals. They are without a doubt my favorite people on this planet.

Living in monasteries, monks choose a simple lifestyle where most modern conveniences and luxuries are foregone. Instead, this lifestyle allows them to cultivate a peace and happiness that few others will ever possess.

"If you smiled at me, I would understand, because that is
something everybody everywhere does in the same language."

Graham Nash, *Wooden Ships*

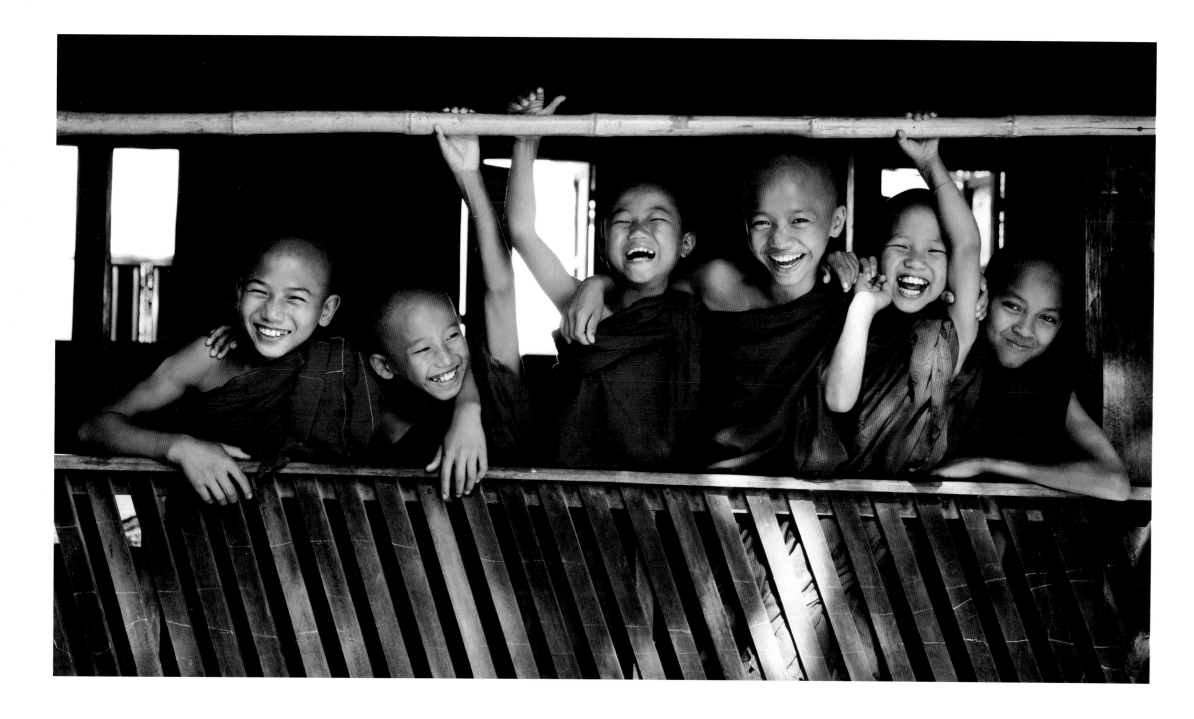

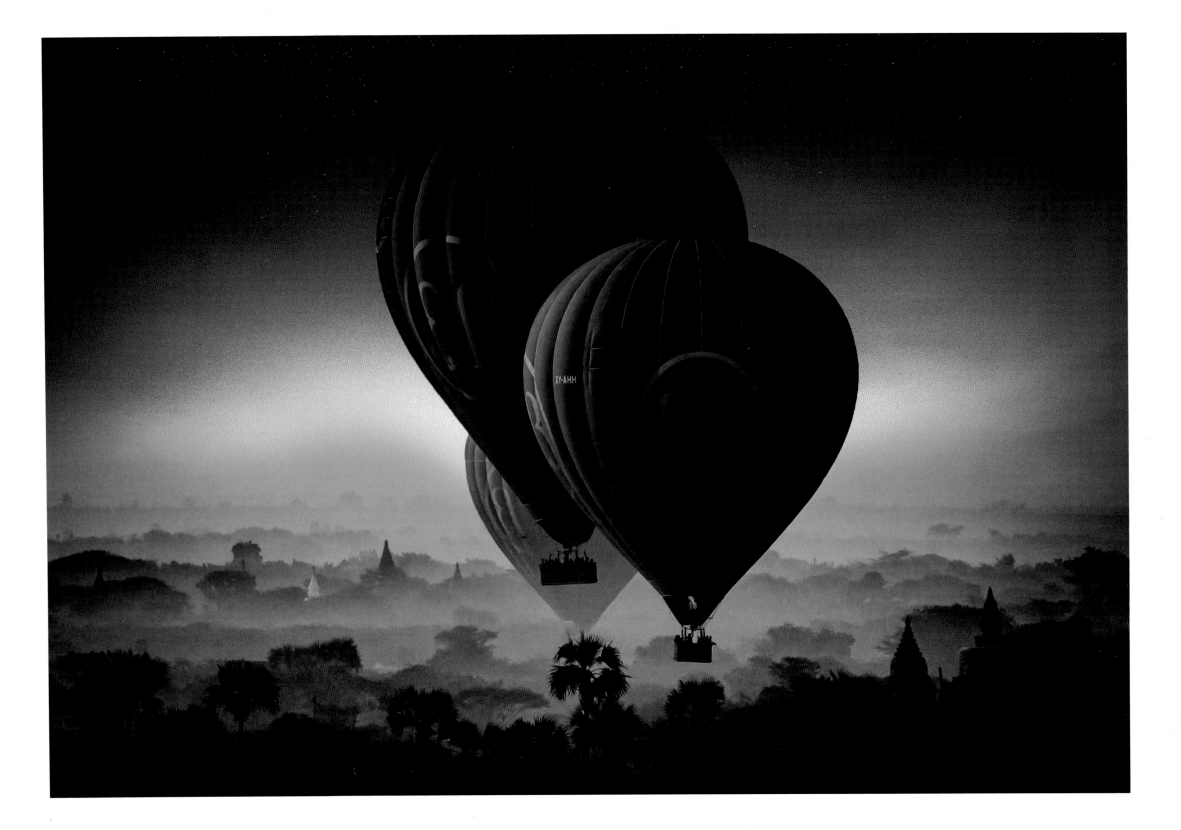

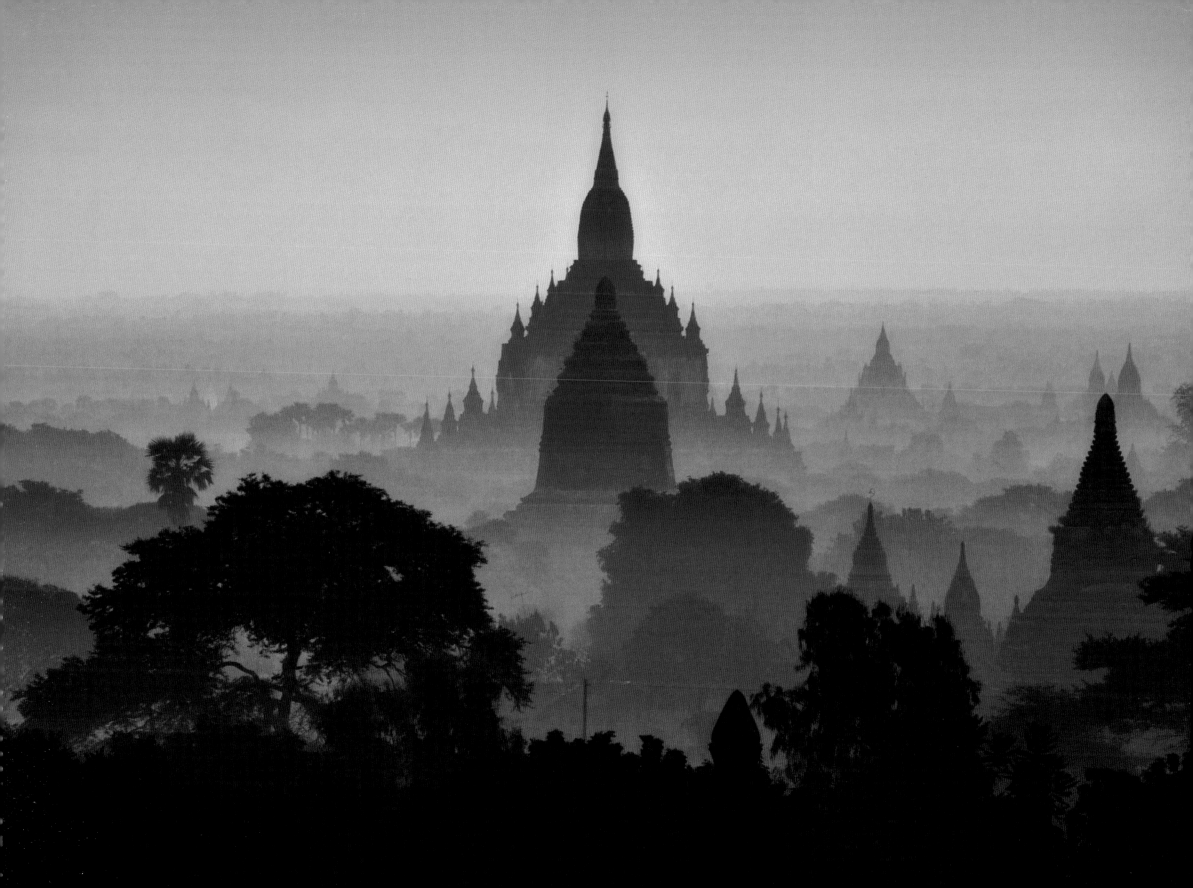

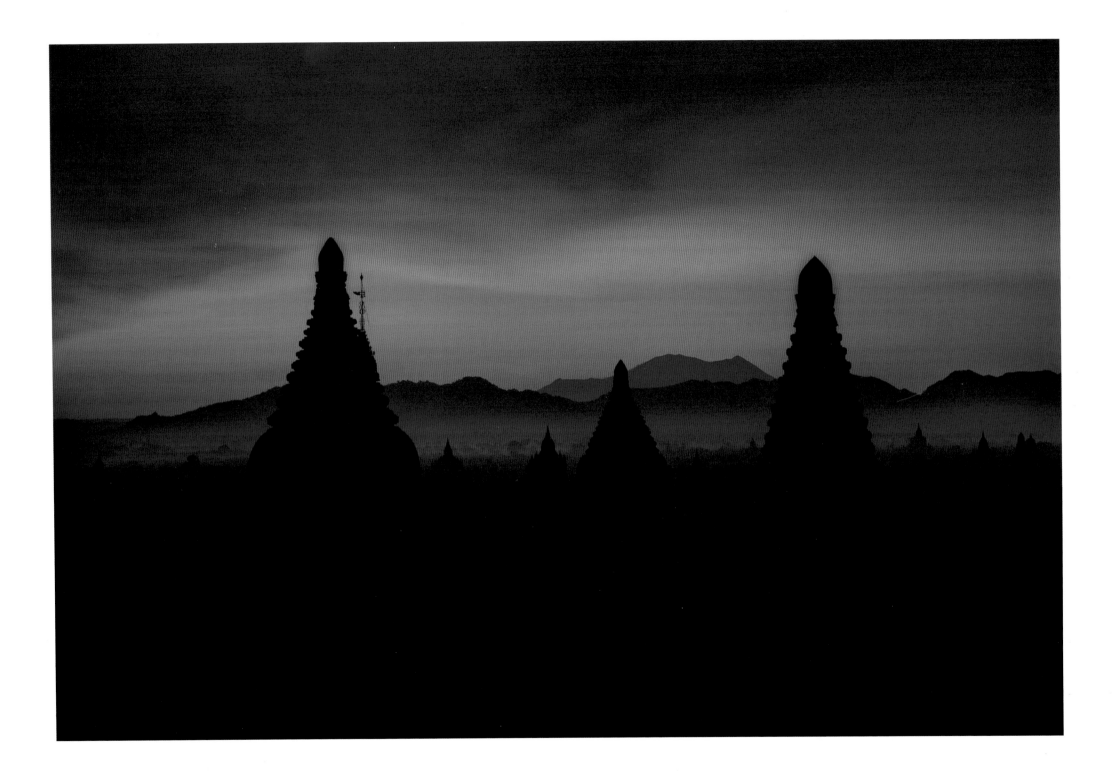

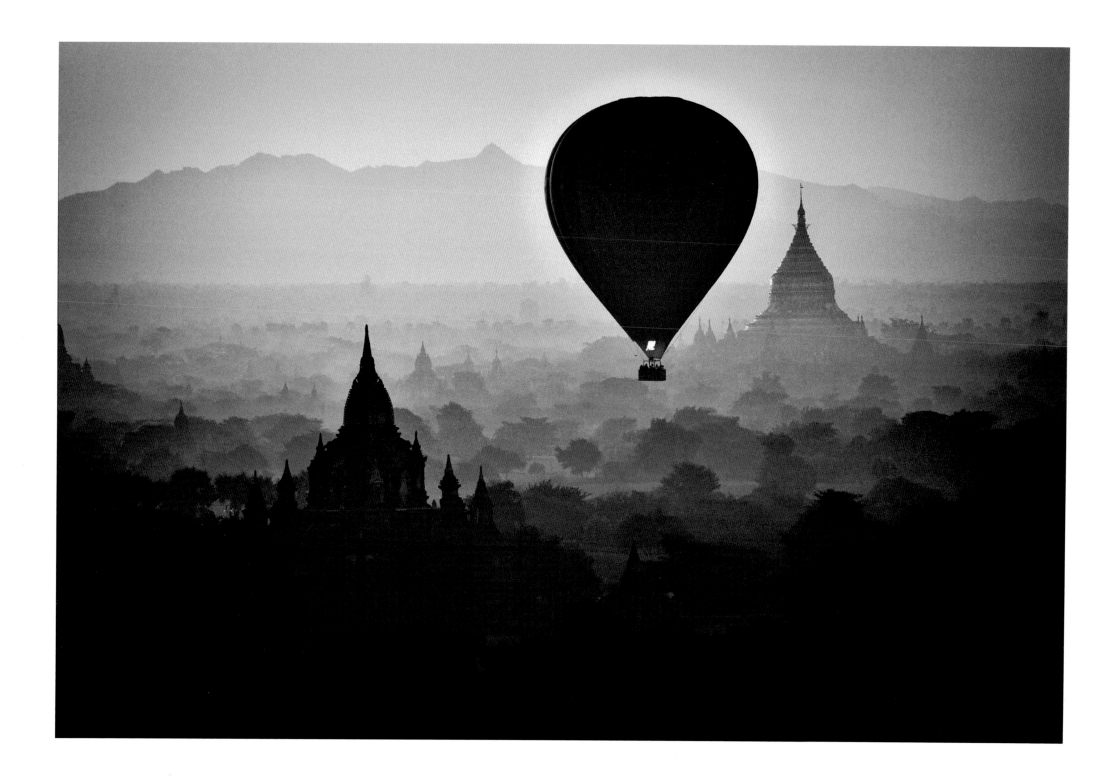

Built between the eleventh and thirteenth centuries, the magnificent temples and pagodas of Bagan number in the thousands and are a feast for the eyes in every direction. When you are gazing across this magical place, you can't help but feel how Marco Polo felt in the thirteenth century when he first journeyed here, noting that it was one of the finest sights in the world with the most beautiful towers he had ever come across.

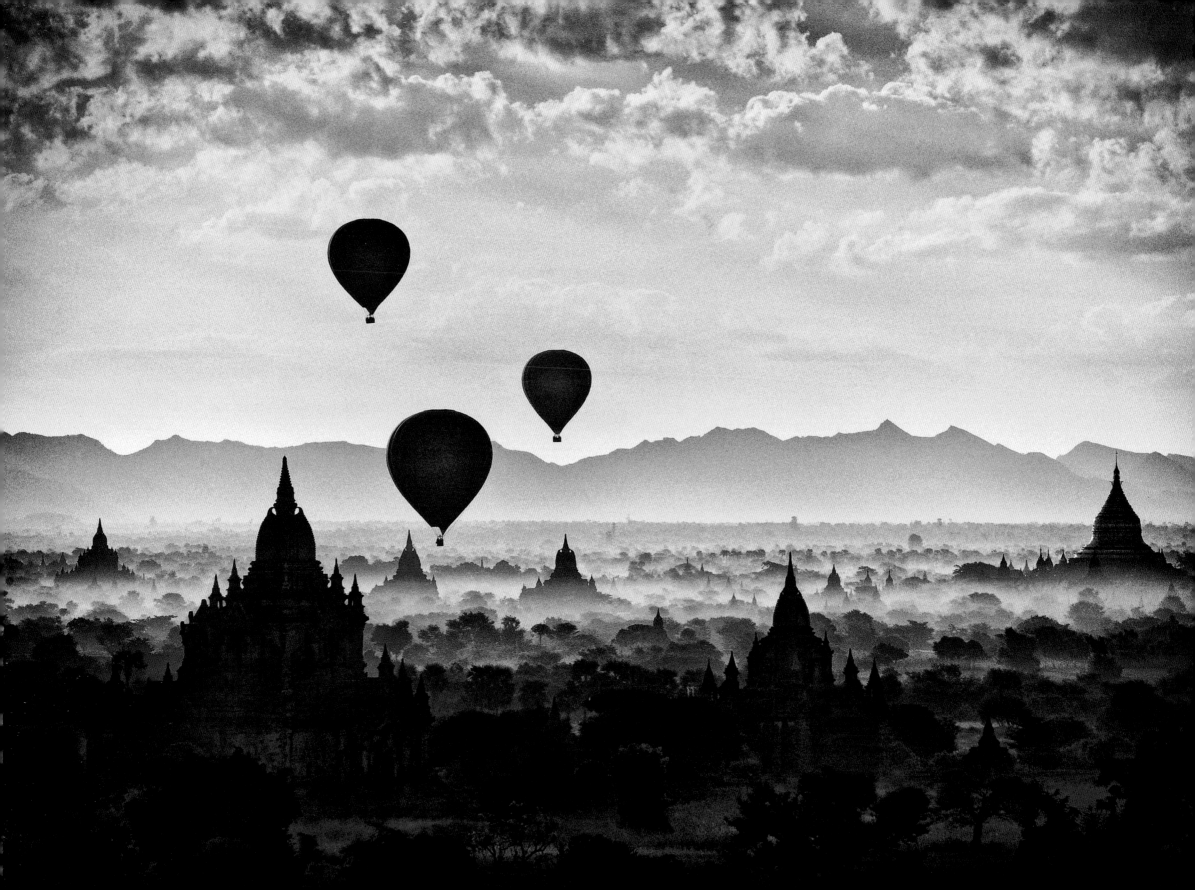

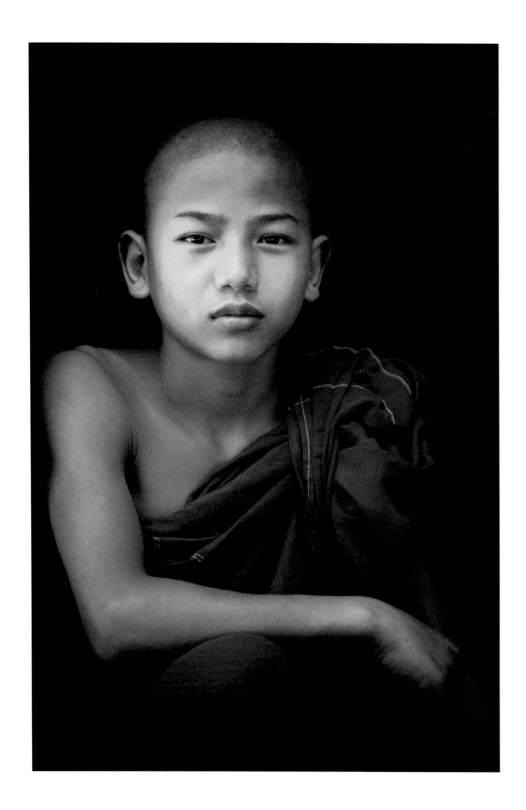
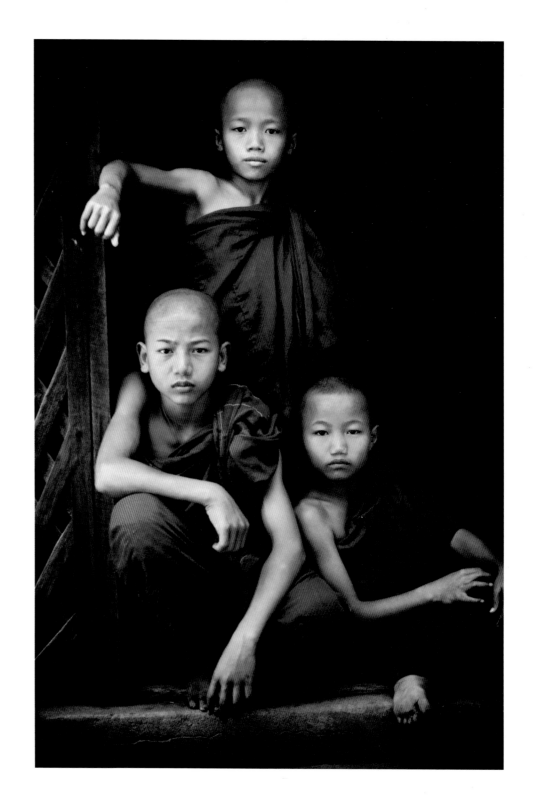

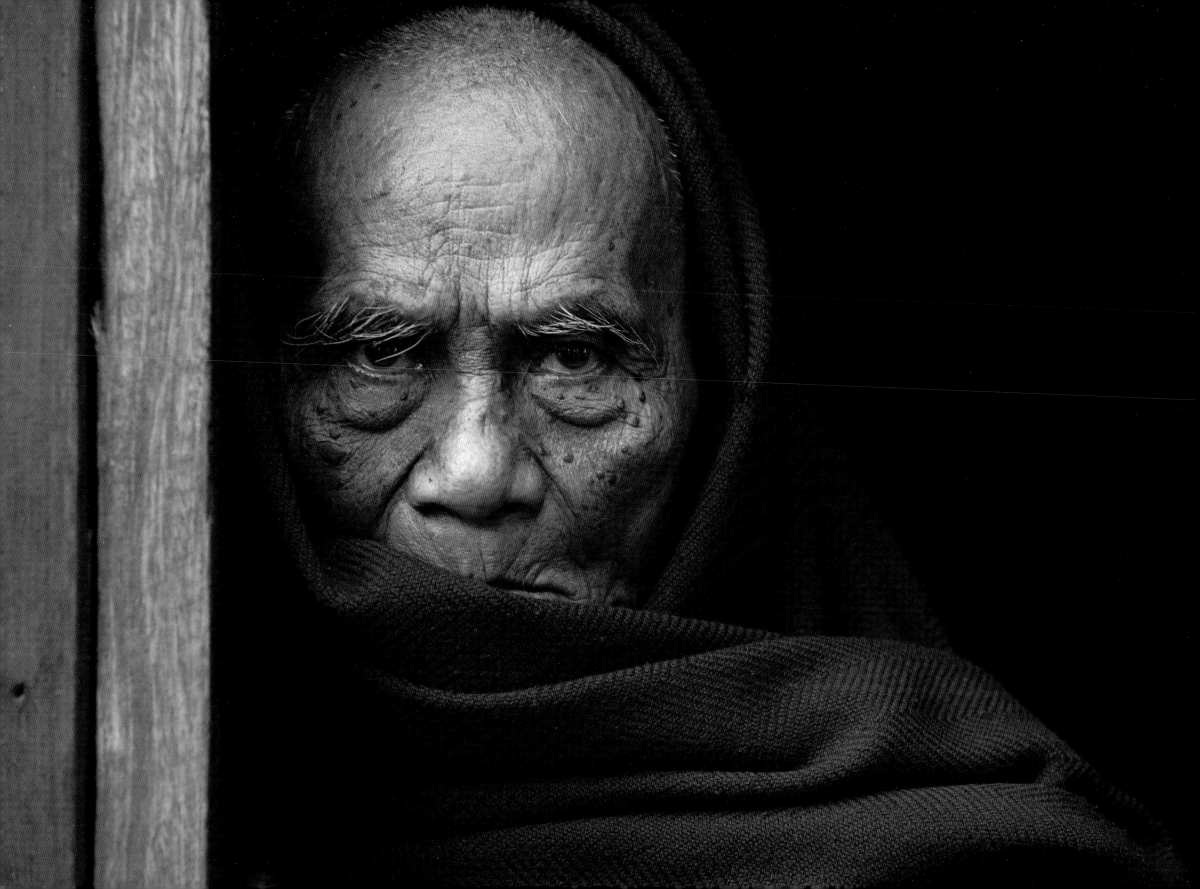

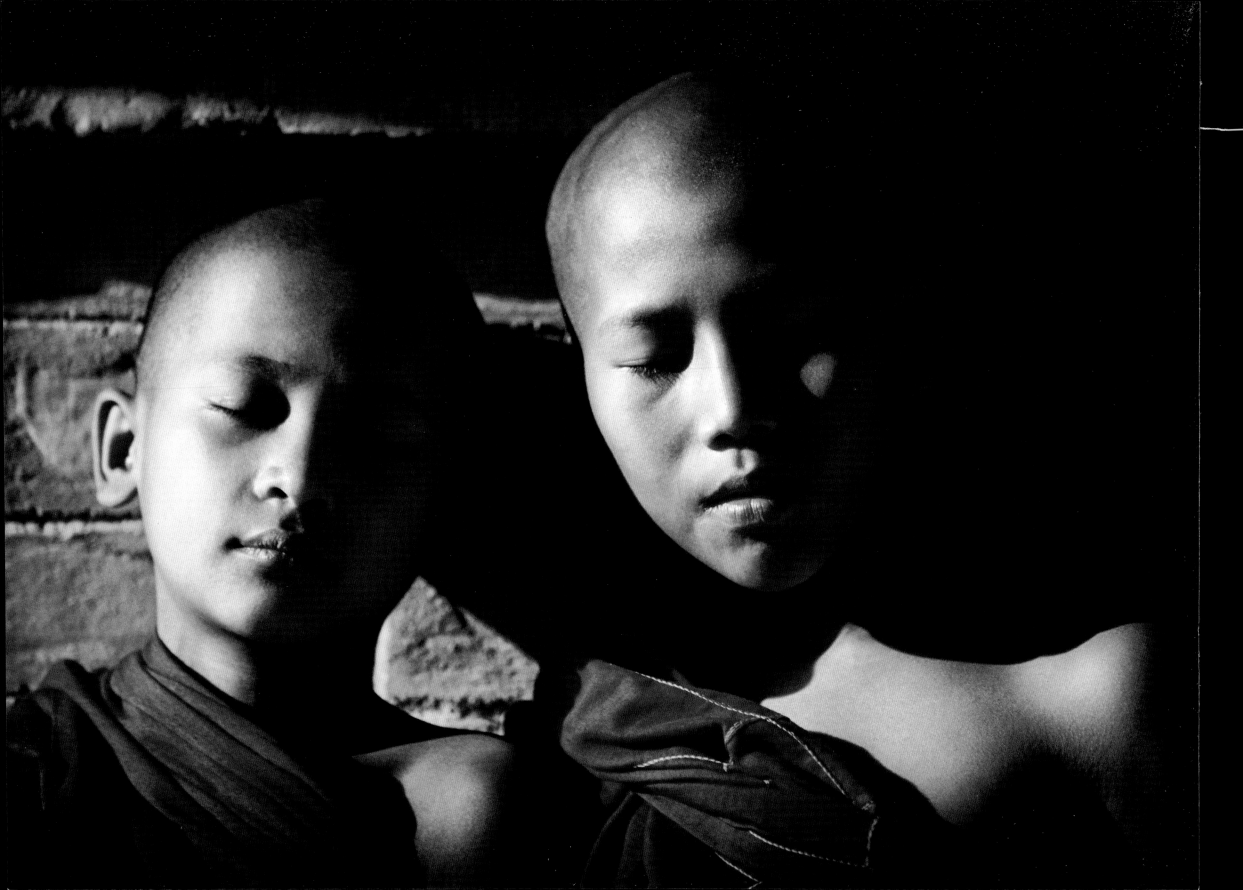

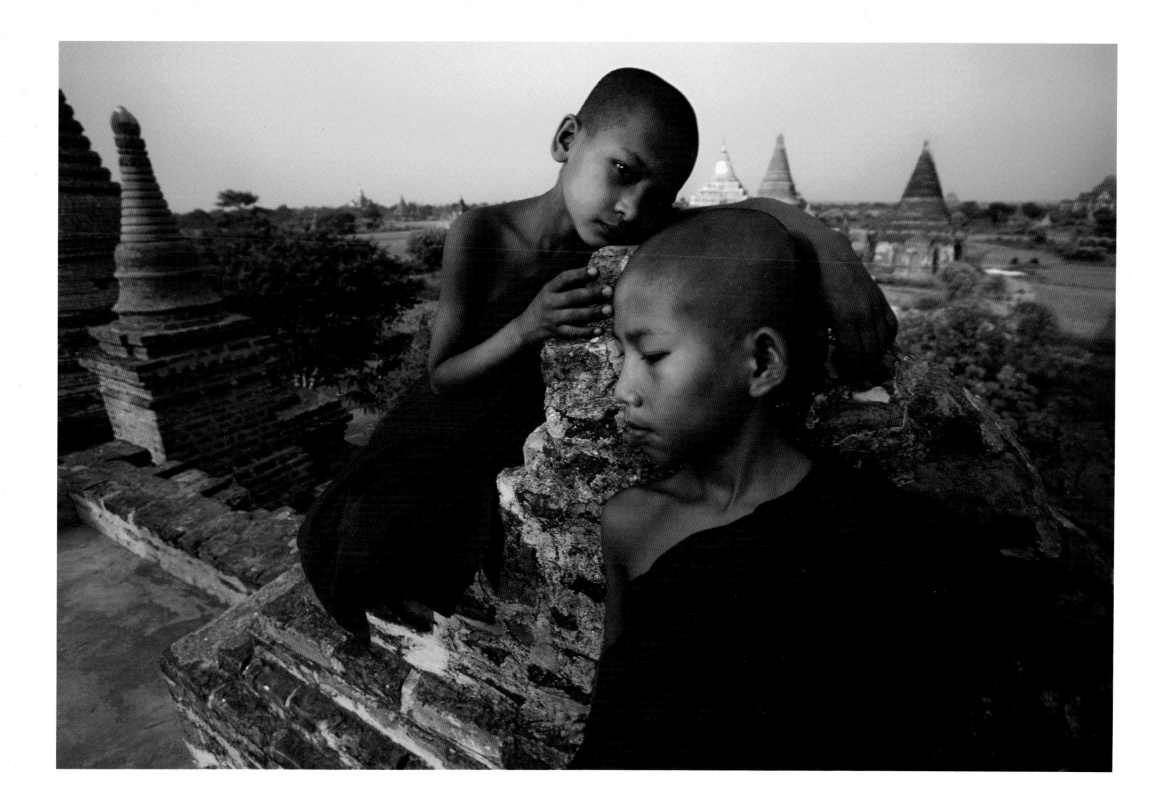

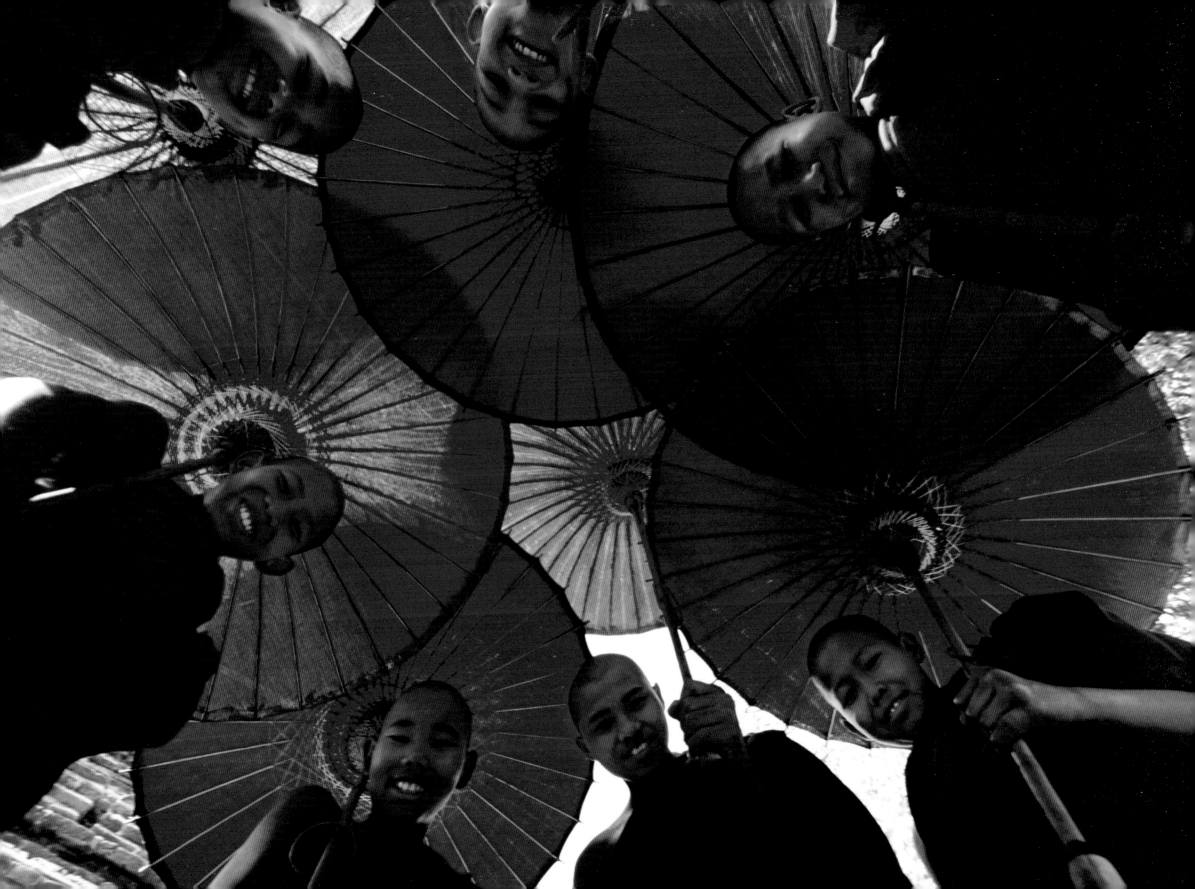

With most people practicing Buddhism, Burma is one of the most religious Buddhist countries on Earth, with tolerance, compassion, and love taking center stage in their beliefs. Their hope and desire is focused on achieving Nirvana, a state of enlightenment where all desire and suffering have been eliminated.

Monks are said to come closer than anyone else to understanding enlightenment through meditation and mental discipline. Just being around my amazing monk friends puts me in a state of Nirvana, as they are the most special people in the world.

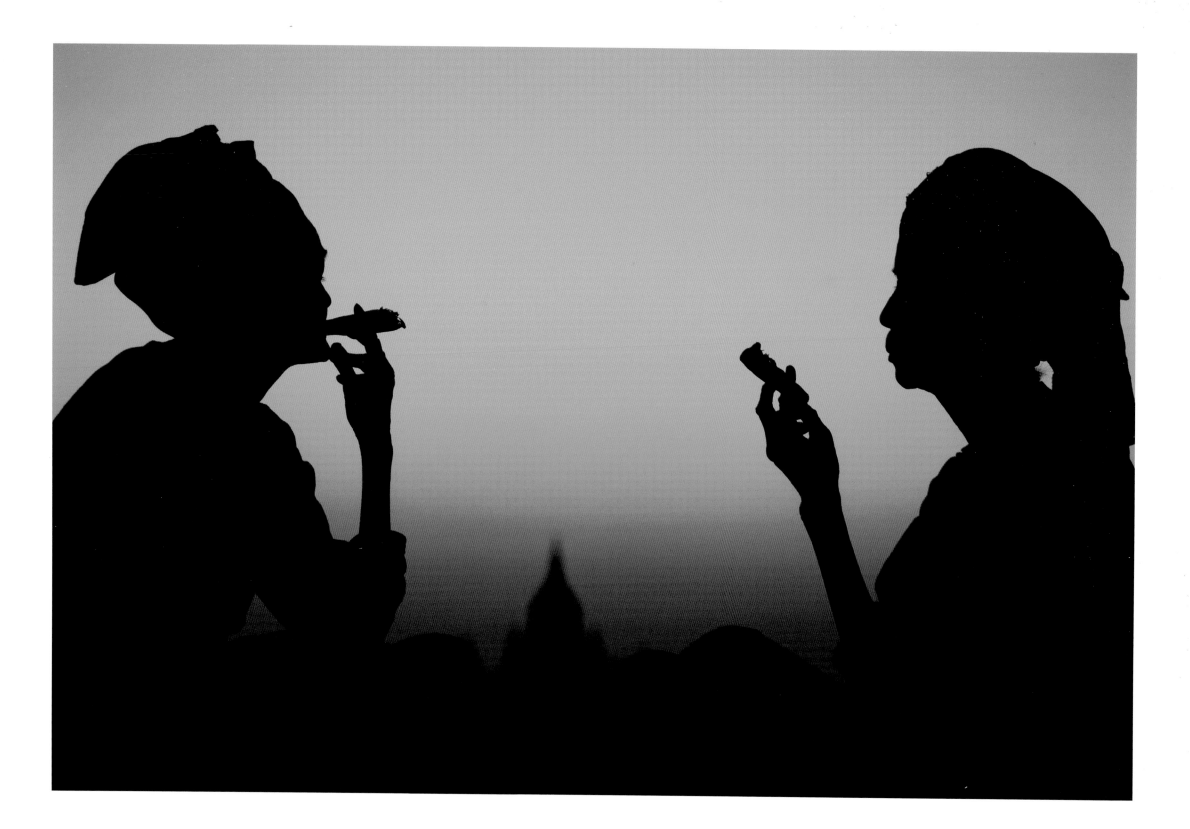

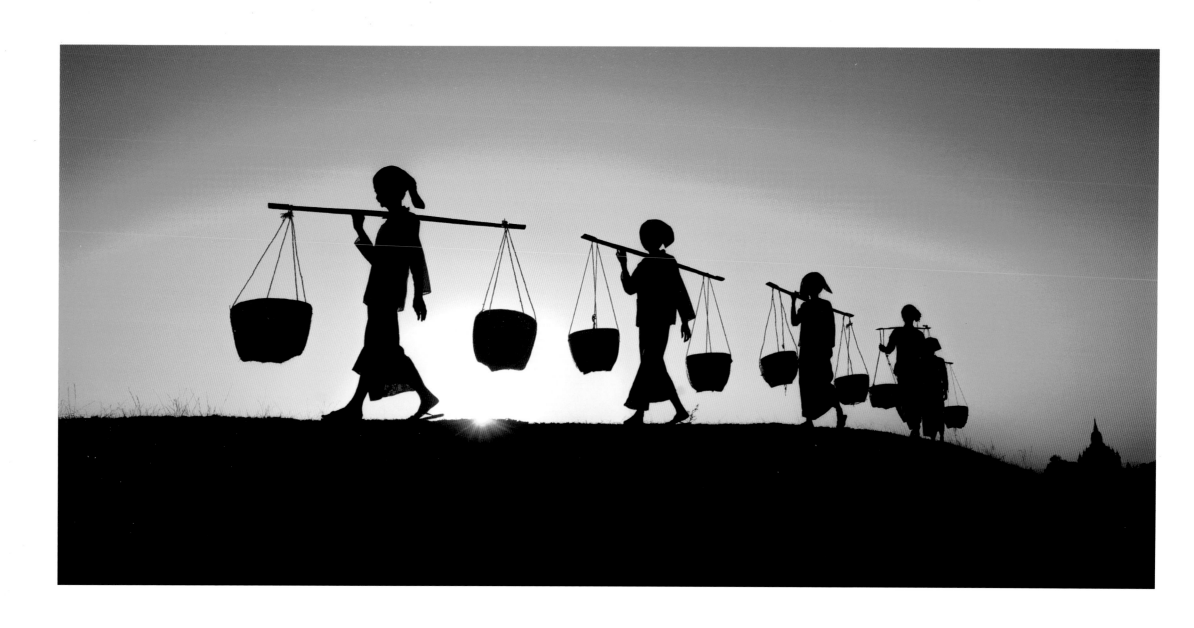

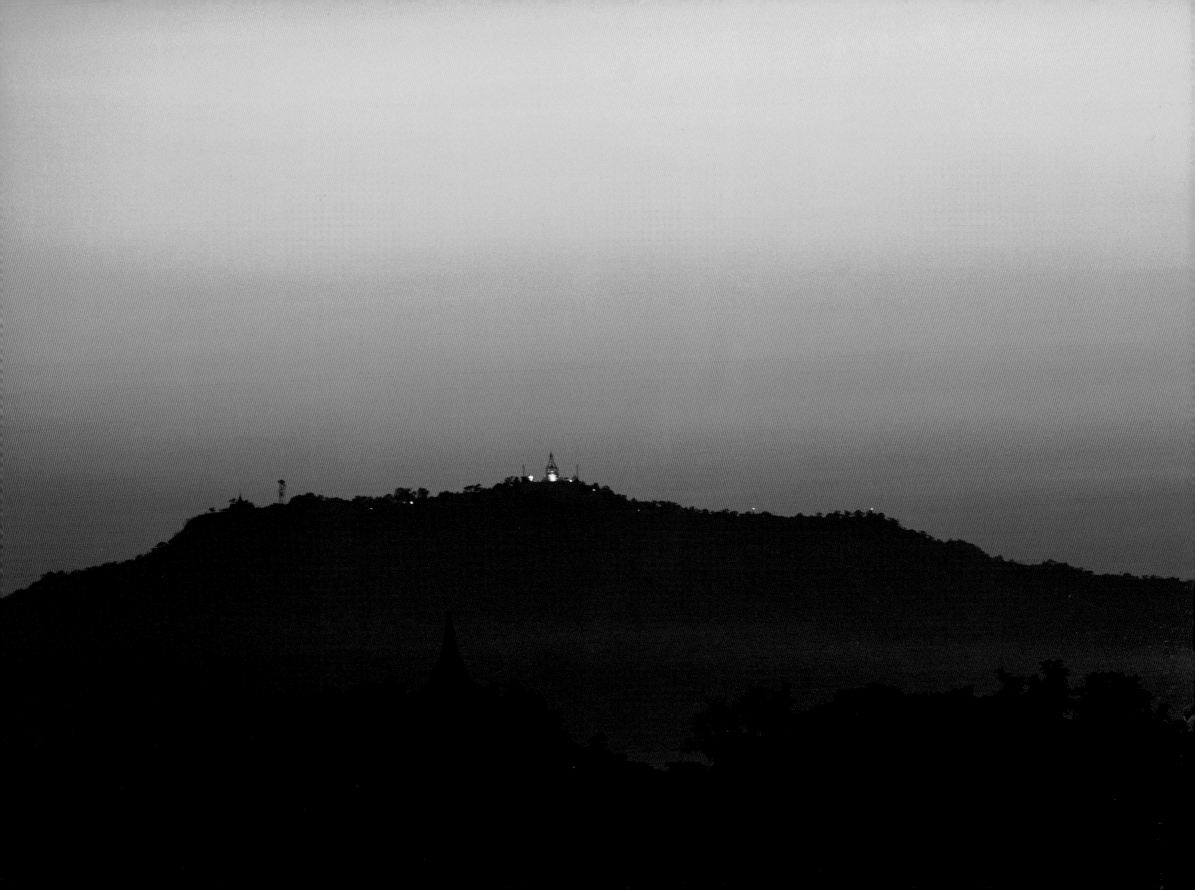

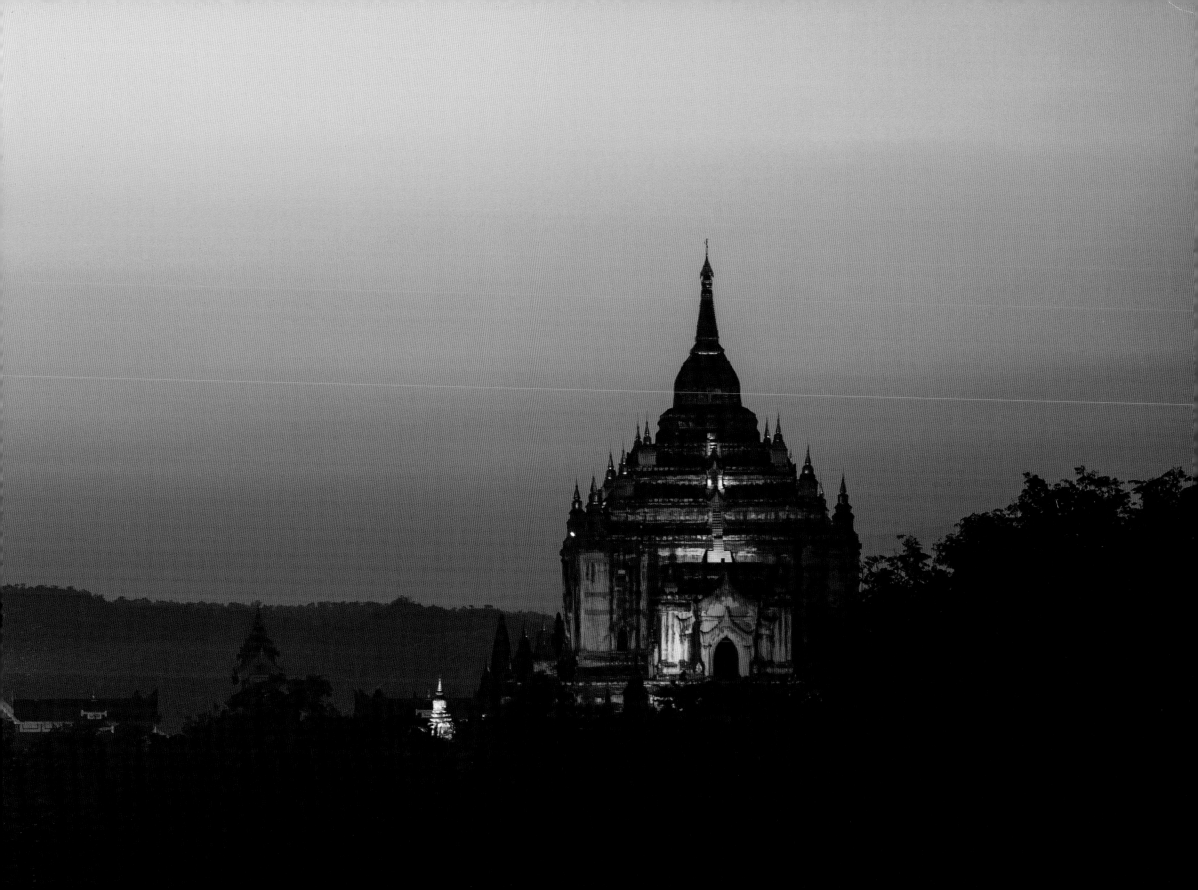

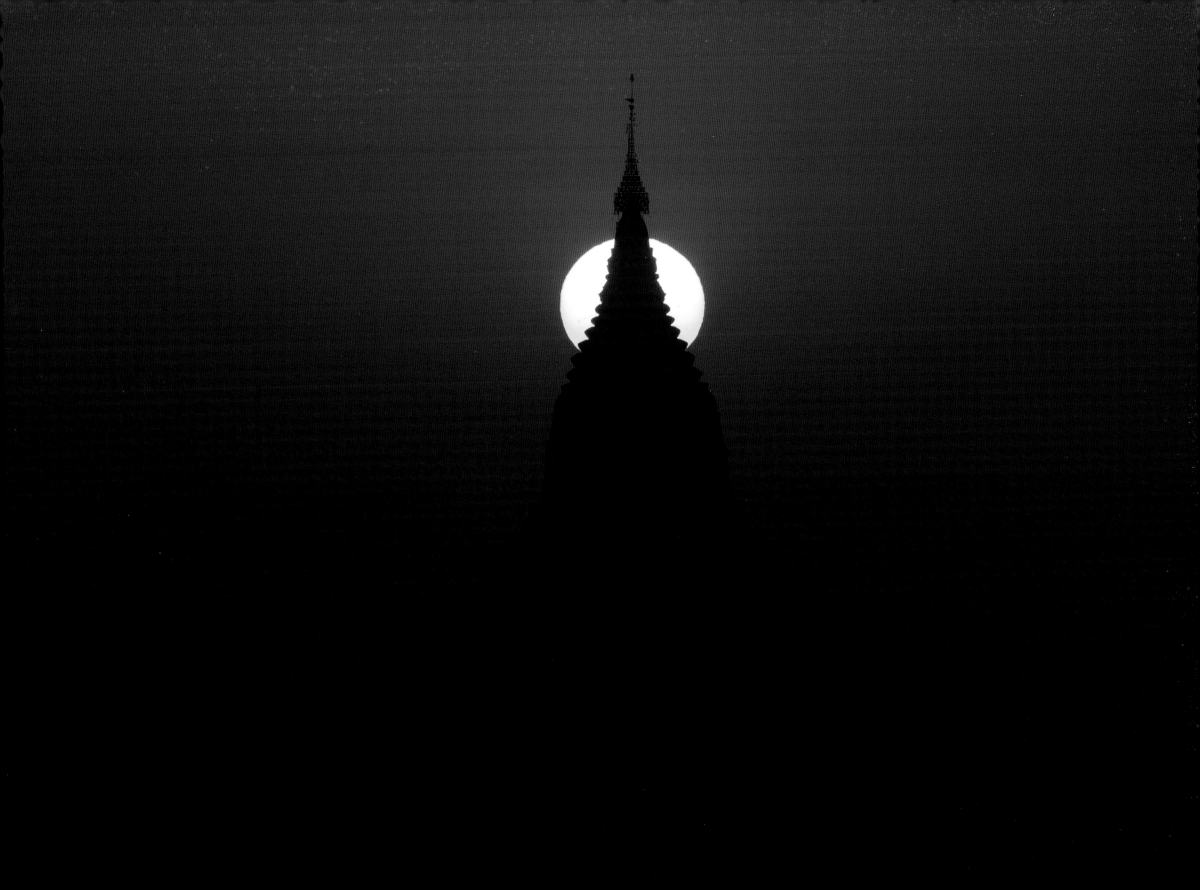

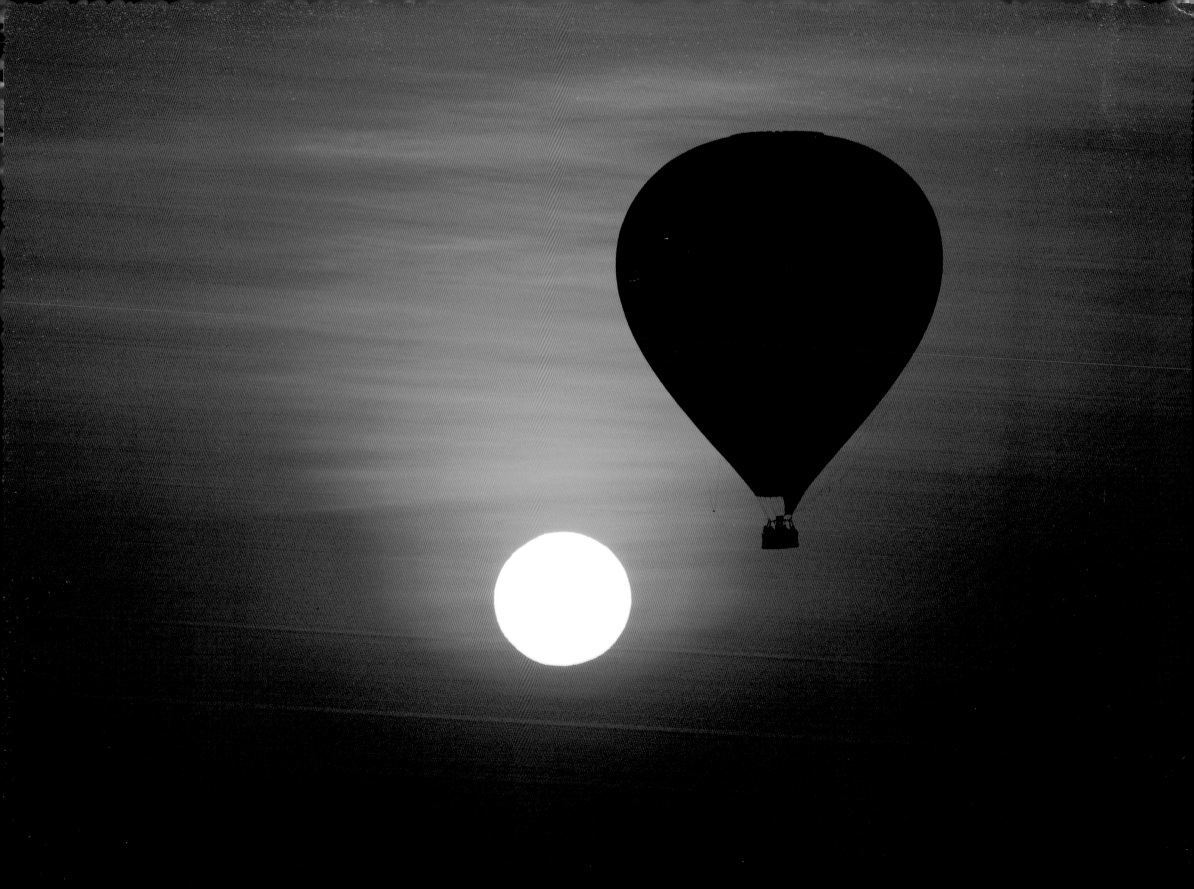

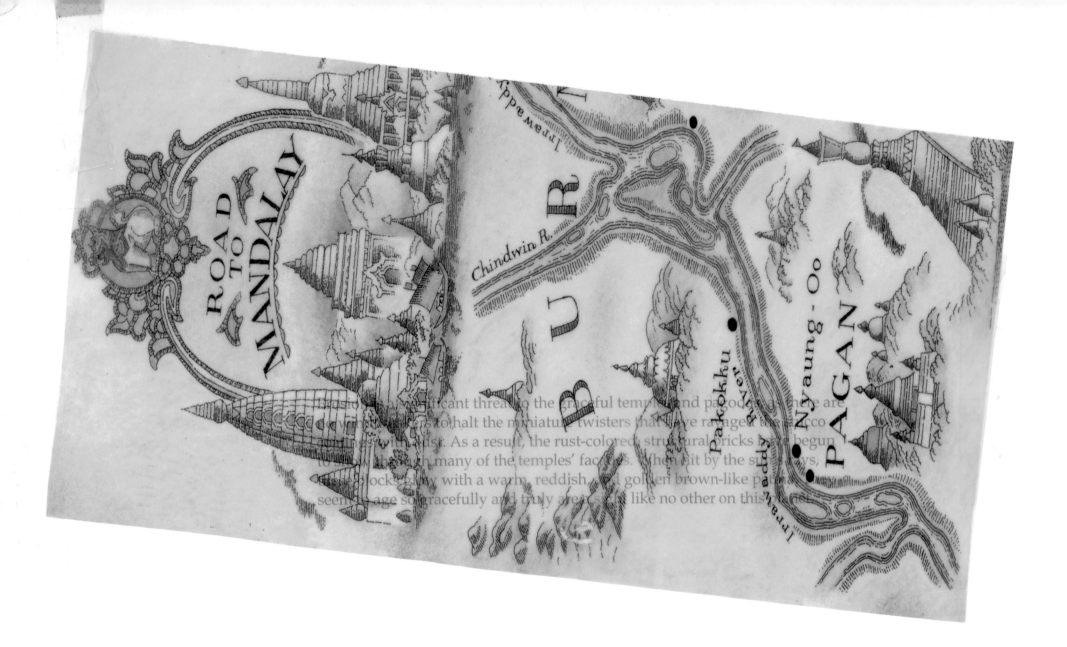

ROAD
TO
MANDALAY

Irrawaddy R.

Chindwin R.

B U R M A

PAGAN

Nyaung - Oo

Pakokku

Irrawaddy River

This poses a significant threat to the graceful temples and pagodas, as there are
covering cloths to halt the miniature twisters that have ravaged the stucco
coatings with dust. As a result, the rust-colored structural bricks have begun
to show through many of the temples' facades. When hit by the sun's rays,
these blocks glow with a warm, reddish, and golden brown-like patina. They
seem to age so gracefully and truly are special like no other on this planet.

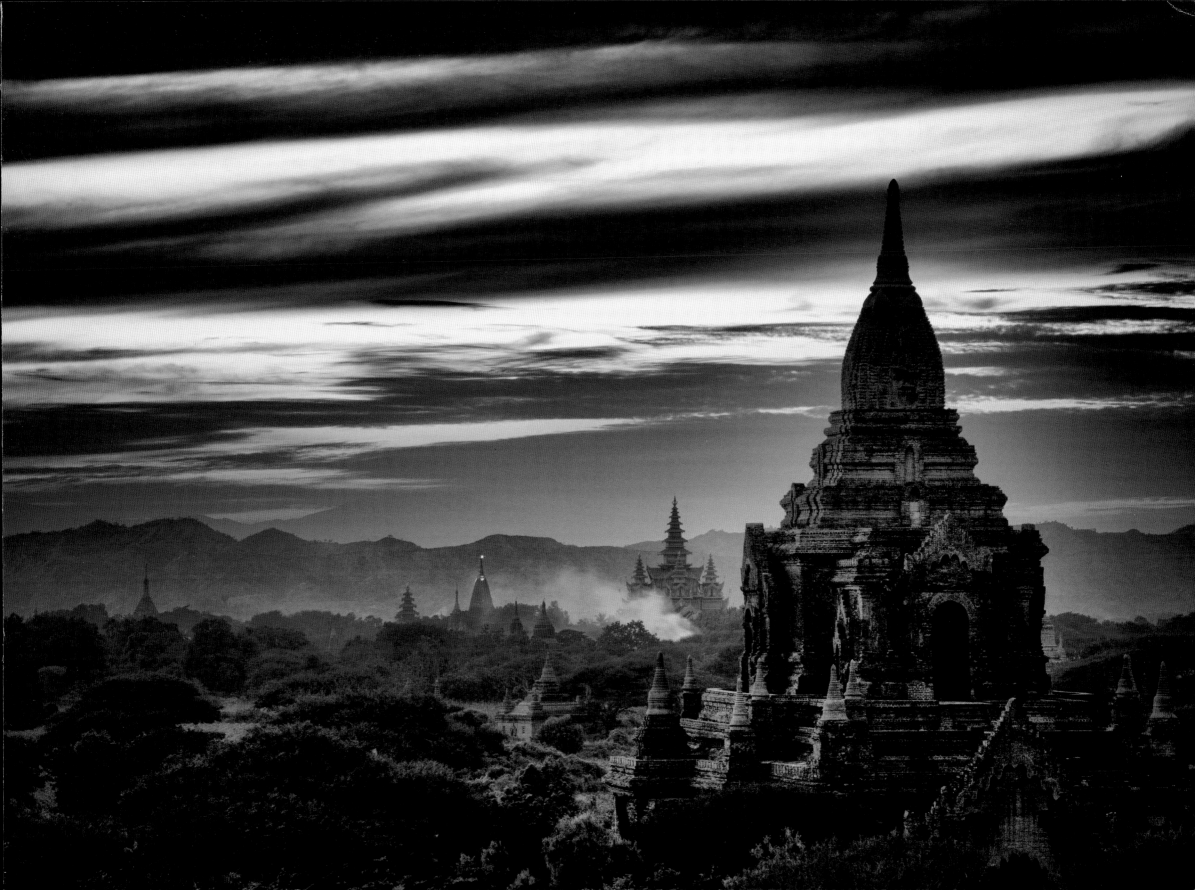

Wearing pink robes and gold sashes, with their heads shaved just like the monks, the nuns of Burma are precious gems. Their kind, gentle souls can leave you speechless.

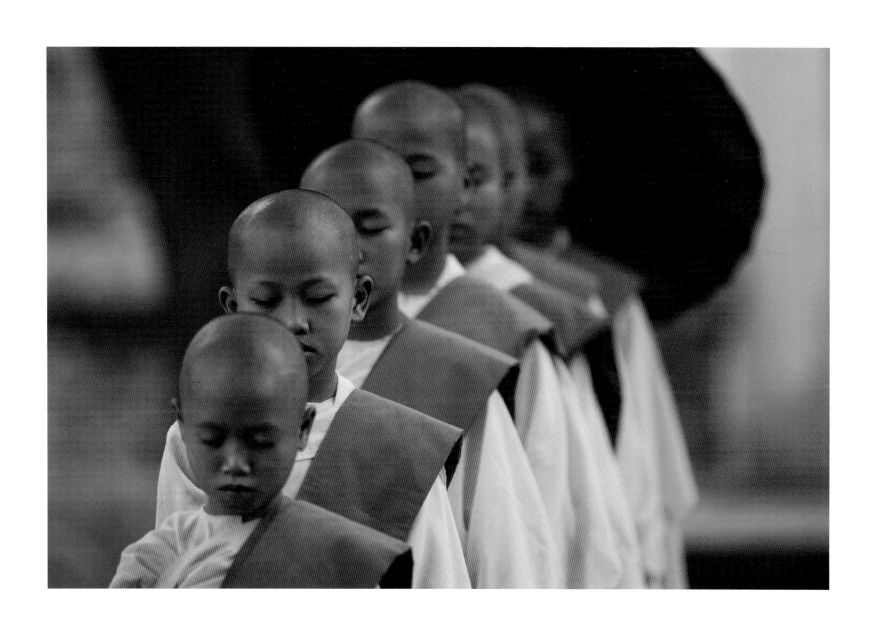

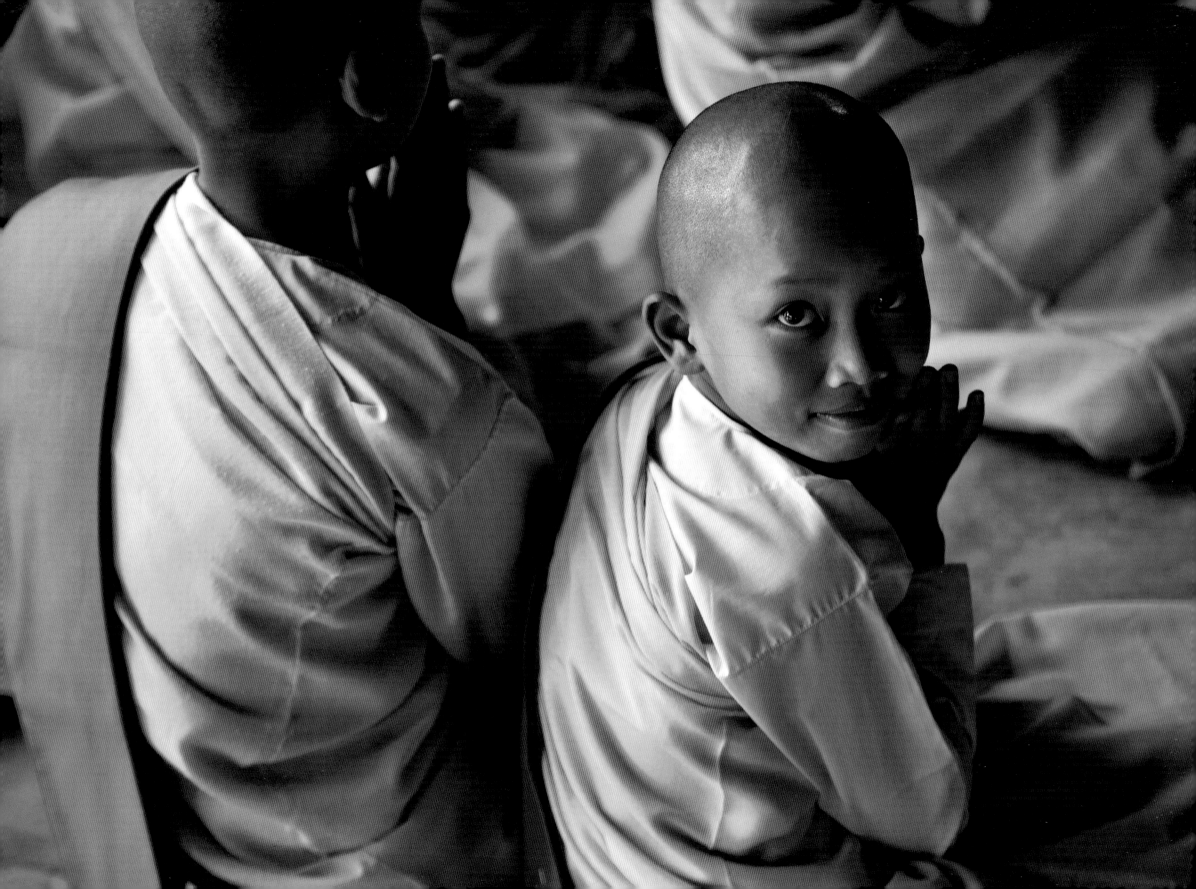

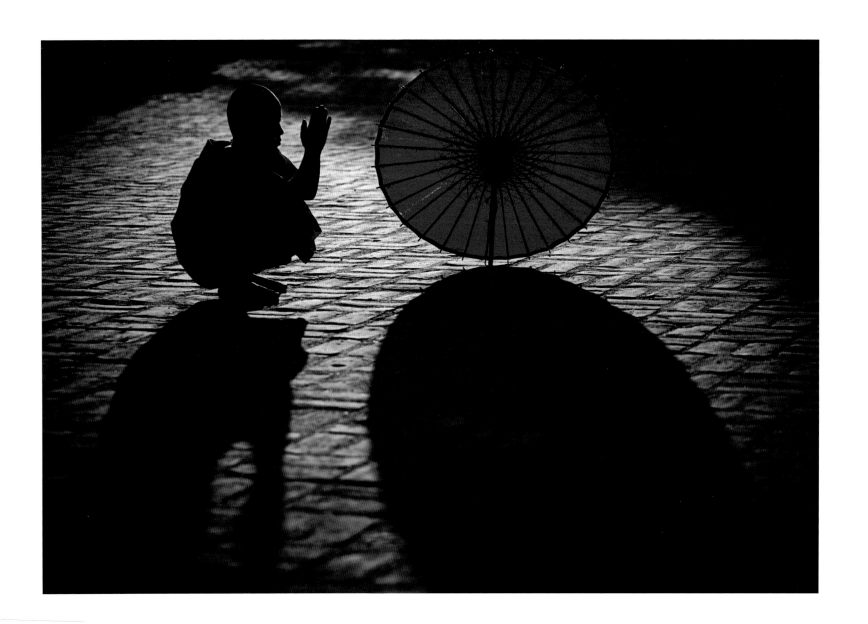

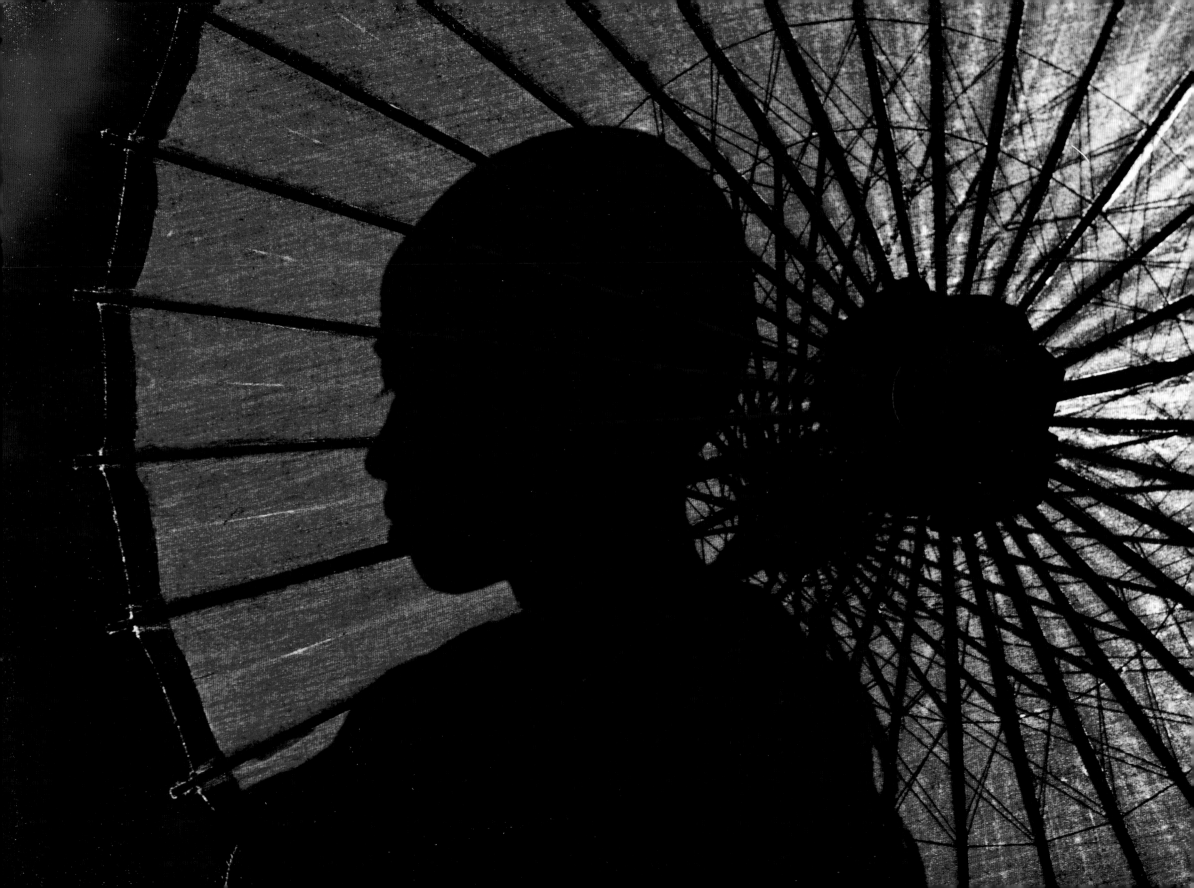

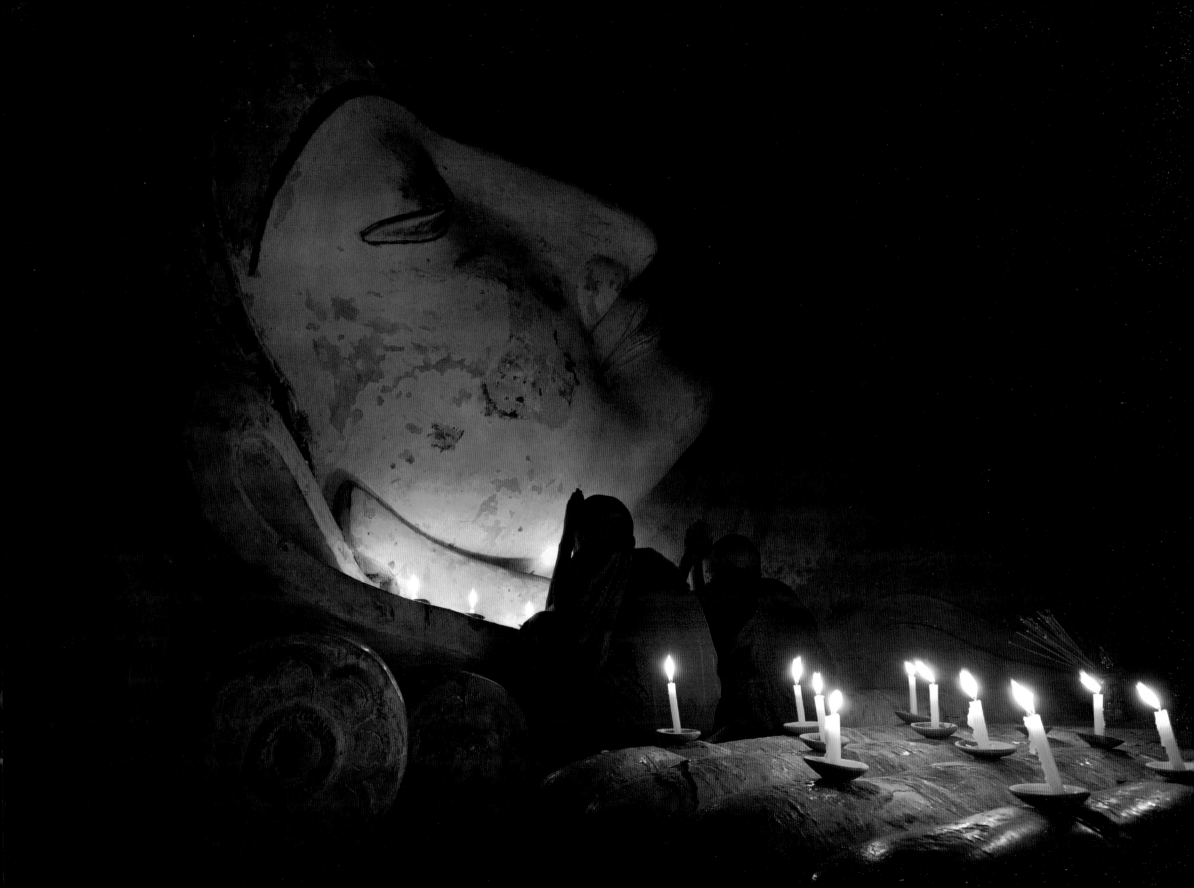

Draped in their distinctive red robes, unique to the monks of Burma, much of their days are spent learning from elder monks and reciting prayers. This guides them to understand the philosophies behind the lessons and teachings of Buddha.

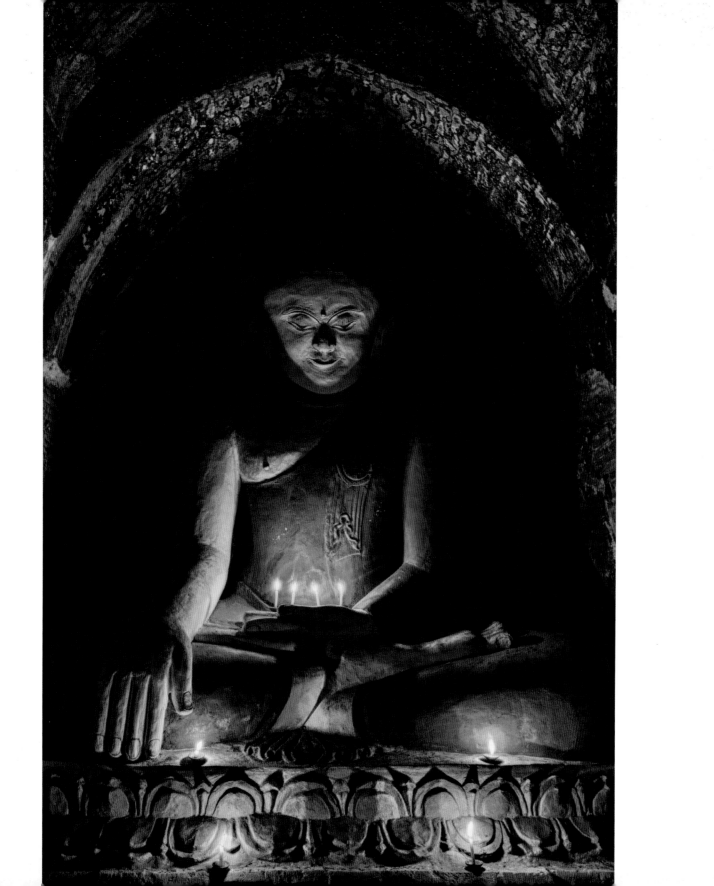

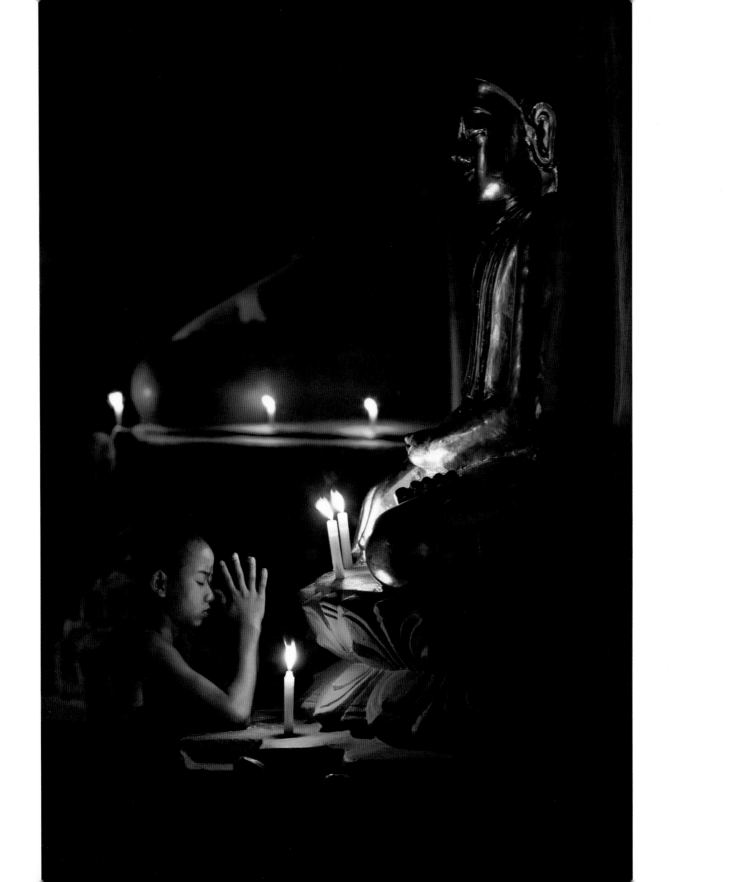

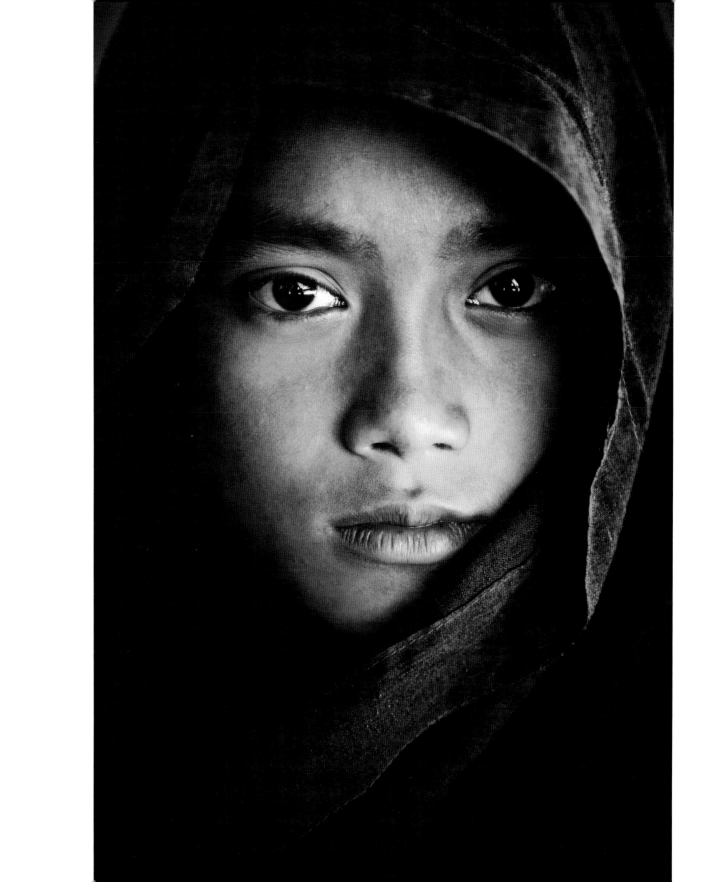

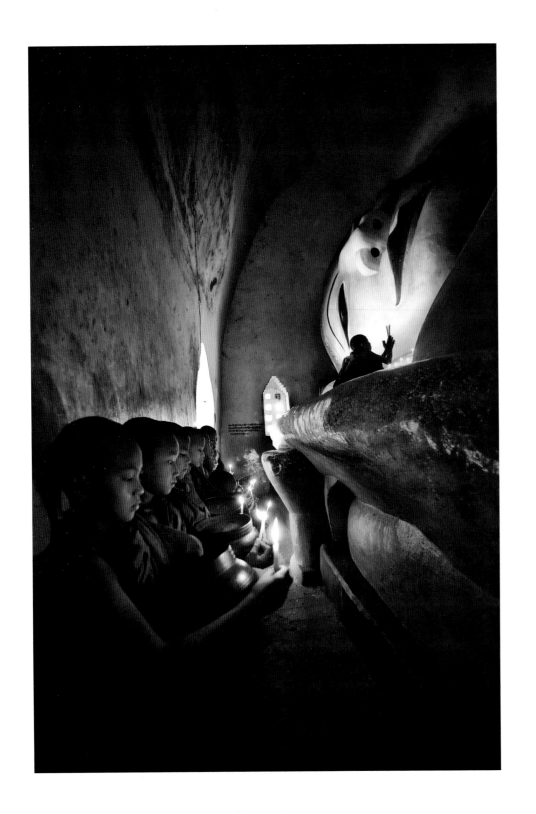
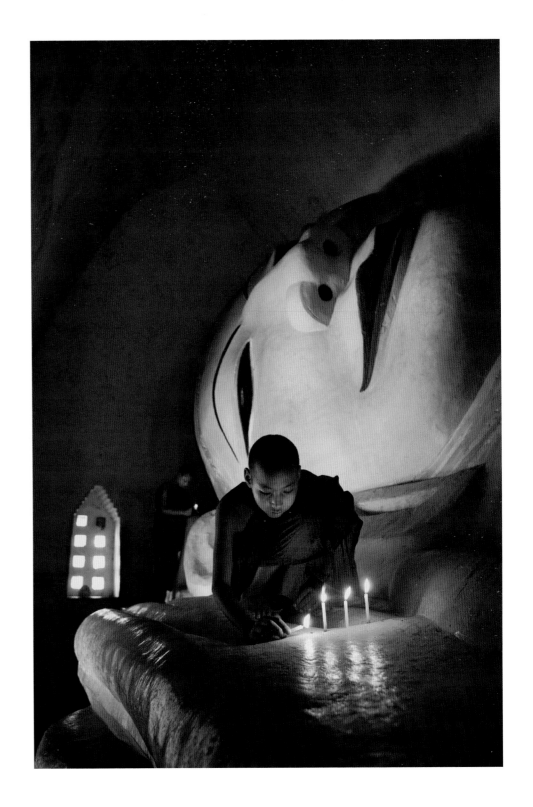

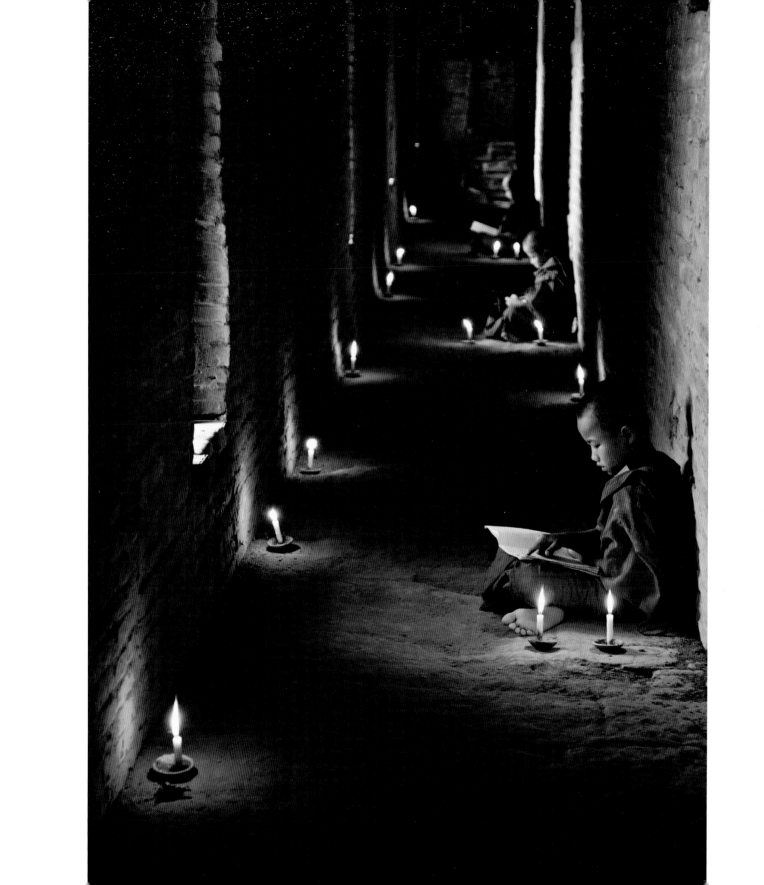

Politically, the future of Burma may seem uncertain. But culturally, ethnically, and spiritually, the people of Burma, like this young monk watching the setting sun over his country, see a bright and shining future brimming with hope.

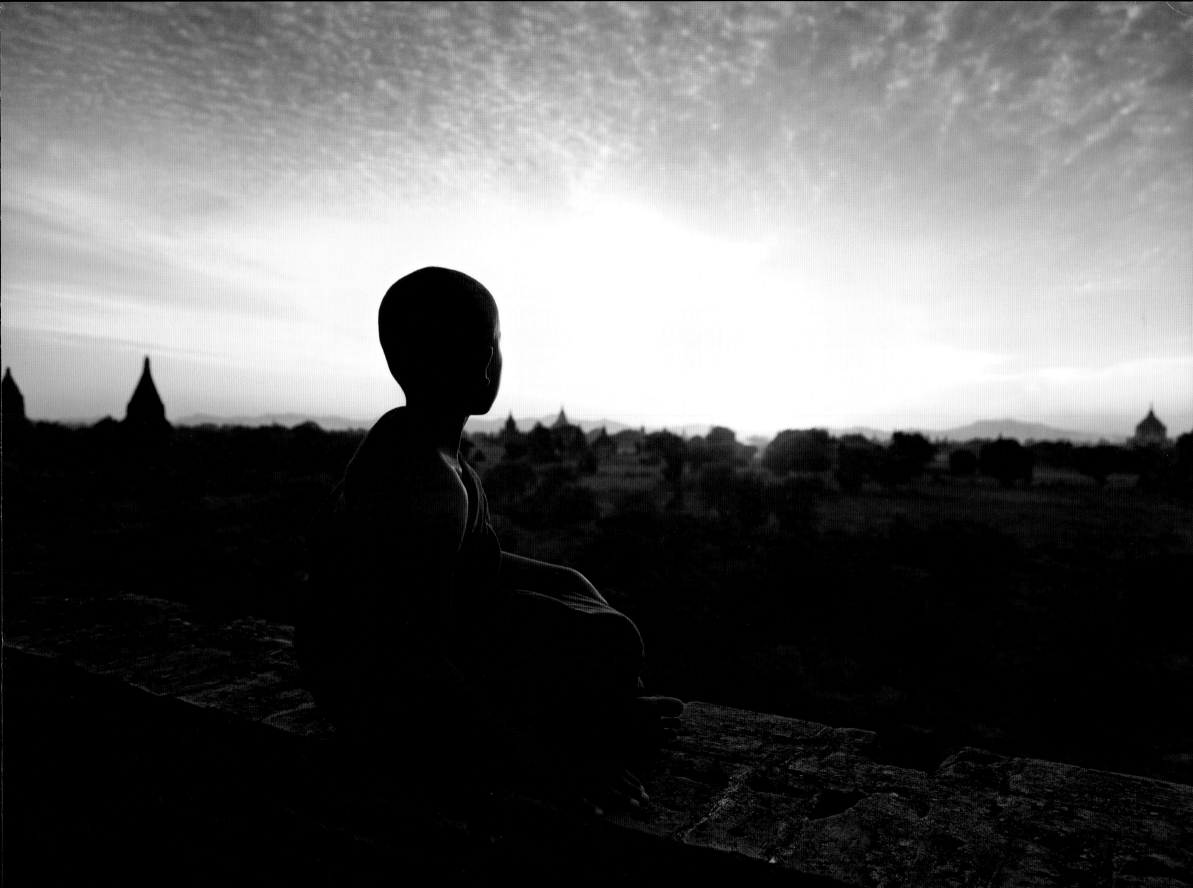

The face paint worn by so many is called thanaka and is a combination of sunblock and makeup. Thanaka face paint has been used in Burmese society since the fourteenth century and is a cherished part of the national identity. Every day, after taking a bath, most women, children, and even some men paint thanaka on their faces.

Burmese people believe that thanaka bark cools their skin, tightens the pores, and controls oiliness, and many talk up thanaka as a traditional Burmese beauty secret. Only the Burmese wear thanaka as a daily cosmetic and skin conditioner, and it is one of those special parts of the Burmese culture that I am so drawn to. Every painted face looks so different.

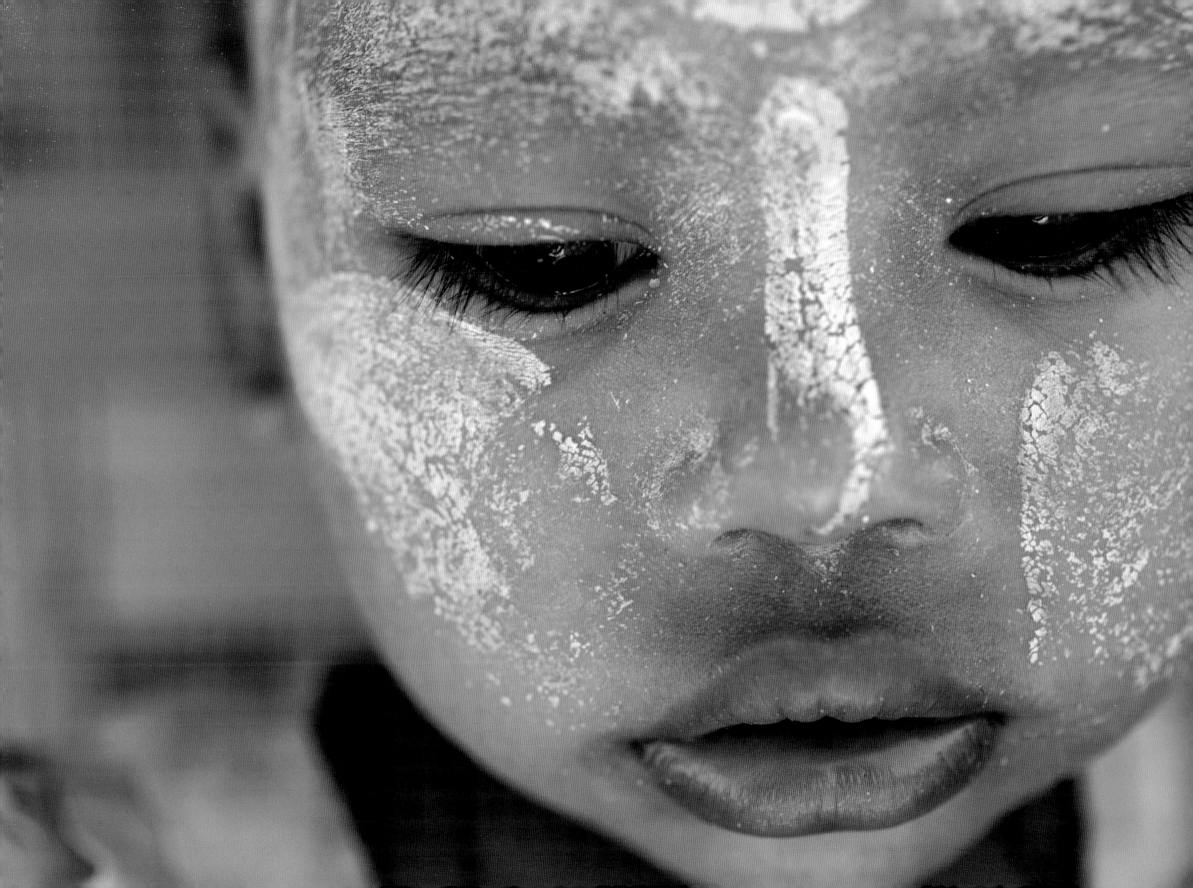

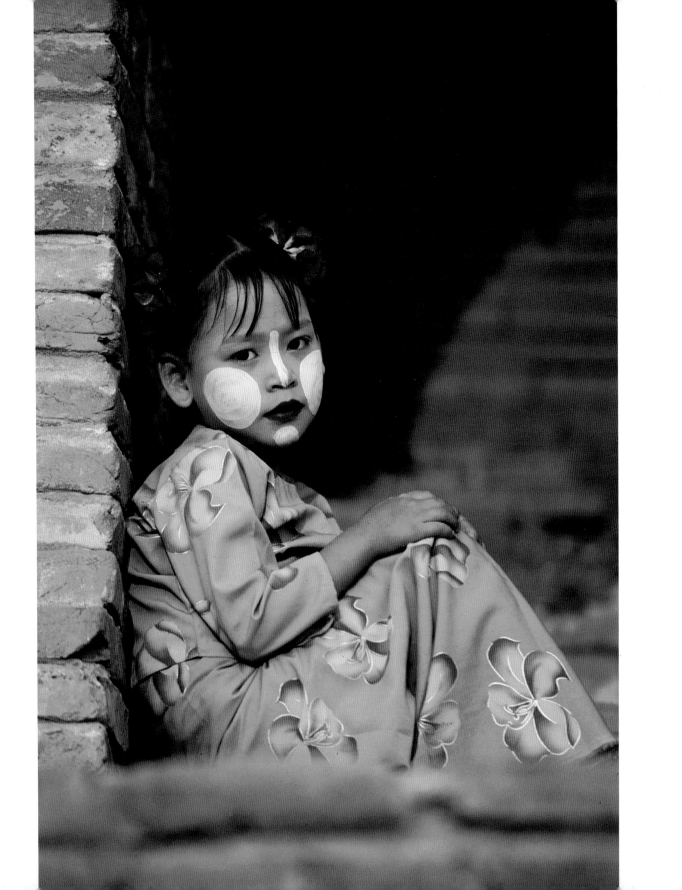

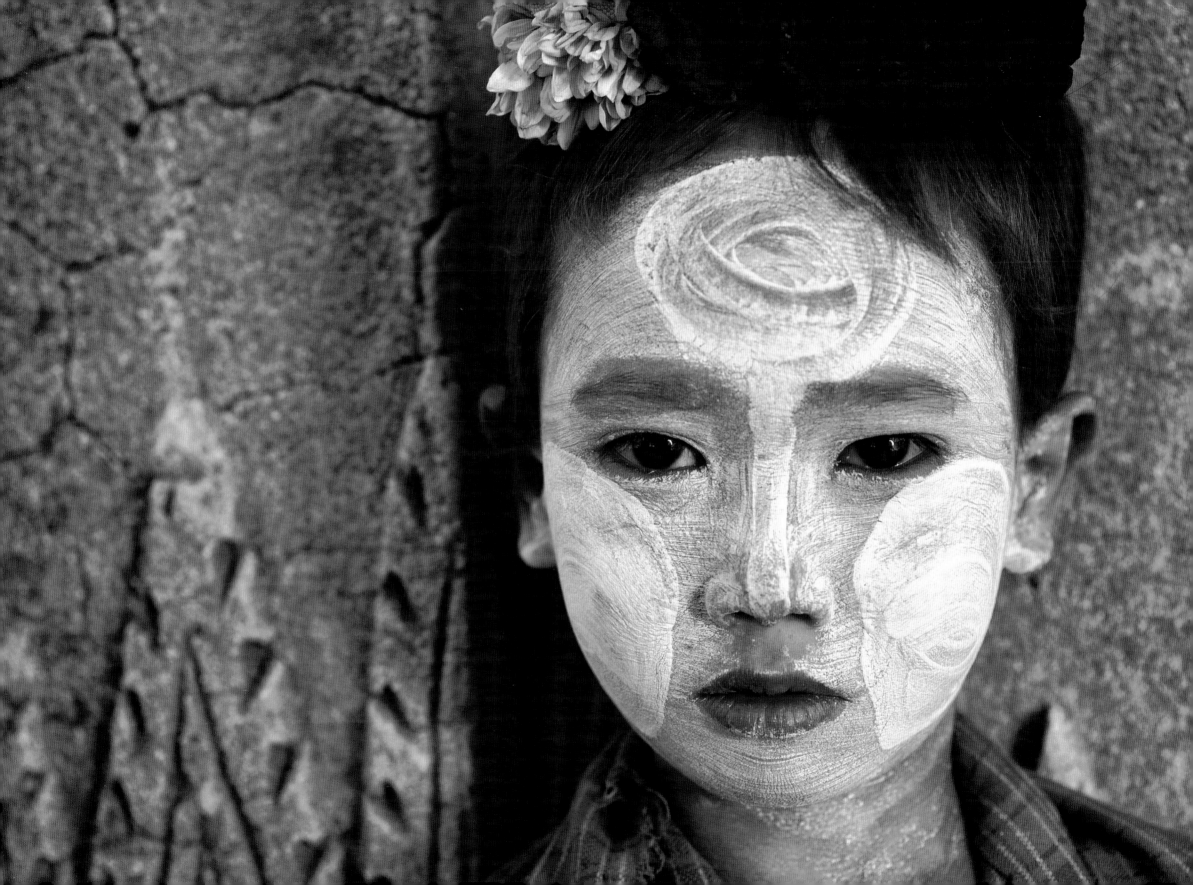

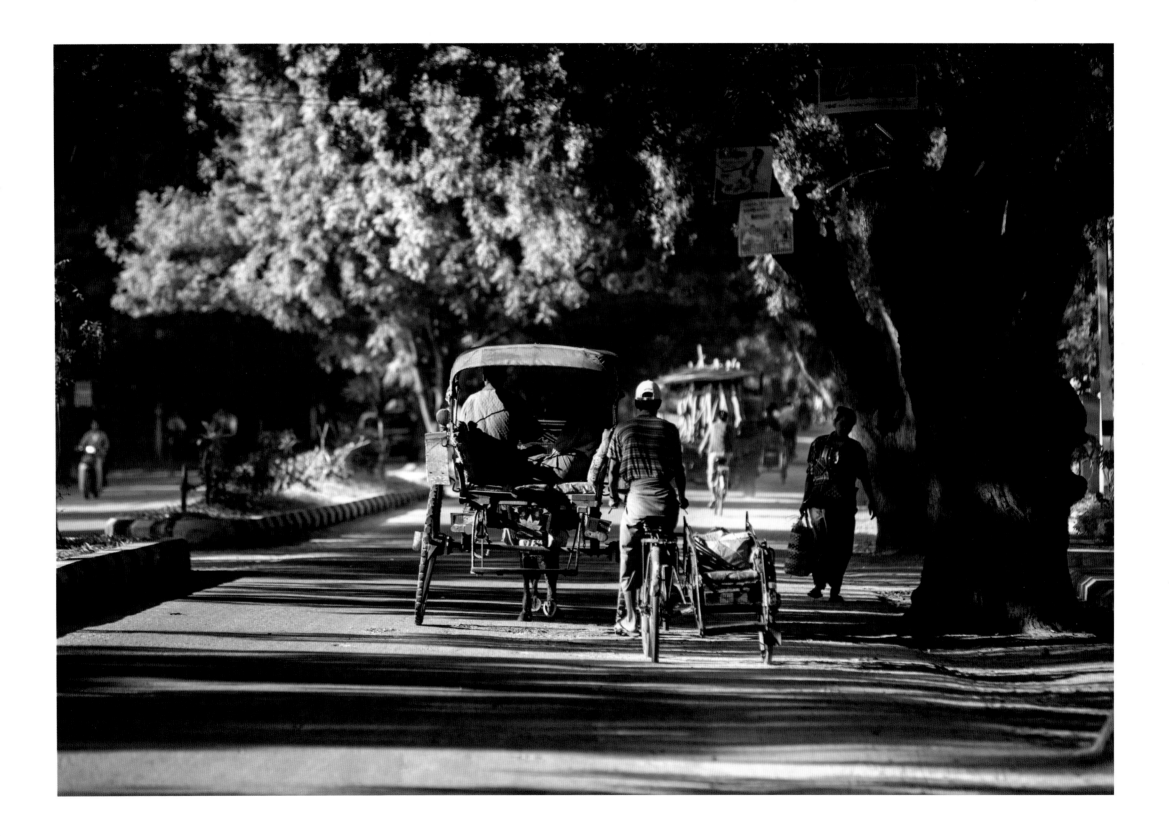

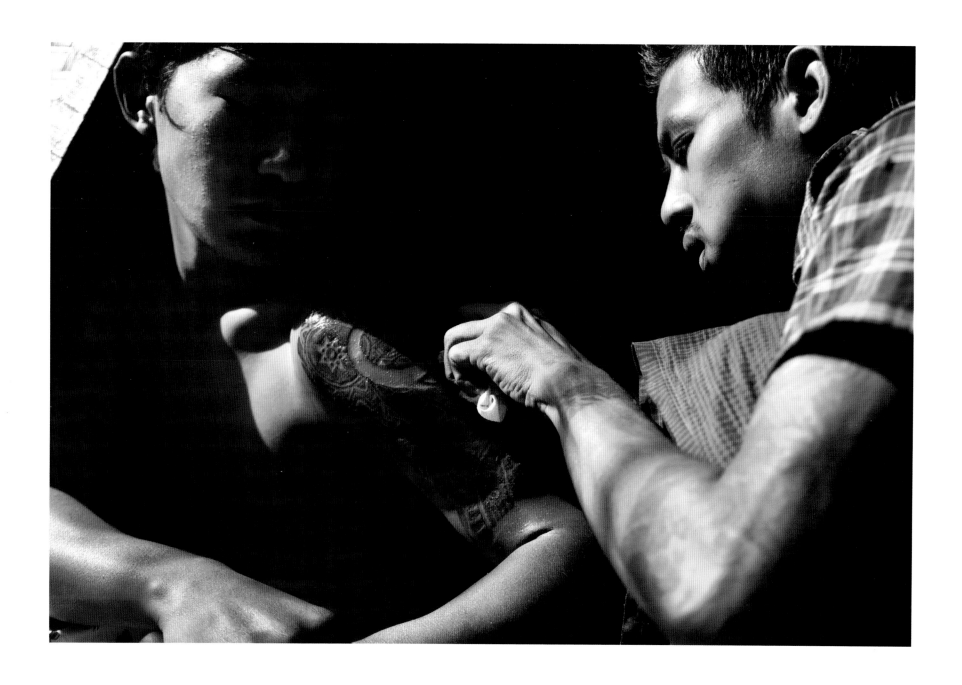

Life throughout Bagan can seem no different than other places on Earth, with young people adorning themselves in tattoos. Yet underneath it all, there pervades a slower-paced lifestyle that is enviable to people from more fast-paced cultures.

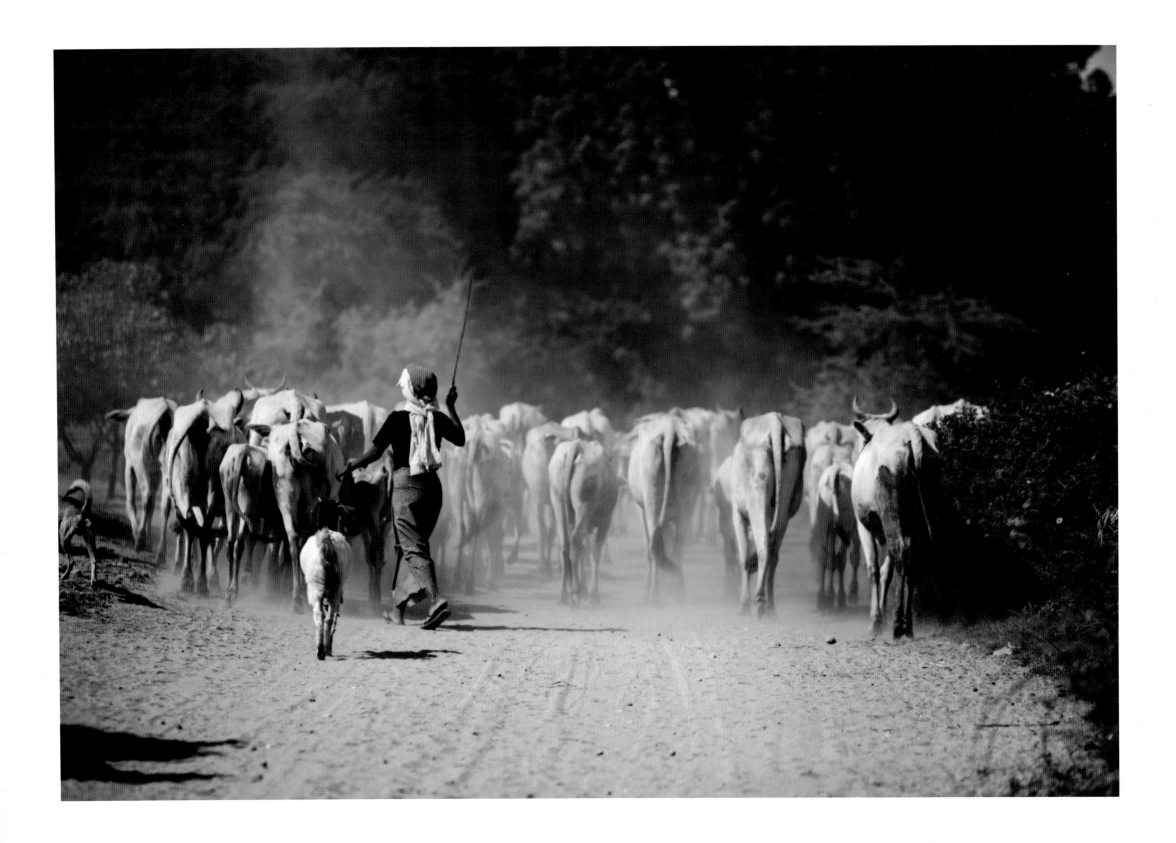

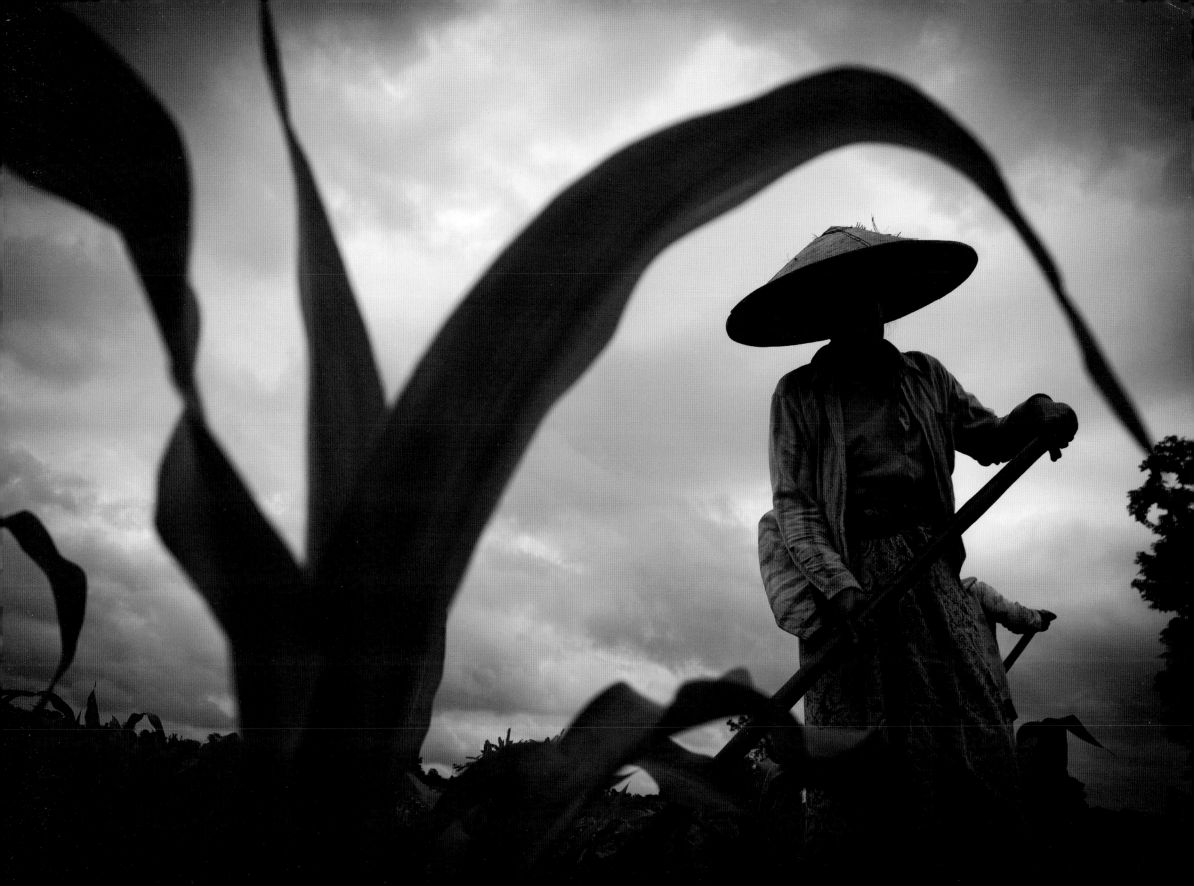

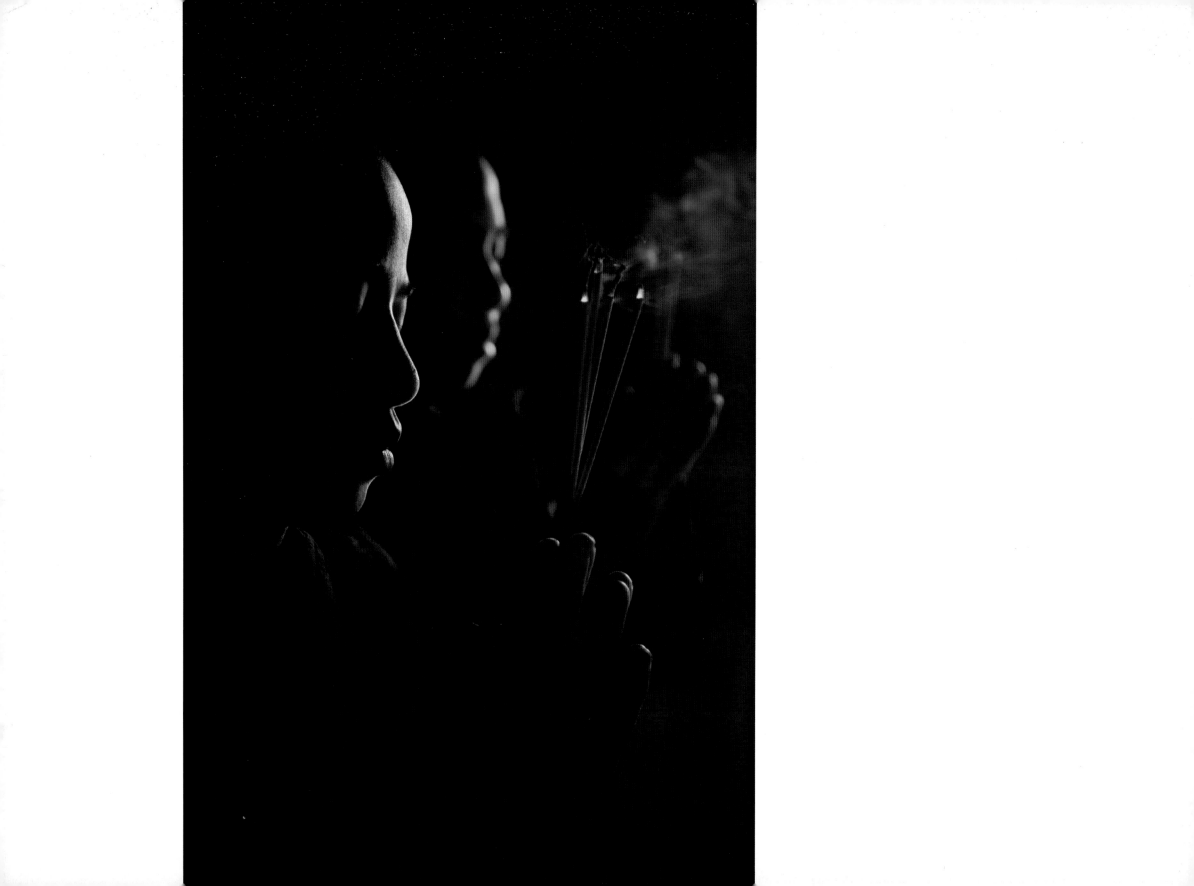

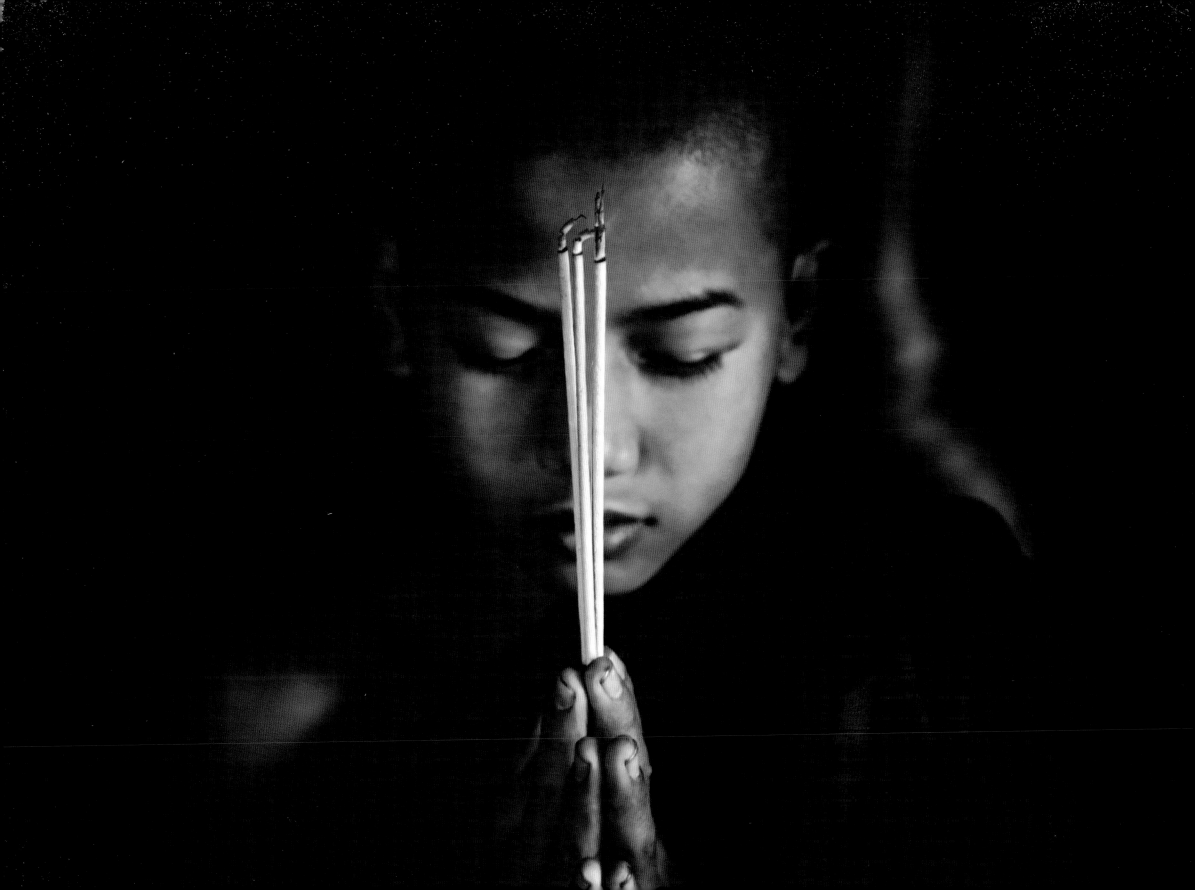

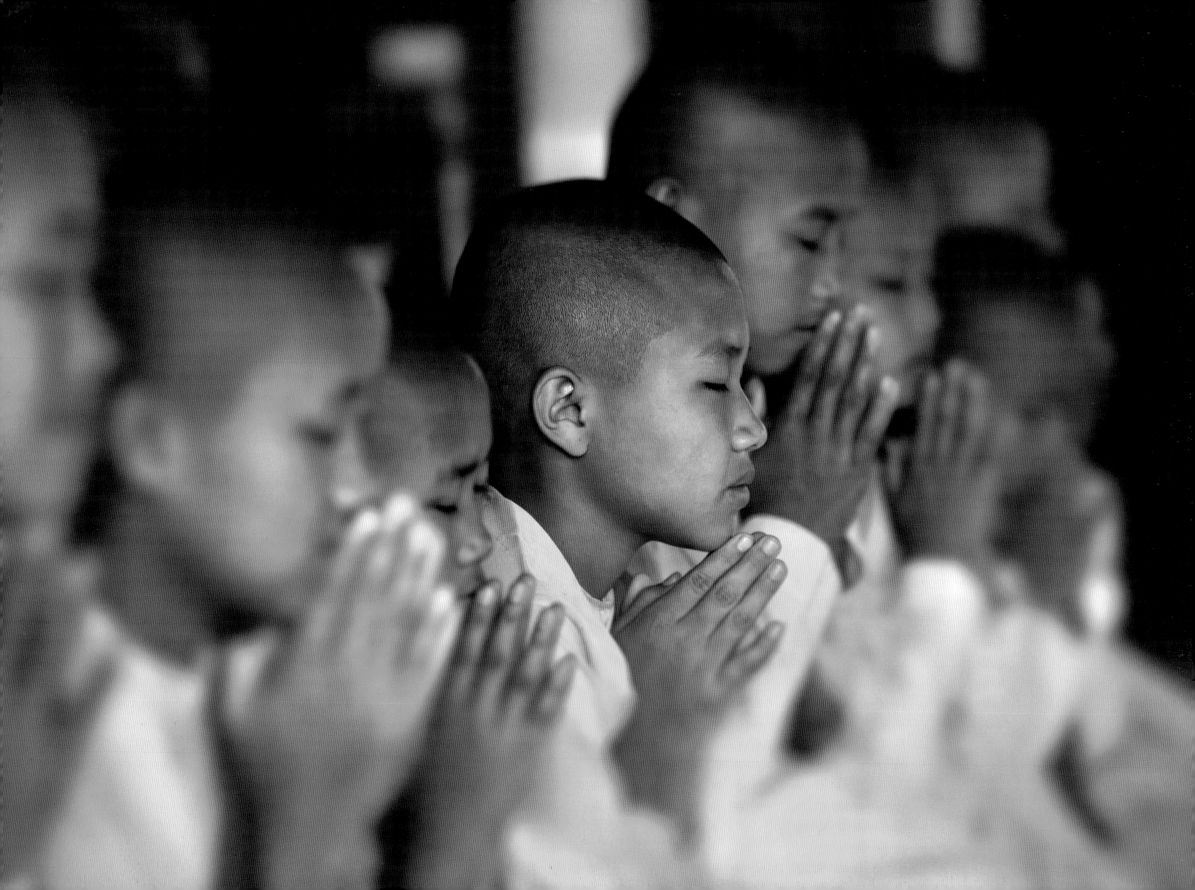

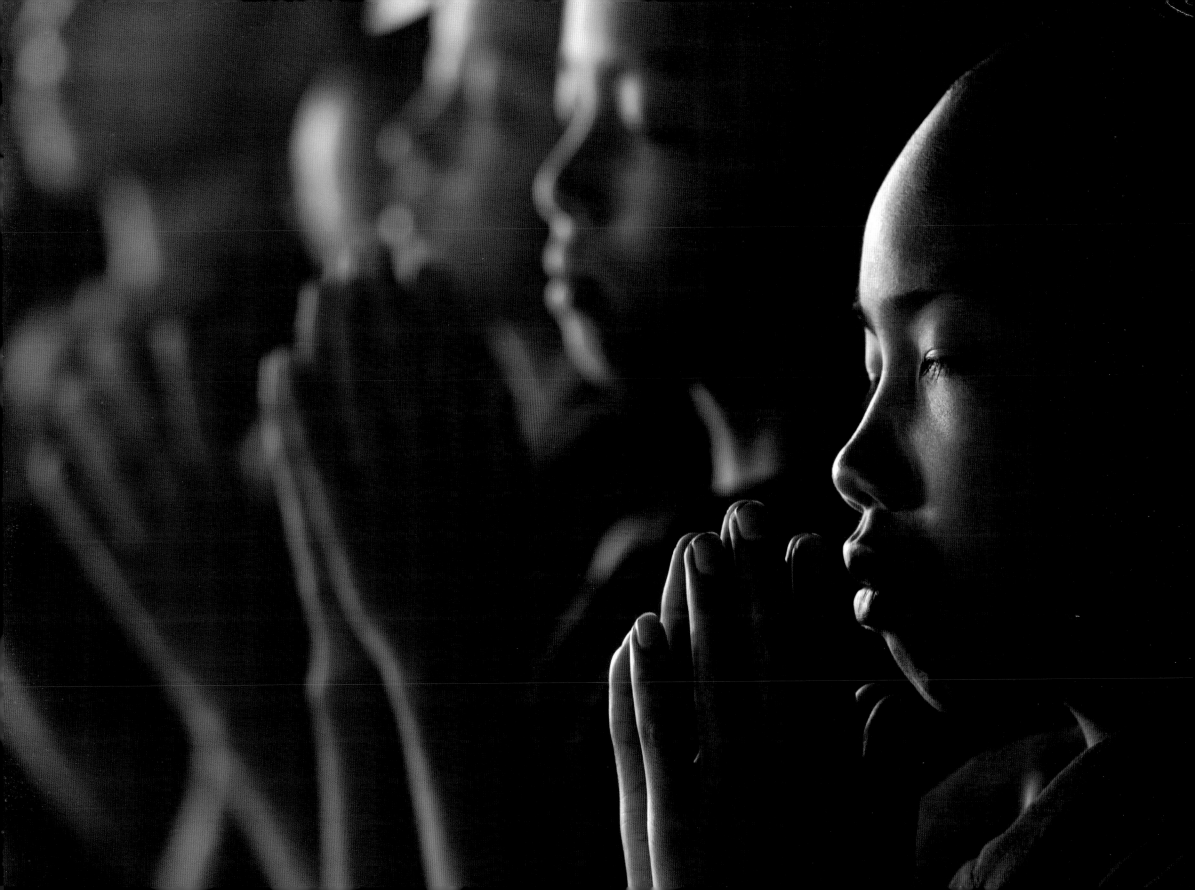

On their pilgrimage through the country, these nuns stayed the night in my favorite monastery. My good friend and favorite monk master gave me special permission to photograph them that evening, and his kindness that night is a present I will never forget.

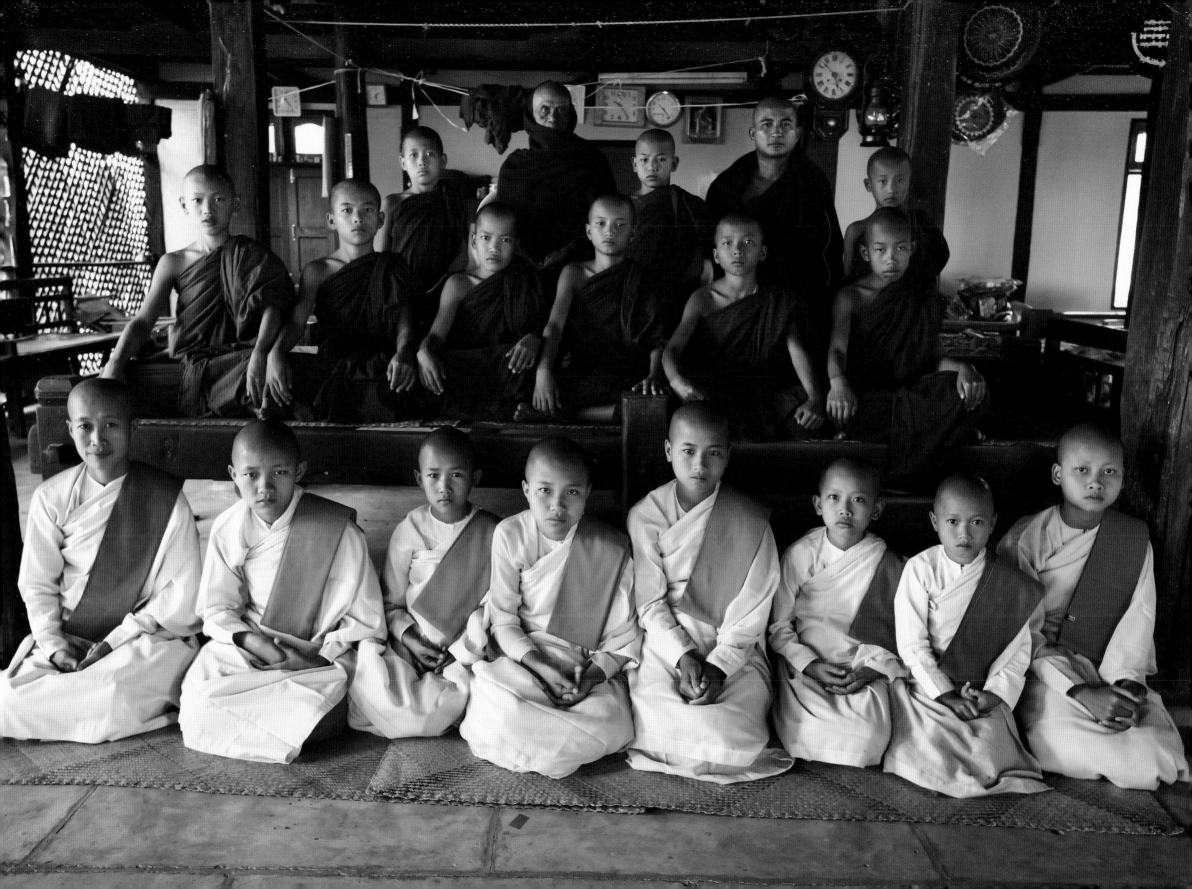

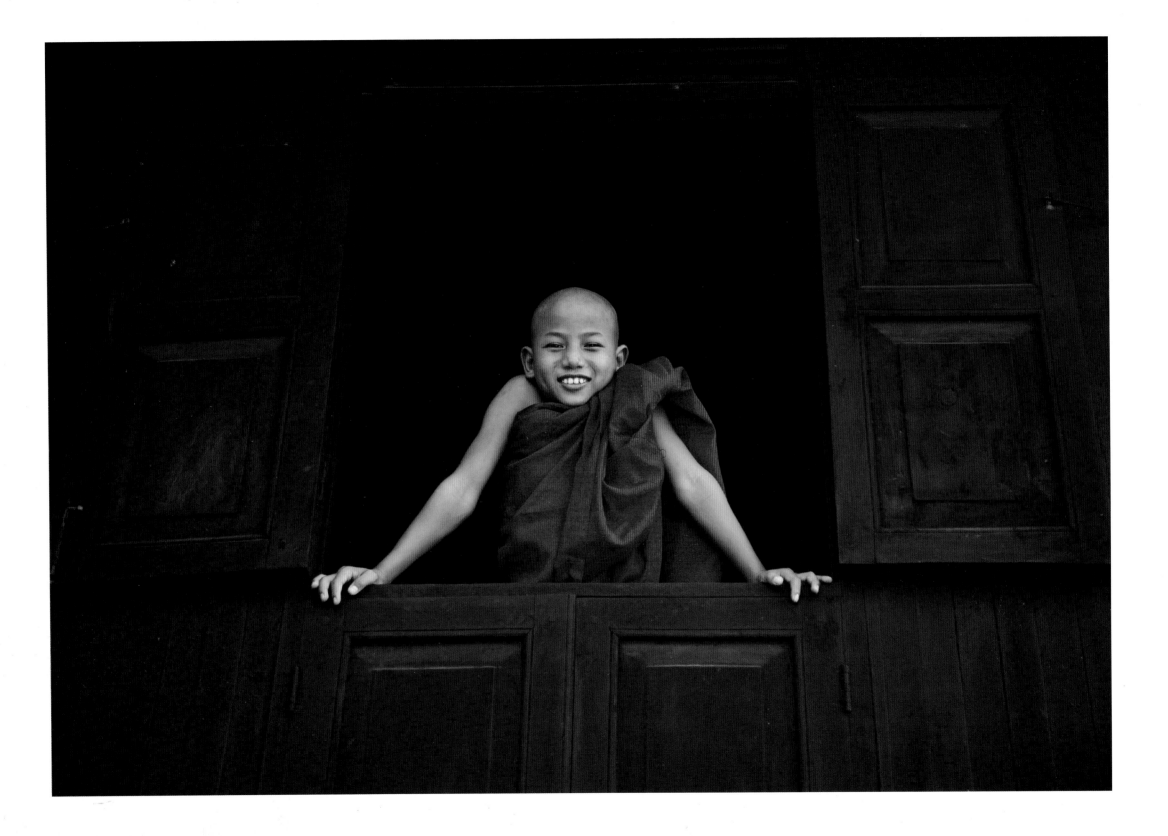

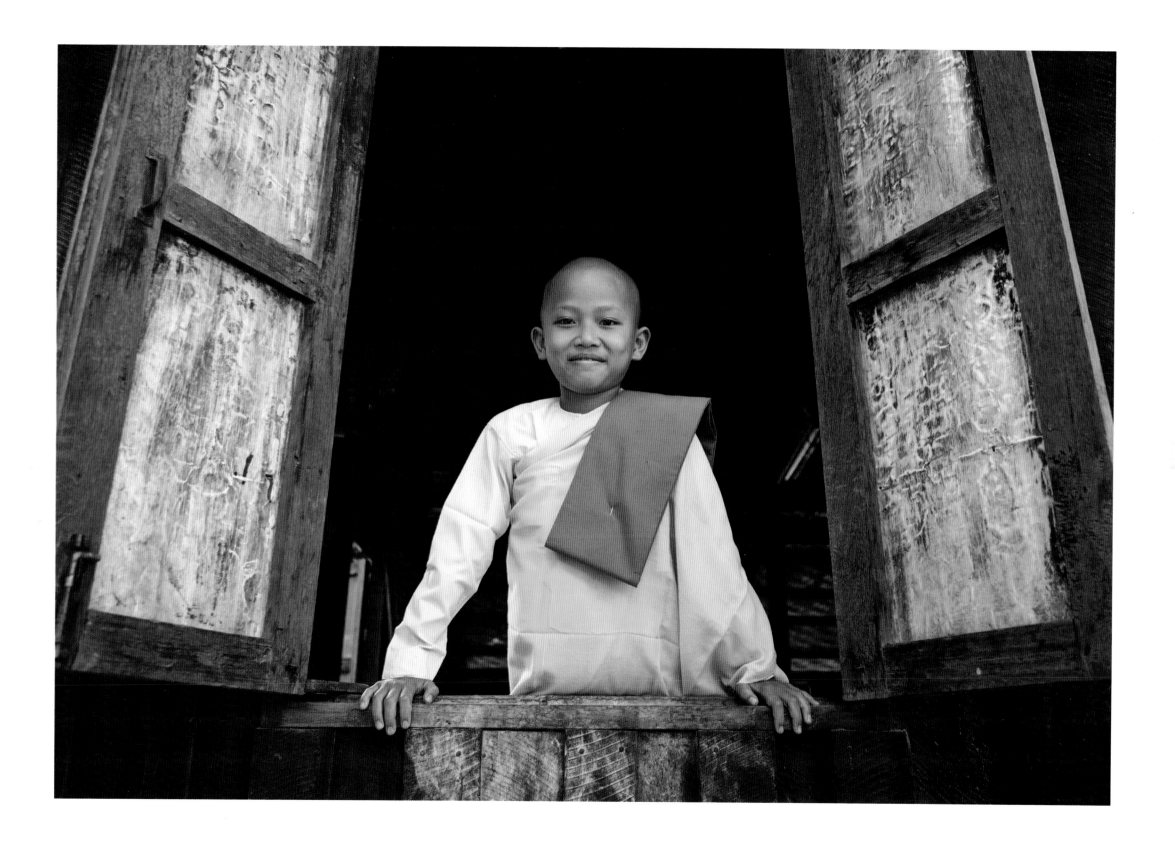

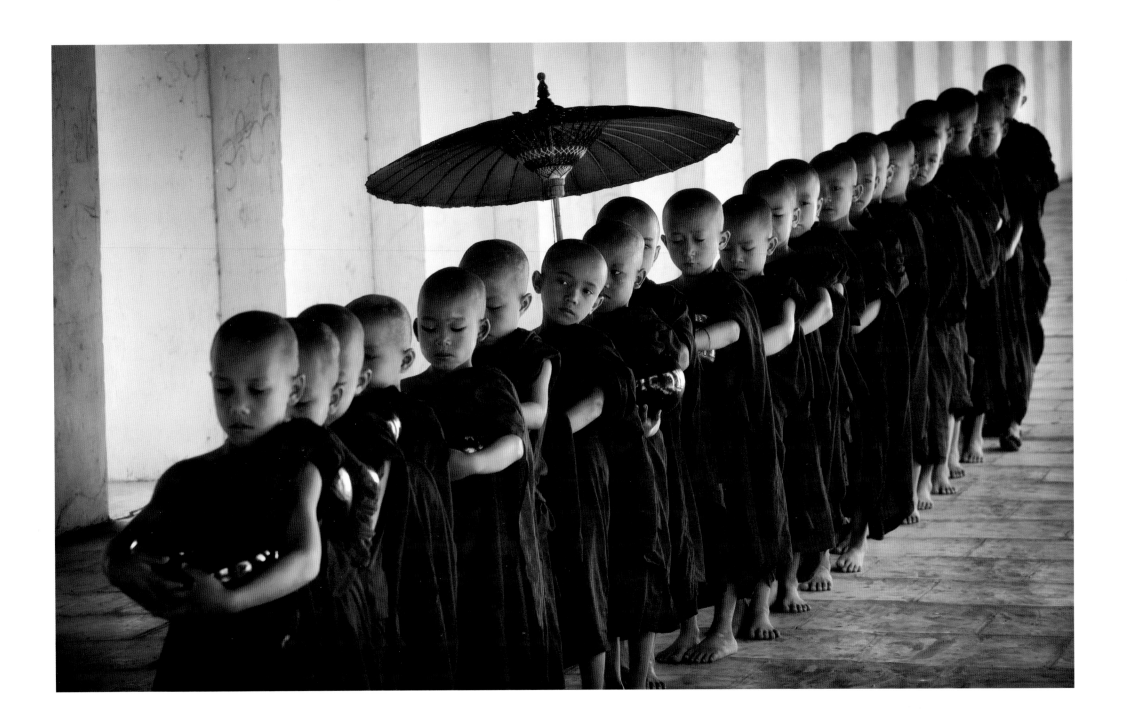

Long lines of monks in their colorful robes are common all over Burma. Young Burmese Buddhist boys are expected to enter the monastery as a novice monk for a few weeks to many months. After this period, they have the choice to stay on as a monk or return to normal life.

On this special day in Bagan, I met this group of young monks carrying rice bowls who did not speak the local dialect. Needless to say, I was so lucky to be at the right place at the right time.

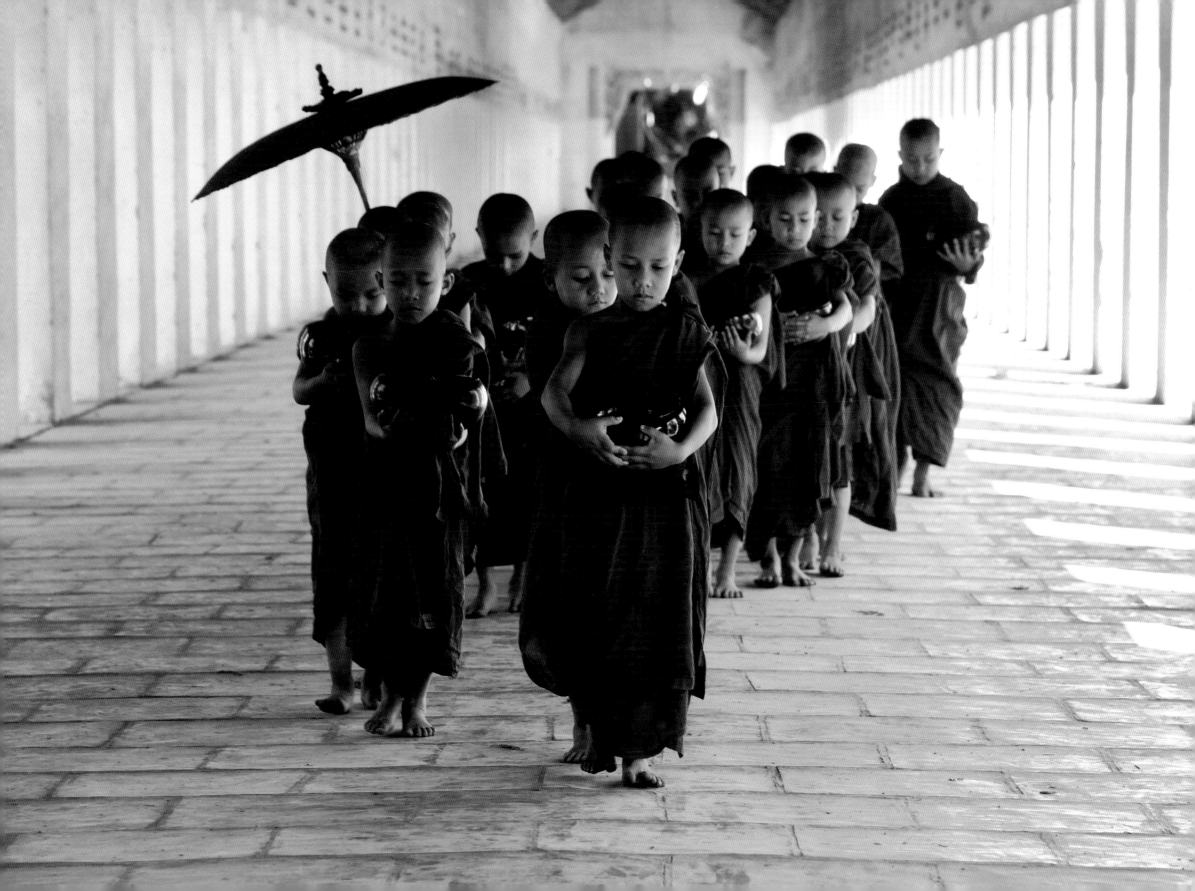

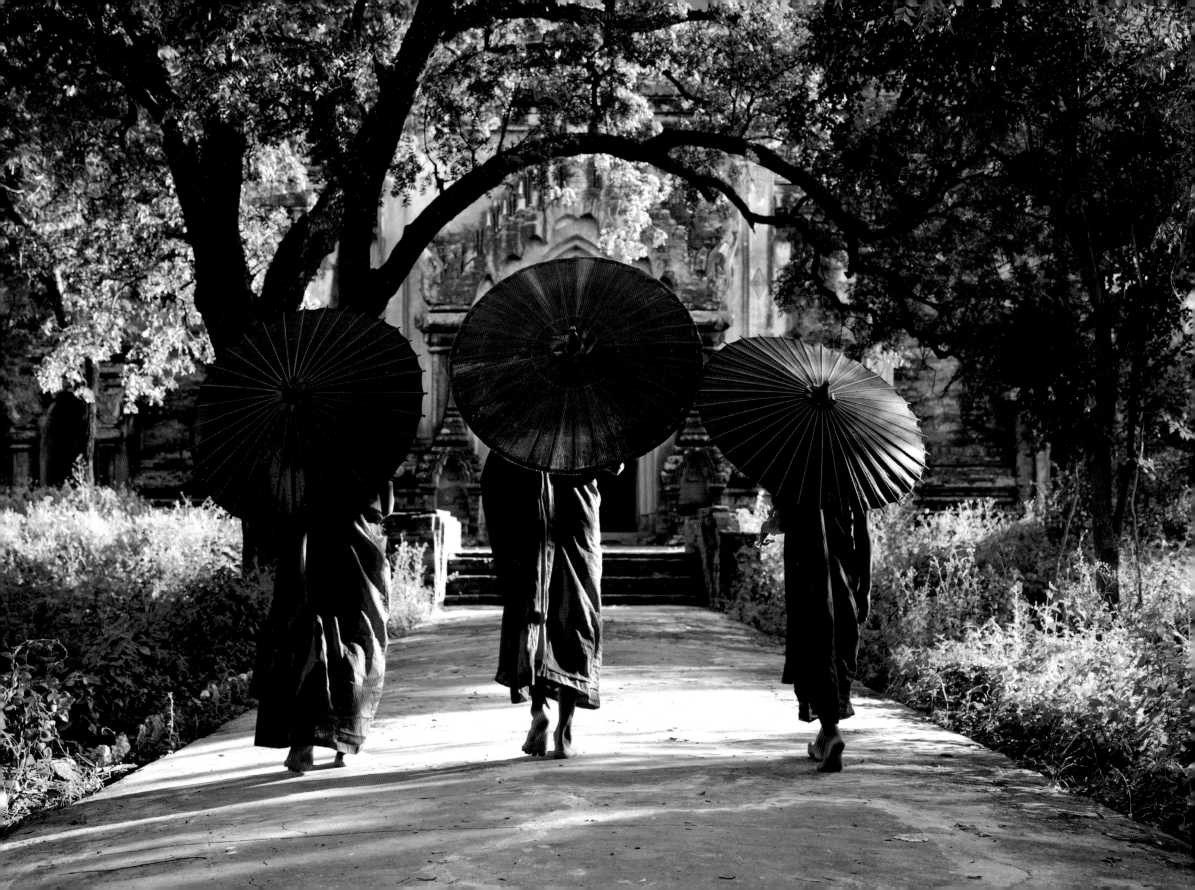

Shaded by their ever-present parasols, these young monks march toward the next activity in their day—and the equally present teachings of Buddha. Why do I love this country so? Look no further. These children represent the hope of an emerging modern country, a dream that is enveloped in the warm embrace of the hopeful spirituality that is Buddhism.

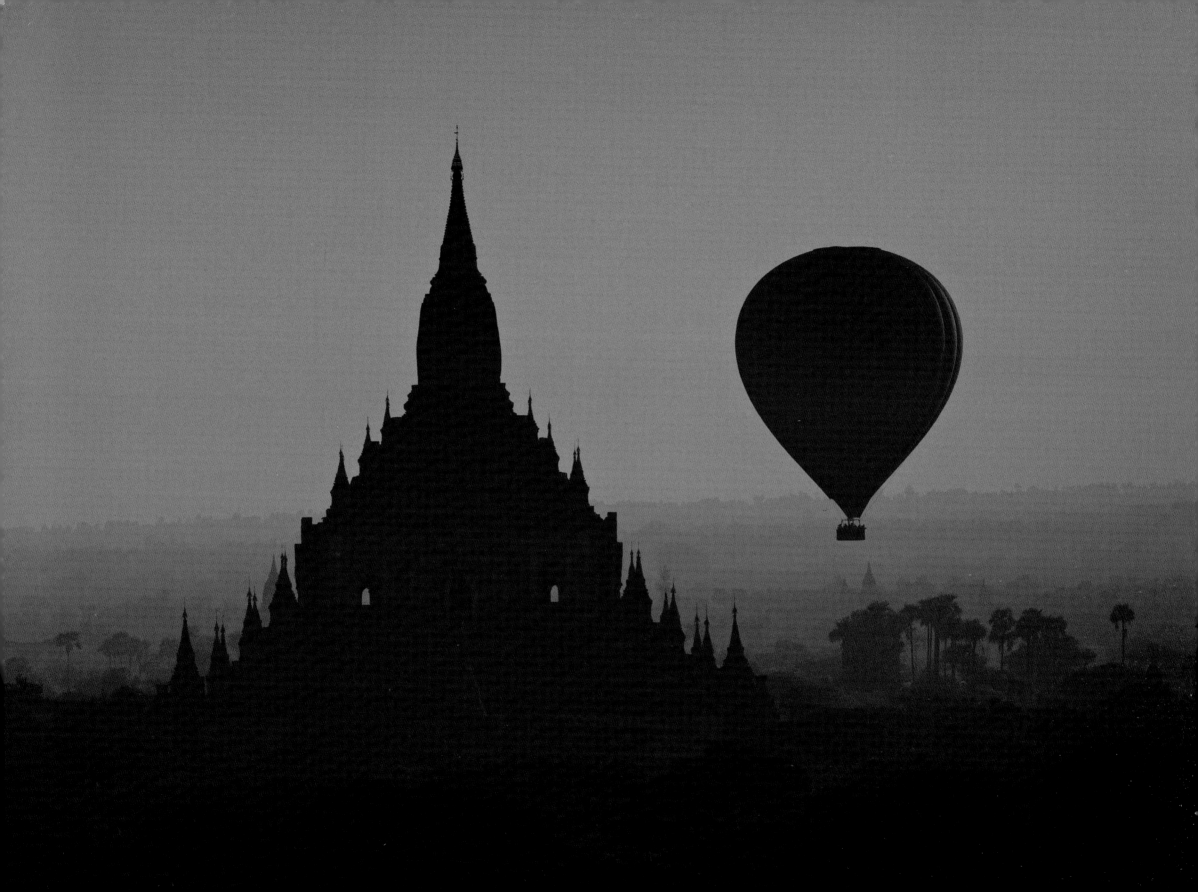

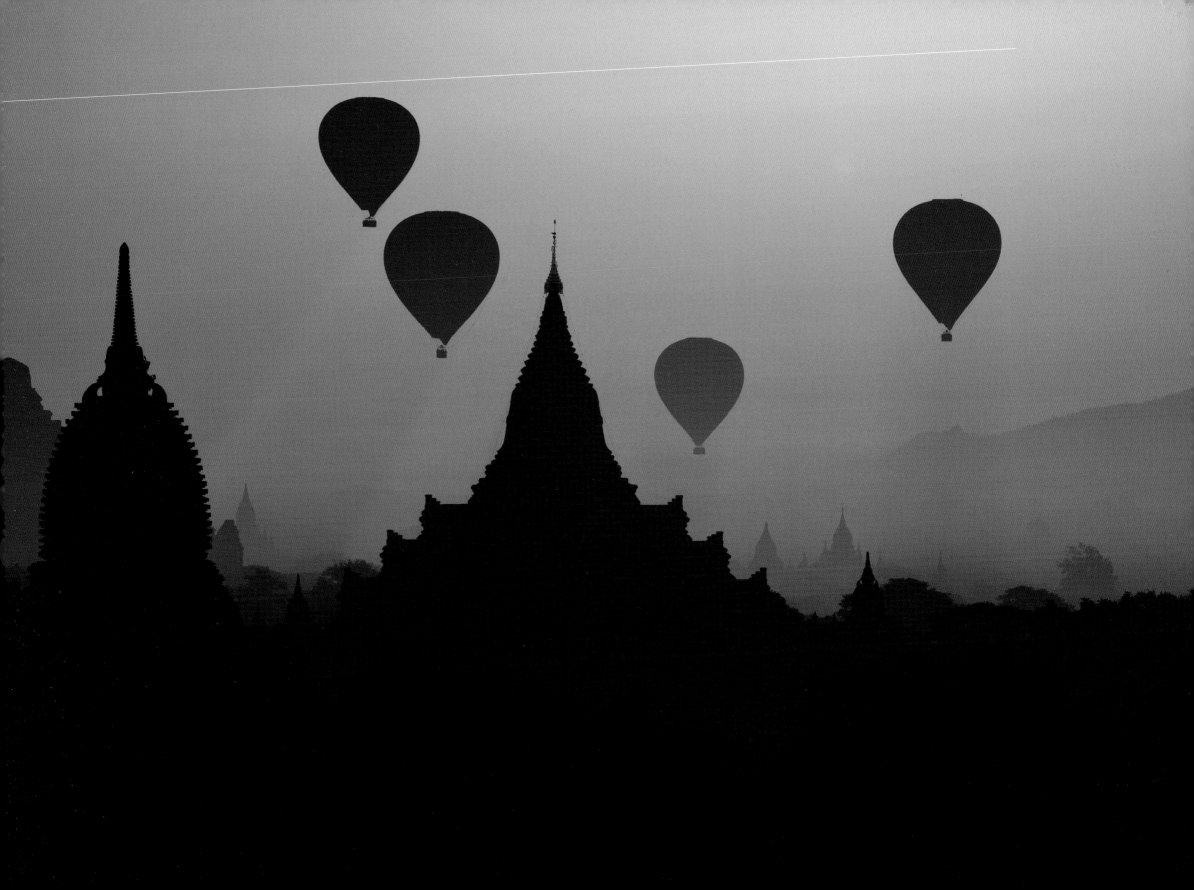

"It is better to travel well than to arrive."

— Buddha

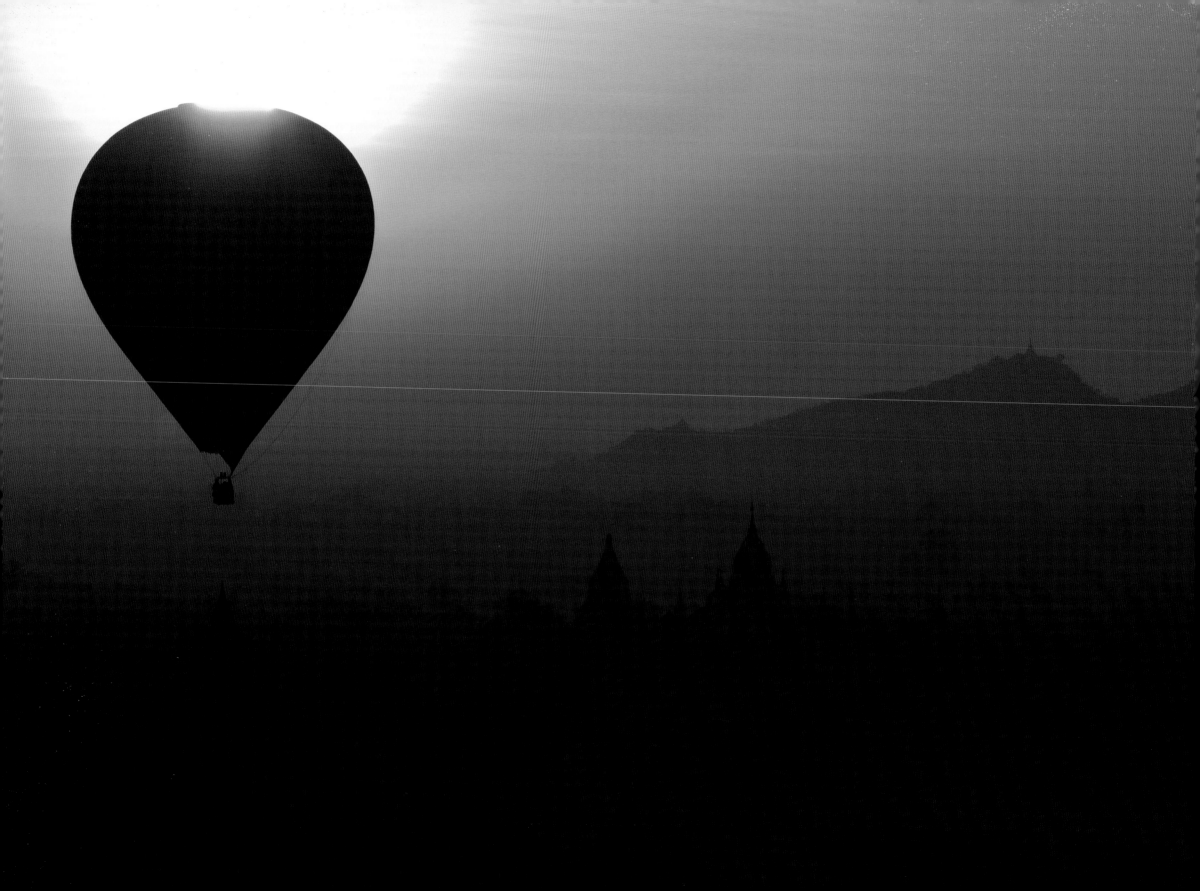

Mandalay

Mandalay is a city of exotic contrasts. Located in the center of the country along the Irrawaddy River, it is at once calm and chaotic. The traffic in Mandalay, a confusion of cars and motorbikes and bicycles, is never-ending. Vehicles buzz by in all directions, guided by some remarkable force that miraculously prevents collisions. The only thing that can be heard above the din of traffic is the resounding song of the Mingun Bell, the largest working bell in the world. It weighs 200,000 pounds and when struck can be heard for miles. And then there is the massive Mingun Temple nearby, badly damaged by an earthquake in 1839. Like Burma itself, the temple is incomplete; rumor has it that if the temple were to be completed, the king would die.

As old as this city appears, it is not. It was built in 1857, the same year that Macy's department store first opened its doors to customers in downtown Manhattan. But the culture that serves as the city's foundation is as old as the forest surrounding it, as timeless as the flowing Irrawaddy River, as breathtaking as the sunset that stains the mist every evening.

On the other hand, Mandalay is considered by many to be the spiritual center of Buddhism. Its countless temples and monasteries serve as schools for Buddhist studies; there are more monks in Mandalay than any other place in the world. In fact, one cannot claim to be a scholar of Buddhist studies until one has spent time among the monks of Mandalay.

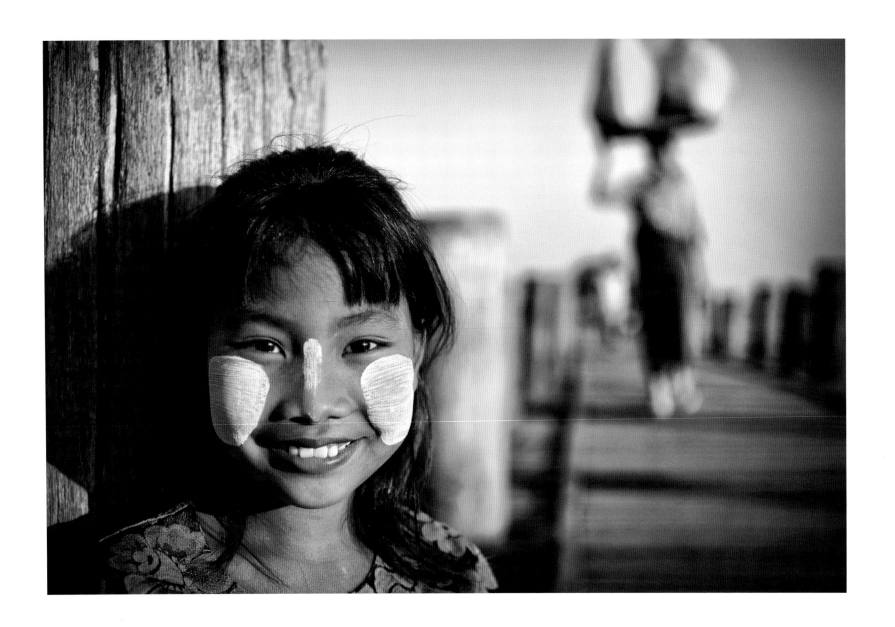

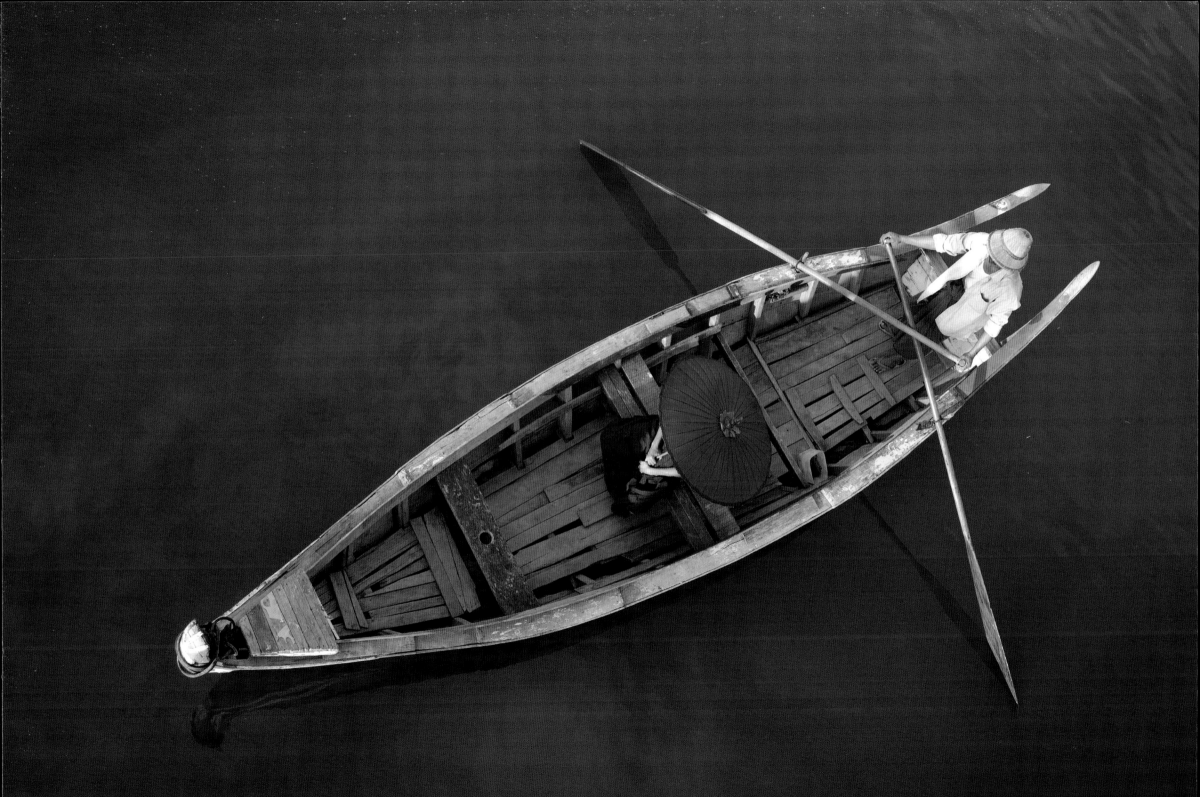

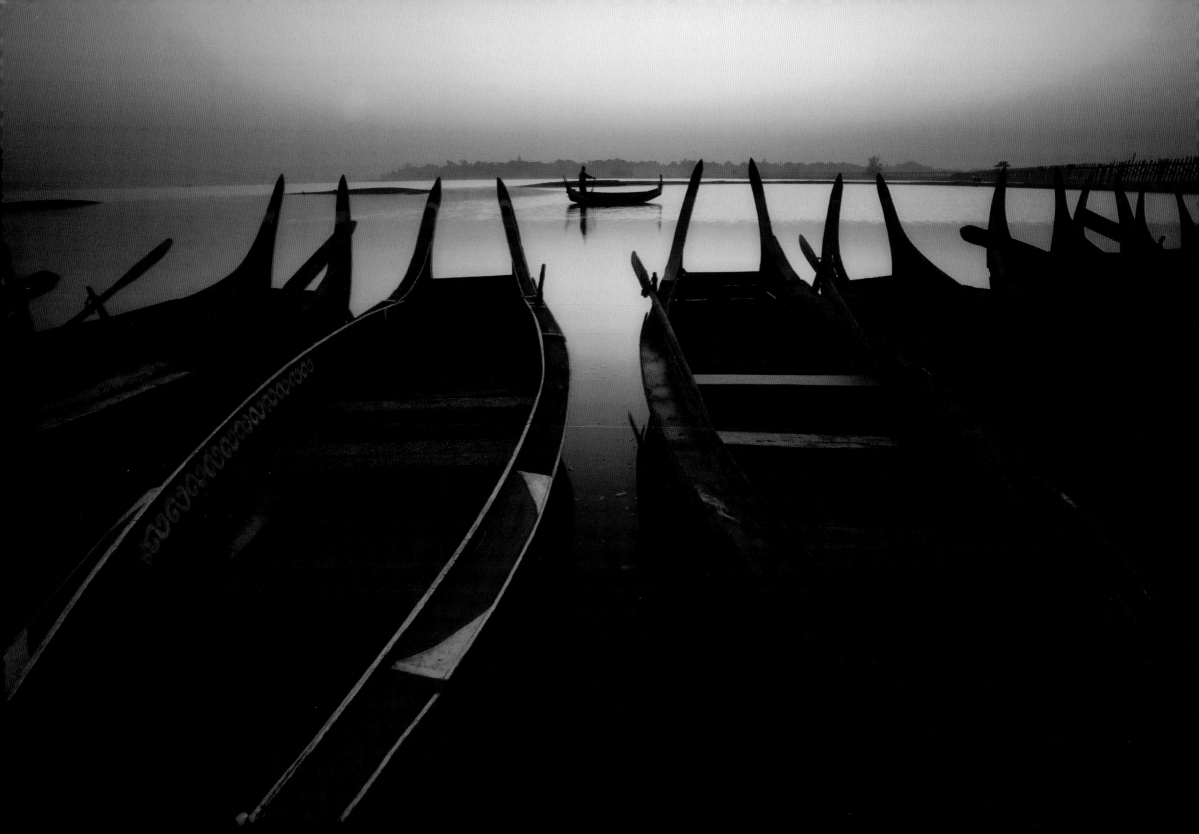

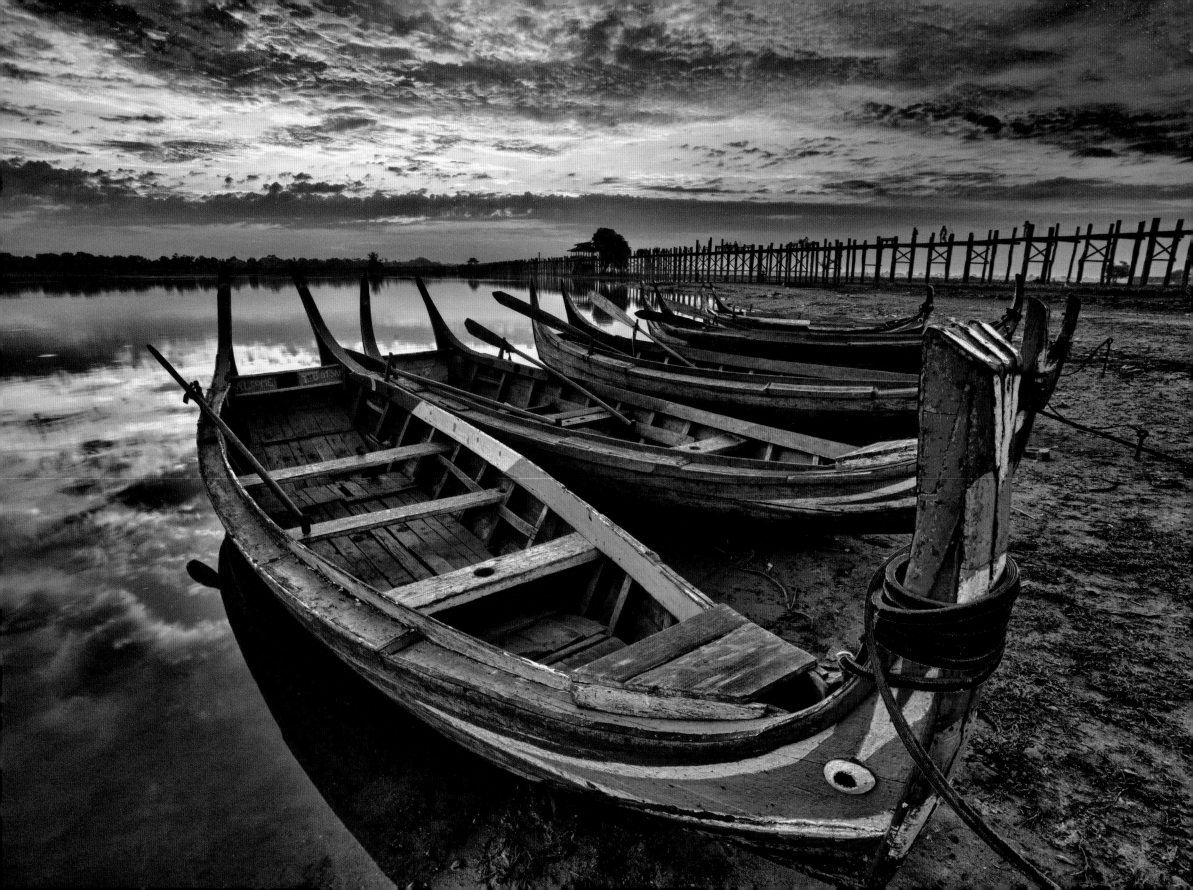

Like a fine watercolor, Burma comprises layers of color. Here the Ubein Bridge, the world's oldest and longest teak footbridge, vanishes into the distance while the hypnotic sunrise bleeds into the placid water. Long tail boats complete the scene.

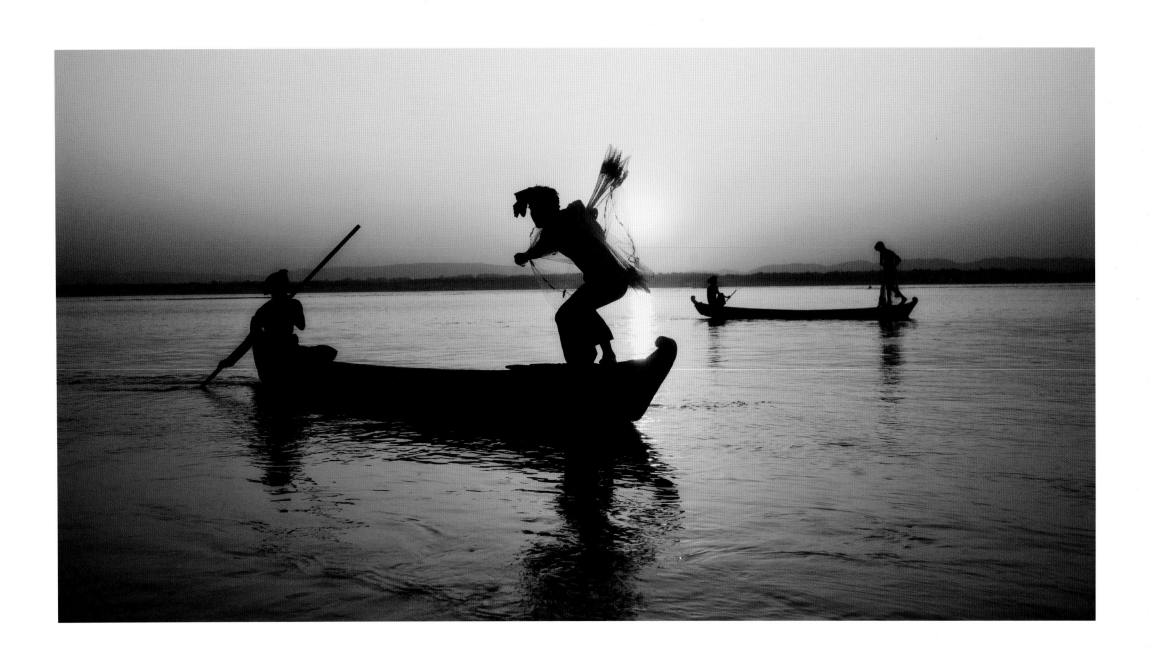

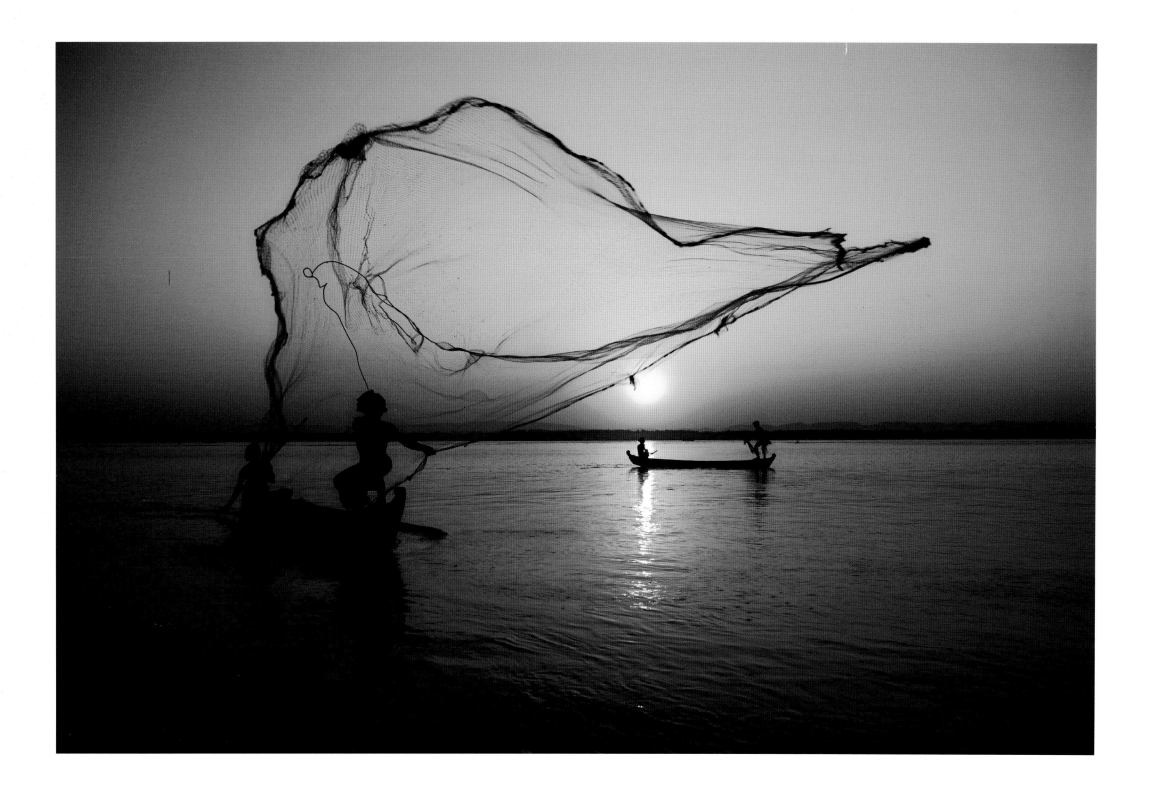

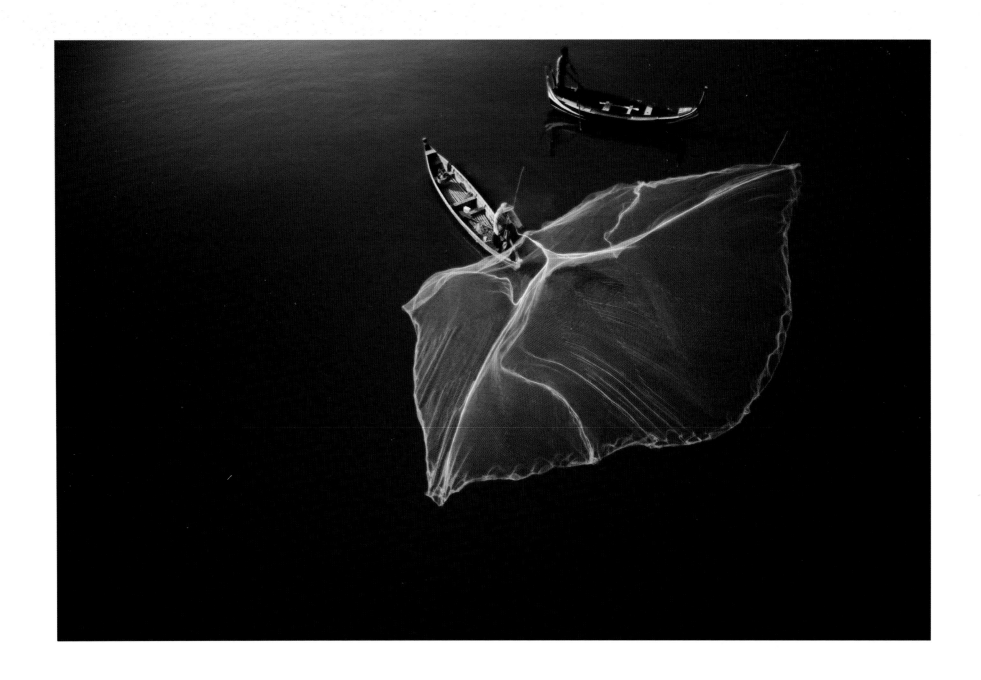

Burma's largest river, the Irrawaddy, is used for trade, transport
and, of course fishing, much like it was back in the sixth century.
Life on the river is ever present, and this vital waterway helps
Burma export many of its goods.

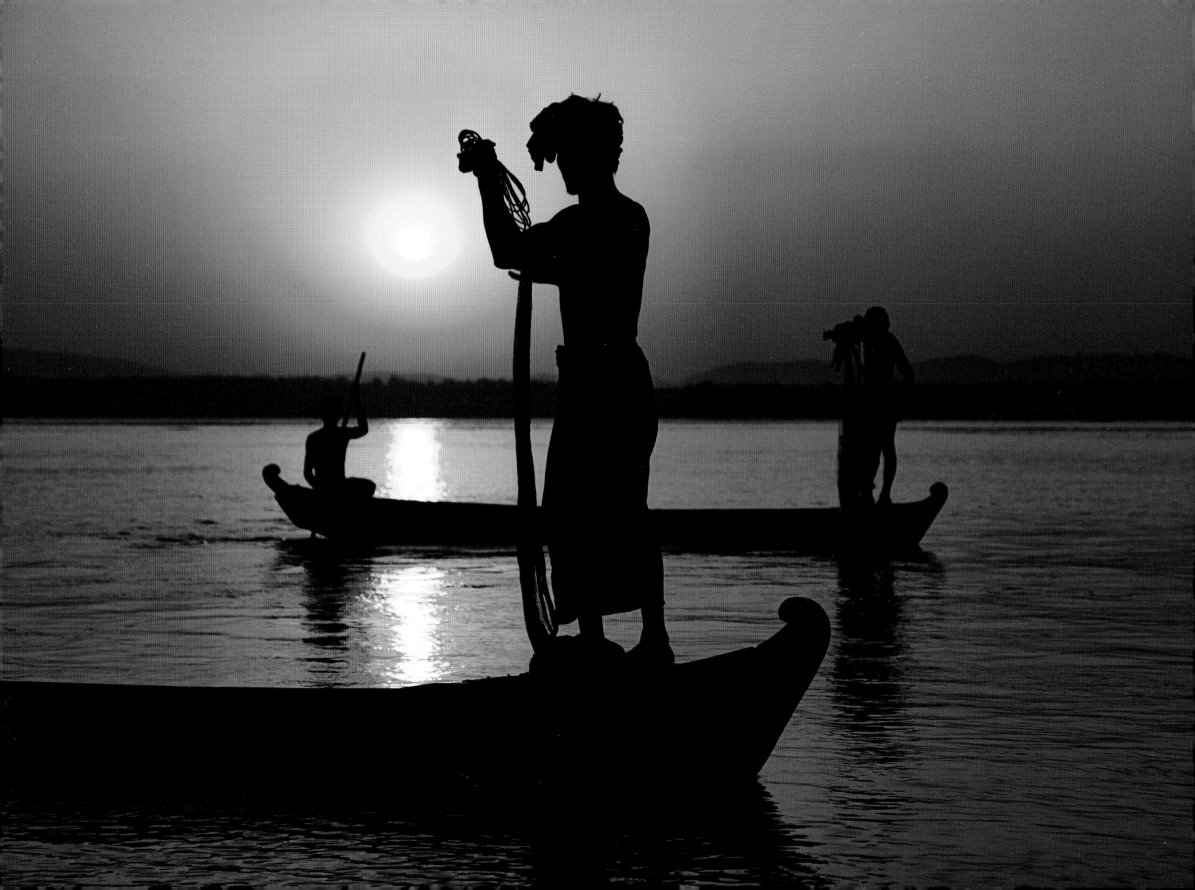

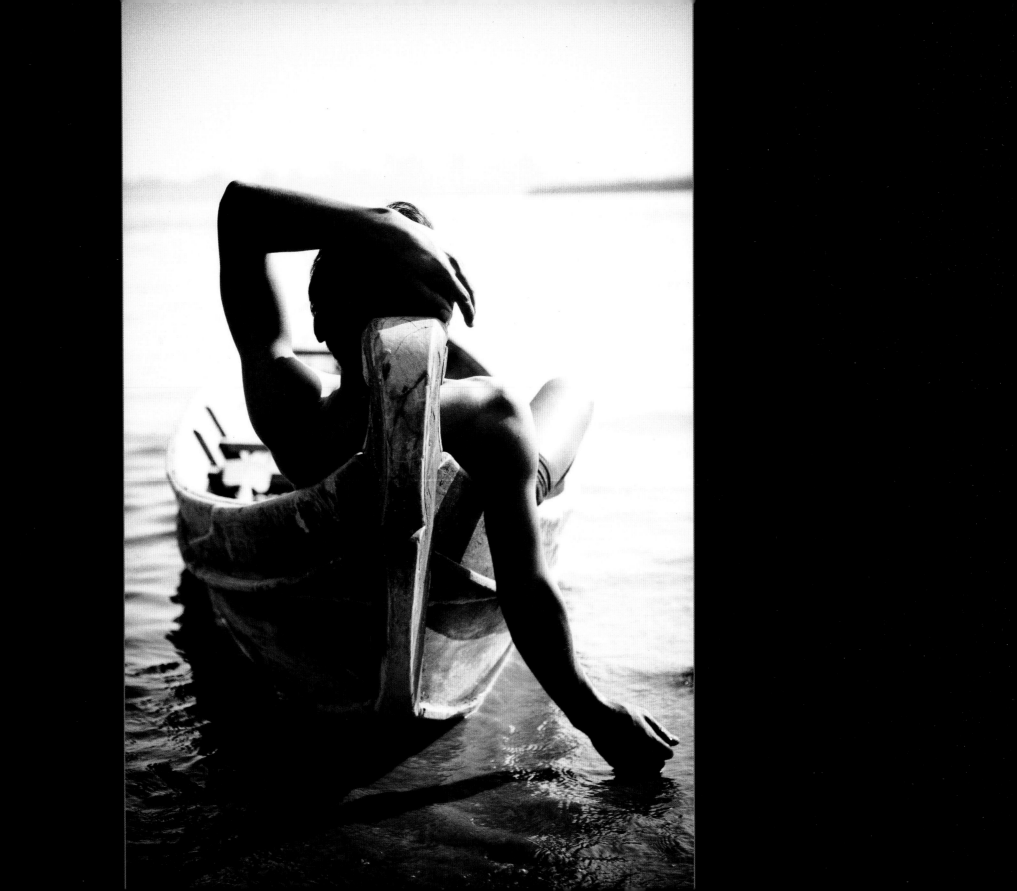

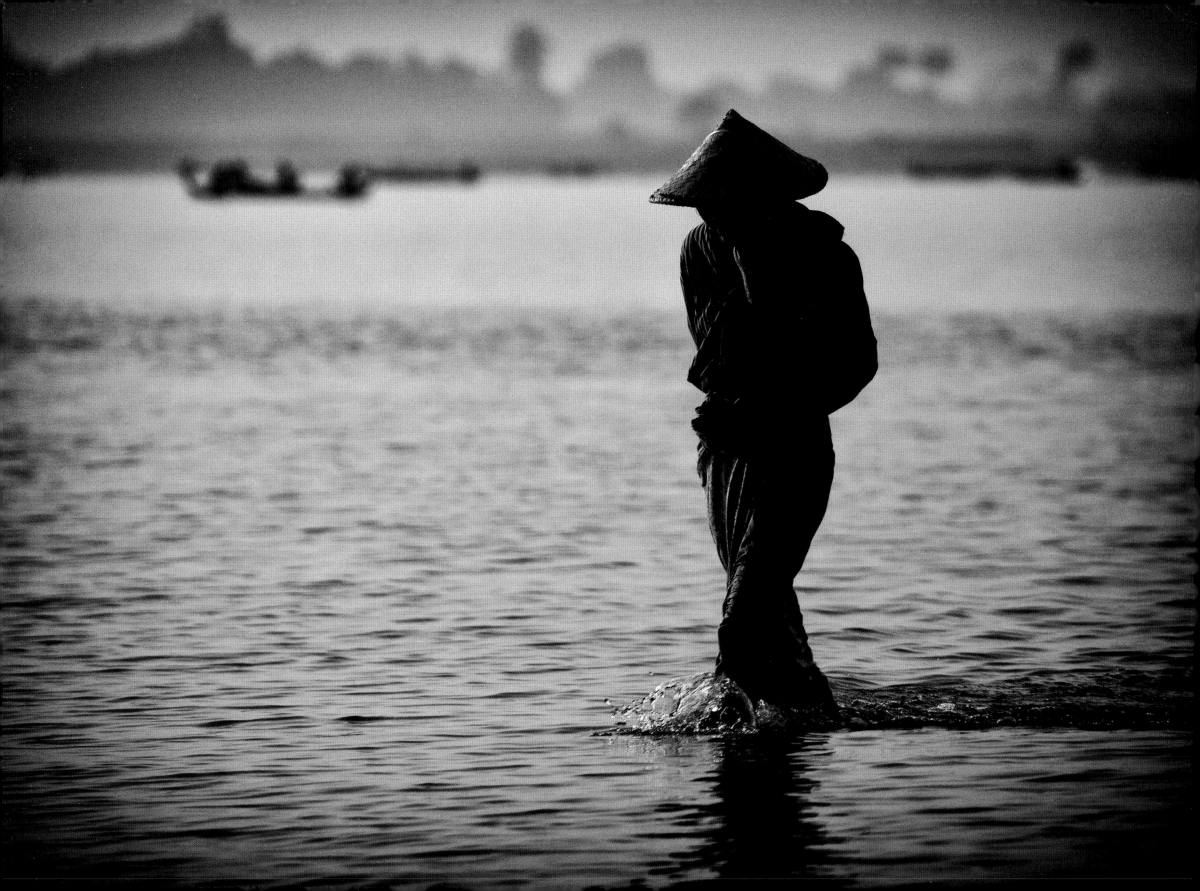

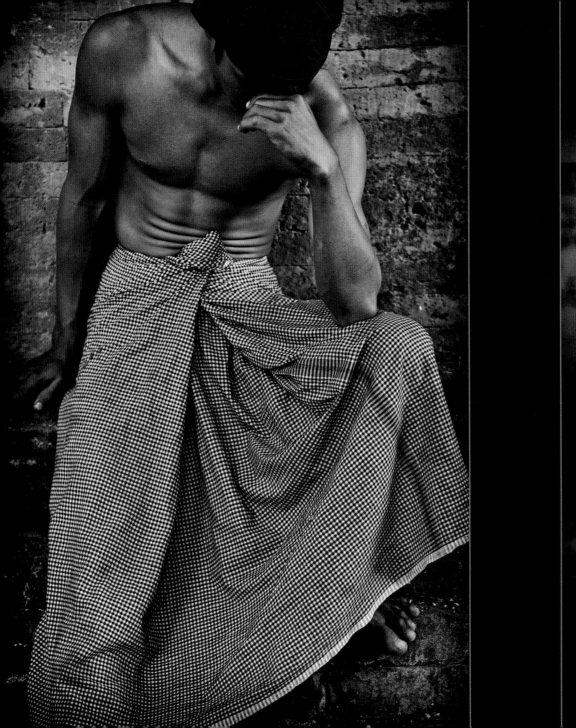
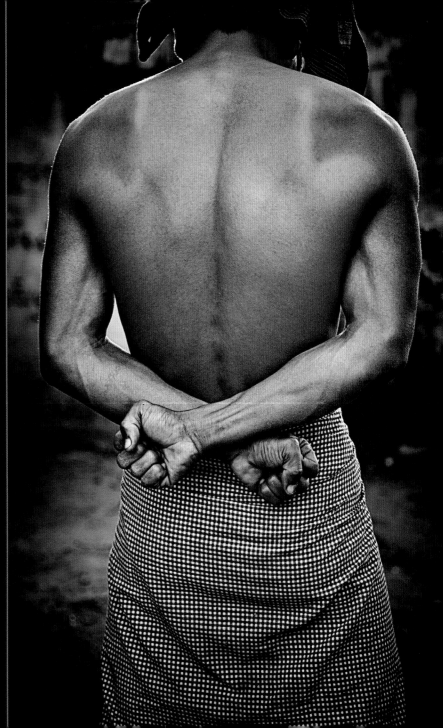

The Longyi is the most traditional piece of clothing in Burma and is worn by both men and women. Most people have a nice collection of them in their closet, and many will save up for an elaborate silk Longyi for special occasions like marriage and festivals.

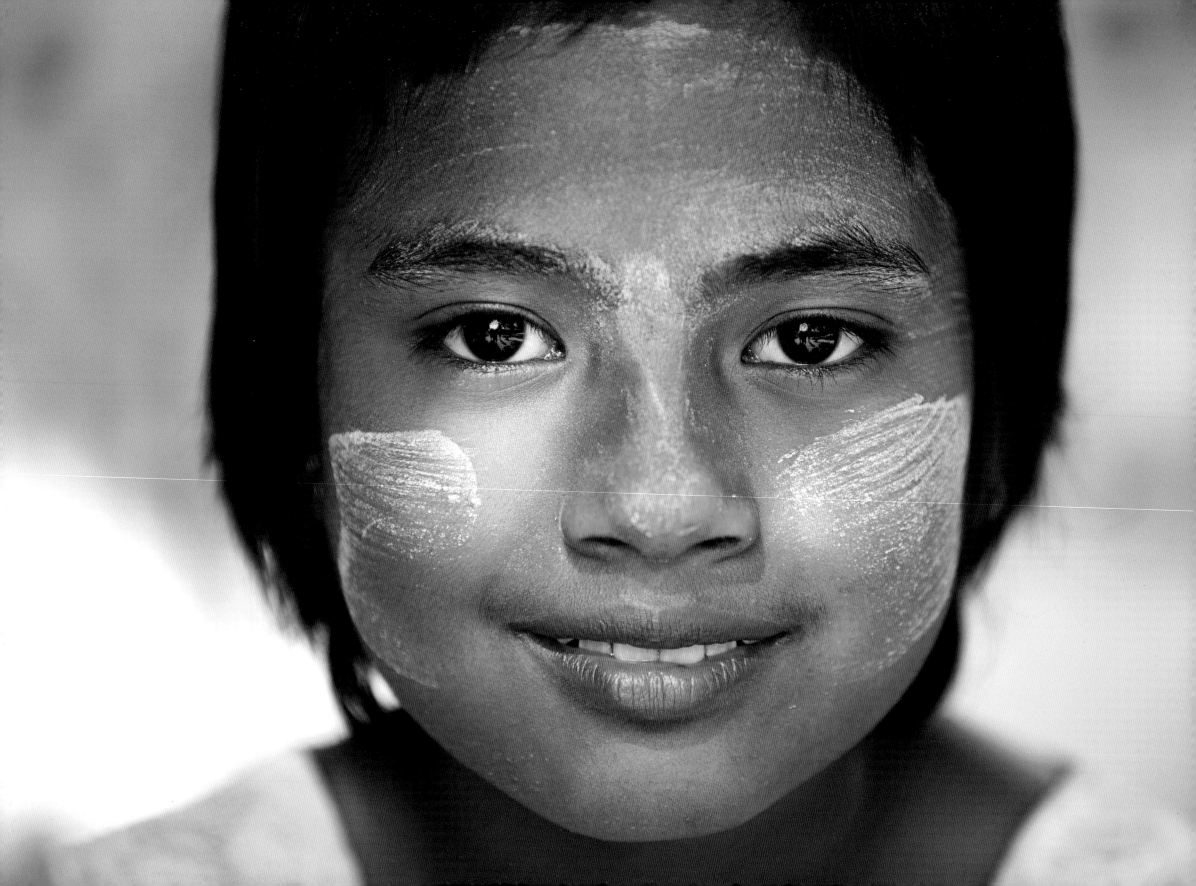

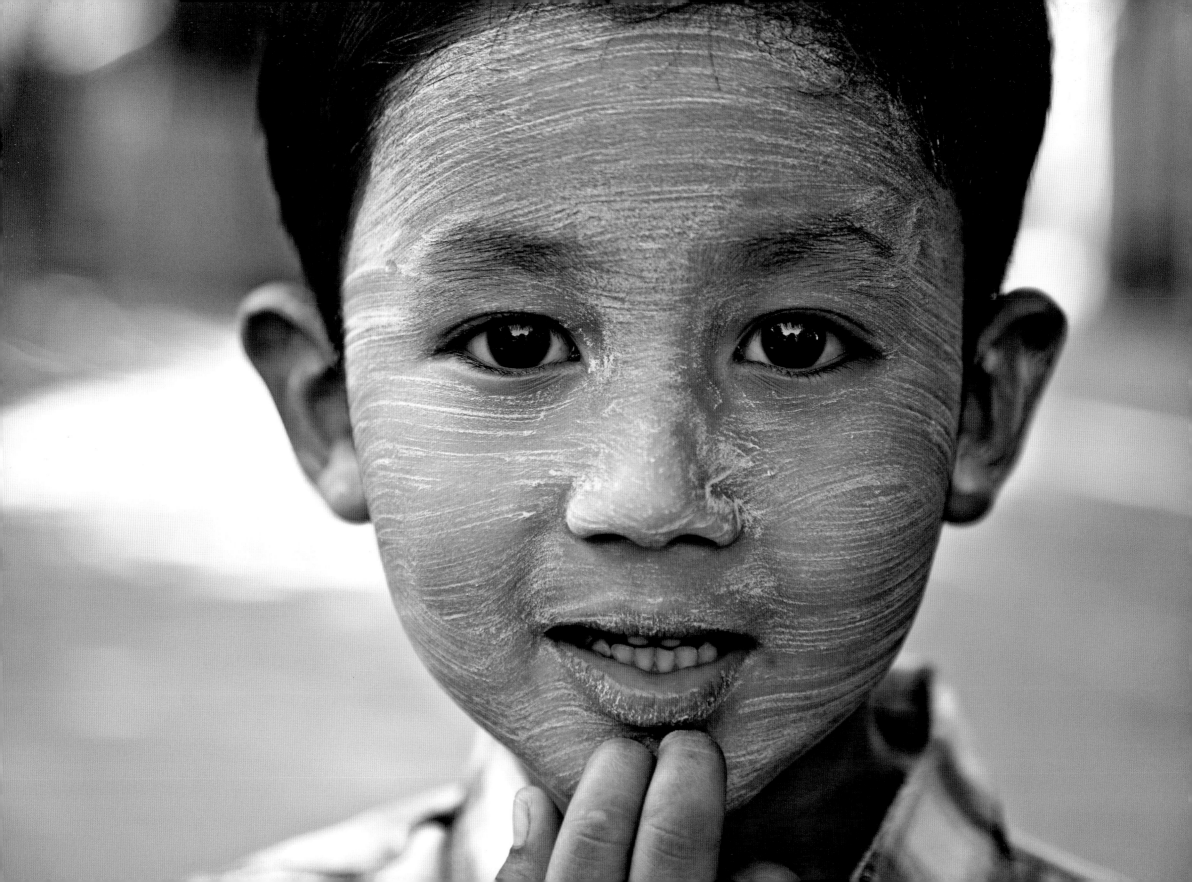

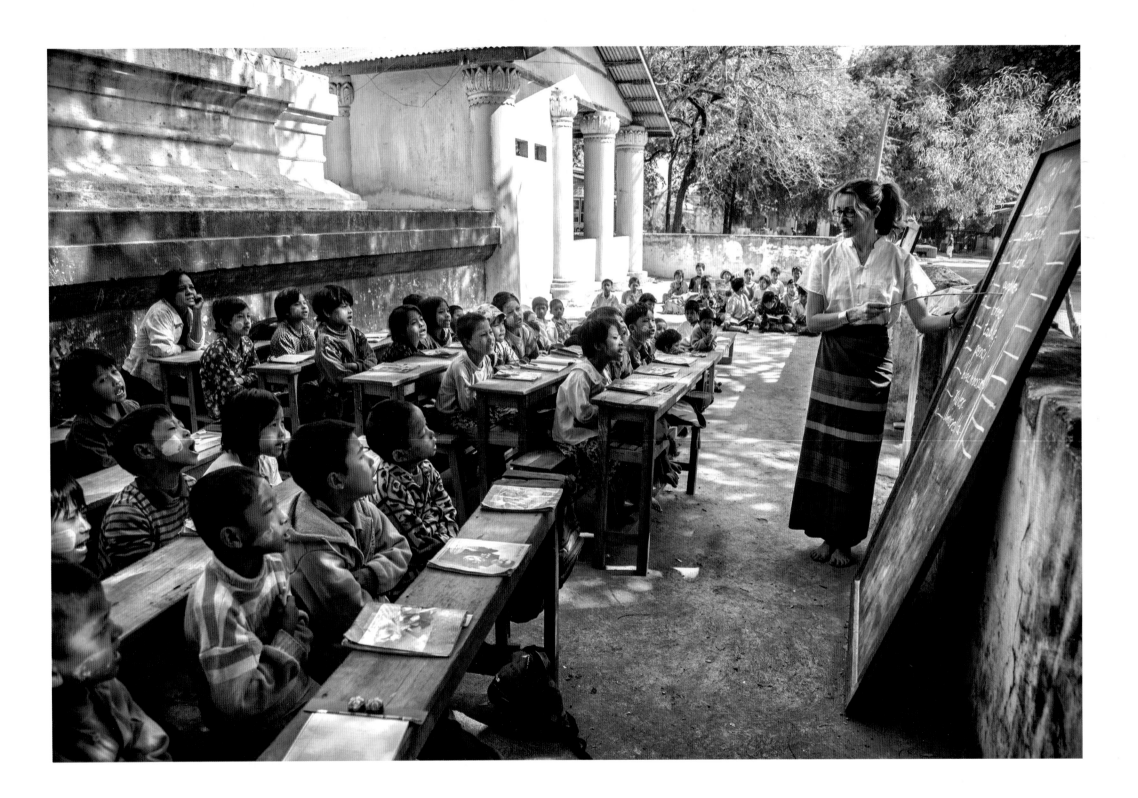

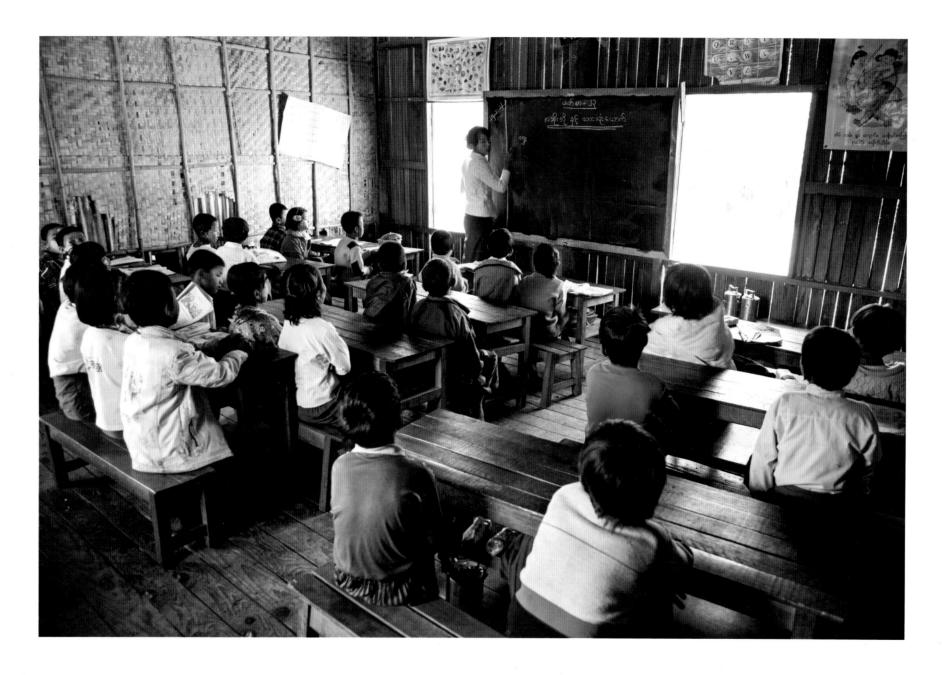

The children of Burma are one of the greatest attractions for me. Whether they are playing, studying, praying, or learning English in an open-air classroom, they represent life, hope, and the promise of a gentle future. These images evoke some of my fondest memories of Burma, my home away from home.

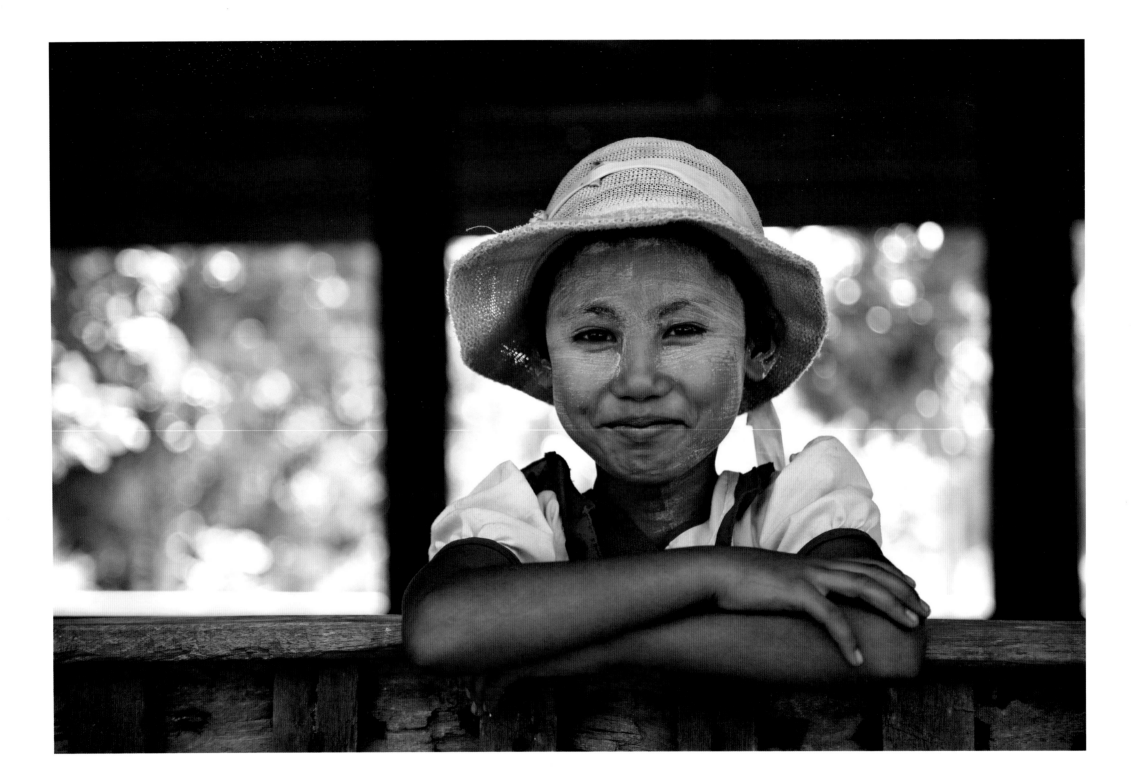

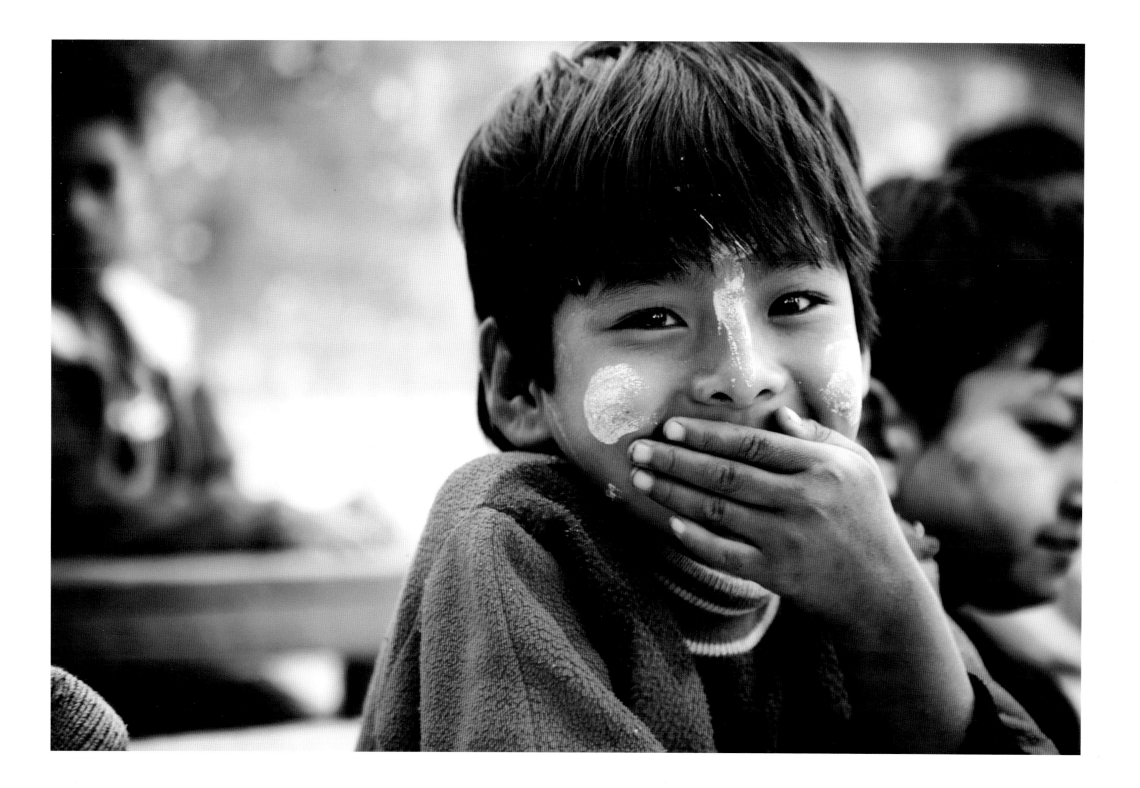

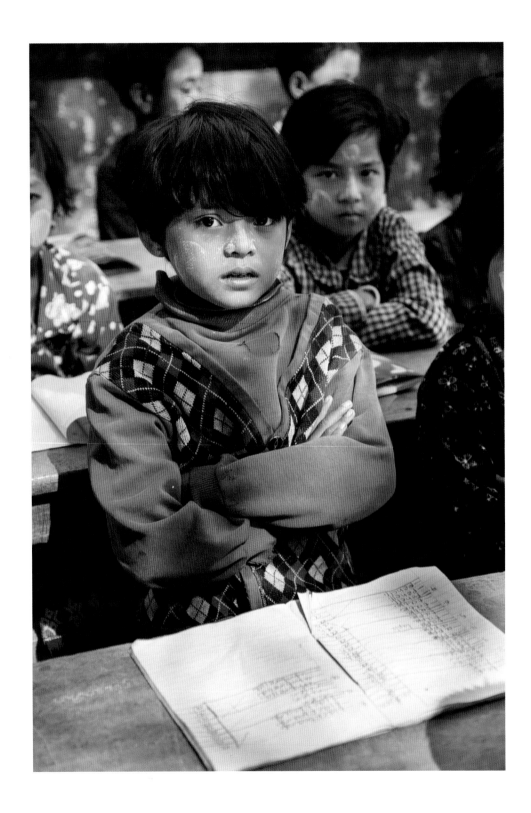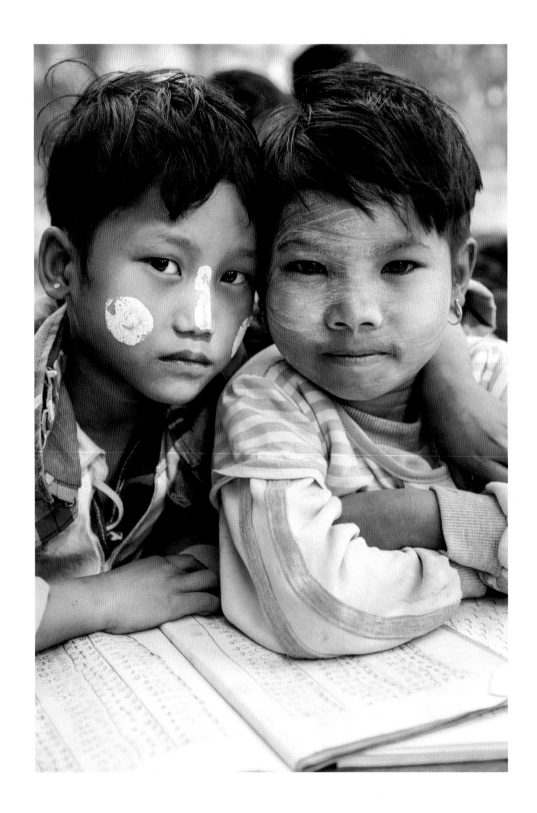

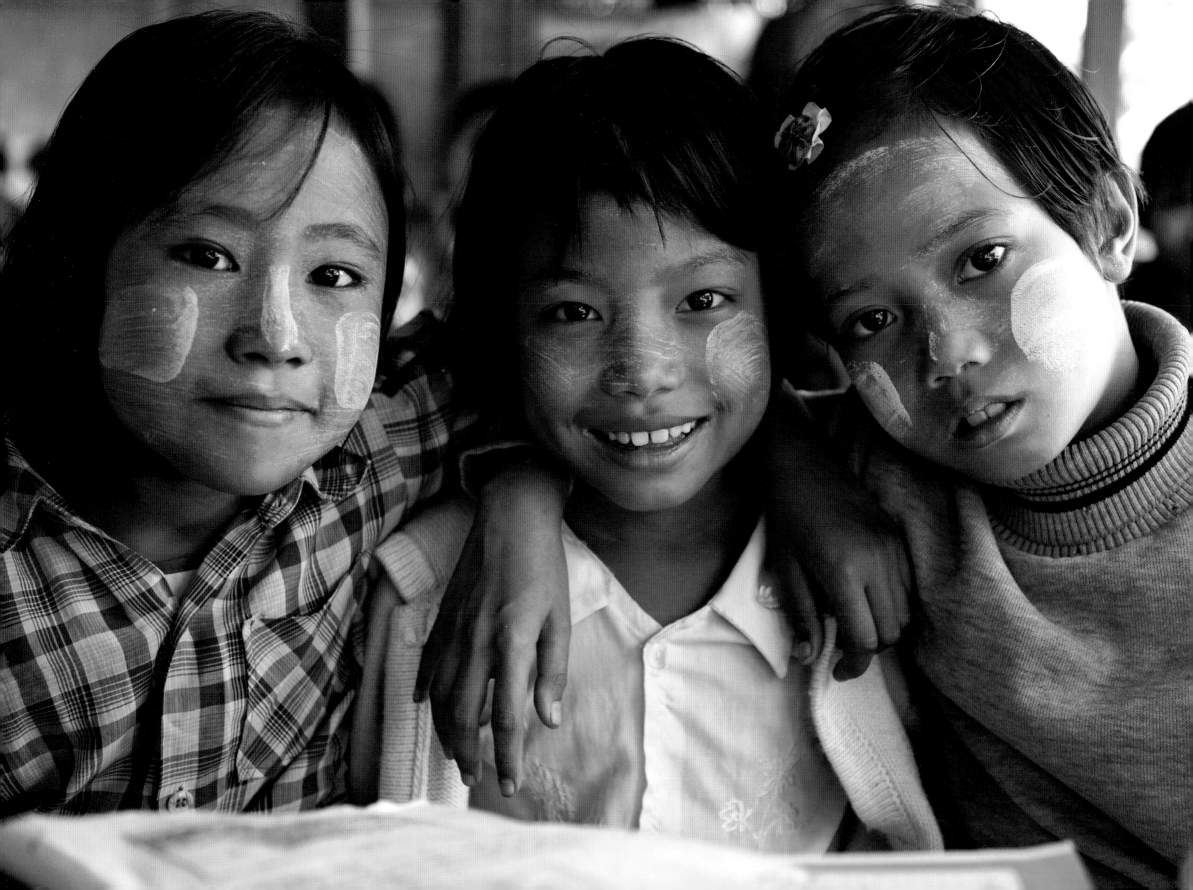

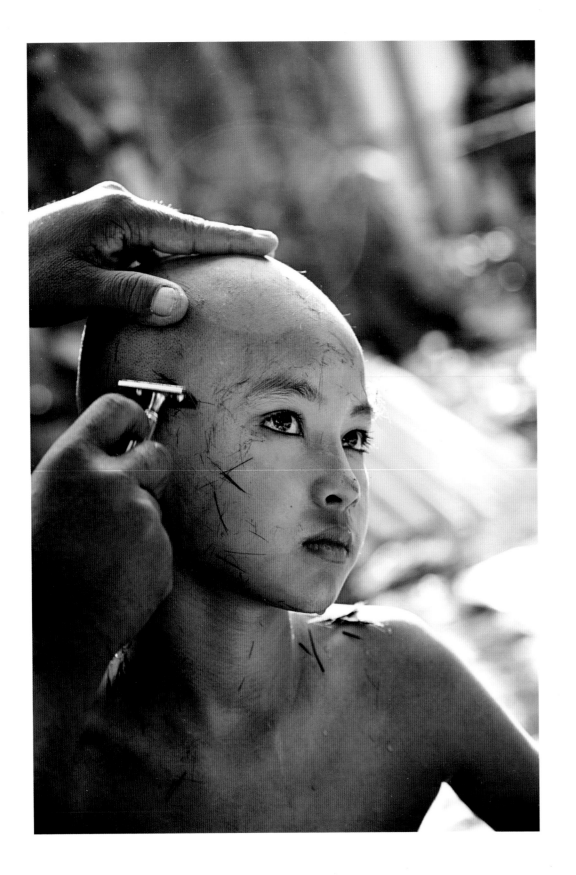
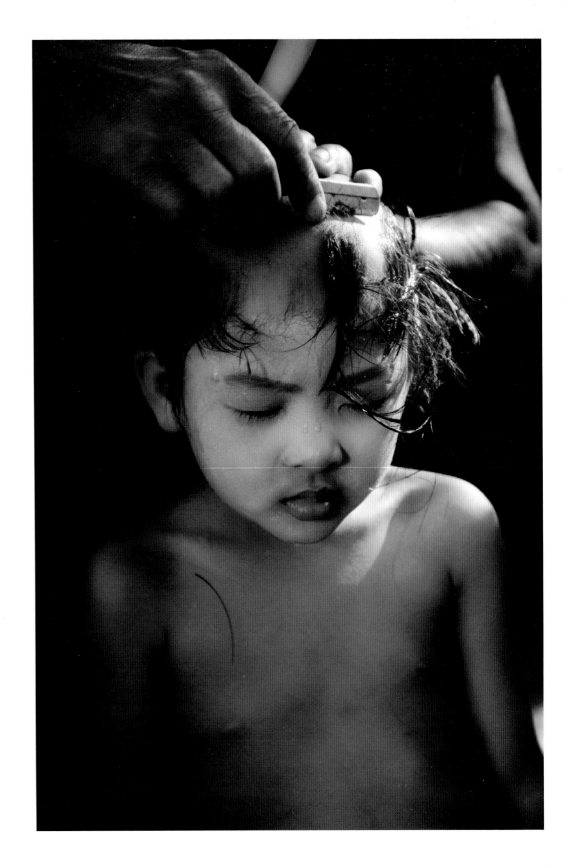

Having their heads shaved is part of the initiation ceremony to become a novice monk. This begins their understanding of enlightenment and embracing of the teachings of Buddha.

At the age of twenty, they are no longer novices and
can stay or leave the monastery as they choose.
As devout Buddhists, their journey to seek
enlightenment never ends.

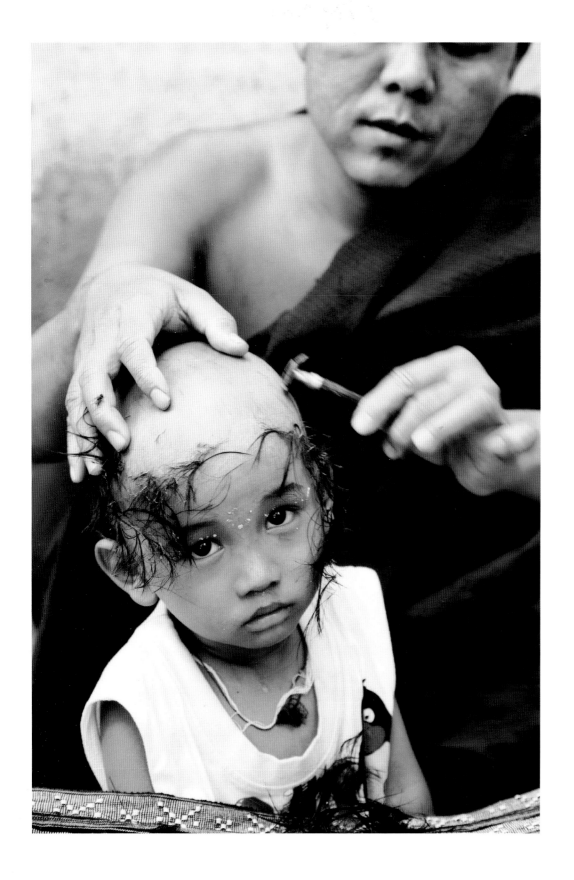
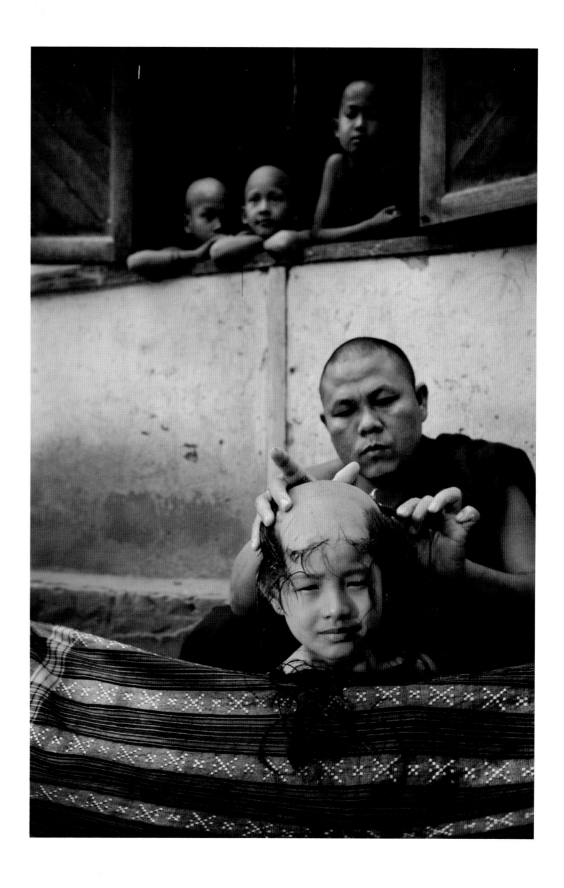

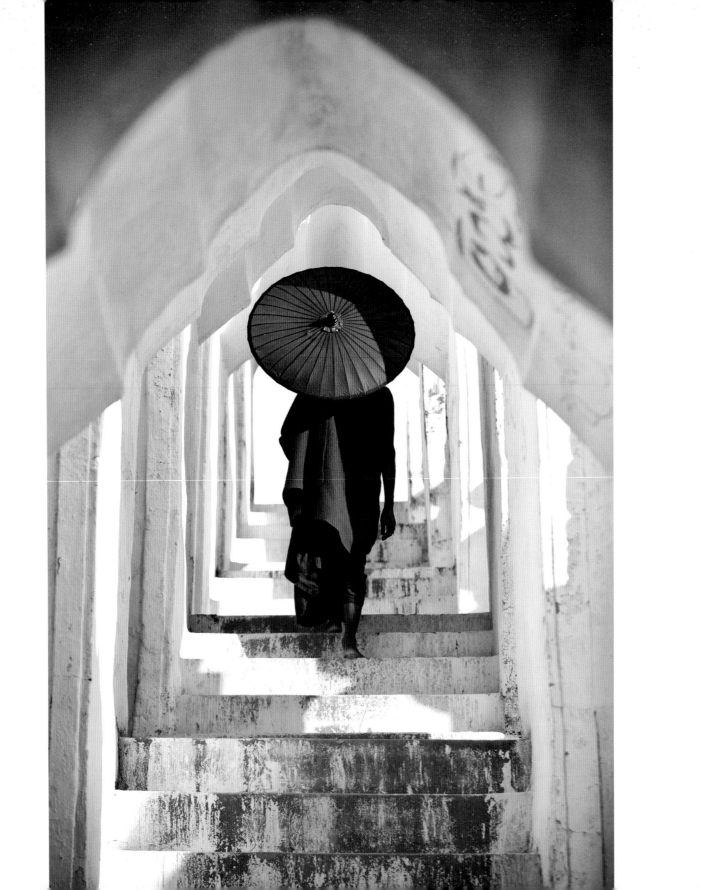

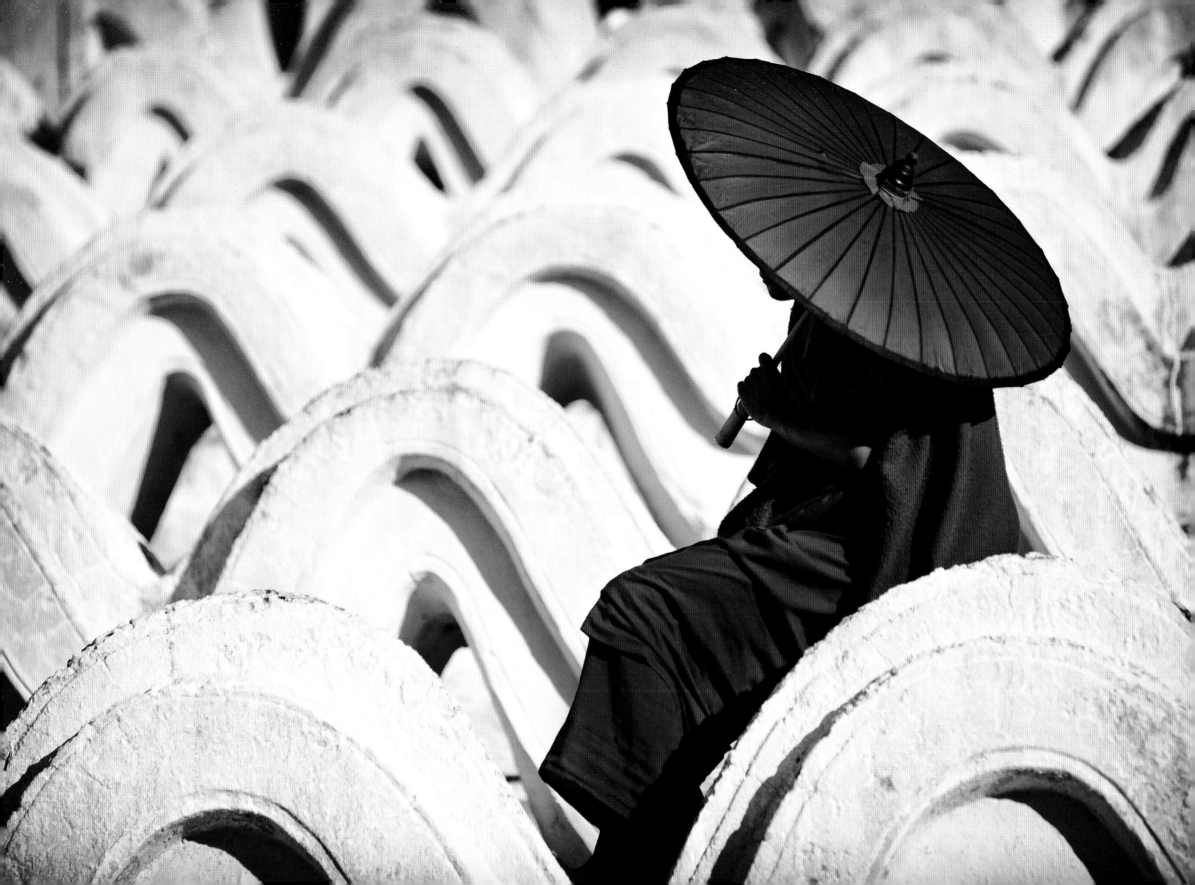

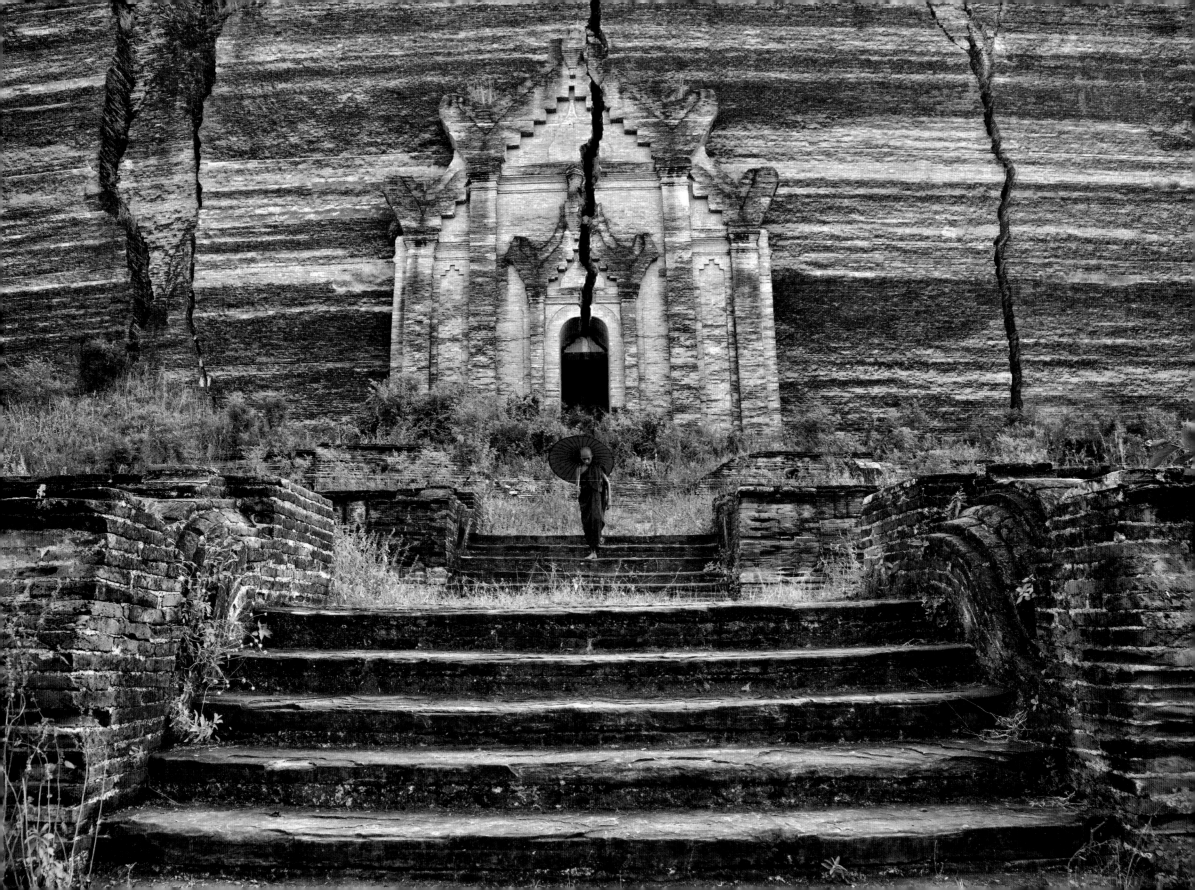

From 1790 until his death in 1819, King Bodawpaya had thousands of prisoners of war and slaves working on the construction of the spectacular Mingun Temple. But with much dissatisfaction prevailing, a prophesy emerged: "As soon as the building of the pagoda was over, the country would also be gone and the King would die." Thus the construction came to a halt, making the people rejoice. Only a third of Bodawpaya's dream was completed.

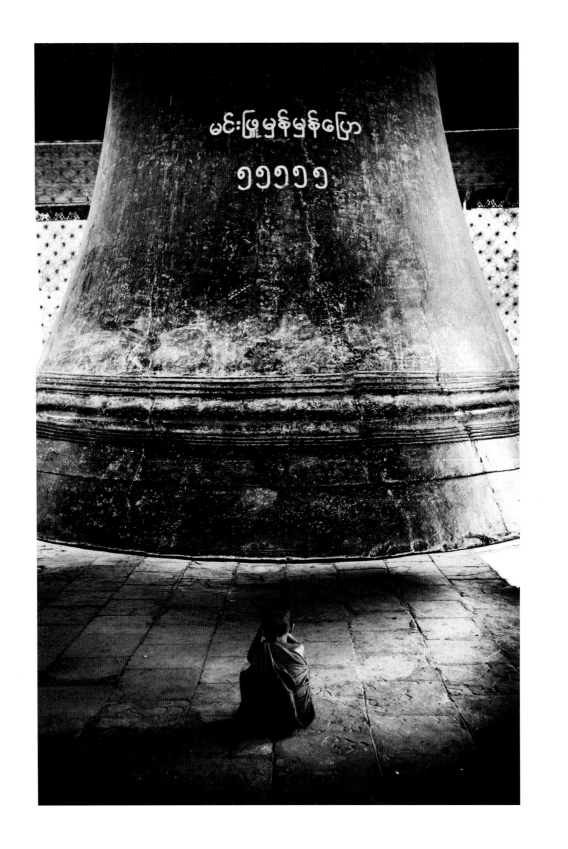

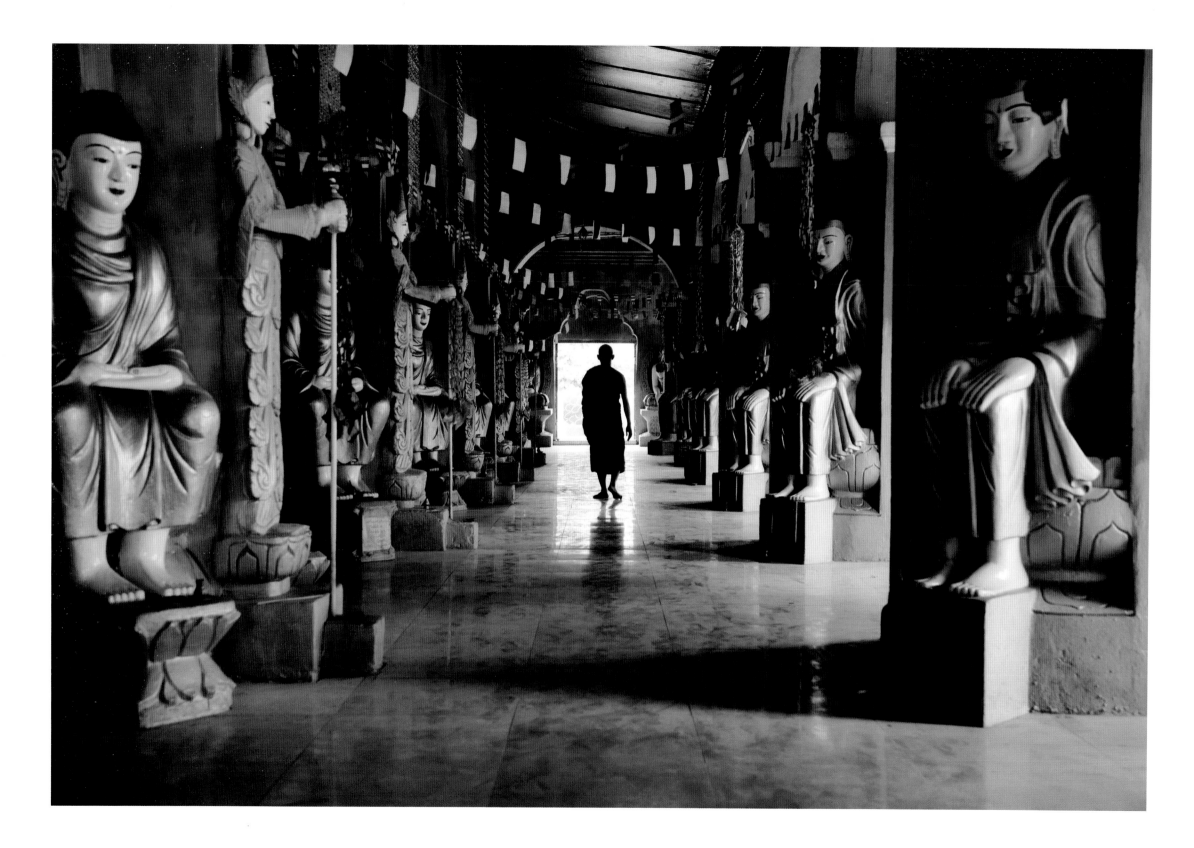

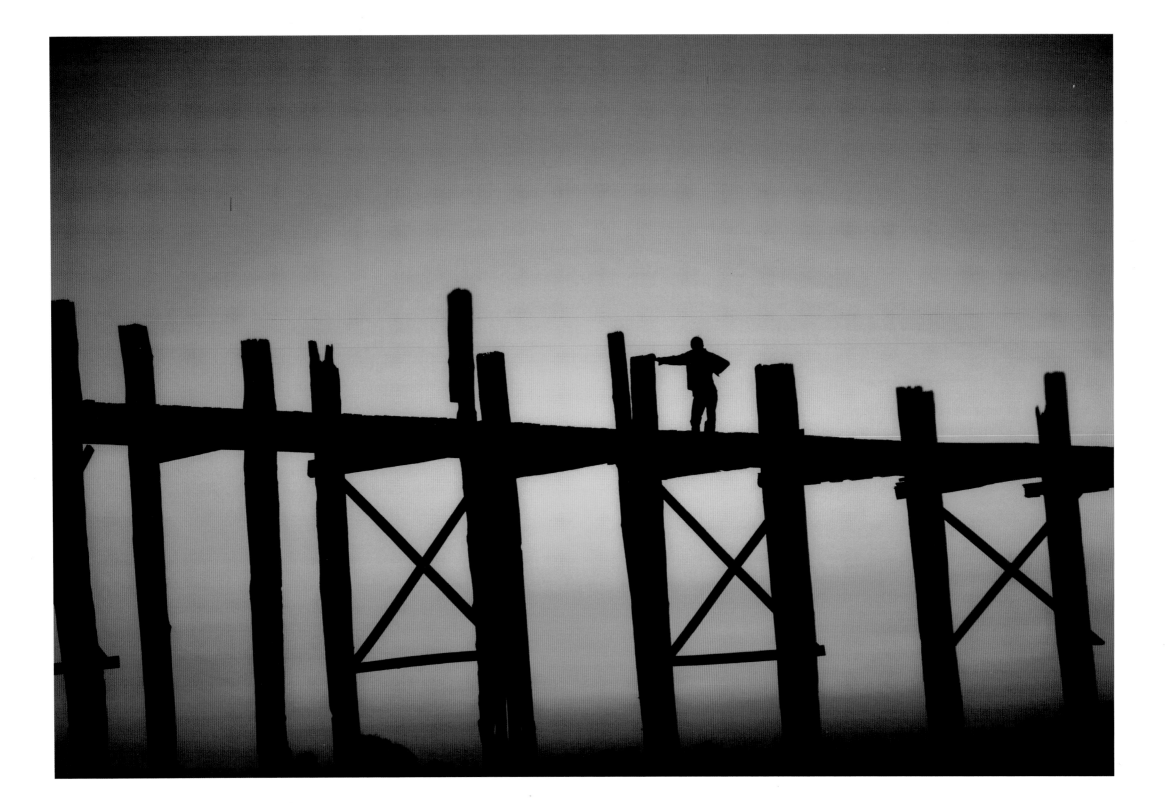

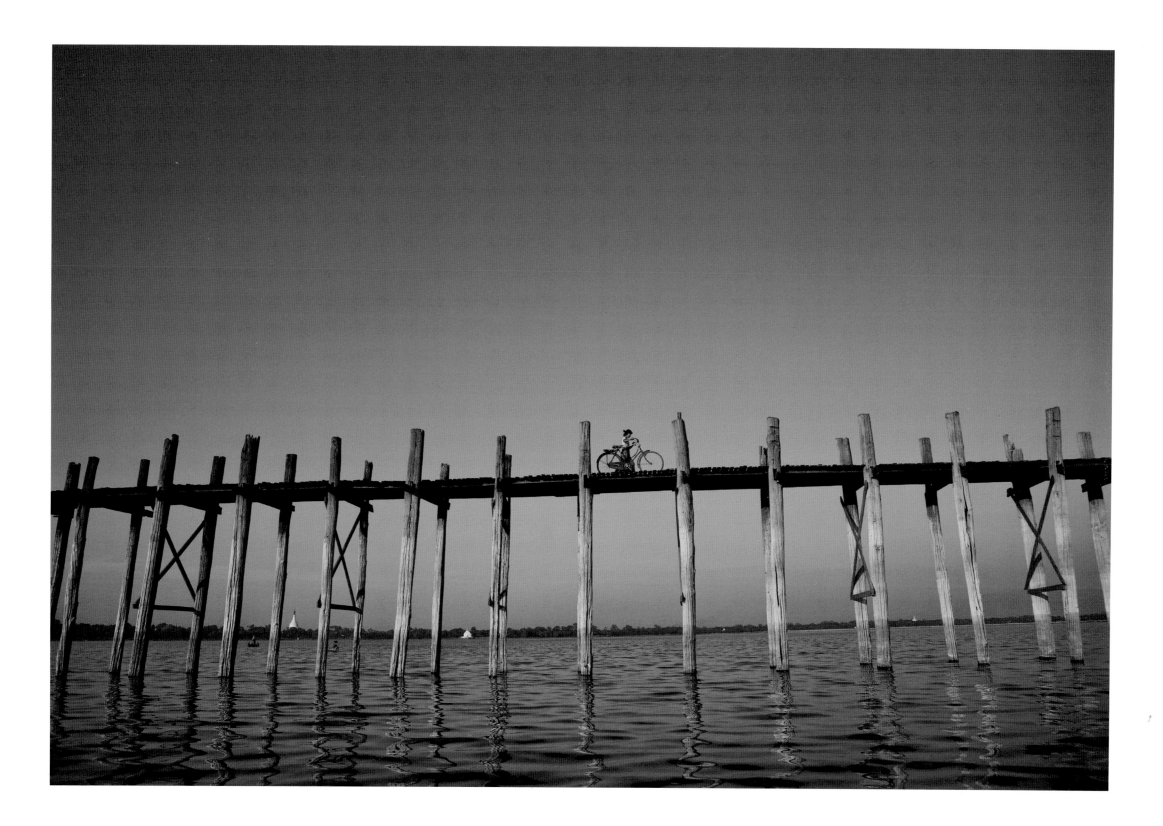

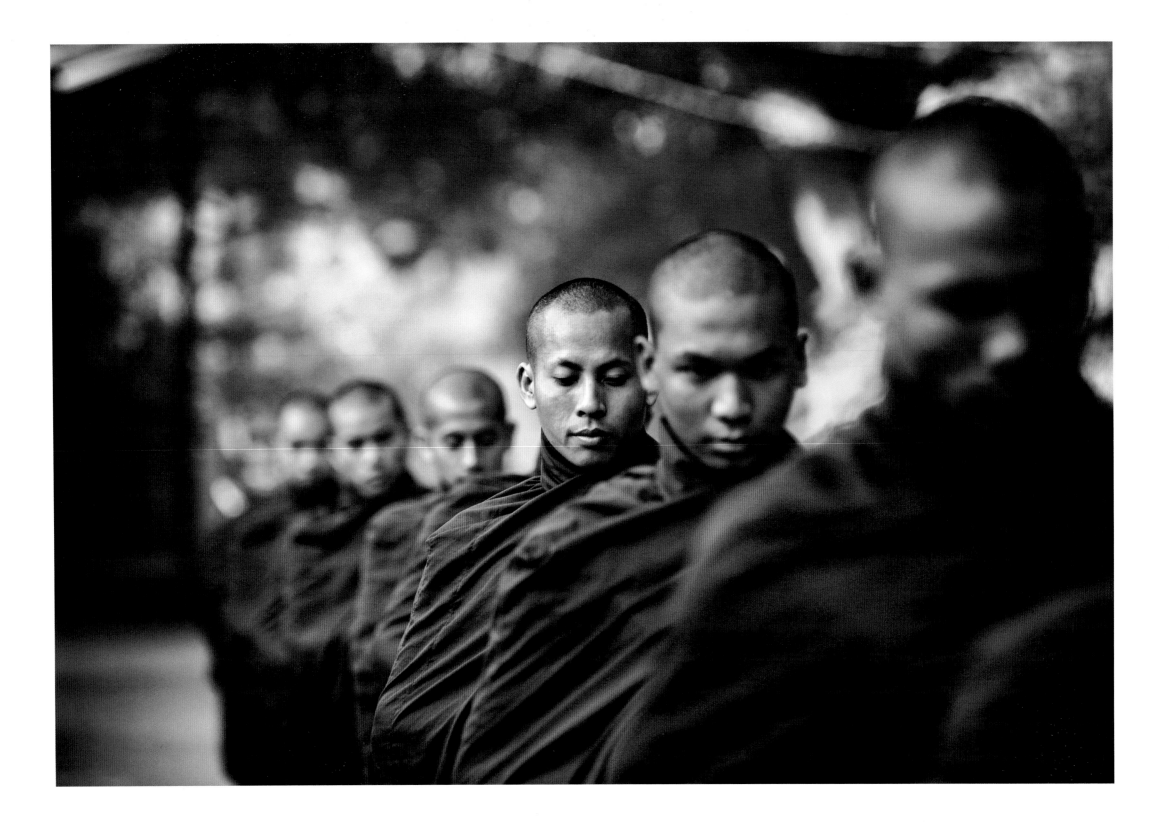

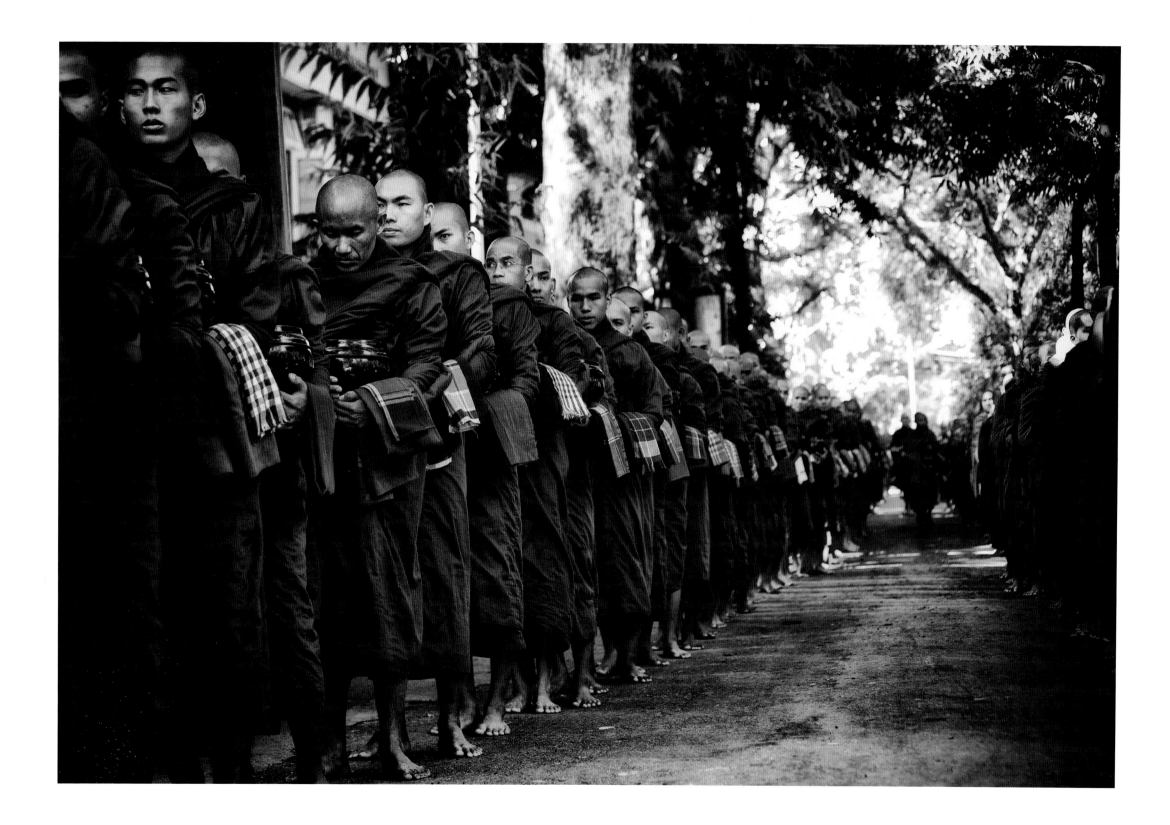

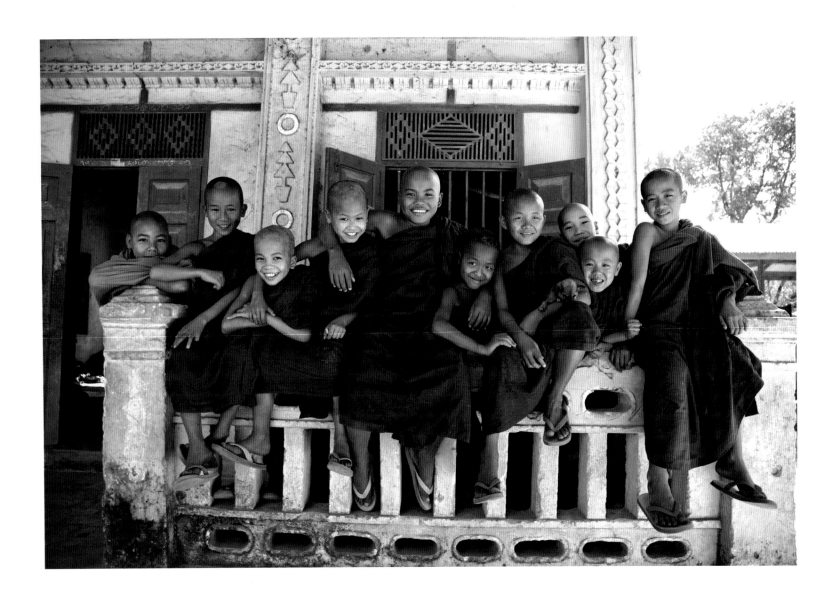

The smiles from my young friends
are contagious.

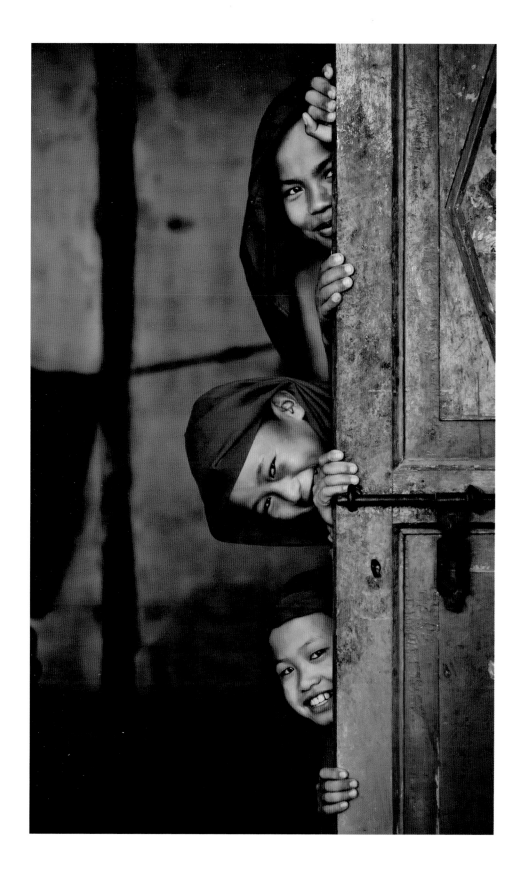
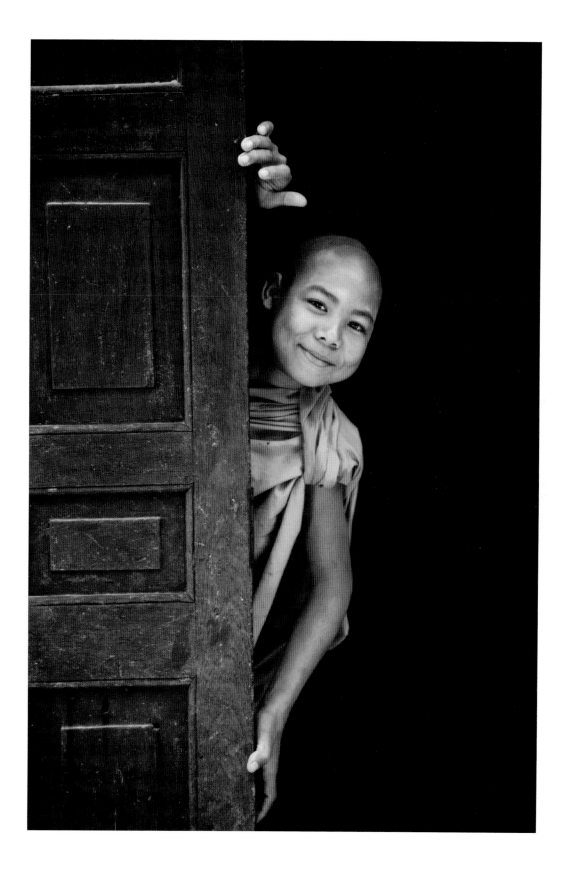

The streets of Mandalay are an exercise in chaos.
The cacophony of car horns, motorcycles, and
clanking bicycles is a twenty-four-hour affair.

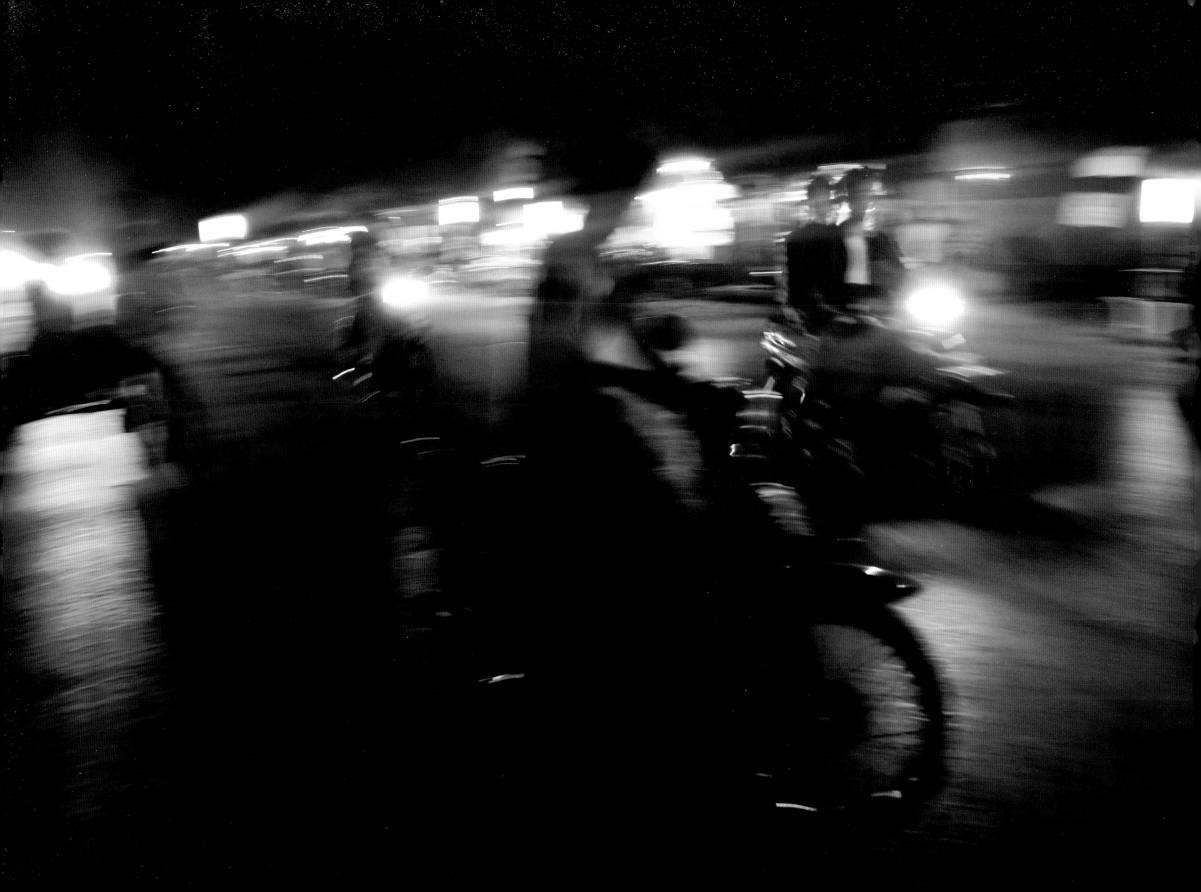

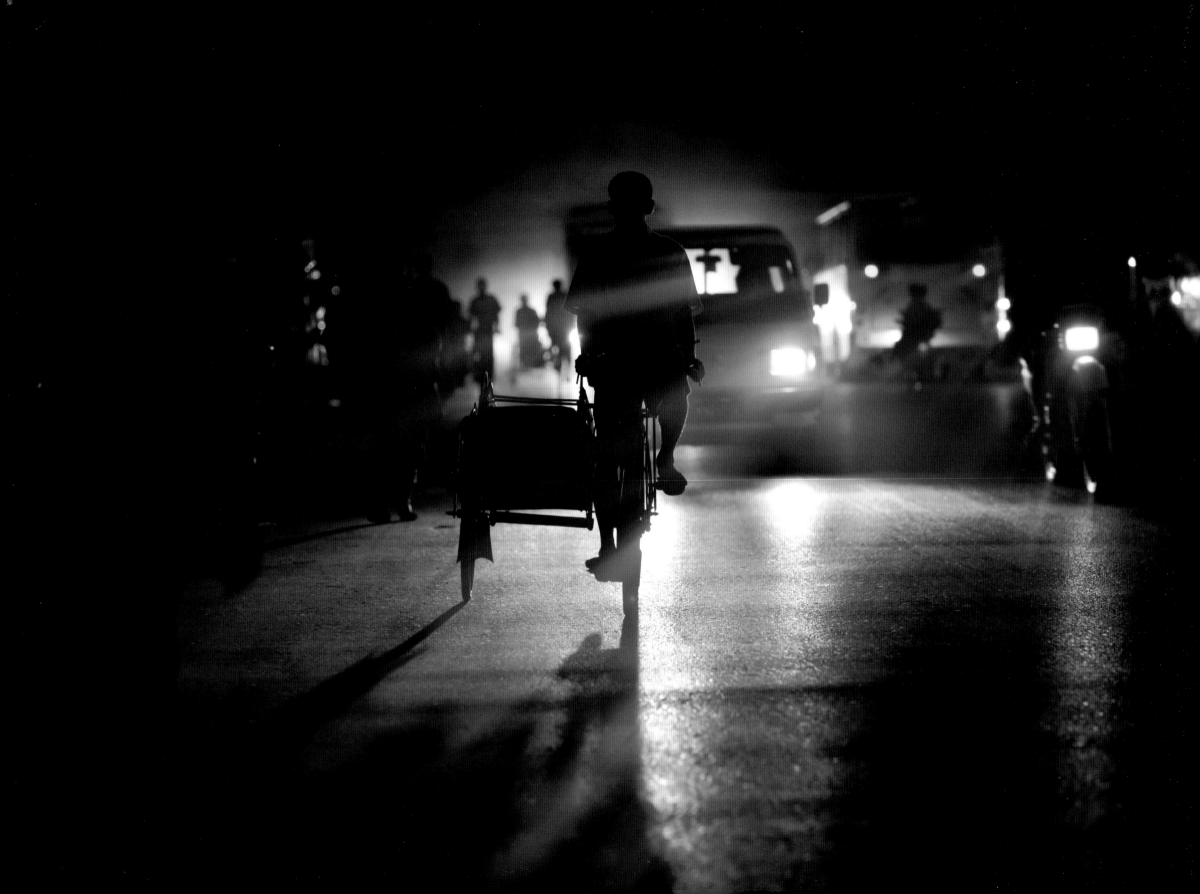

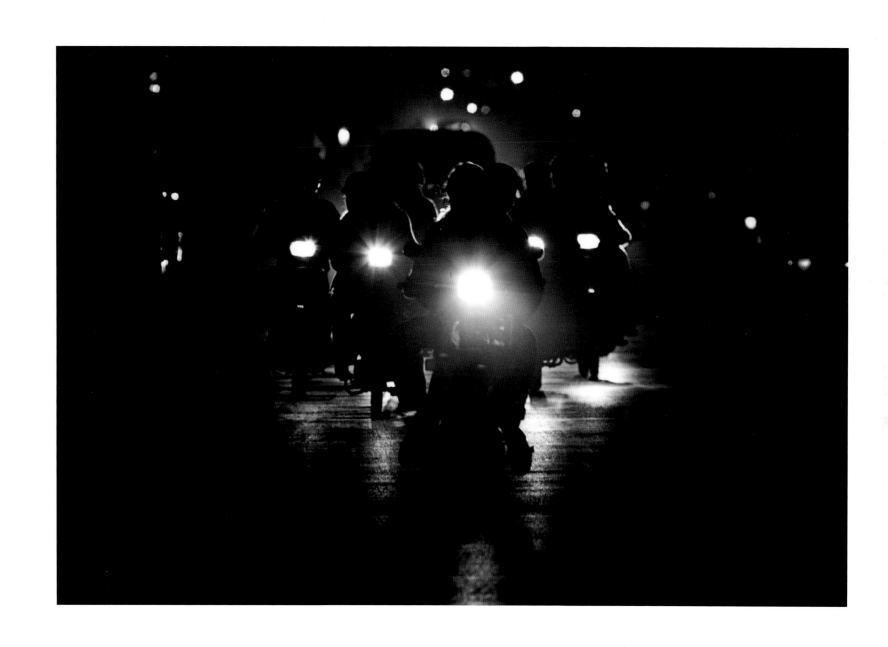

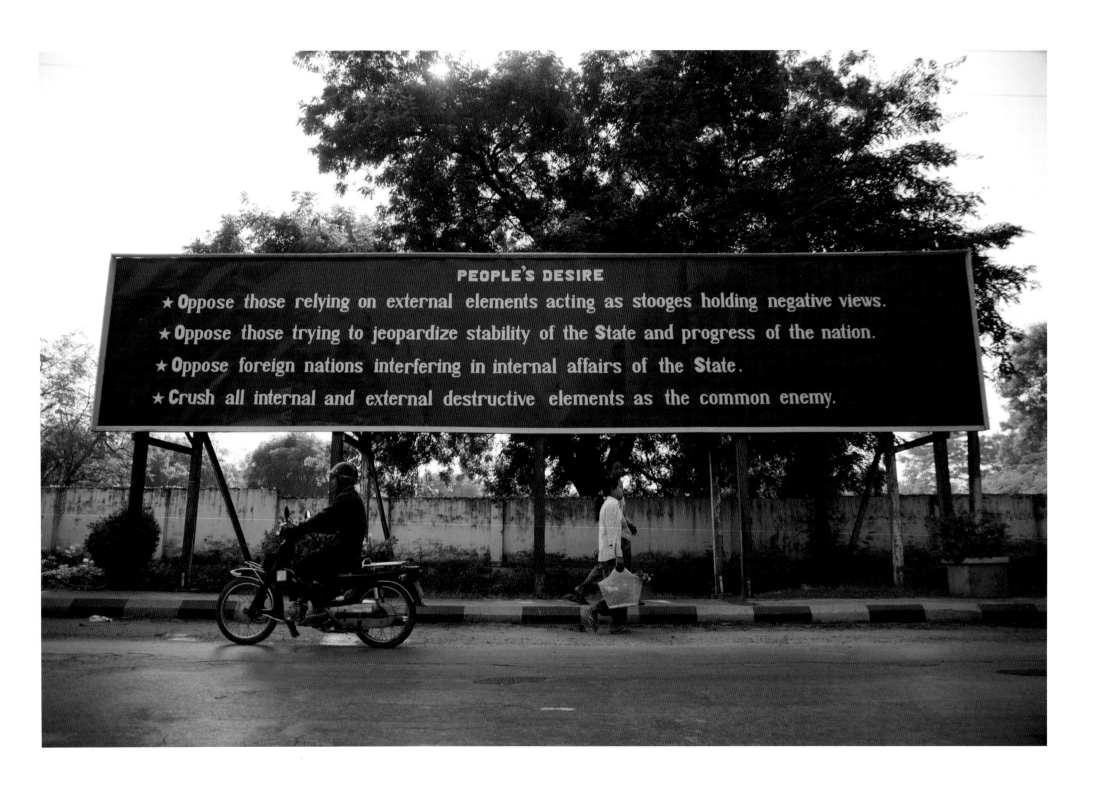

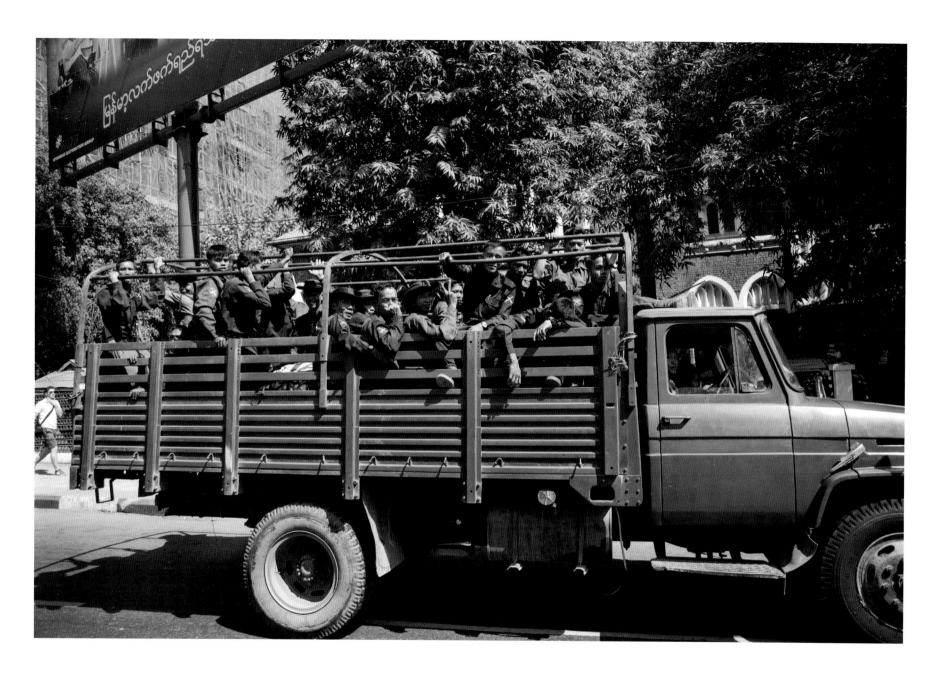

Whether a sign depicting views from the government or a truck full of soldiers driving through town, reminders of the military rule still sprinkle the landscape.

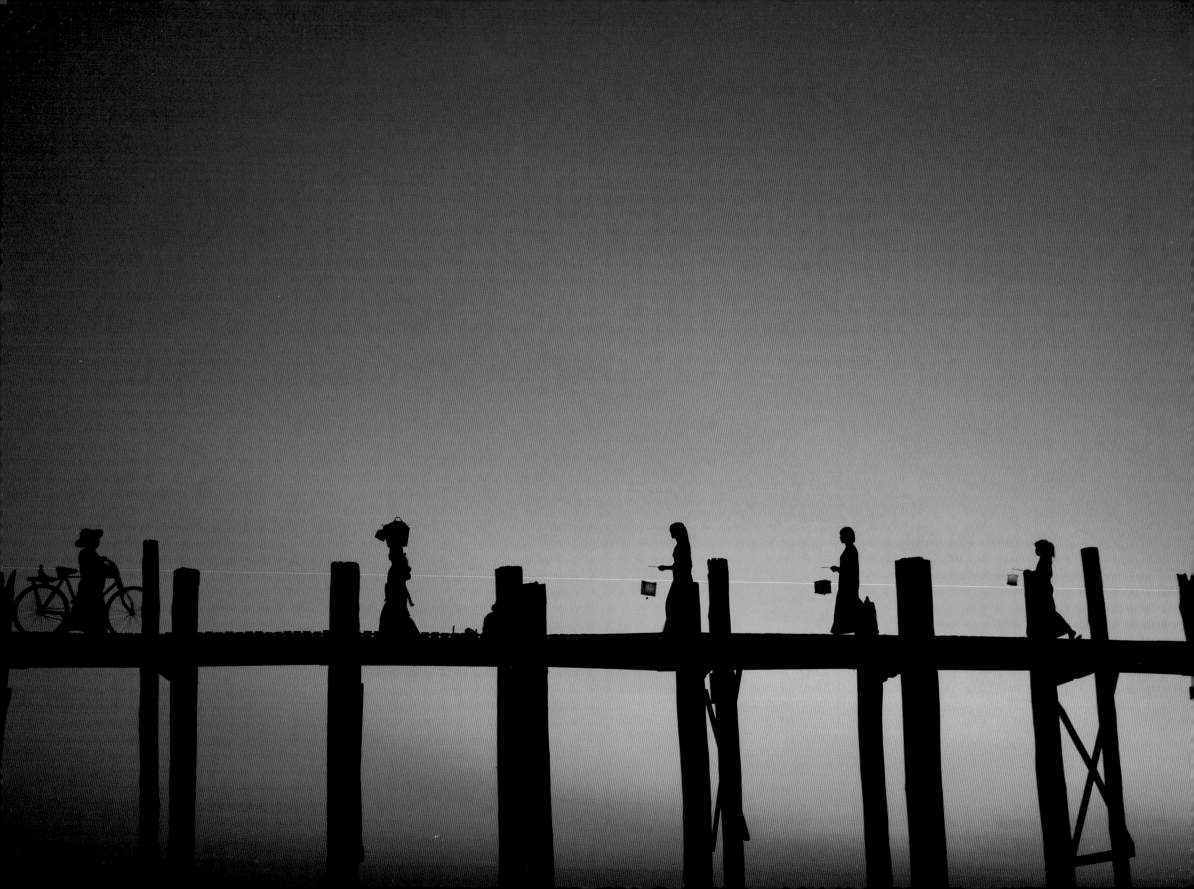

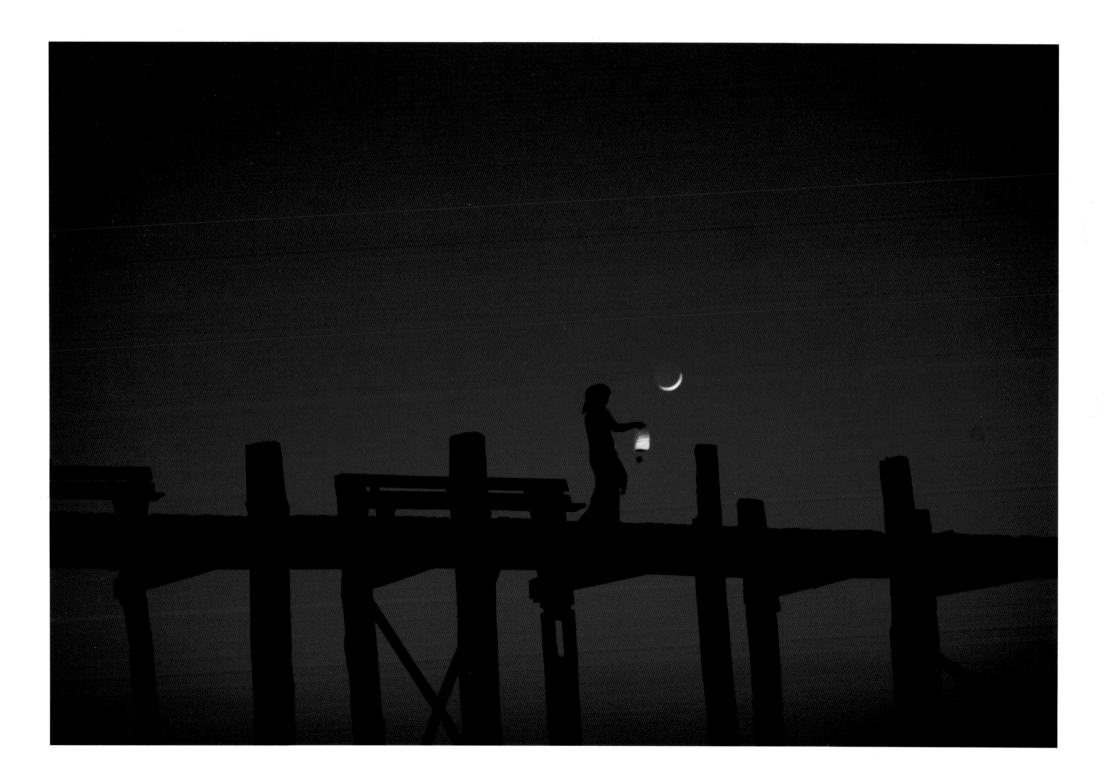

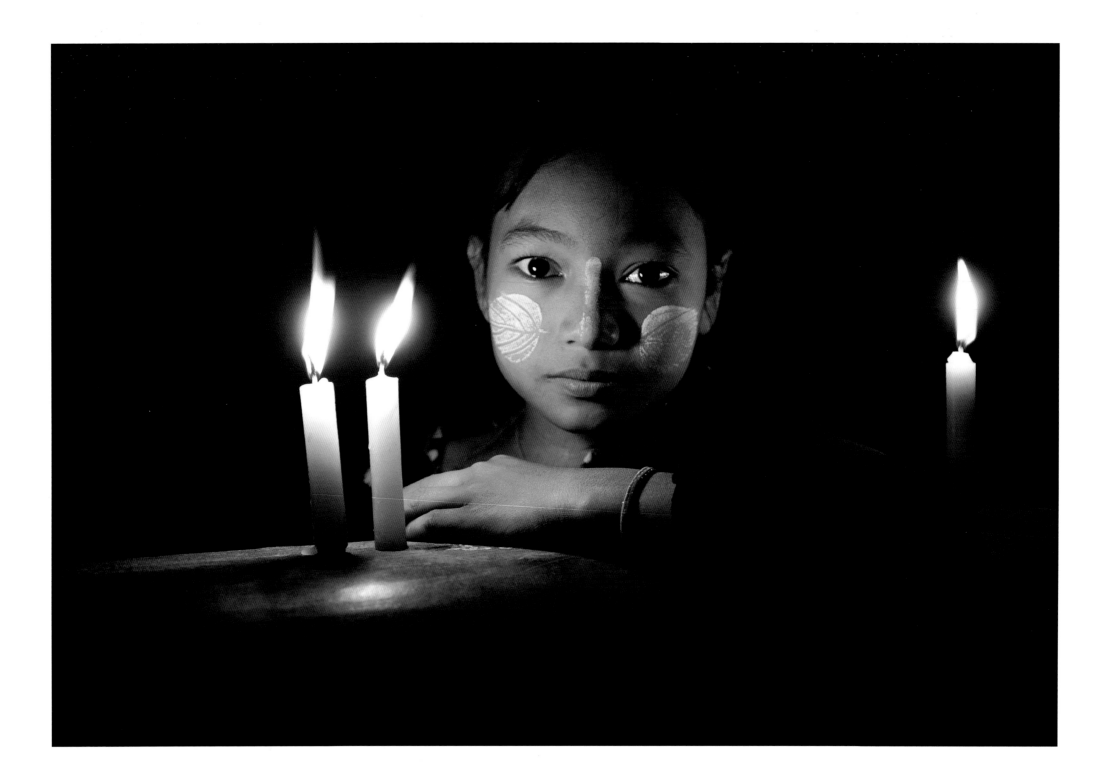

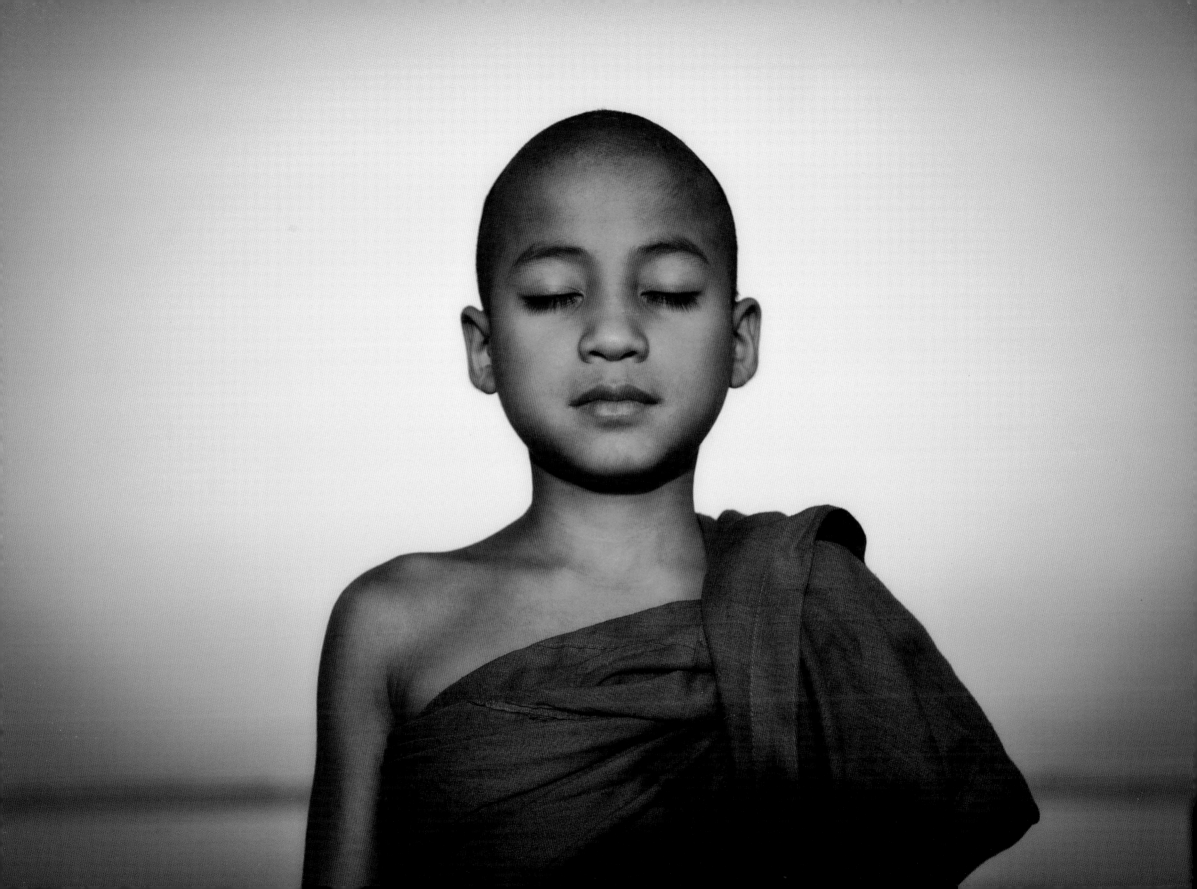

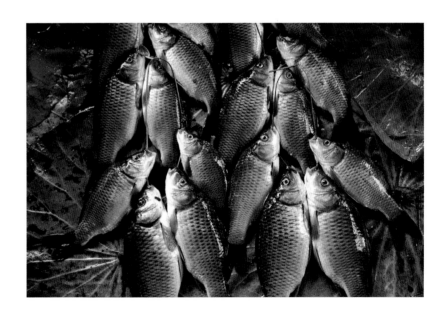

Inle Lake

Located in the remote grasslands of Burma southeast of Mandalay, Inle Lake is an ecosystem and cultural phenomenon all its own. The average depth of the lake is five feet, yet in monsoon season the depth doubles. Ten miles long and four miles wide, the lake and its environs are different than any other part of Burma, a uniqueness that stems from its remote location. Roads here are mere suggestions; going almost anywhere involves a voyage over water in a long tail boat. Everything is distant from everything else here, but no matter. The sights, sounds, and smells of Inle fill the senses.

Every moment is a photograph, and while fog often envelops the shoreline here, even the fog provides gifts and surprises. Images pop up around every corner: fishermen in their long boats, their legs wrapped strangely around the paddles; small villages clustered along the water like clumps of mussels clinging to a rocky shoreline. These are the Intha people; relatively few remain. Intha means "Sons of the Lake," and it fits these people well. They are a subsistence people, living on the fish they catch and the produce they harvest from floating gardens.

Their manner of fishing has made them famous; long before the sun comes up they leave the village in their long boats, standing at the stern with one leg wrapped around the paddle and the other free to wield the fishing net. When they spot their prey, they scoop fish into their nets in a smooth, flowing motion. But there is more. Every five days, there is a movable feast: A floating market that migrates around the lake to serve all the area's inhabitants, providing the few things they need that they cannot provide for themselves such as tools, baskets, silks, produce, and even boat parts.

Inle Lake is long and thin north to south, reminiscent of one of its best-known inhabitants—the Padaung. Best known for the practice of wearing brass rings around their necks, arms, and legs, Padaung women are often called the long-neck women of Burma. The brass rings are first worn when the girls are about five years old, and as they grow older, more rings are added. The weight of the brass pushes down the collar bone and compresses the rib cage, yielding the unmistakable look of the Padaung.

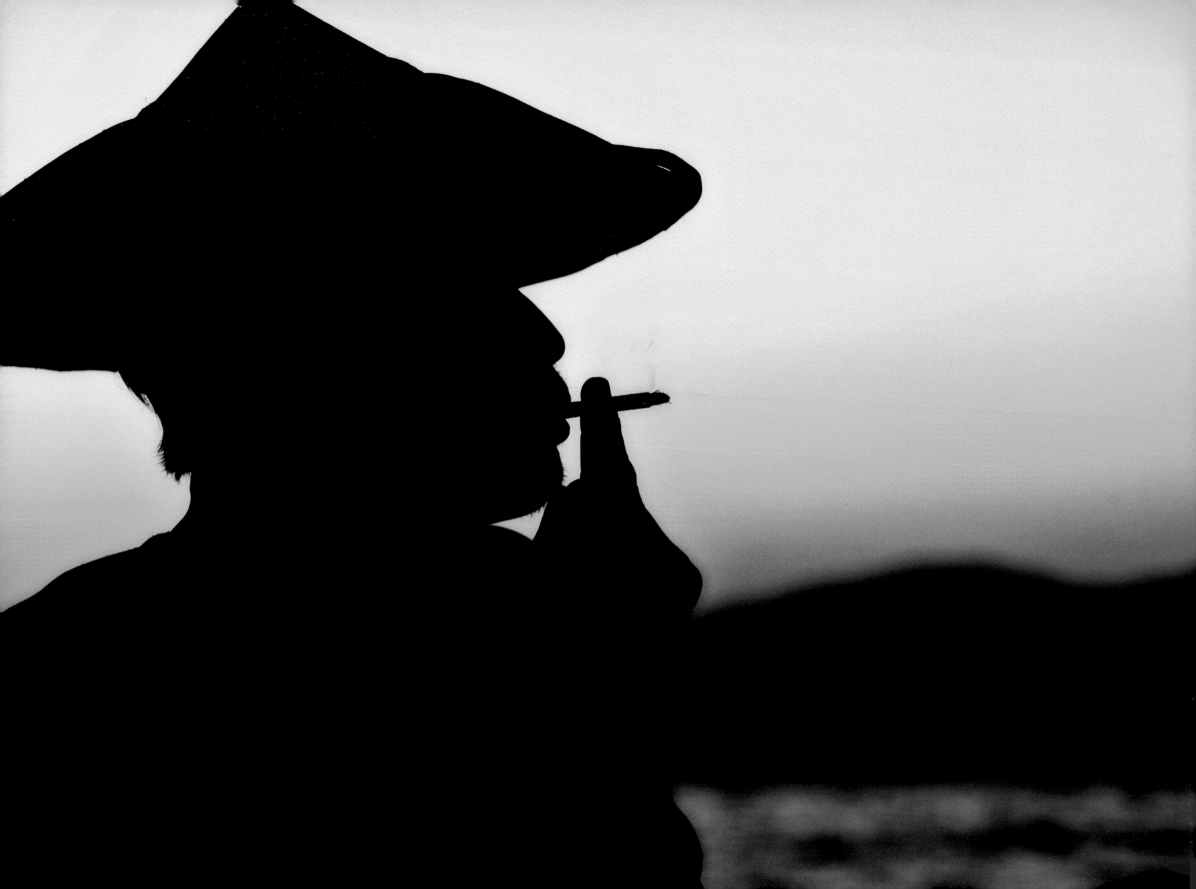

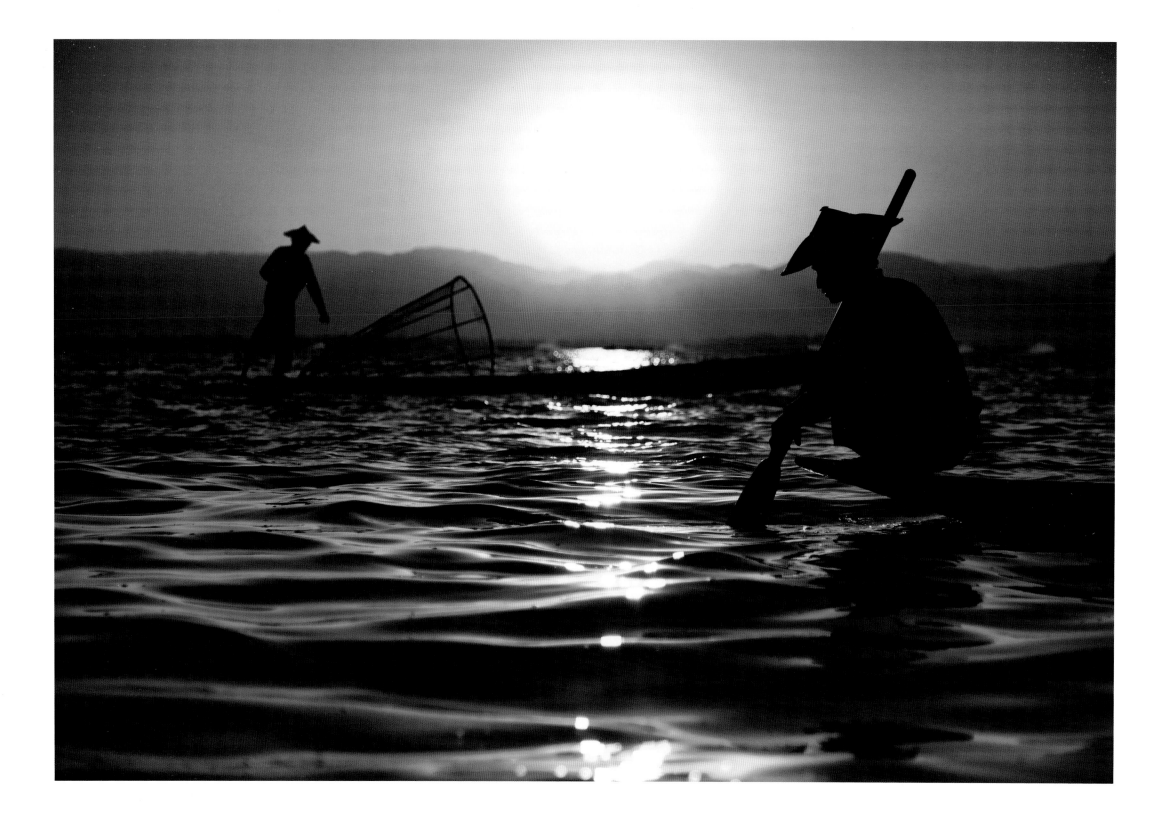

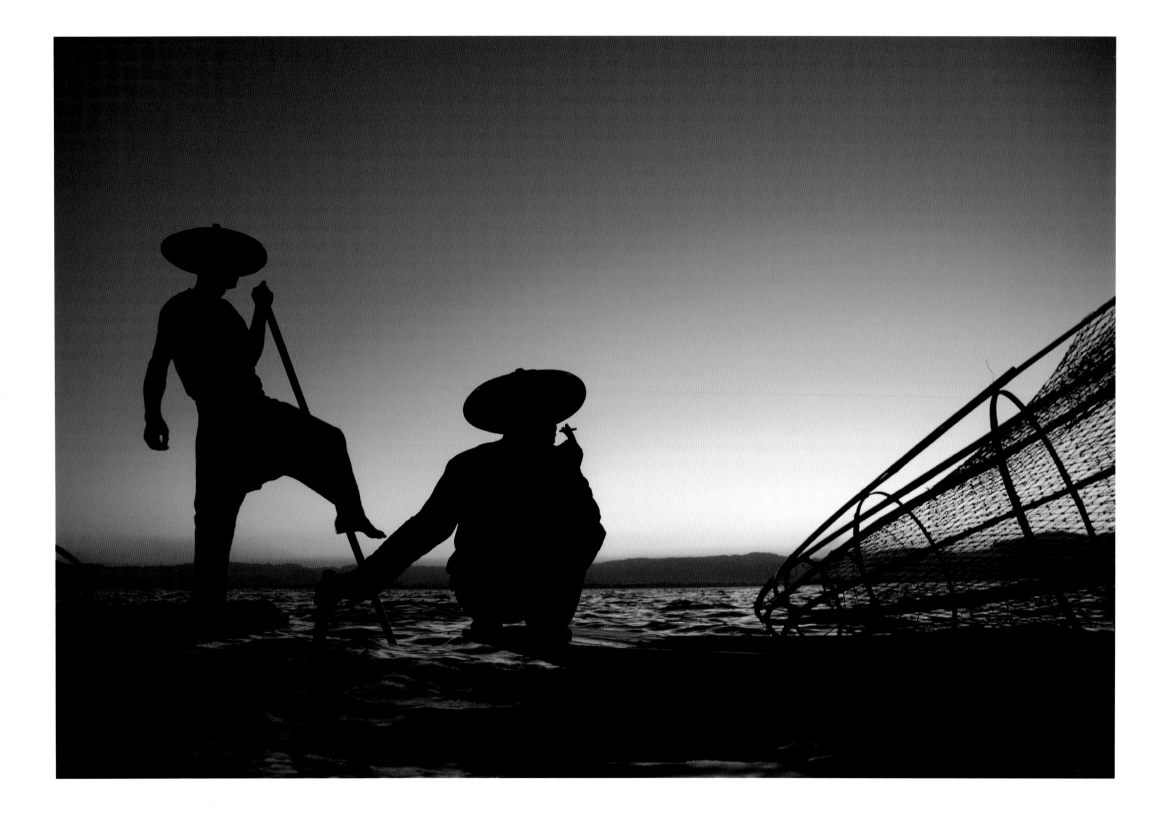

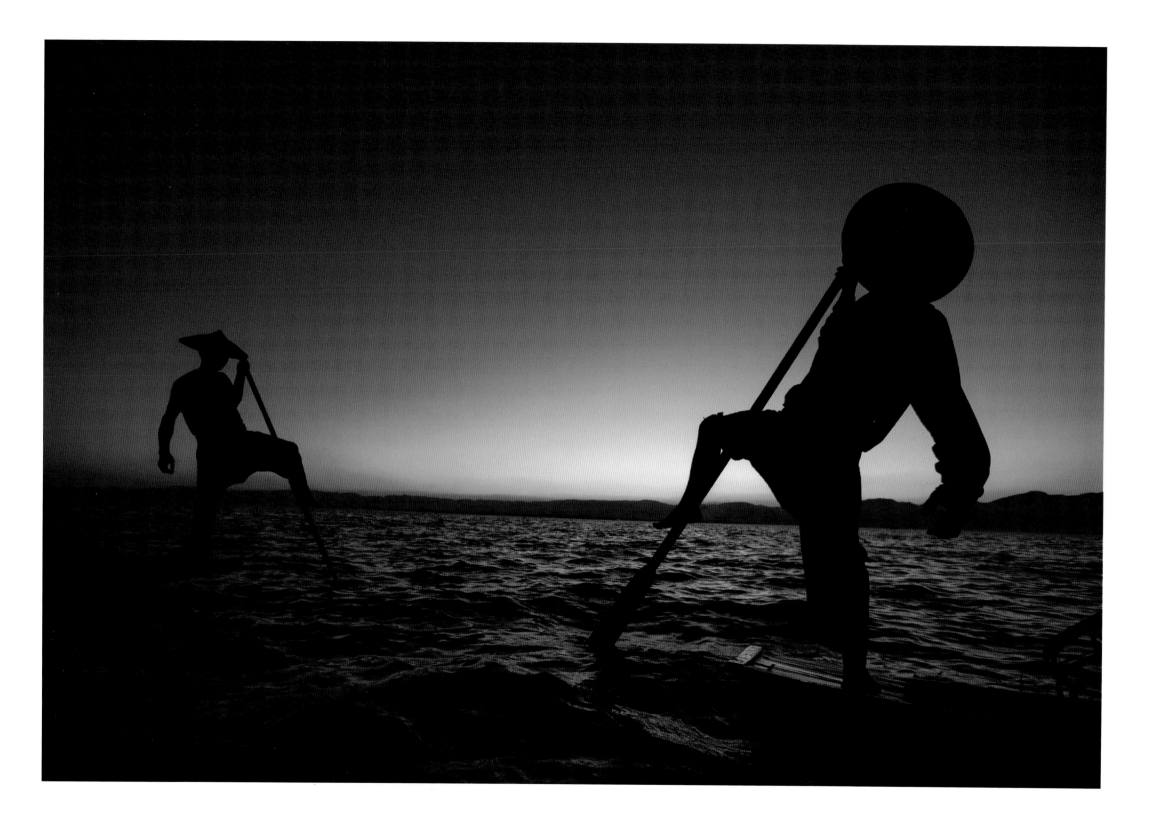

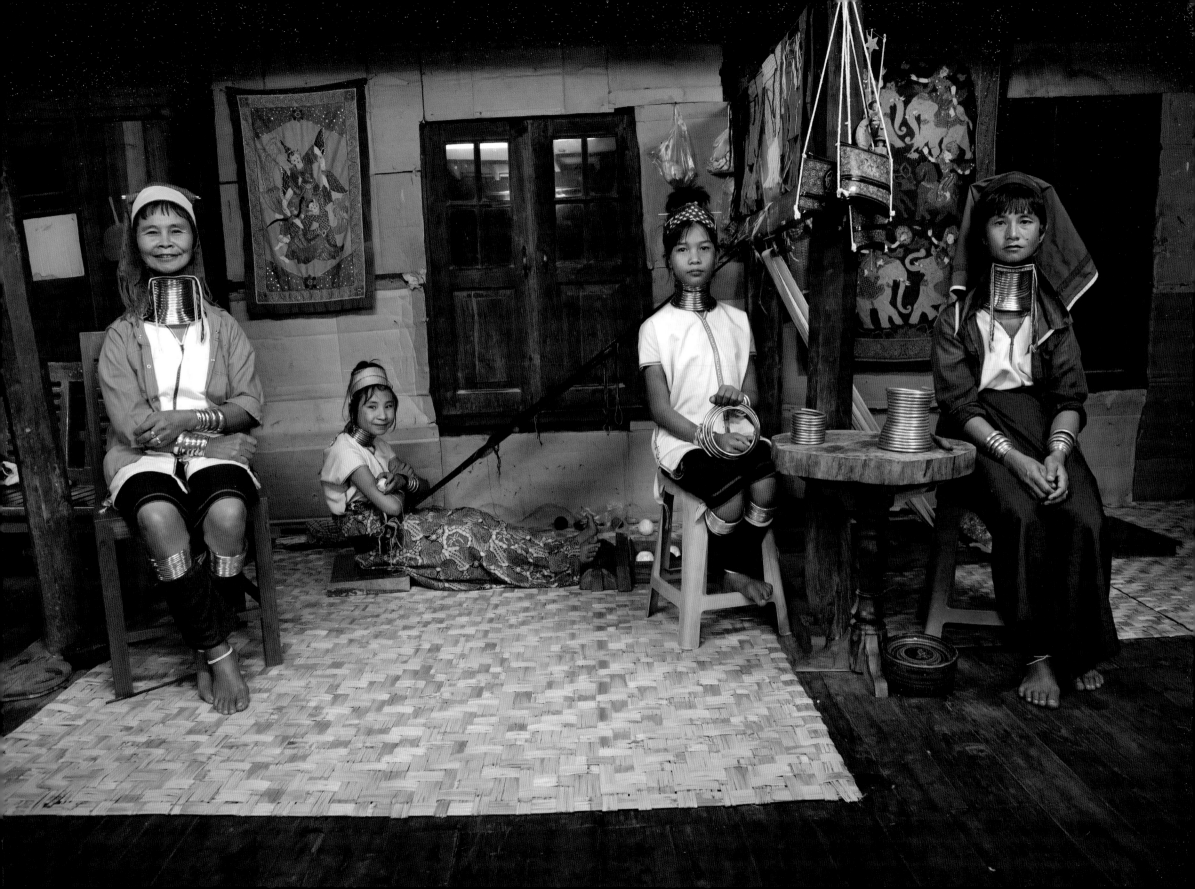

The necks of the Padaung women are no longer than the necks of women everywhere; the illusion is created when the heavy brass rings compress the collar bones and rib cage to give the appearance of a long, graceful neck.

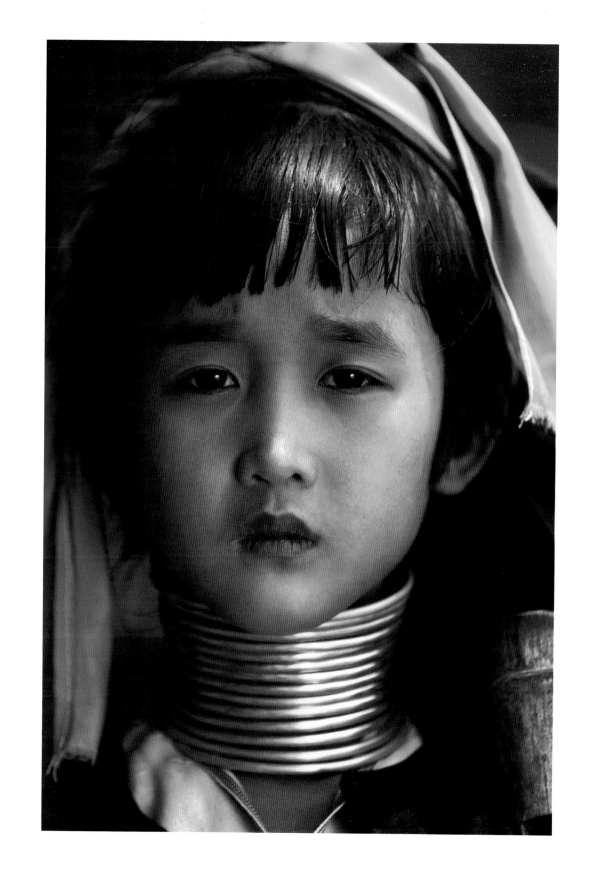

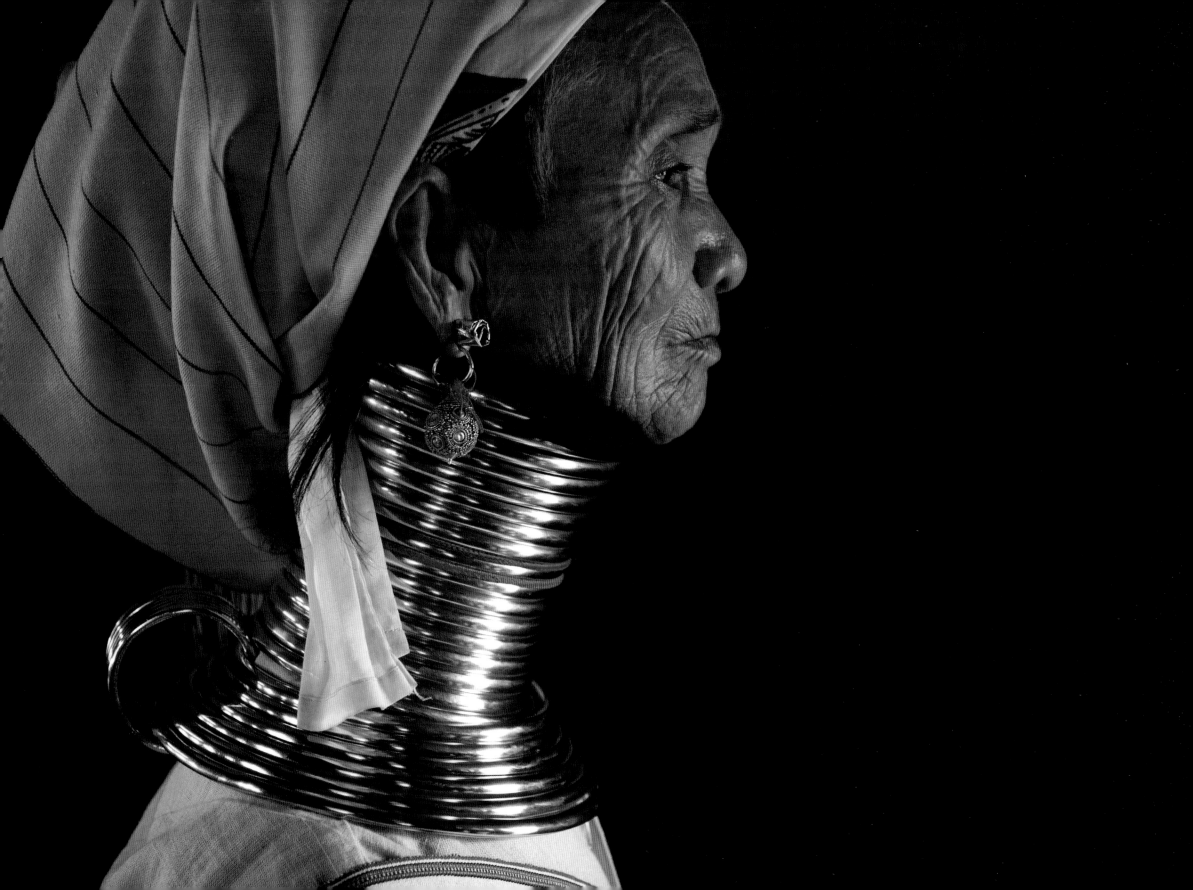

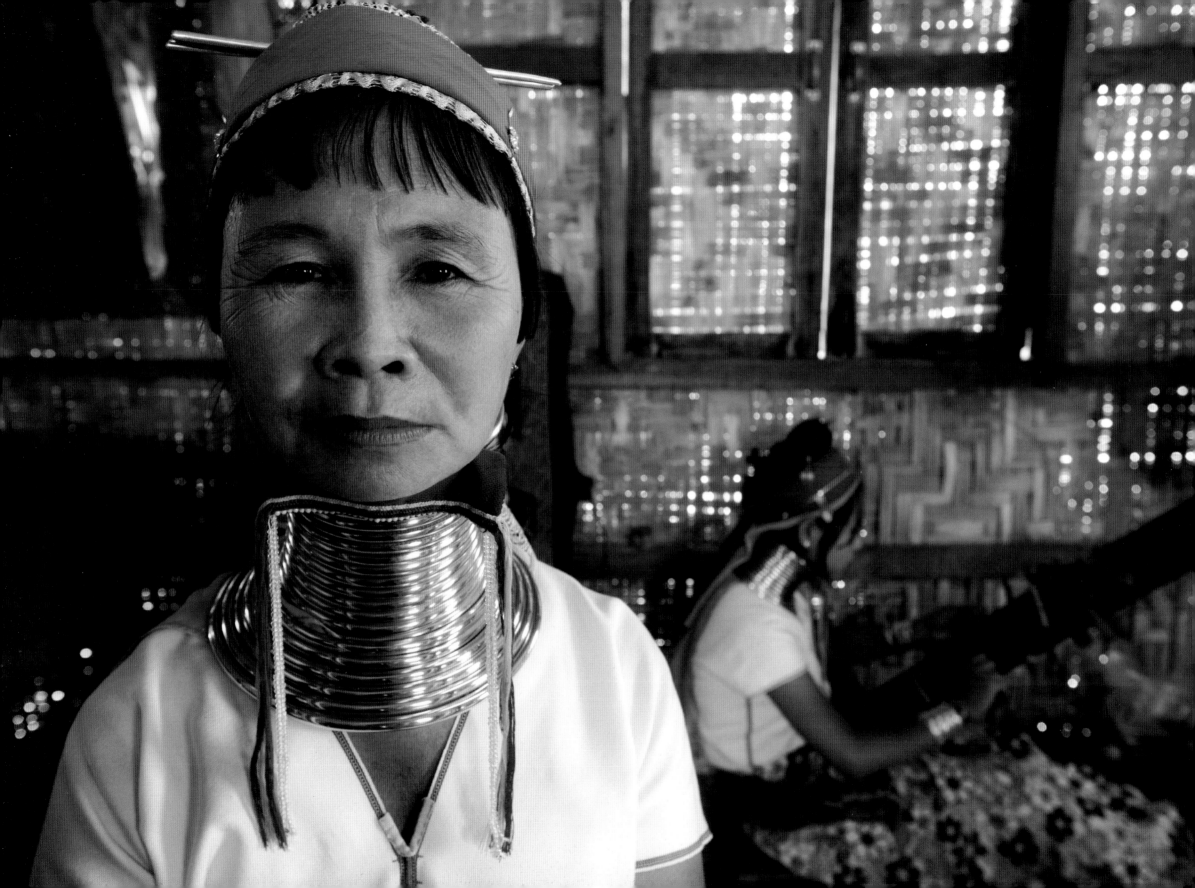

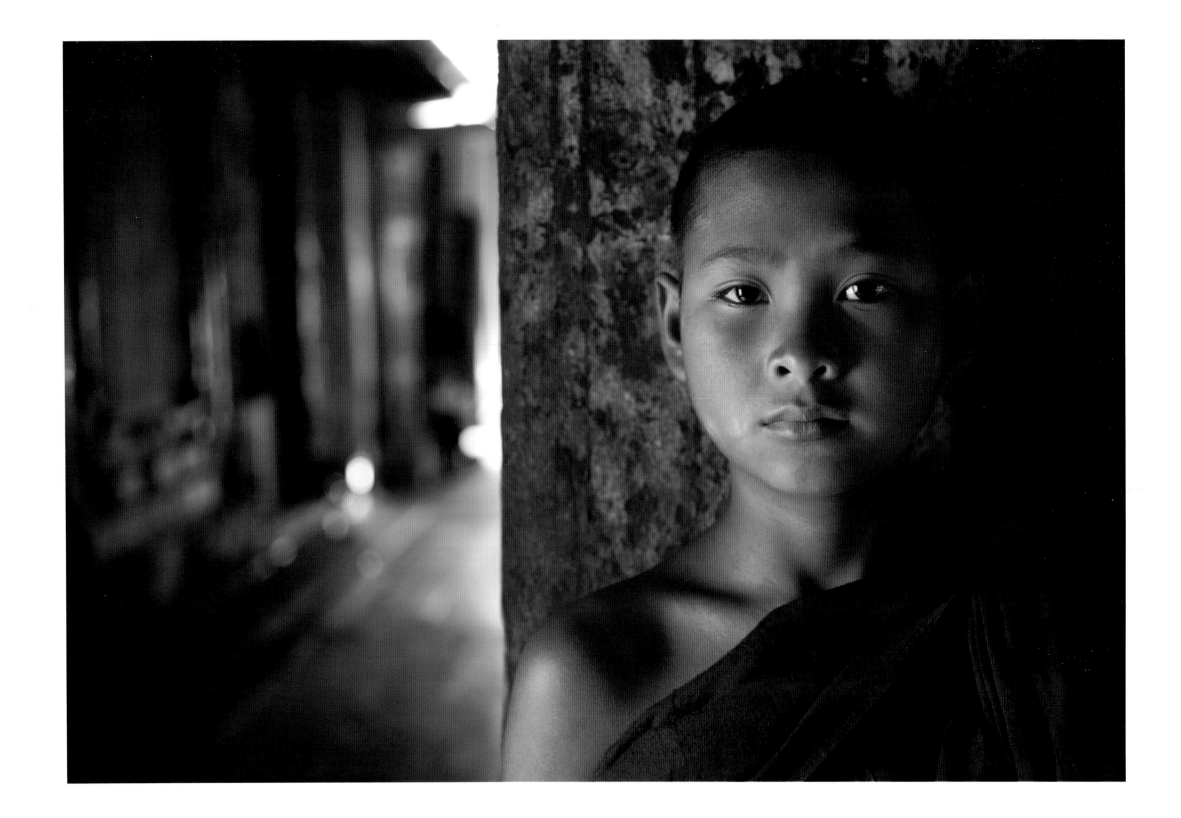

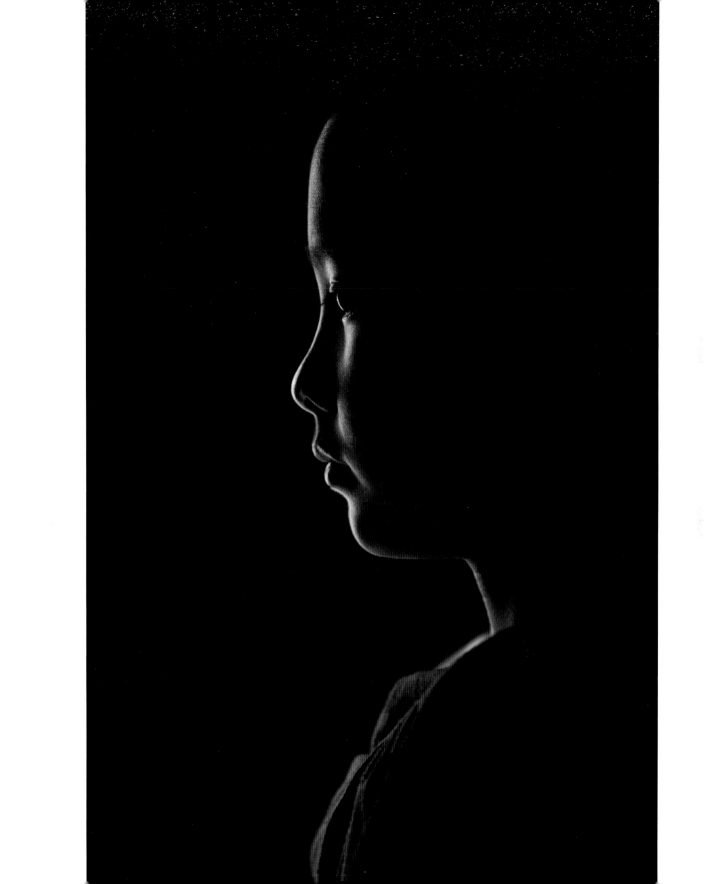

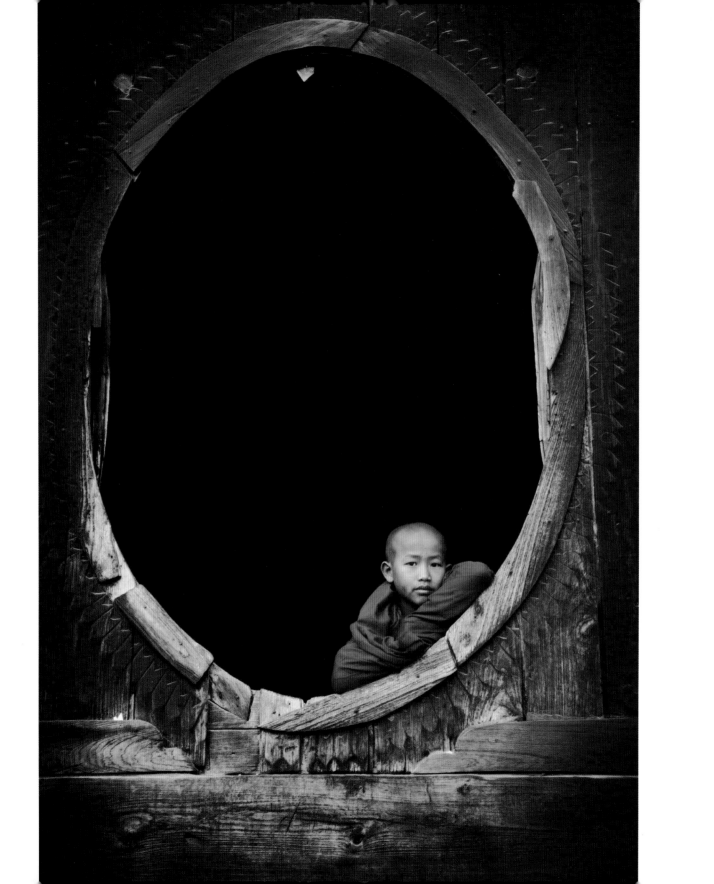

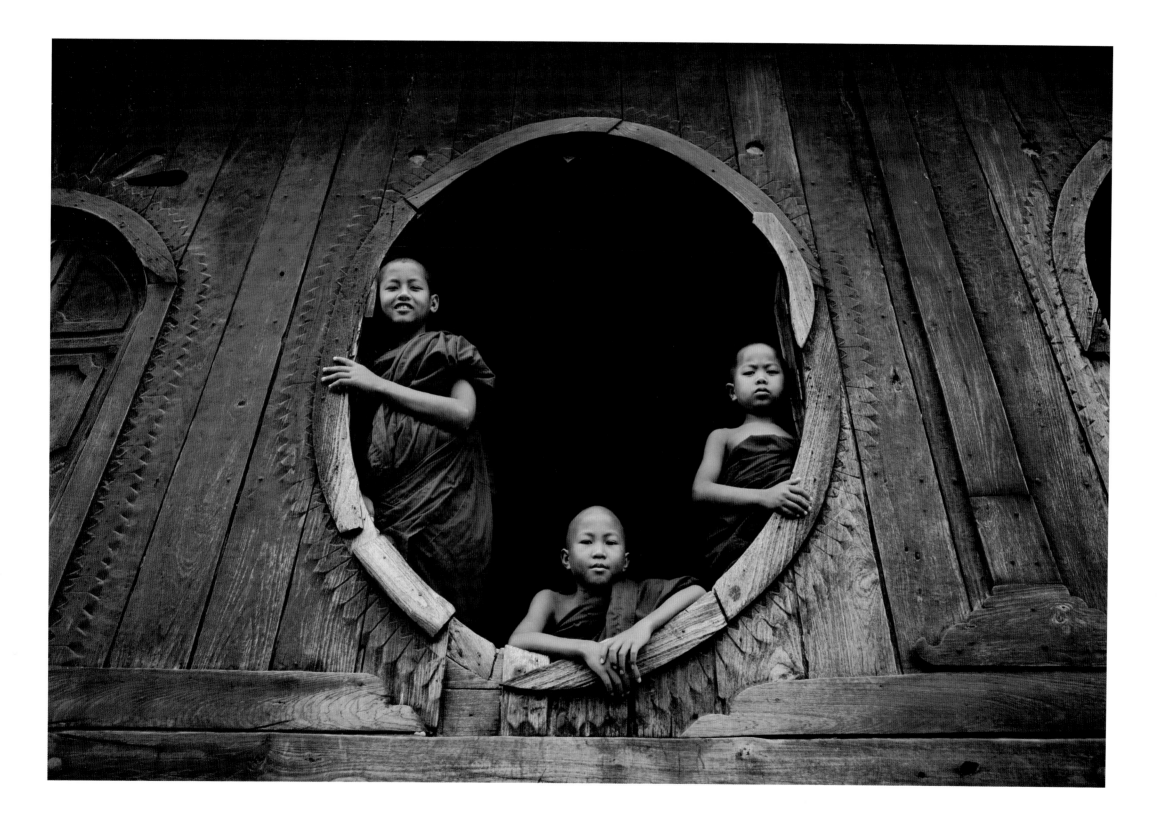

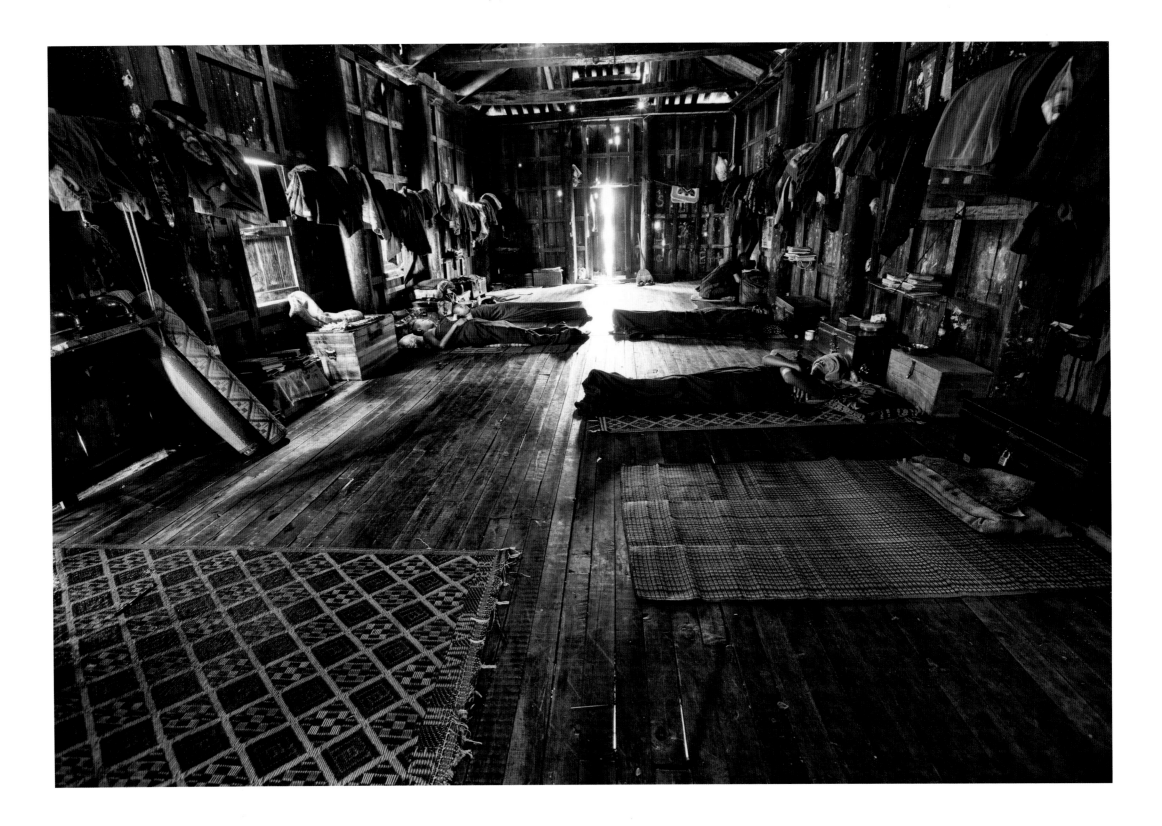

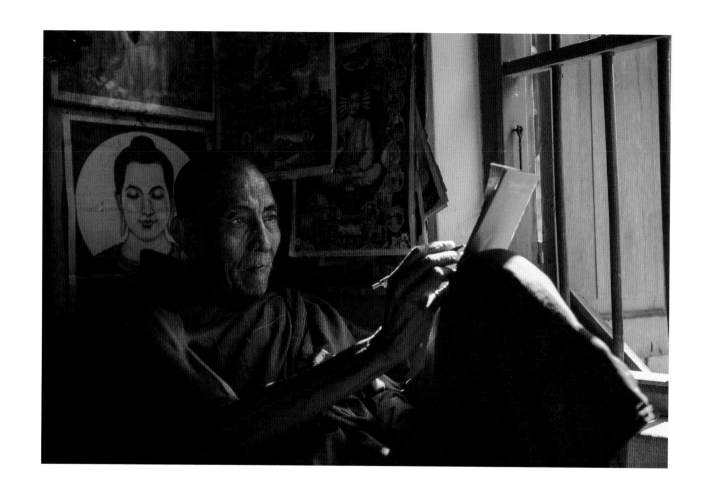

A rare glimpse of young and old monks at rest. They are very self-efficient as they cook their own food, wash their robes, and clean the monastery daily. Aside from all of this, they manage to spend most of the day studying and praying.

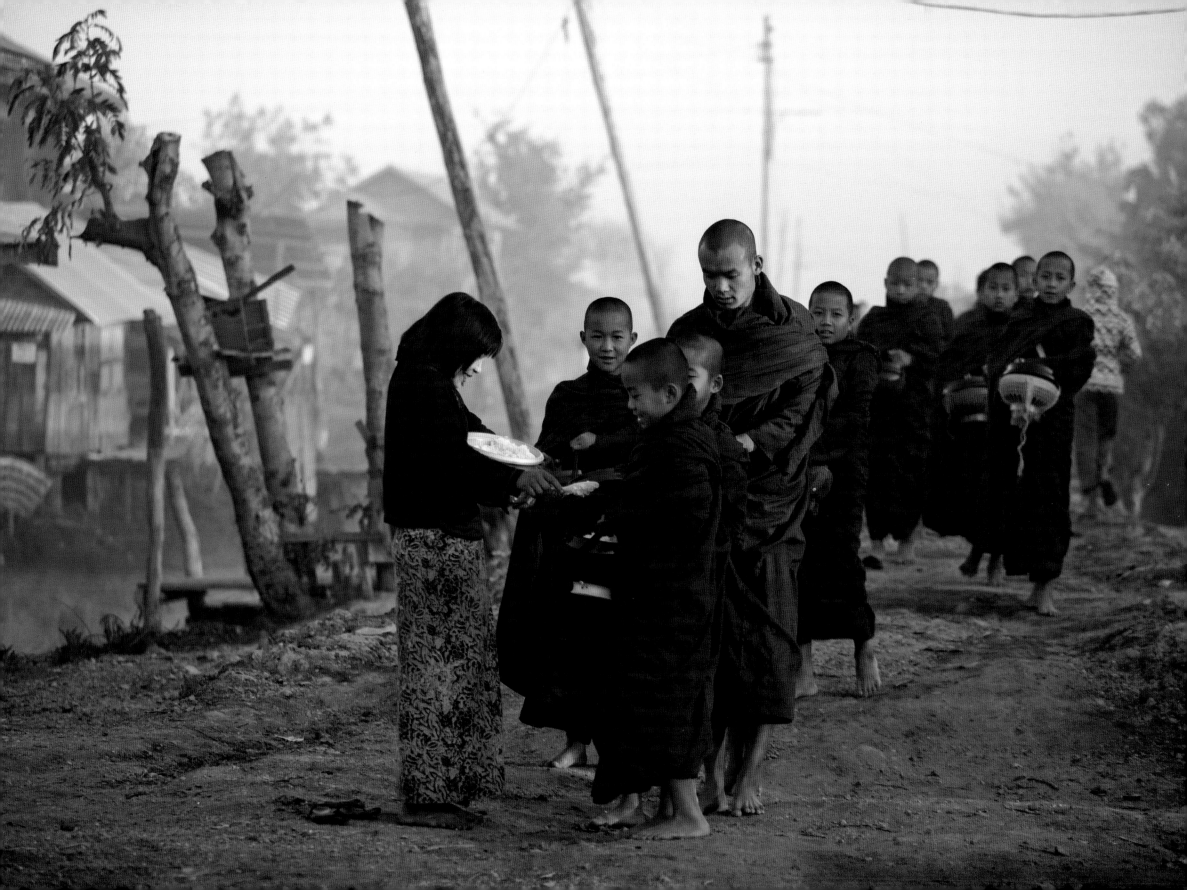

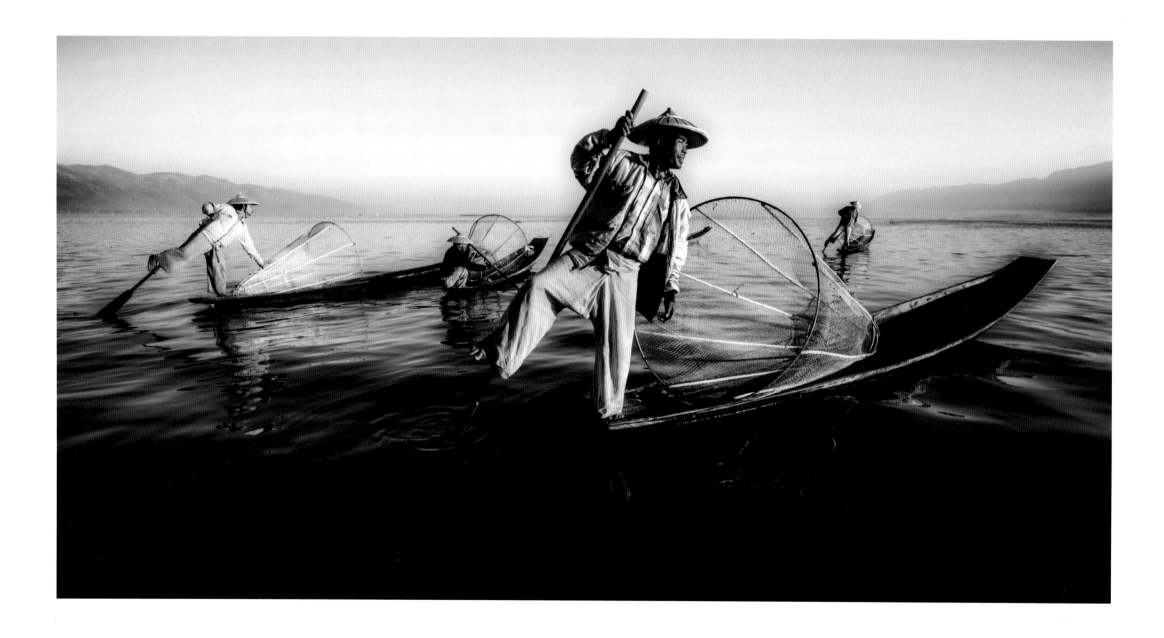

Much of Lake Inle is covered with reeds, making it difficult to navigate from a sitting position. The fishermen of Inle have come up with a unique way of overcoming this challenge. By standing at the stern with one leg wrapped around the paddle, they can see over any obstacles and also see fish in the water, which they capture with a net in their other hand.

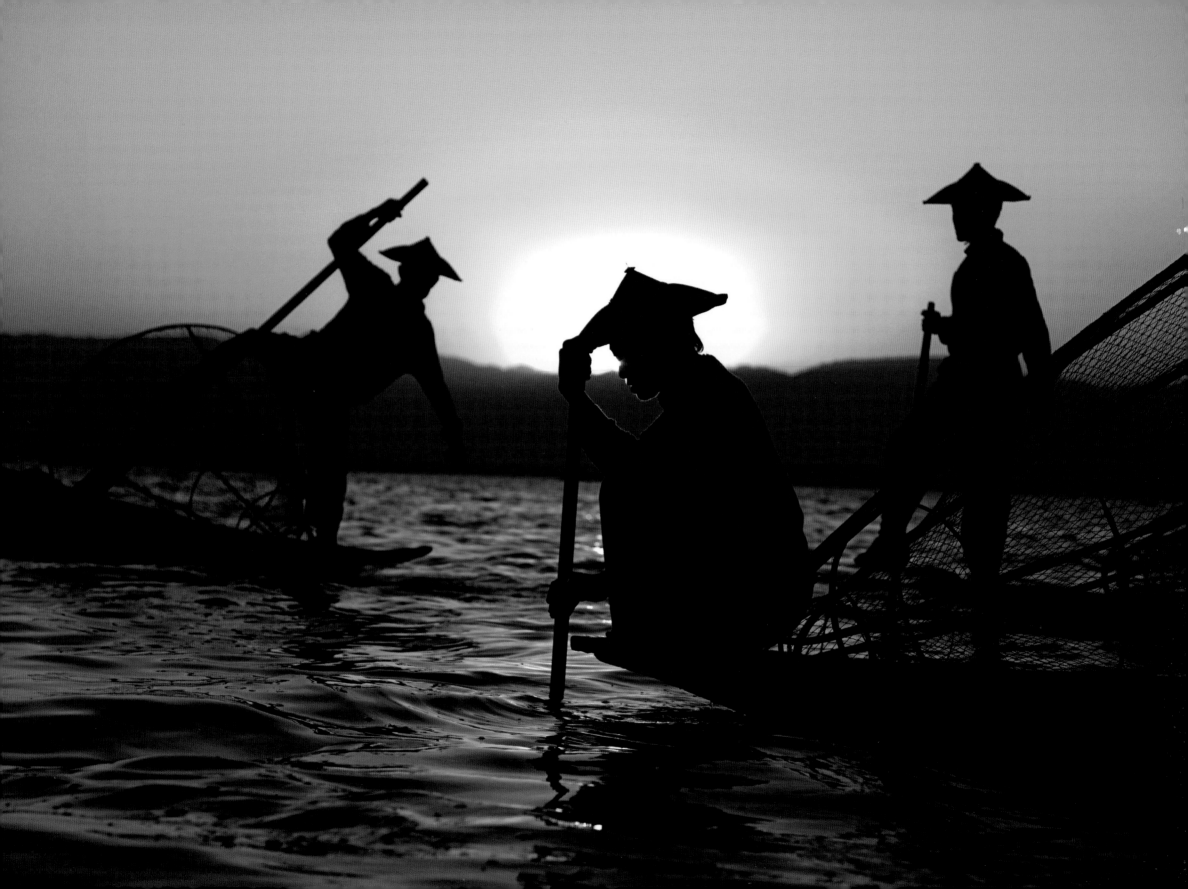

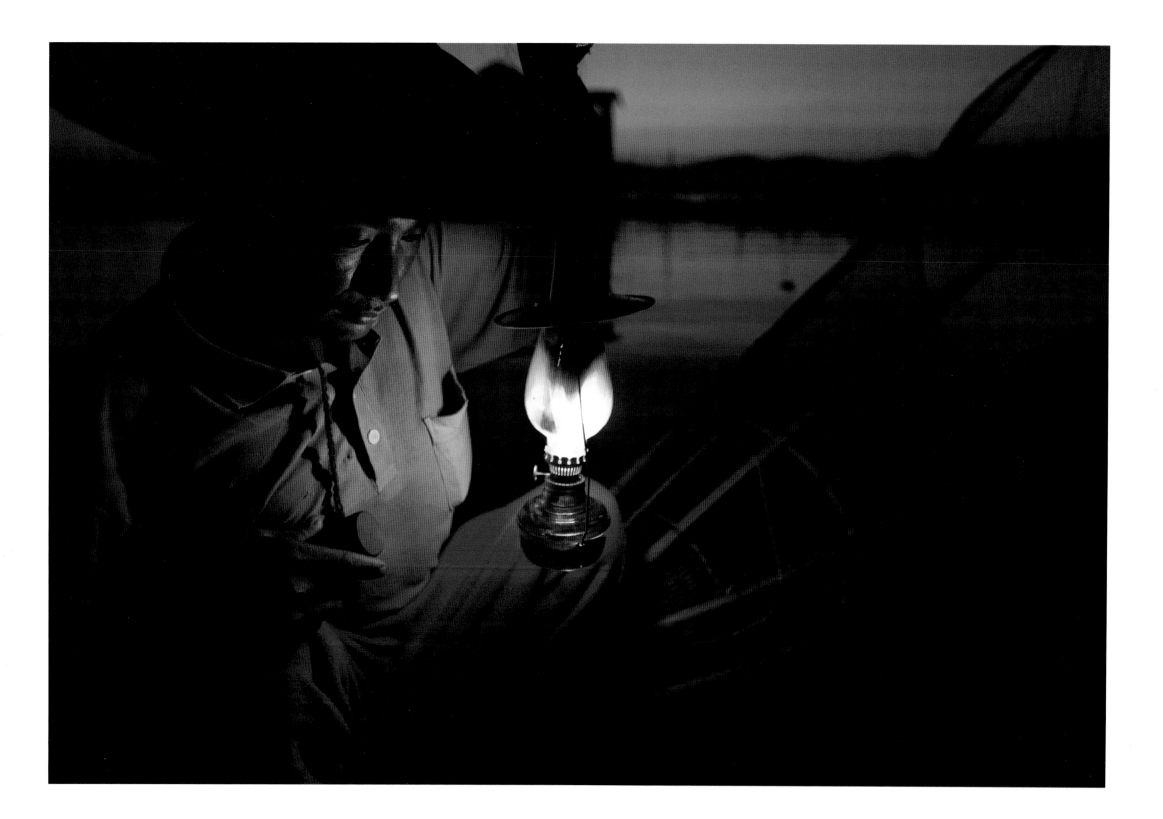

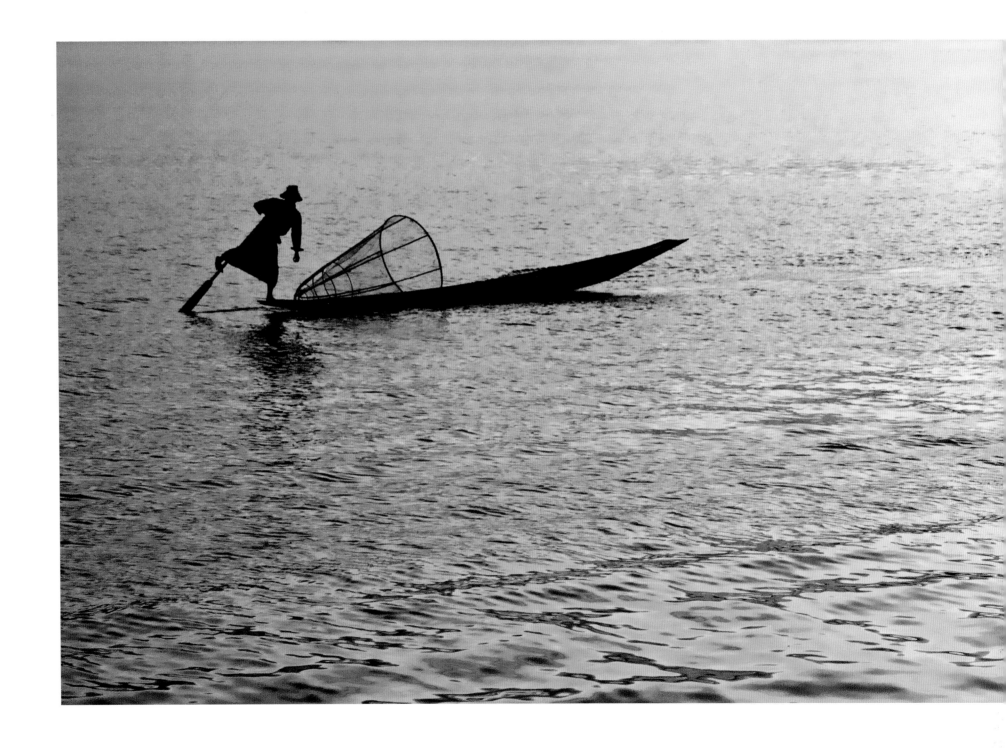

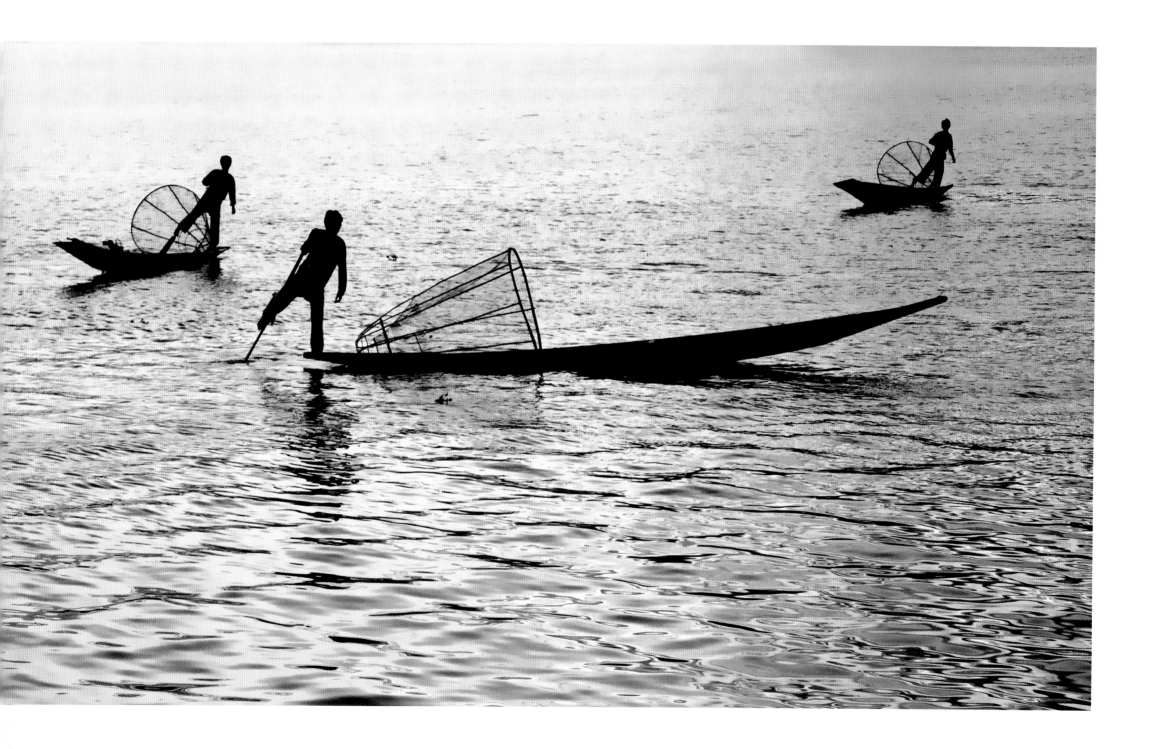

Most of these fisherman cannot afford motors for their boats and paddle with one foot from their home to the fishing spots. I cannot comprehend how they can paddle like this for so long, but they do, every single day.

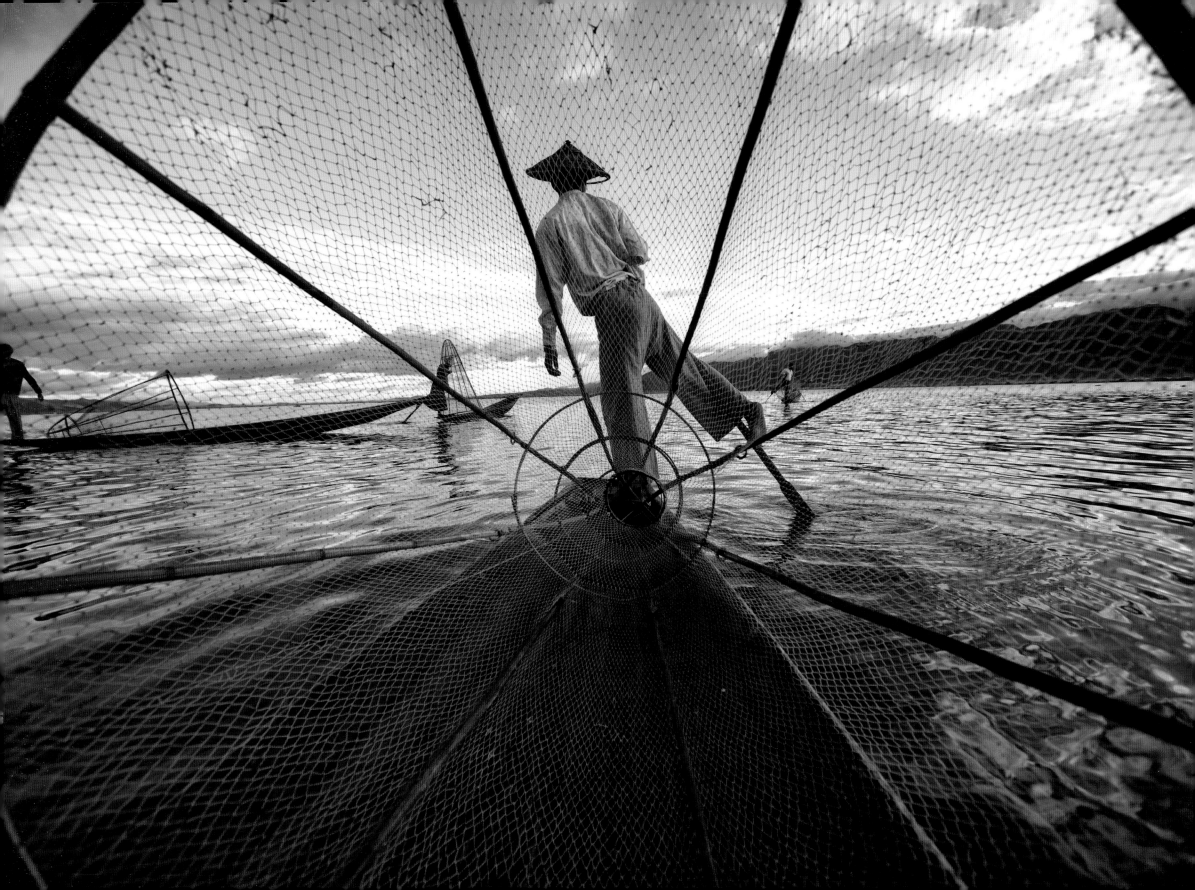

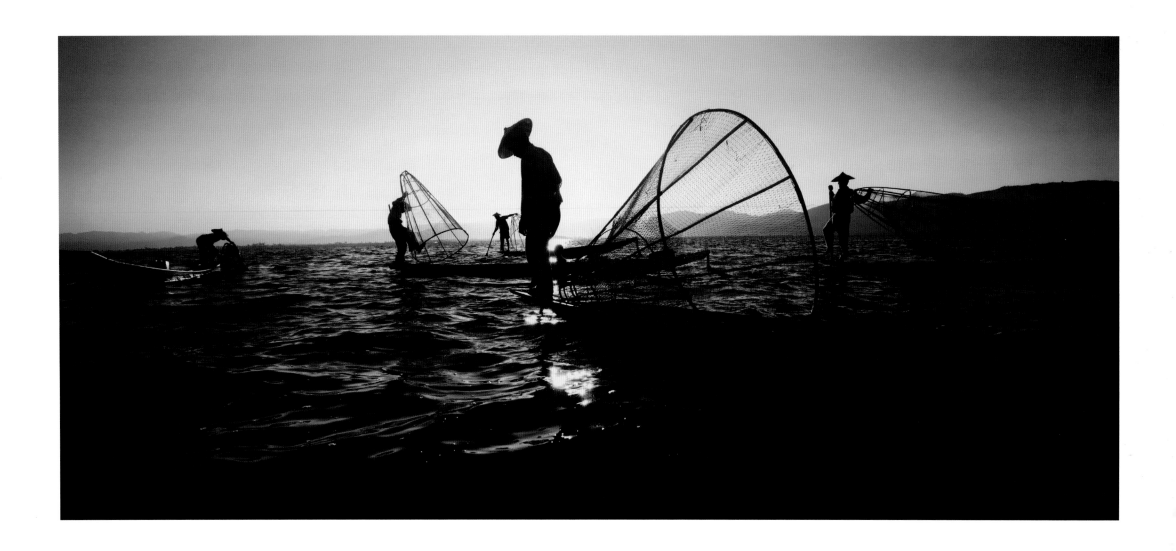

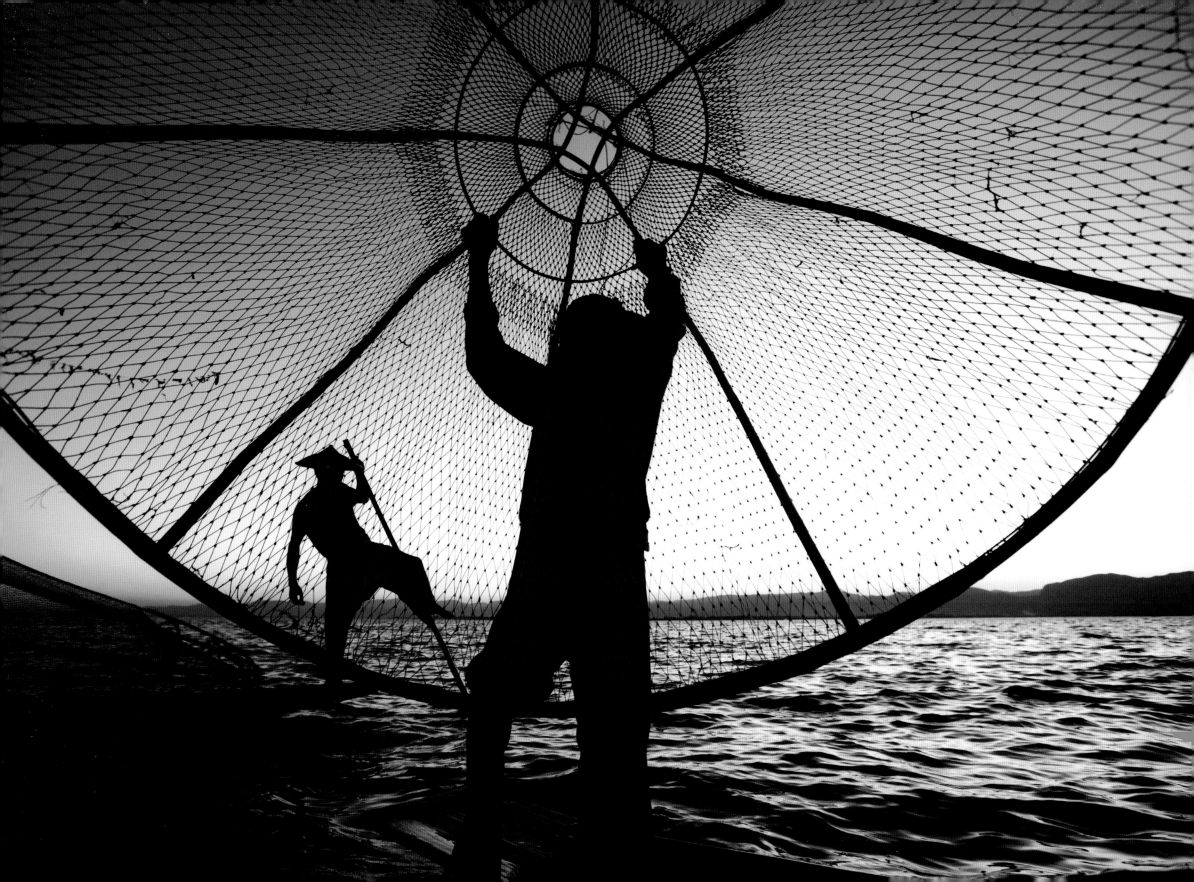

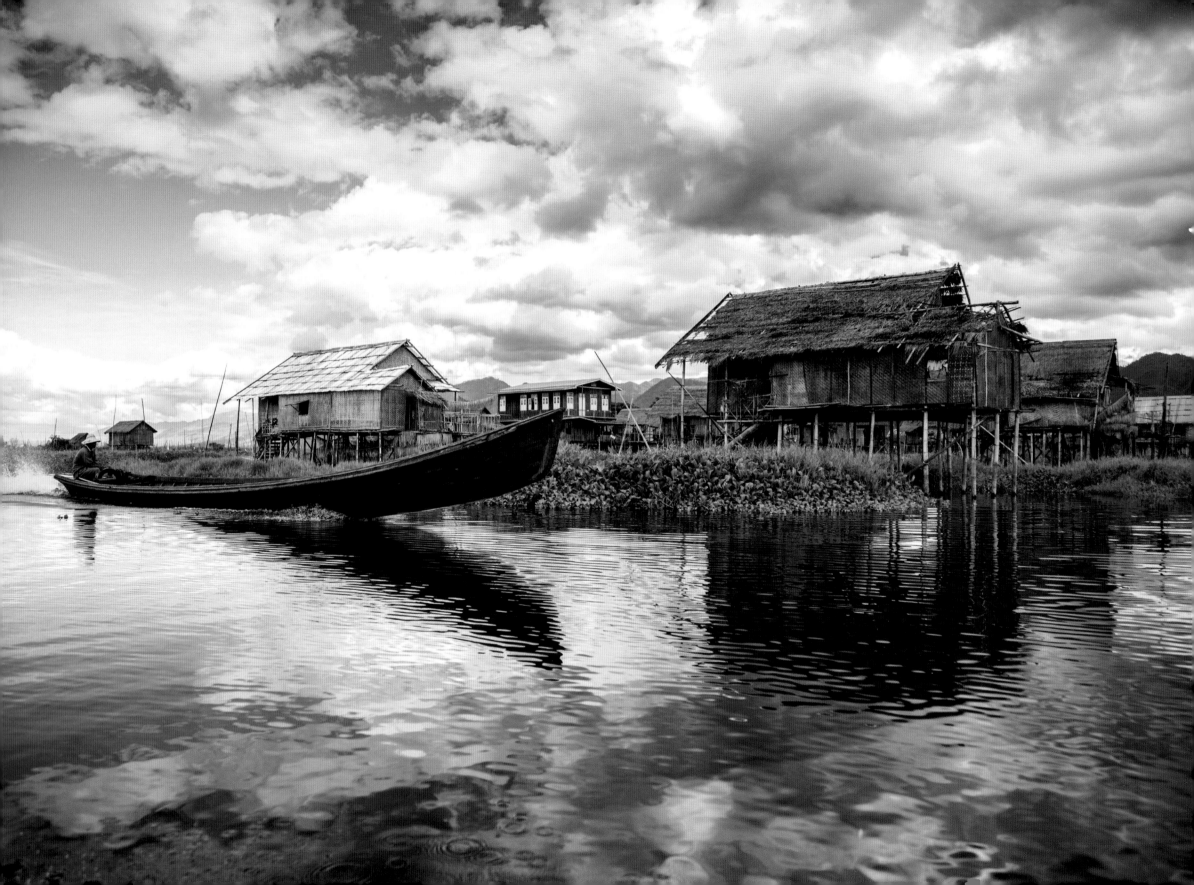

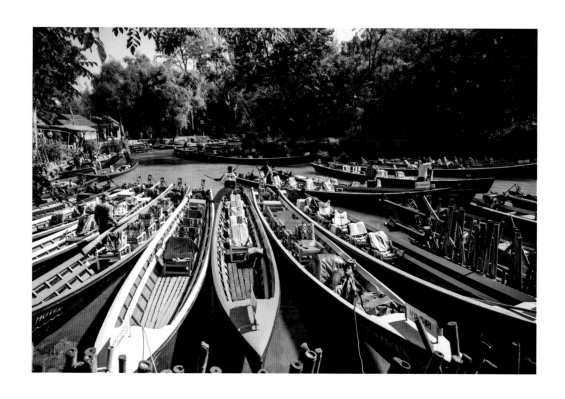

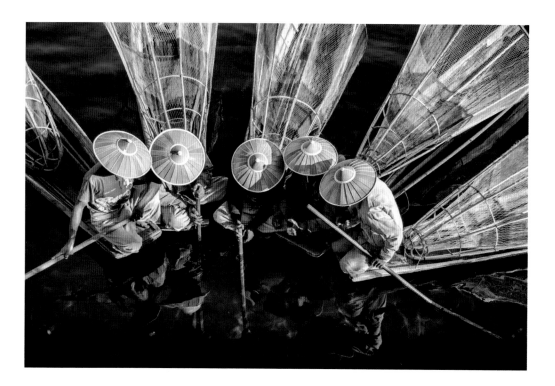

Unlike any other place in Burma, life on and around Inle Lake
means that having access to a boat is a necessity, not an option.

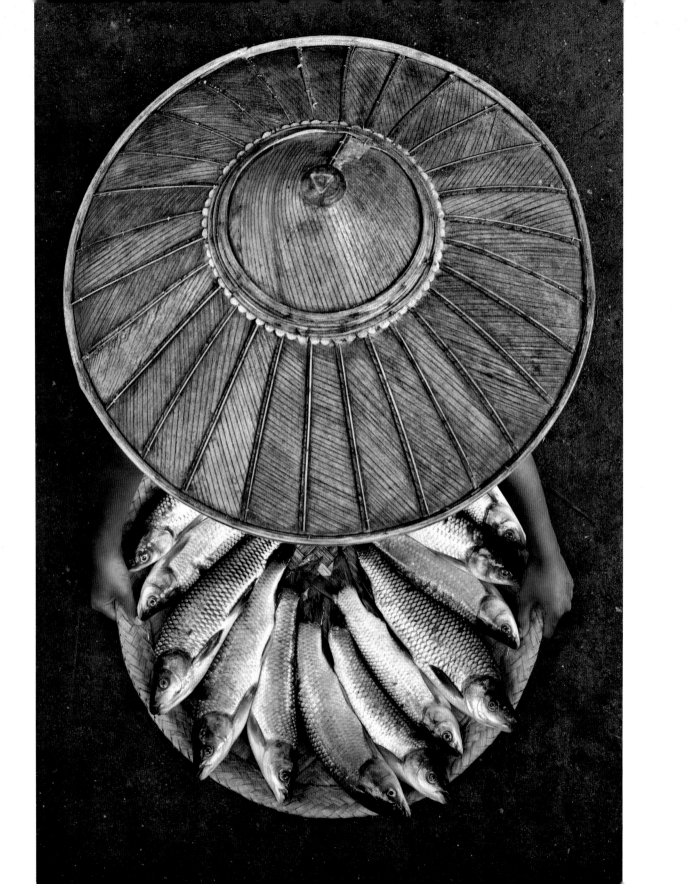

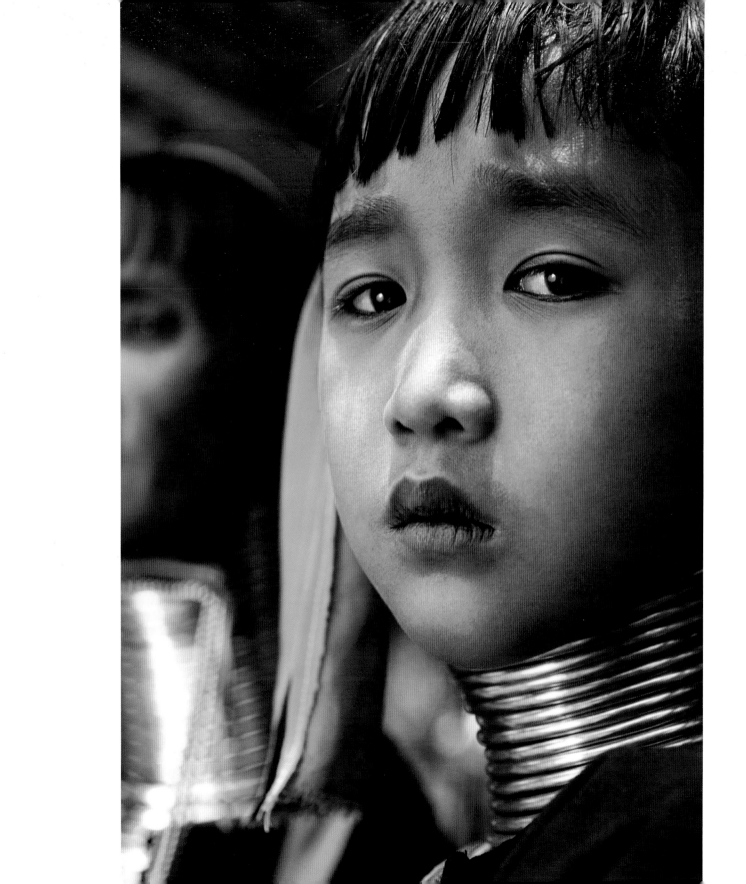

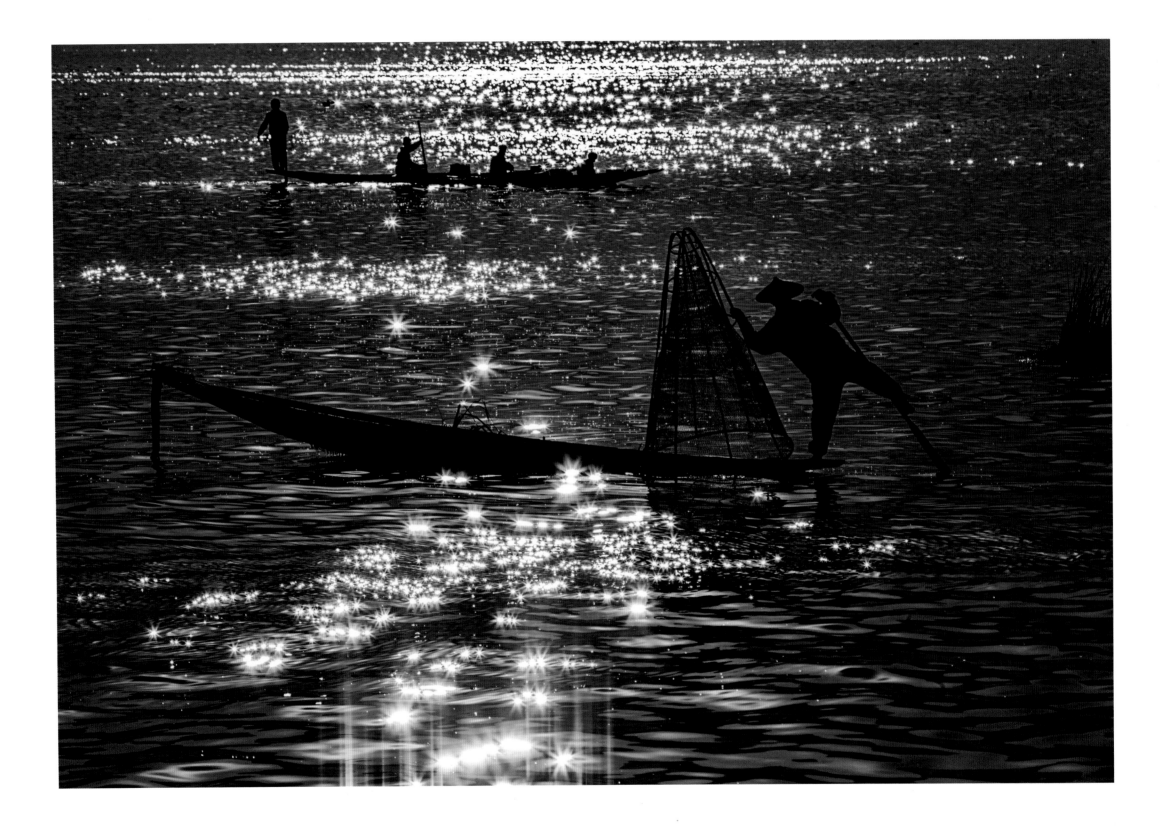

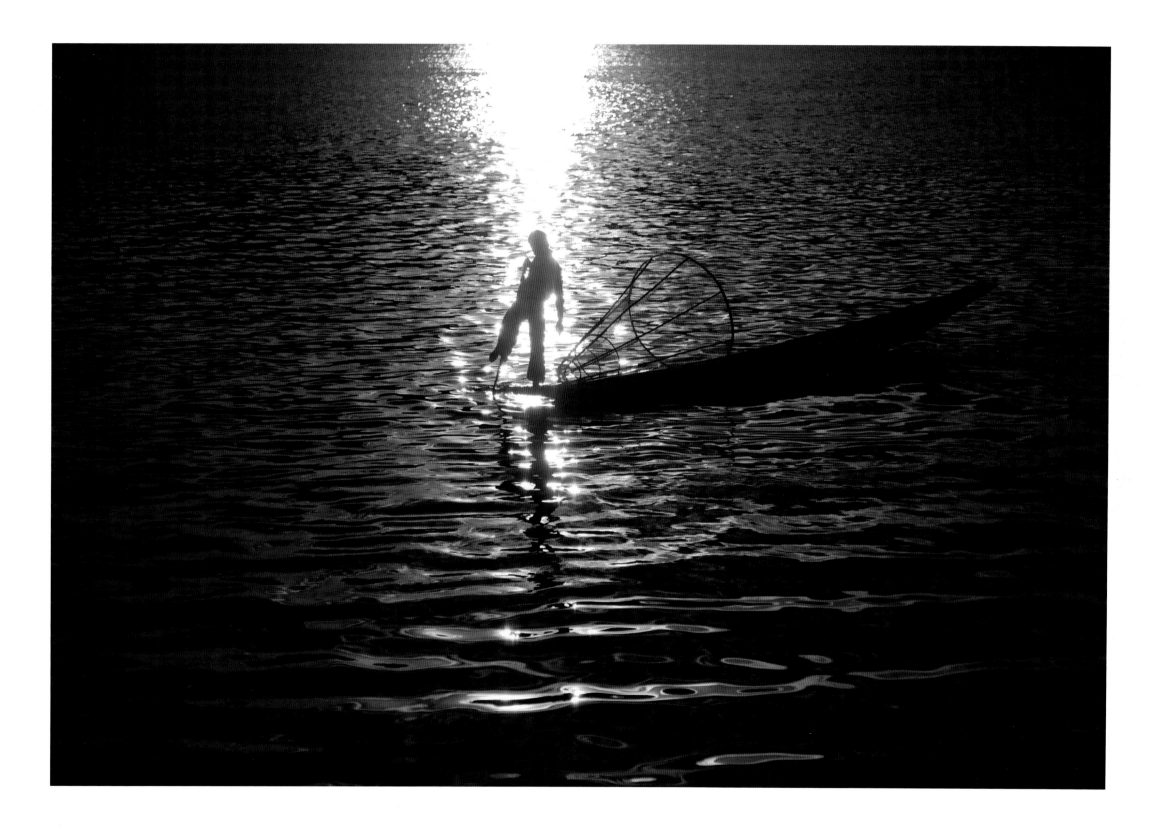

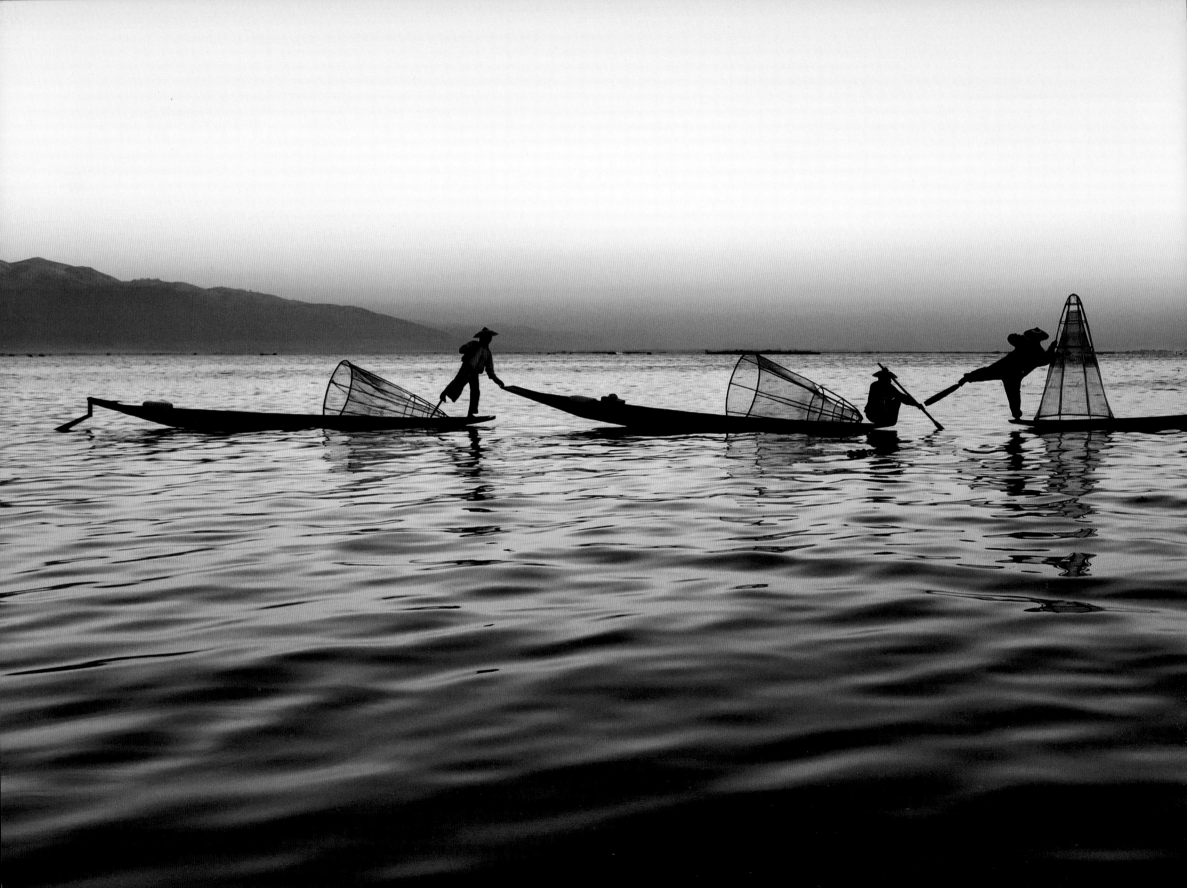

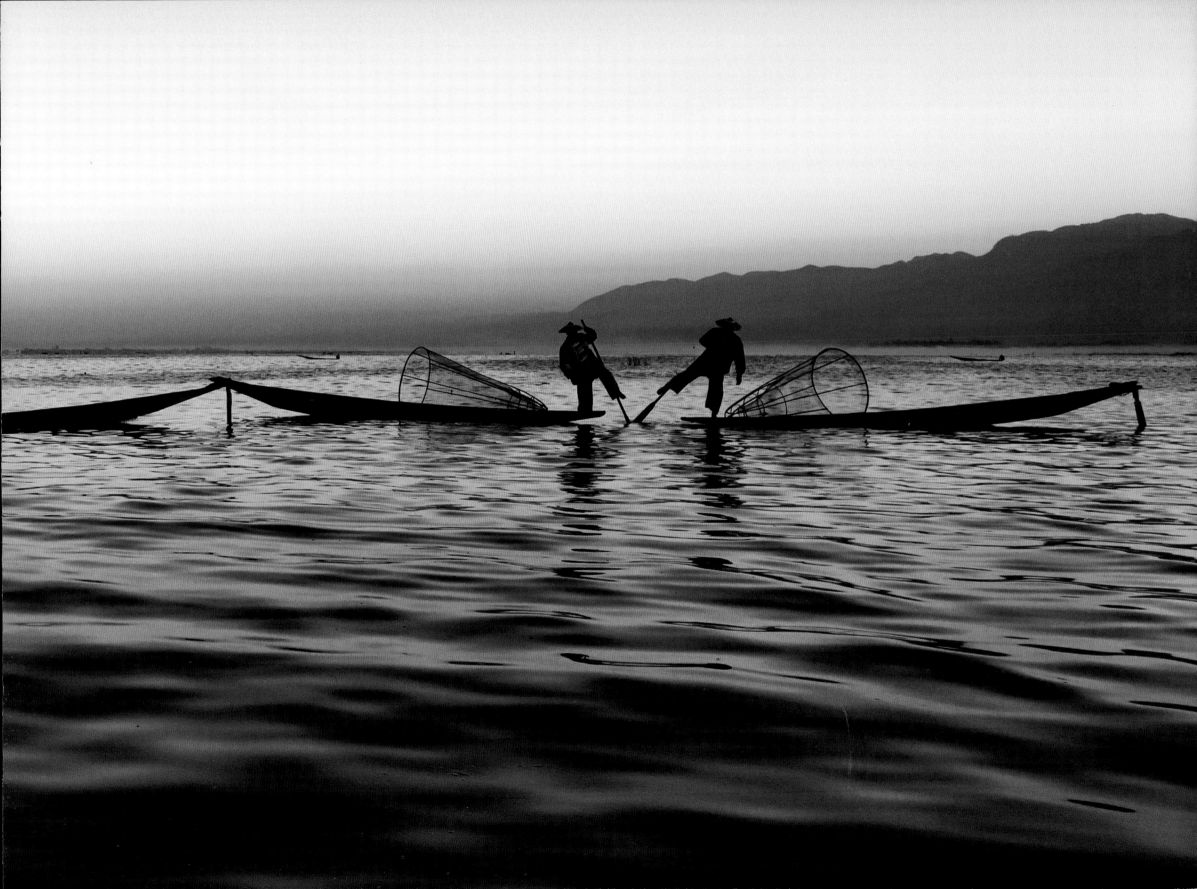

Mrauk

The name, when spoken, evokes crows and ravens, and I have to admit that there are times when I wonder if there is anyone else here. This is Burma at its purest: smoke and mist engulf the countryside, giving a prehistoric feel to the place. The streets are cracked and broken, heaved about by tree roots and time. Venturing to Mrauk is not for the timid, as the journey there can be rough.

This place is remote enough that tourists are a curious rarity, treated well by the local people, but in the way they might treat, say, an odd but friendly animal that walks into town. Cars are partly unheard of; ox carts and bicycles are the main forms of transportation. One look at the local fire station and you know you've gone back in time. There are few creature comforts in this rustic location, but the views from above and around every corner and alleyway are worth every sacrifice.

Mrauk is a small, neglected corner of Burma, and unlike the more tourist-oriented parts of the country, most of its temples lie in various stages of decay. One exception is the Shitthaung temple, sometimes called "the Shrine of 80,000 Images." Built in 1536, the temple celebrates the Buddhist victory over Islam and is a shrine to the three worlds that comprise the Buddhist universe.

Mrauk lies squarely in the monsoon belt of Burma, and the only way to get here is by boat, a seven-hour trip that can be harrowing if done during the rainy season. Sometimes an express boat can get you there in half the time if you are lucky enough to find one. But the weather can take its toll, as this place gets four feet of rain a year, most of it between May and October. The rain falls, the rivers flood; but life goes on. Although this city is incredibly remote inside Burma, it is also one of my favorite places to venture to.

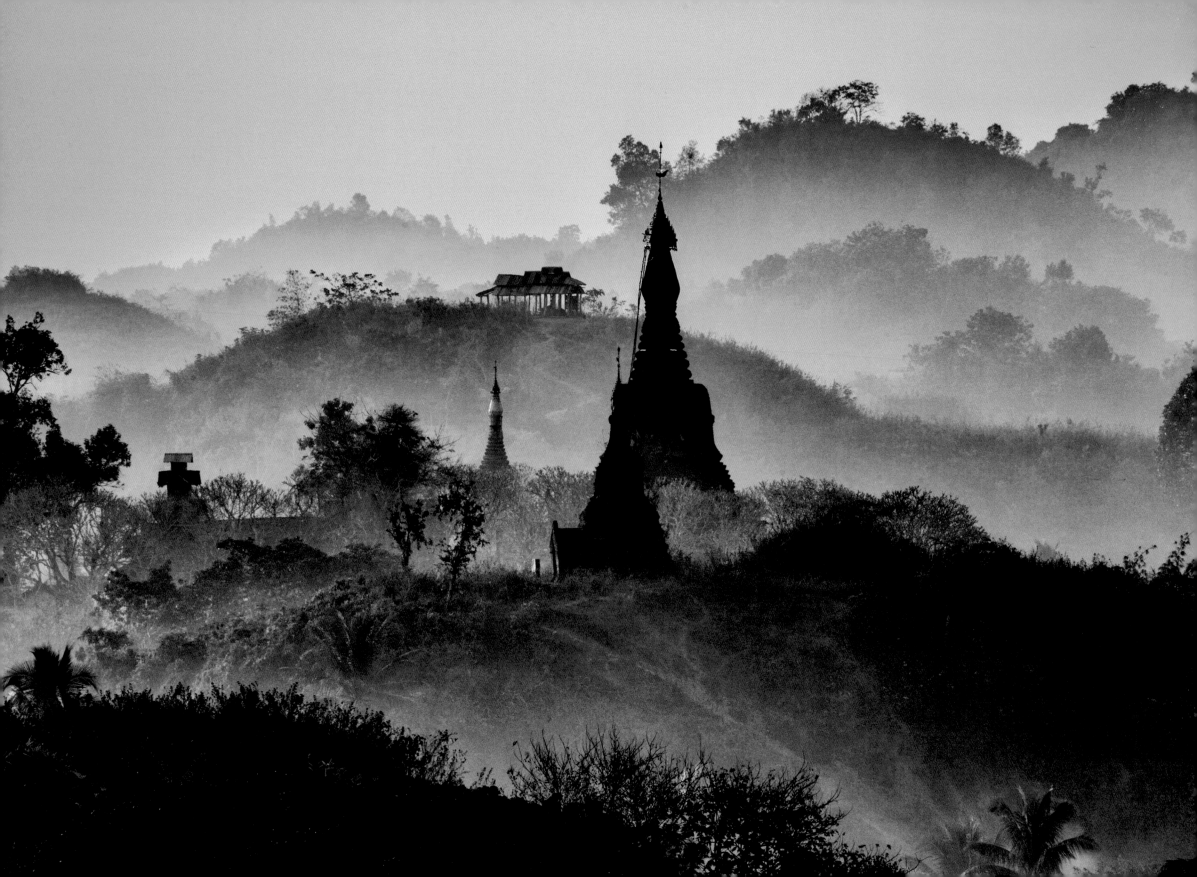

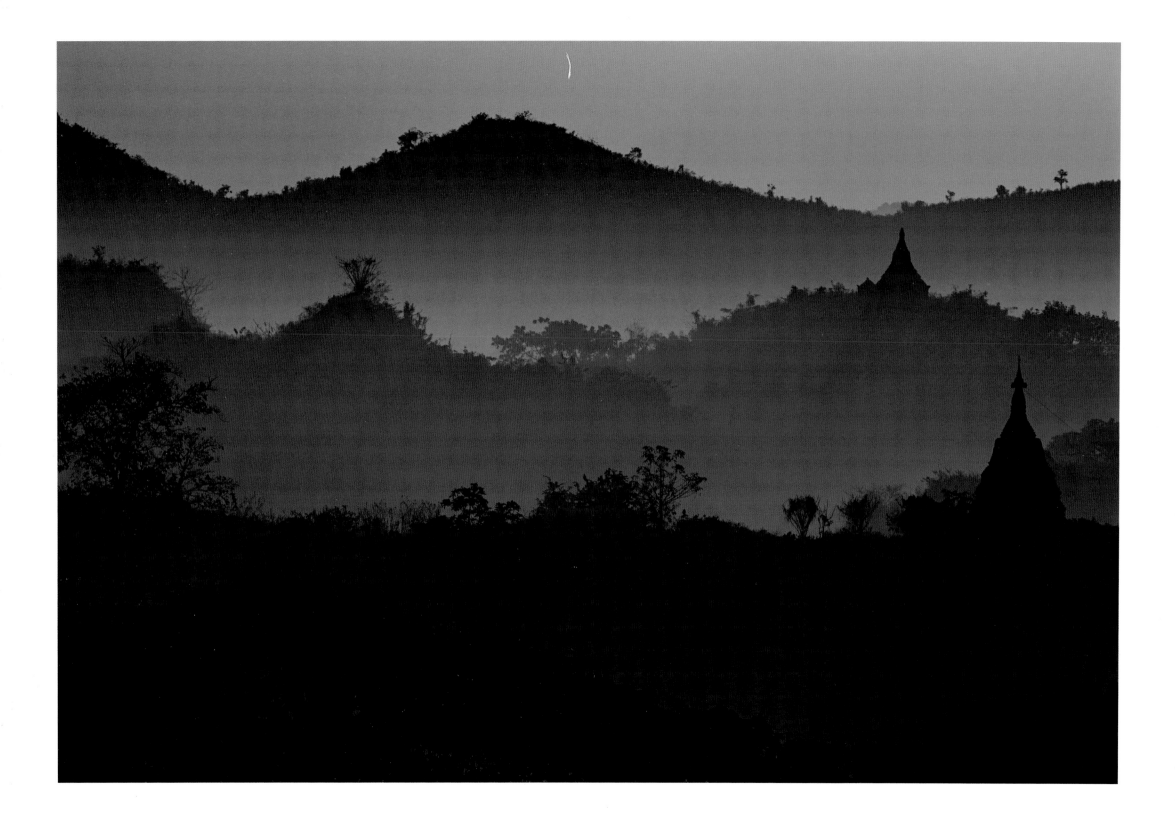

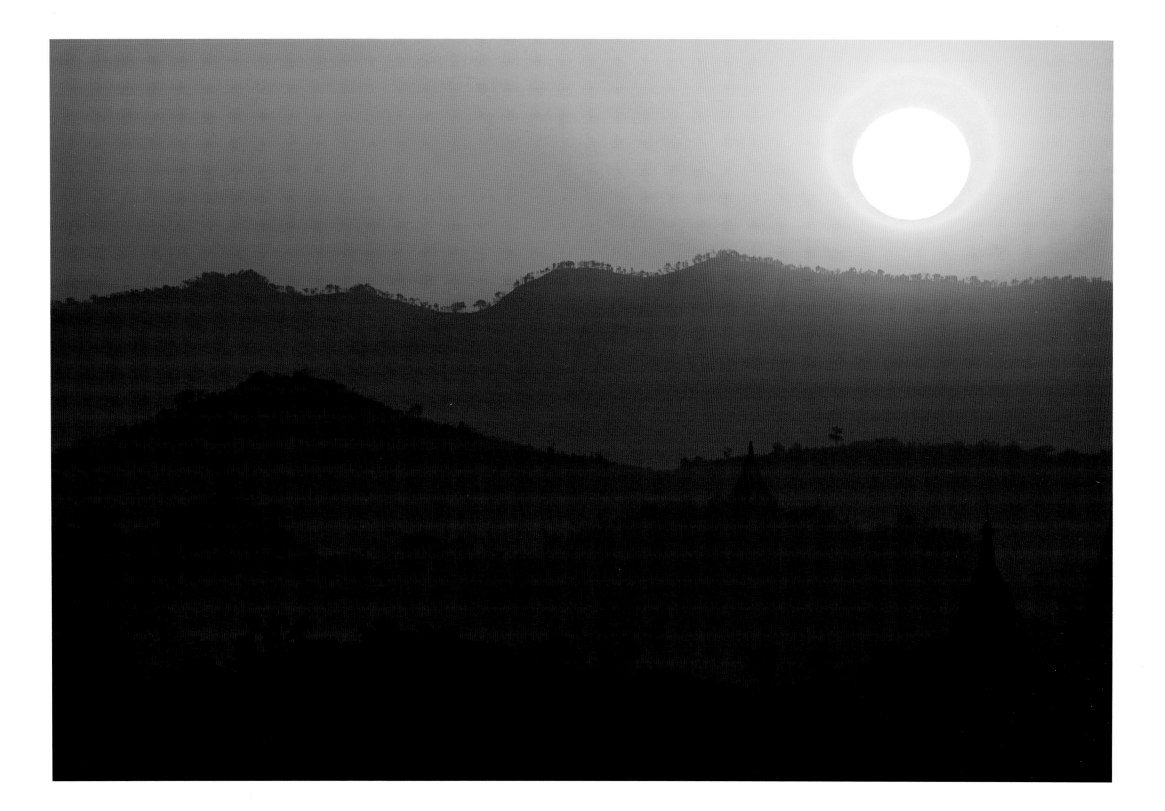

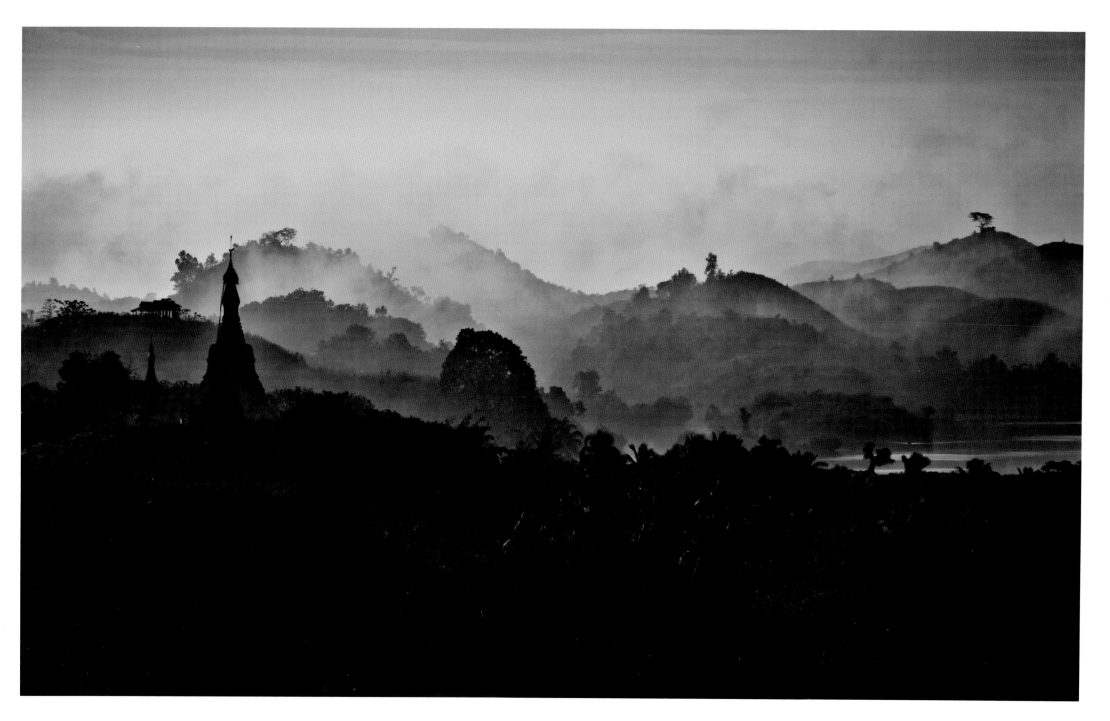

Wandering through Mrauk, you can't help but feel as though you have gone back in time. The awe-inspiring landscape is as ethereal as anywhere I have been on this planet.

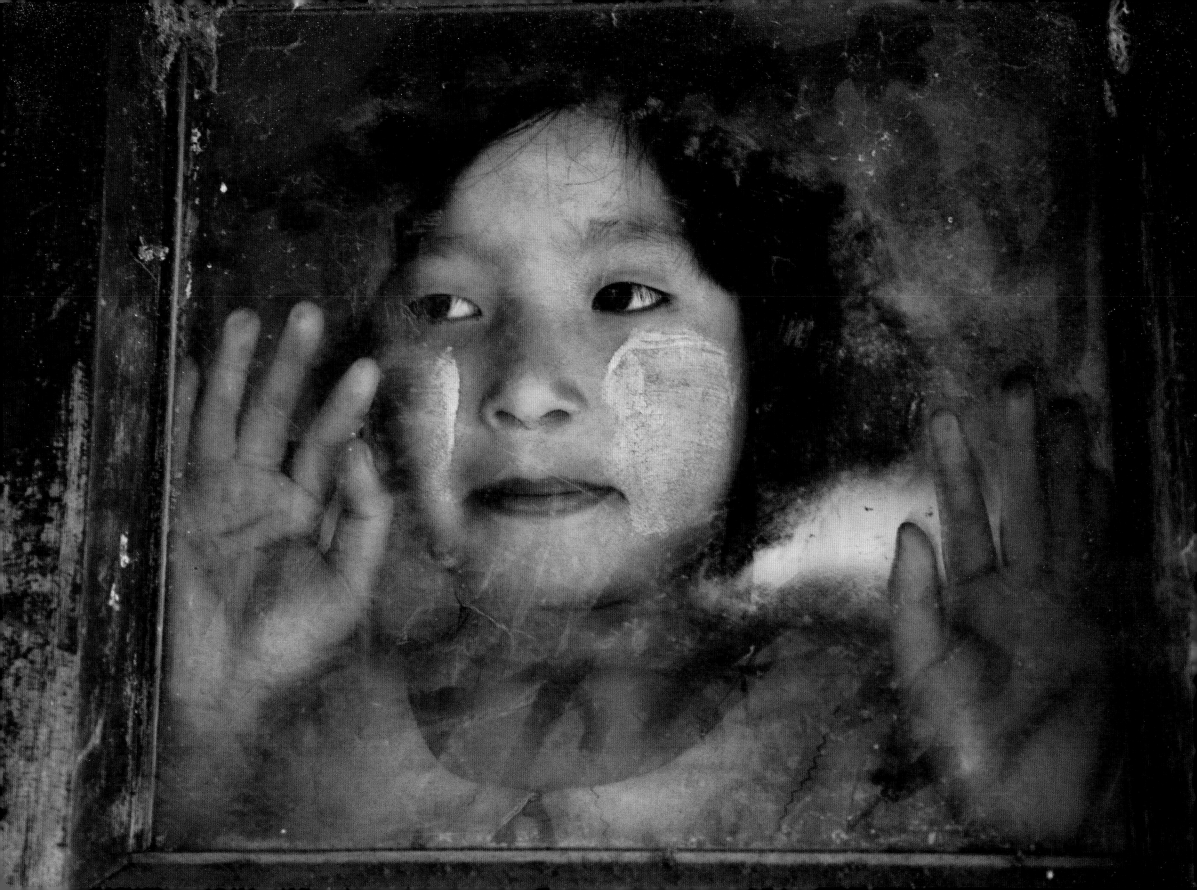

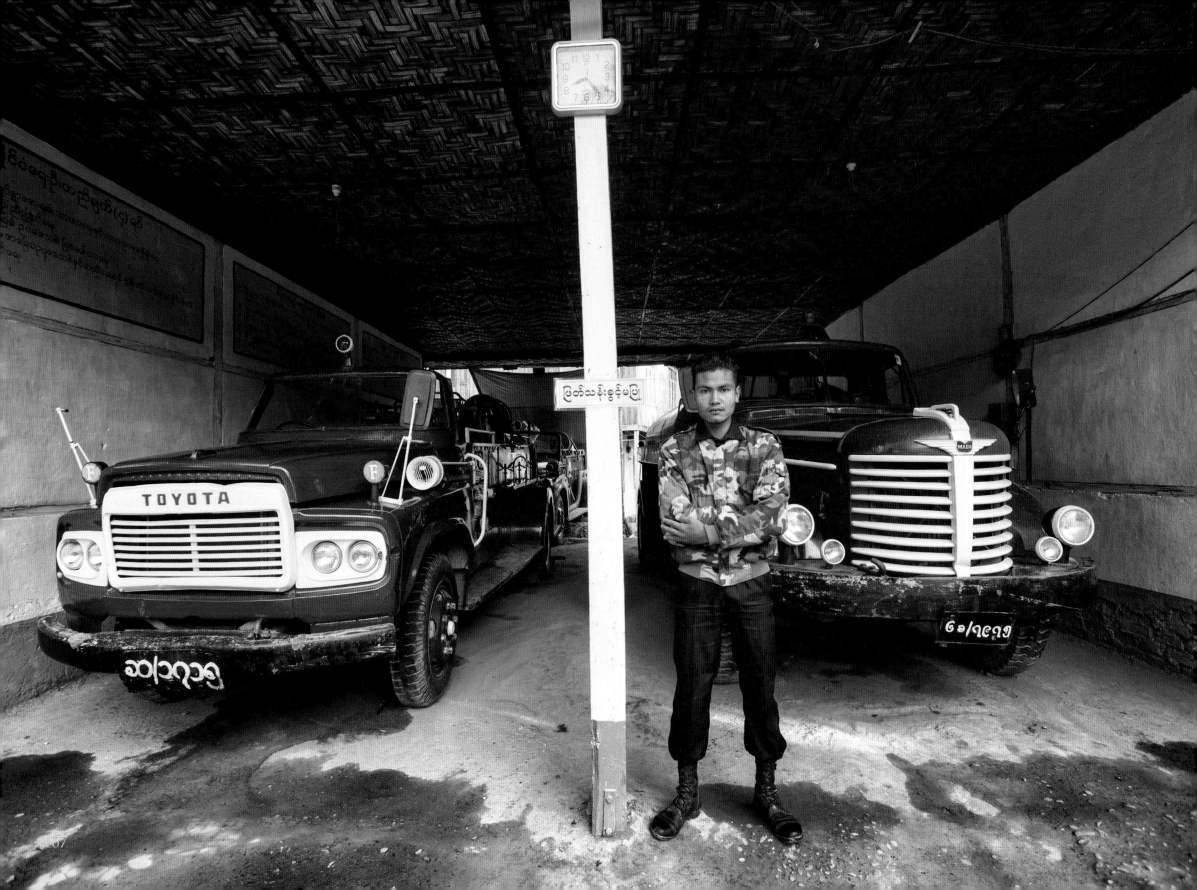

The rustic, lone fire station in town seems fitting
for a town that feels so ancient. A guard keeps
watch as there are no doors to the fire house.

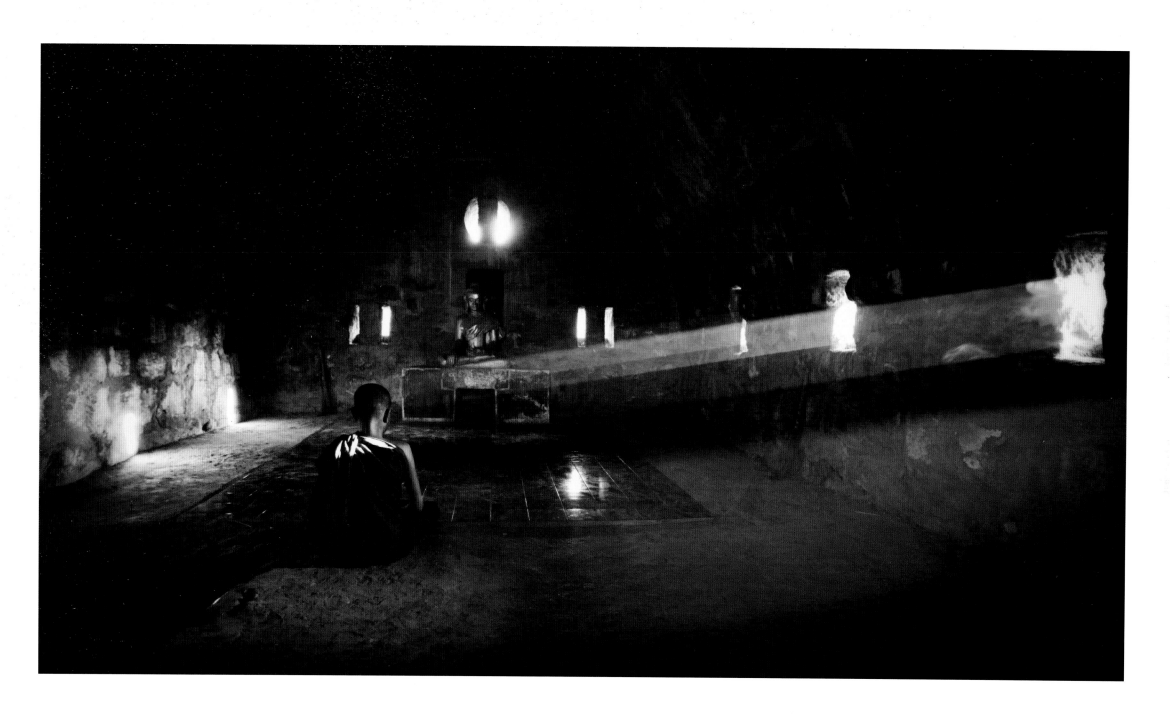

Monks and nuns praying in monasteries are an ever-present
part of this magical country, and being with them daily
seems to bring more clarity to your own life.

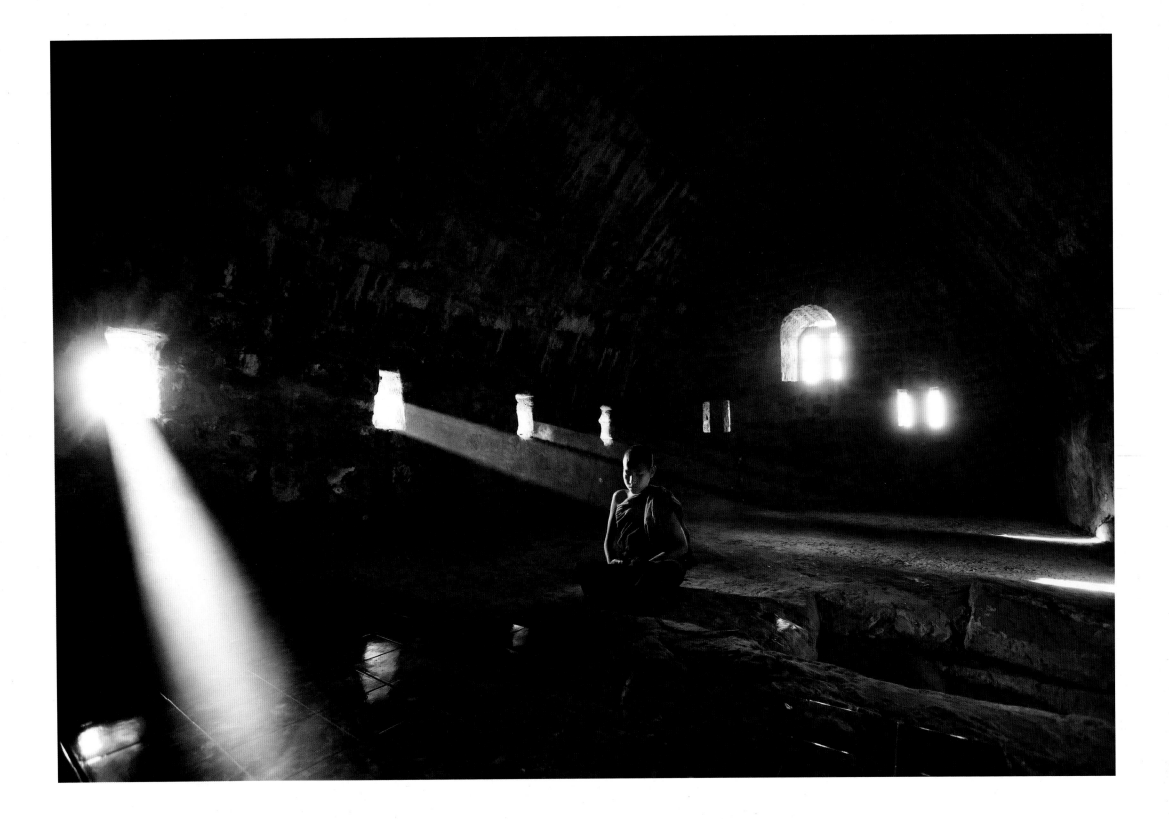

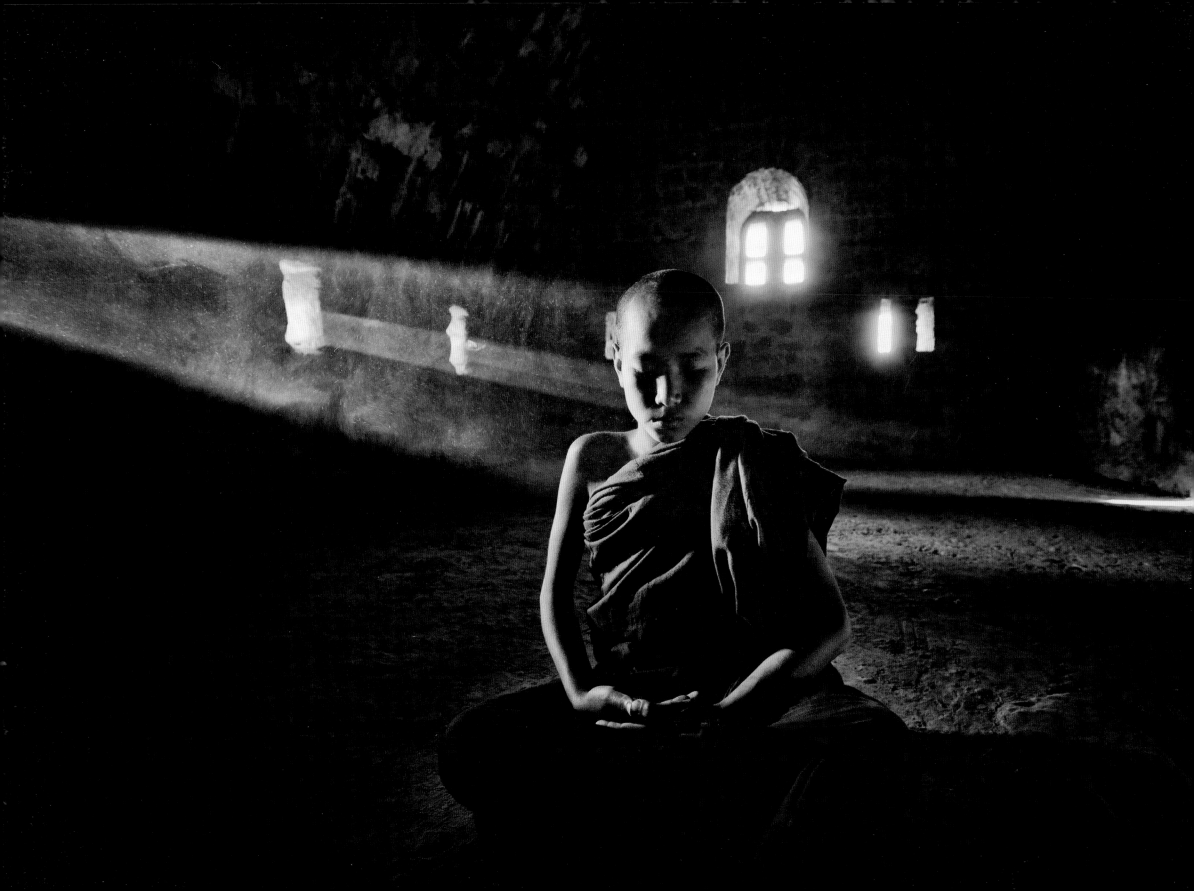

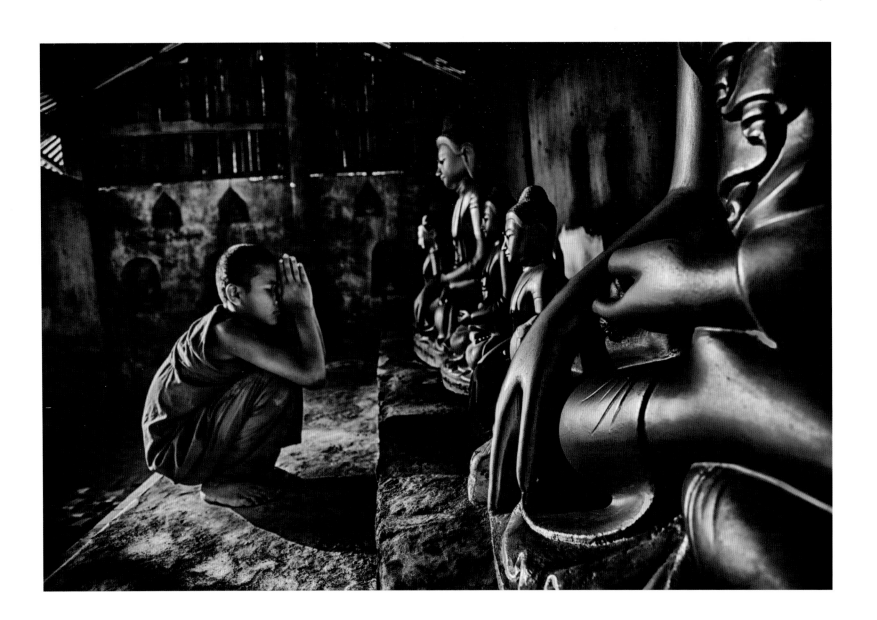

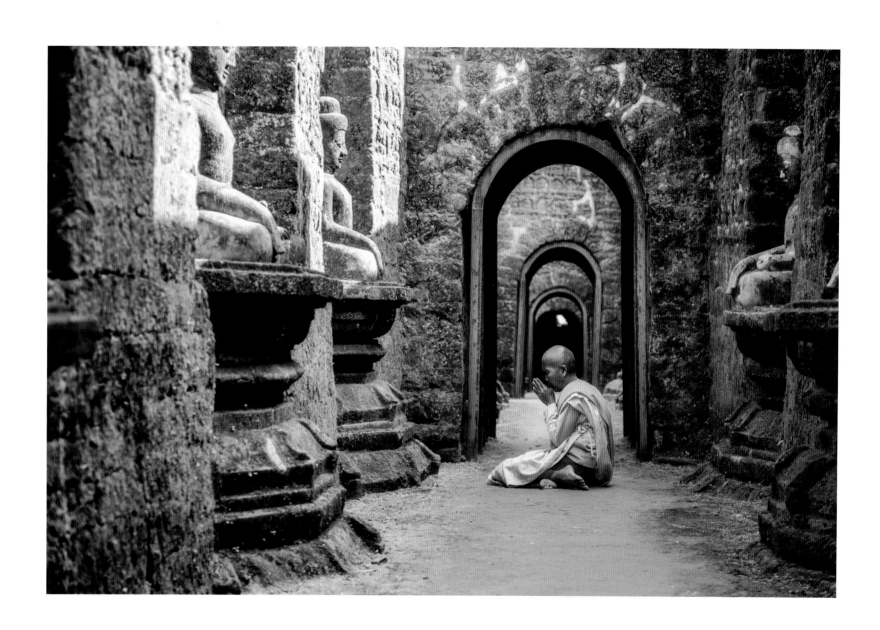

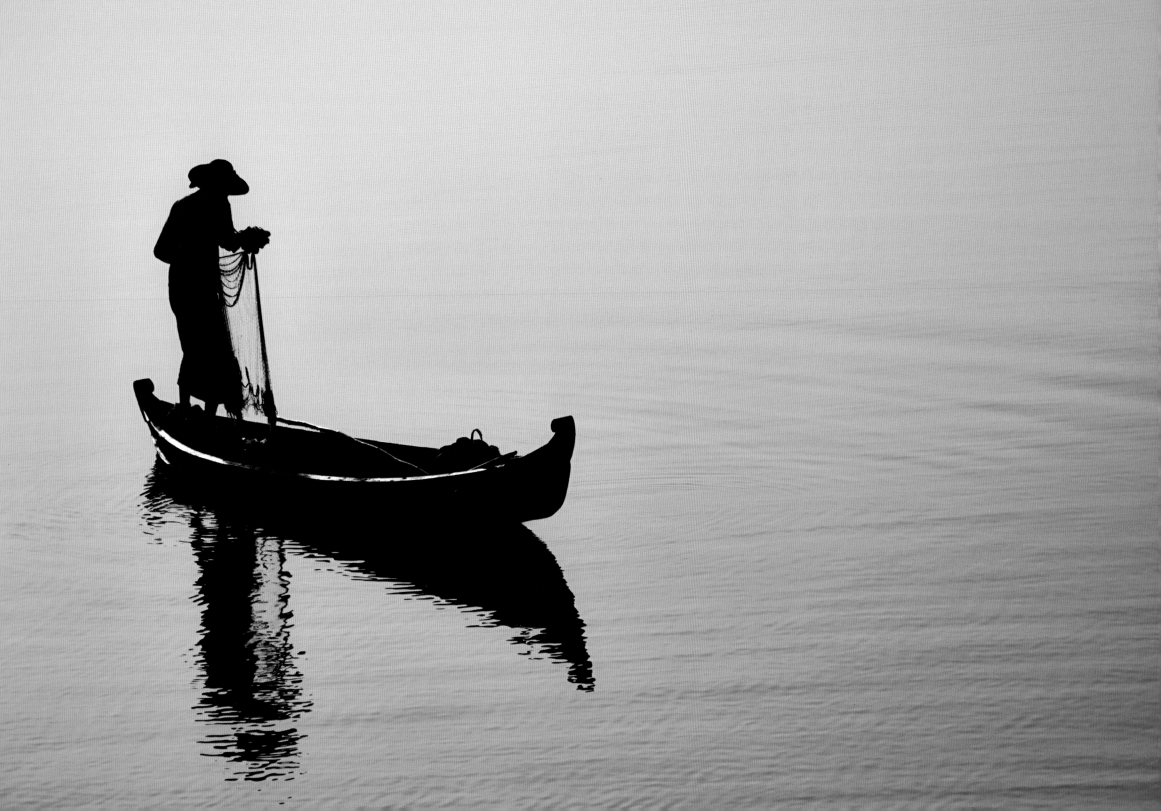

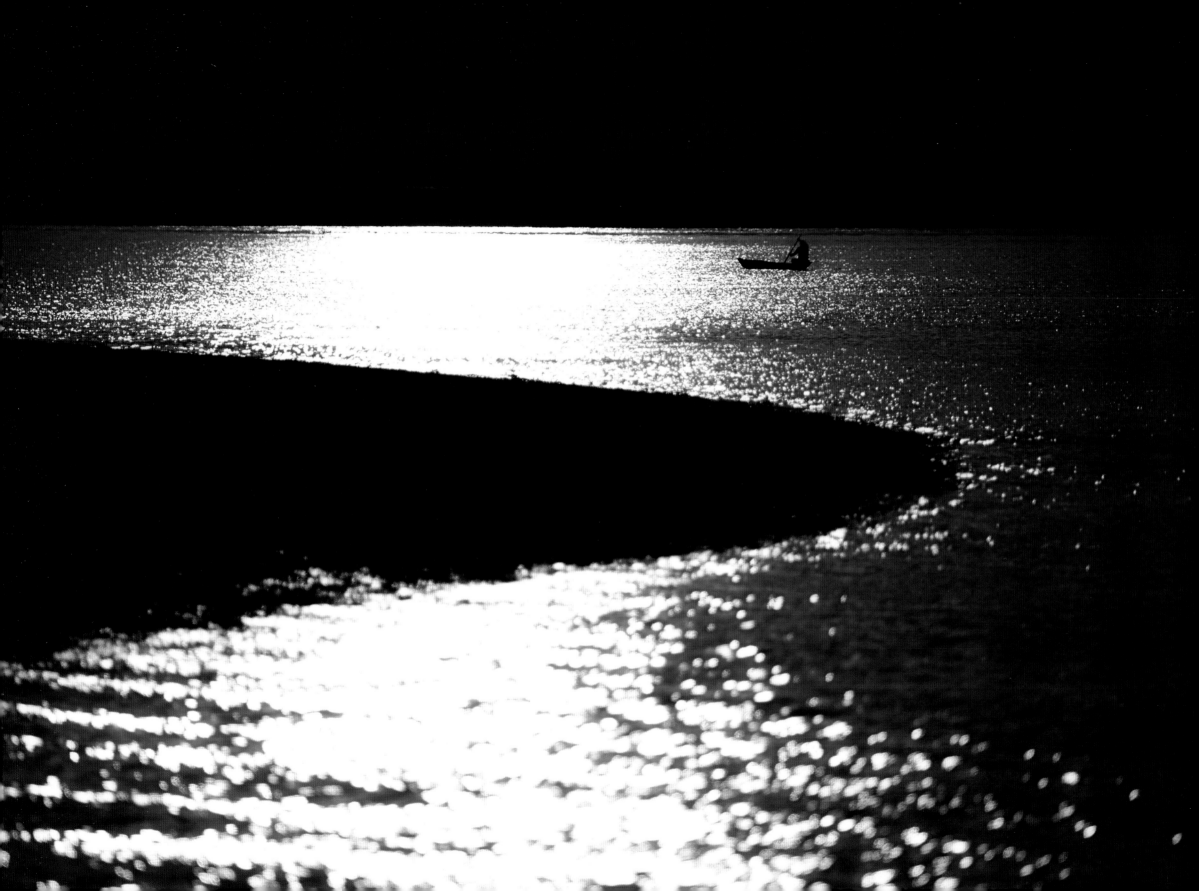

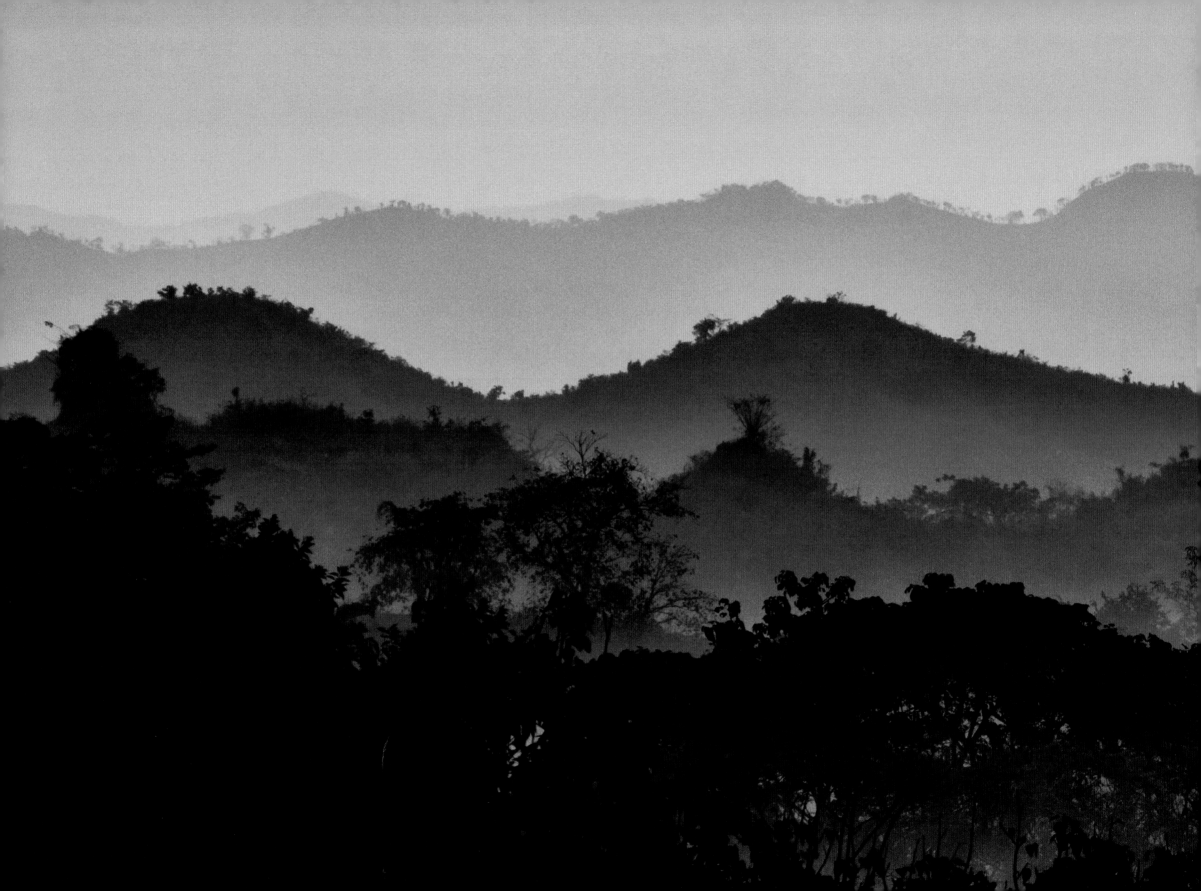

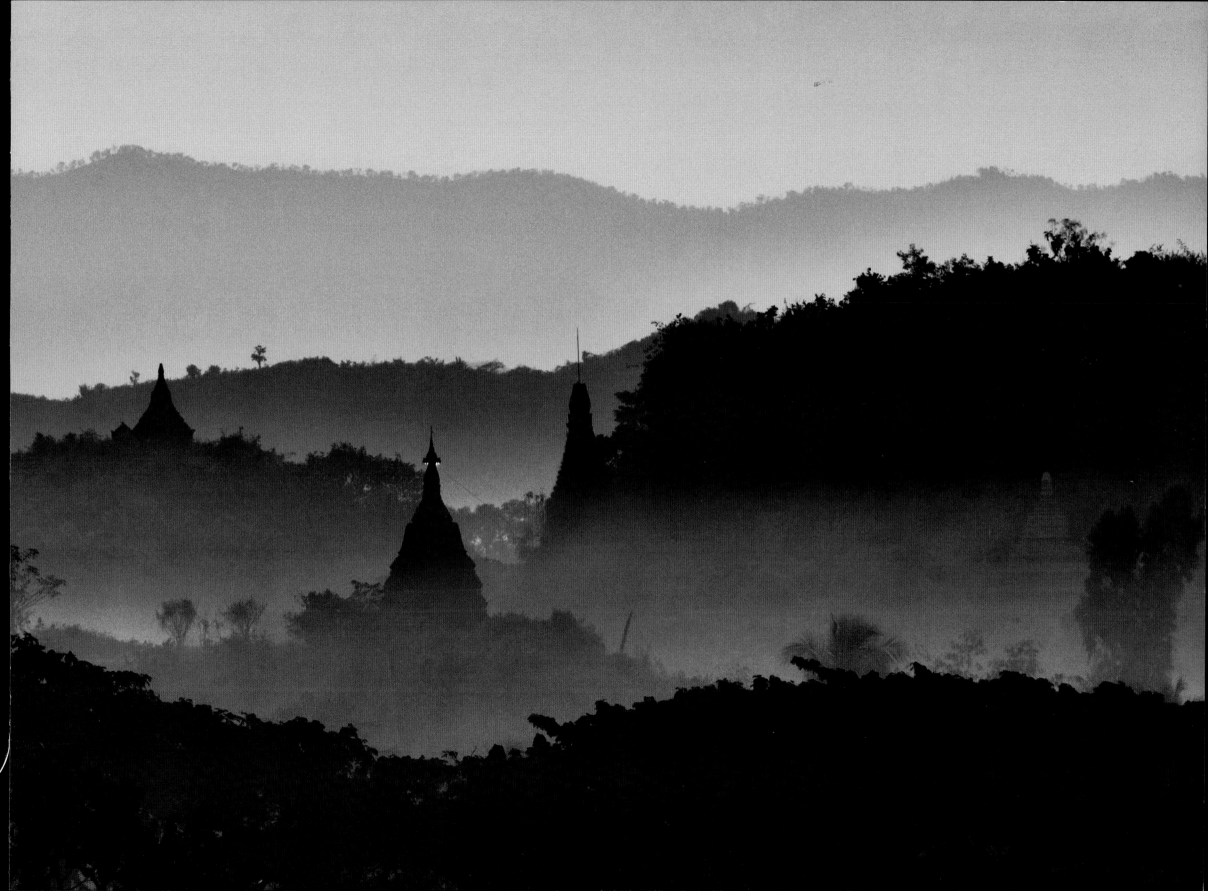

Yangon

Yangon, or as it is perhaps better known, Rangoon, is a cultural enigma. Situated at the mouth of the Irrawaddy River, it has the hustle and bustle of a modern metropolitan city, with overgrown, leafy avenues and a turn-of-the-century feel thanks to the fact that it was Britain's colonial capital and still has the look — albeit somewhat decayed now with the passage of time. And because the city does not allow motorbikes, it seems quieter than many Asian cities.

Everyone smiles here; everyone is selling something. Flower markets and fish markets are everywhere, and even after decades of economic stagnation, political strife and mismanagement, and cultural isolation, there is a sense of vibrant life here that I have felt nowhere else. Burma may have one of the most underdeveloped economies in the world, but it is impossible to return home untouched by the soft-spoken people and their culture. Economic and political issues aside, there is hope here.

The heart of Yangon is the religious center point of Burma. And towering above it all is the stunning Shwedagon Pagoda, with so many layers of gold leaf applied to its outer surface that it has the appearance of gold wool. Its official name is Zedi Daw, but it is better known as the Great Dagon Pagoda or the Golden Pagoda. It can be seen for miles throughout the bustling city.

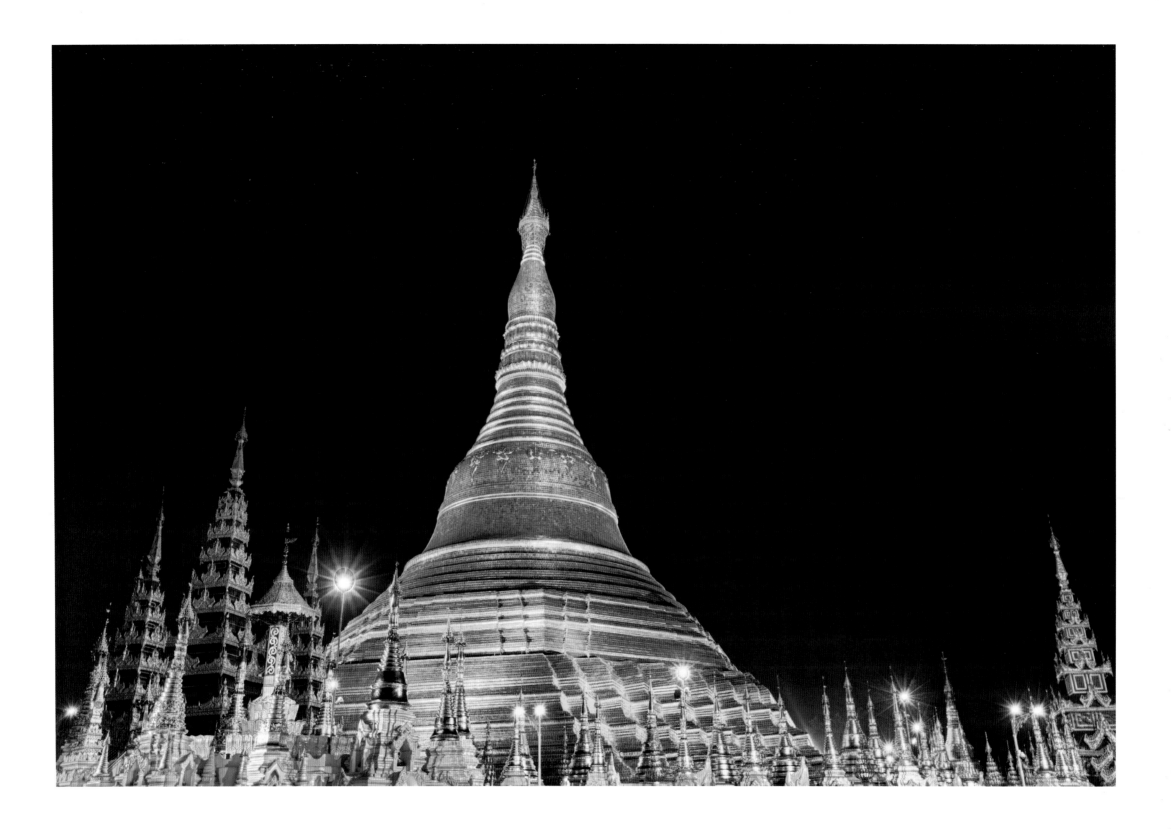

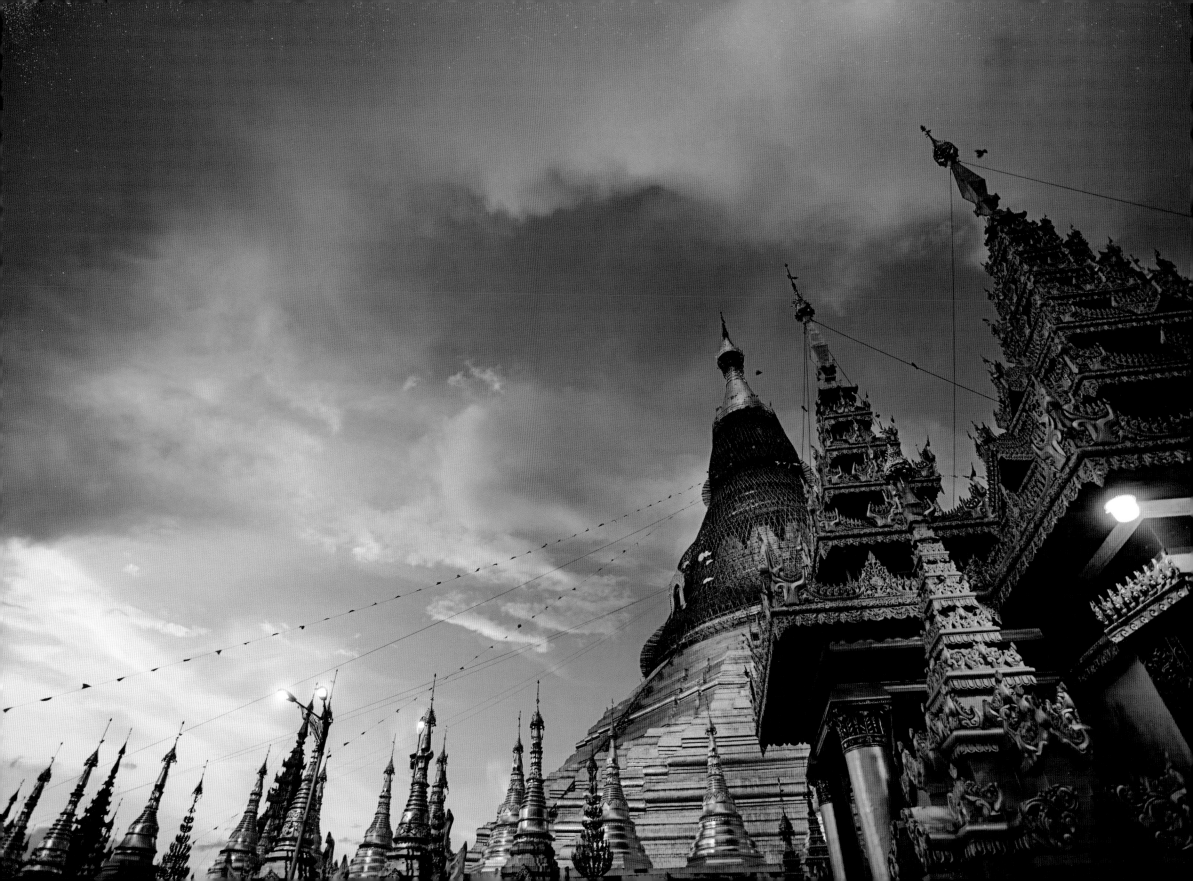

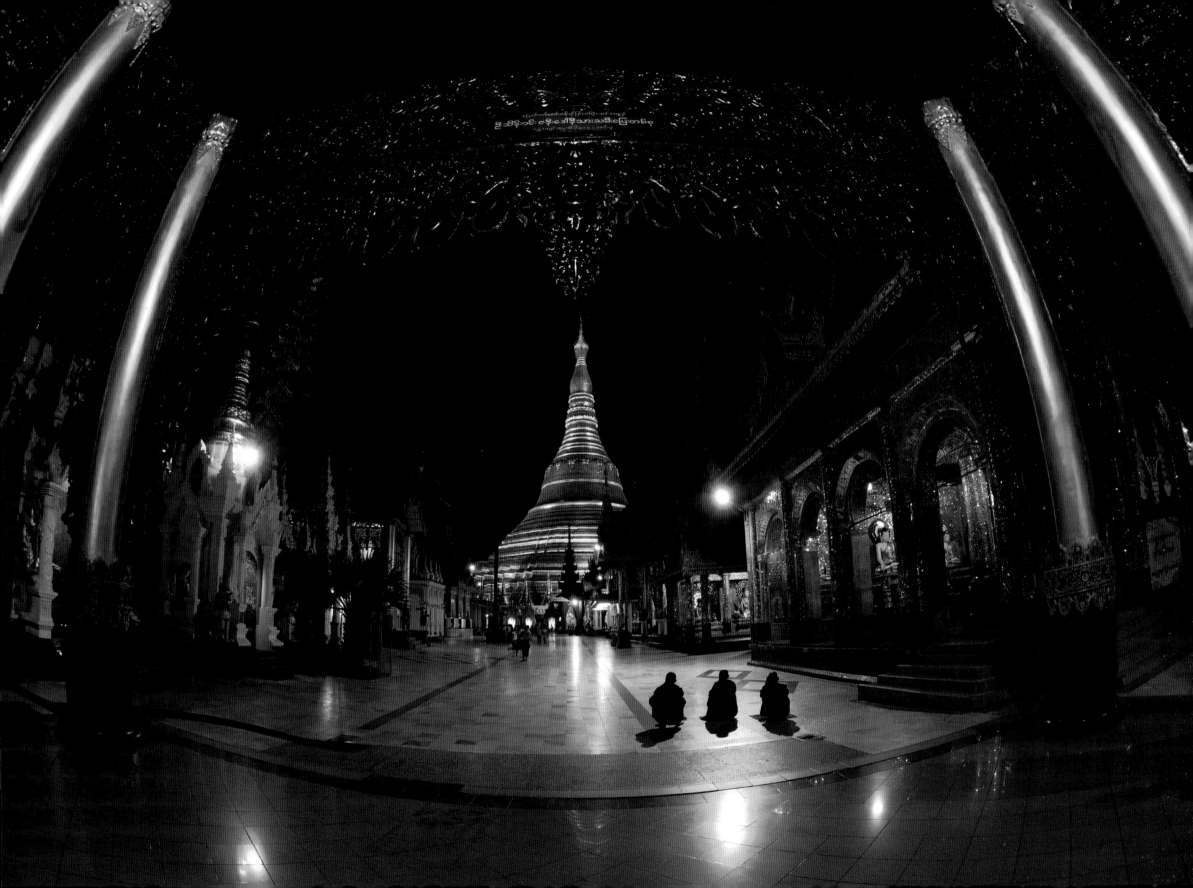

The most religious and spiritual place in all of Burma, the Shwedagon Pagoda is enshrouded in gold that has been donated by the people since the fifteenth century. The crown or umbrella is tipped with 5,448 diamonds and 2,317 rubies. The very top, the diamond bud, is tipped with a 76-carat diamond. Walking around this awe-inspiring circular pagoda is one of the most amazing experiences that anyone can have in Burma.

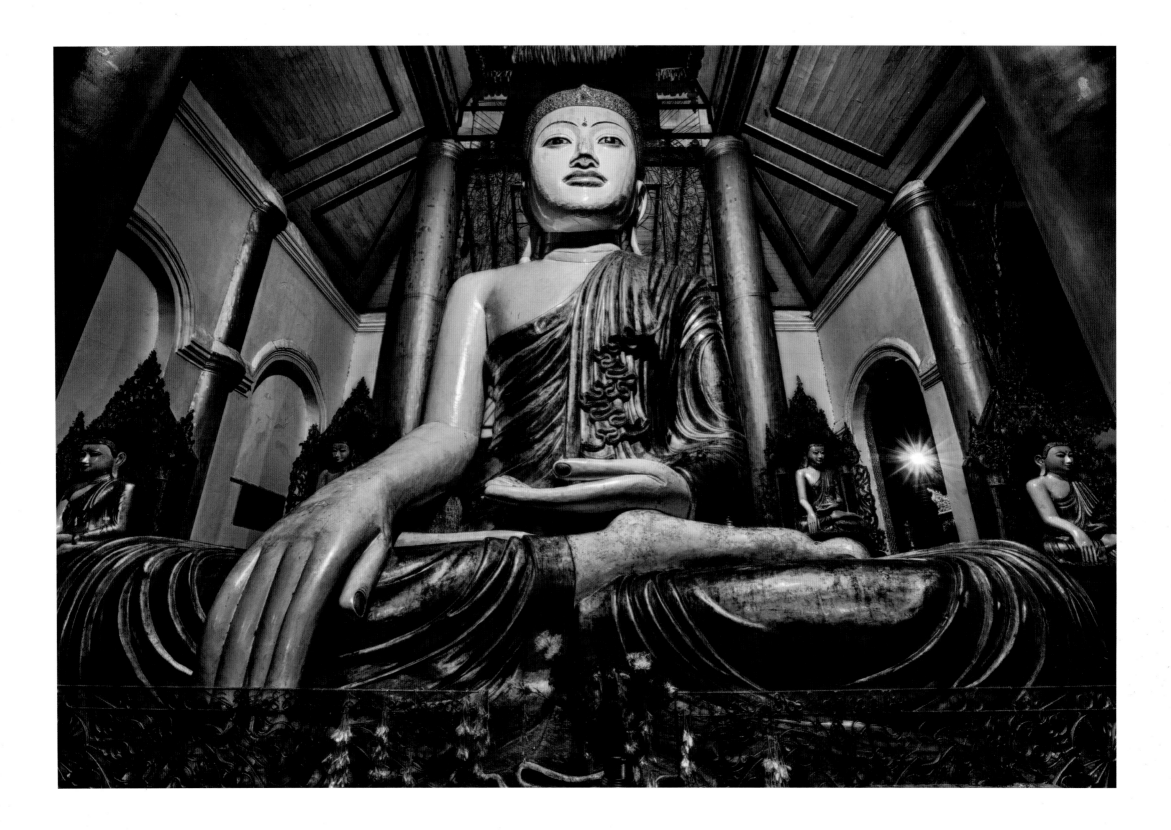

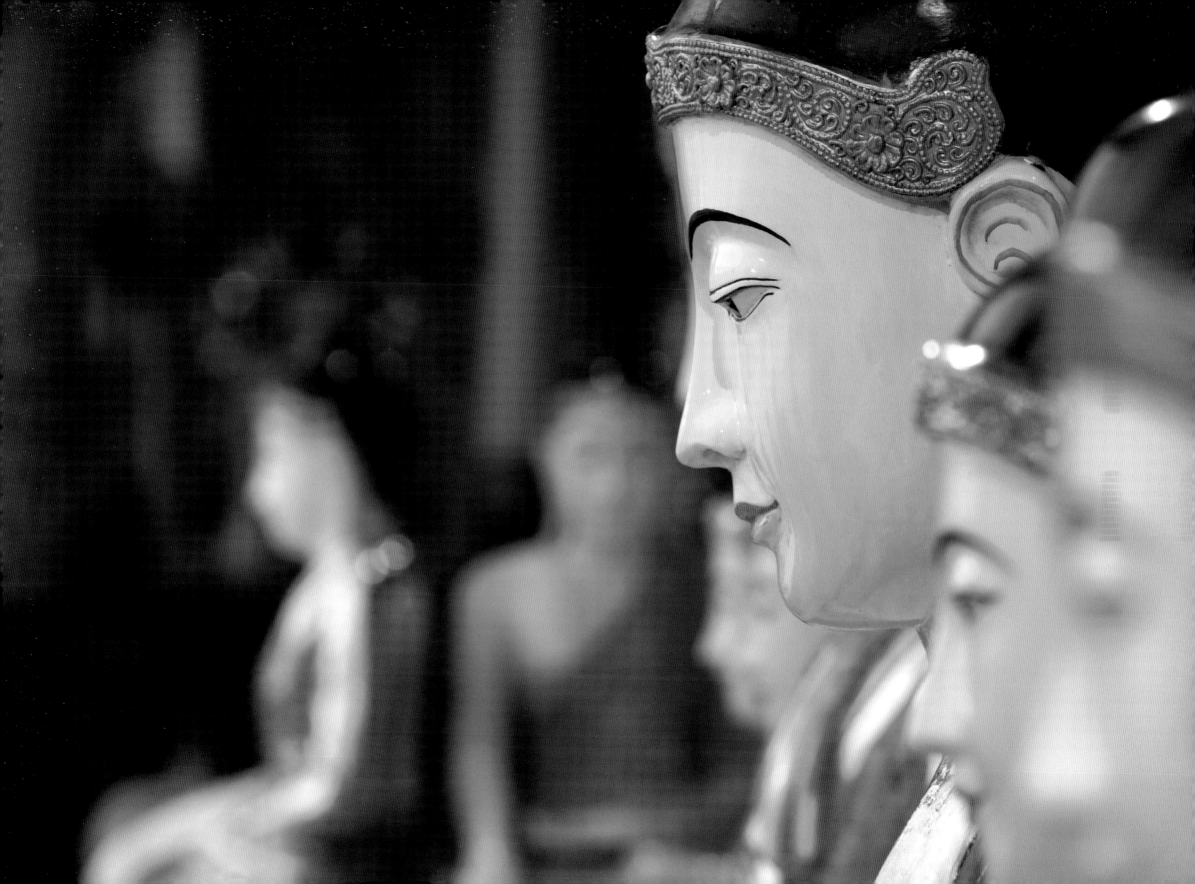

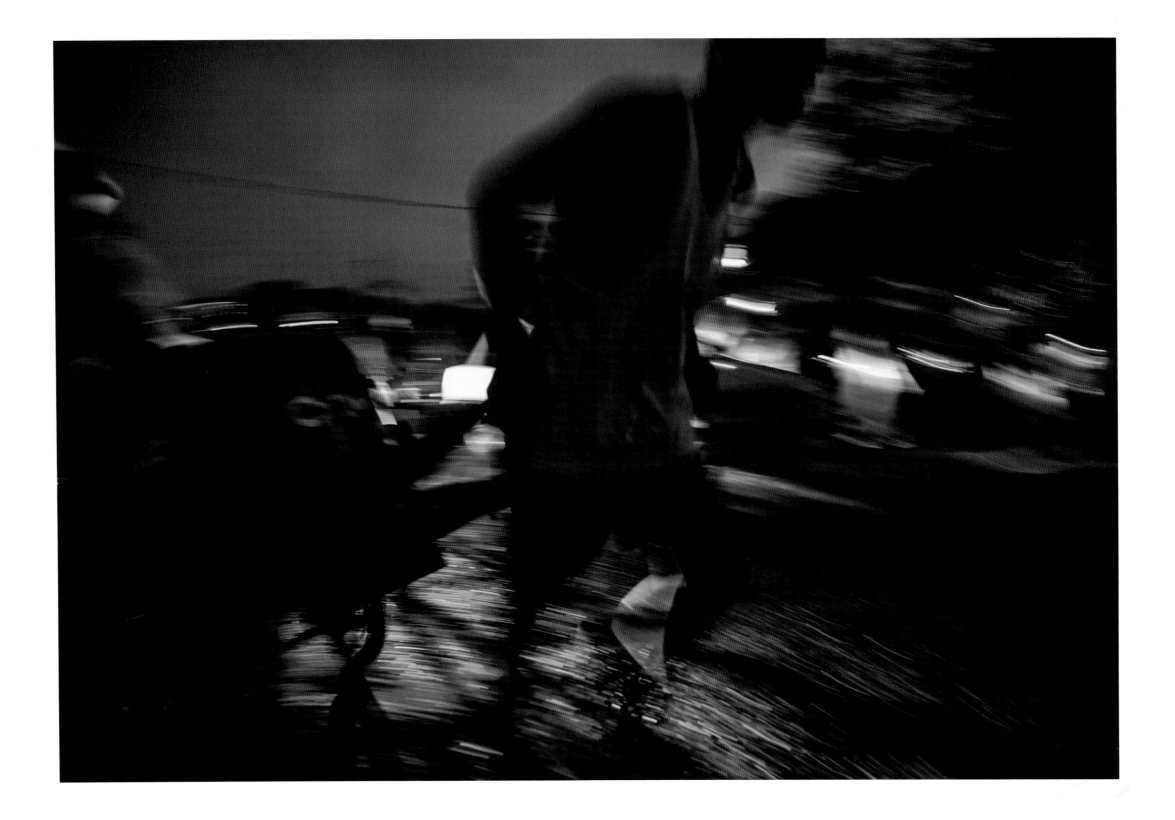

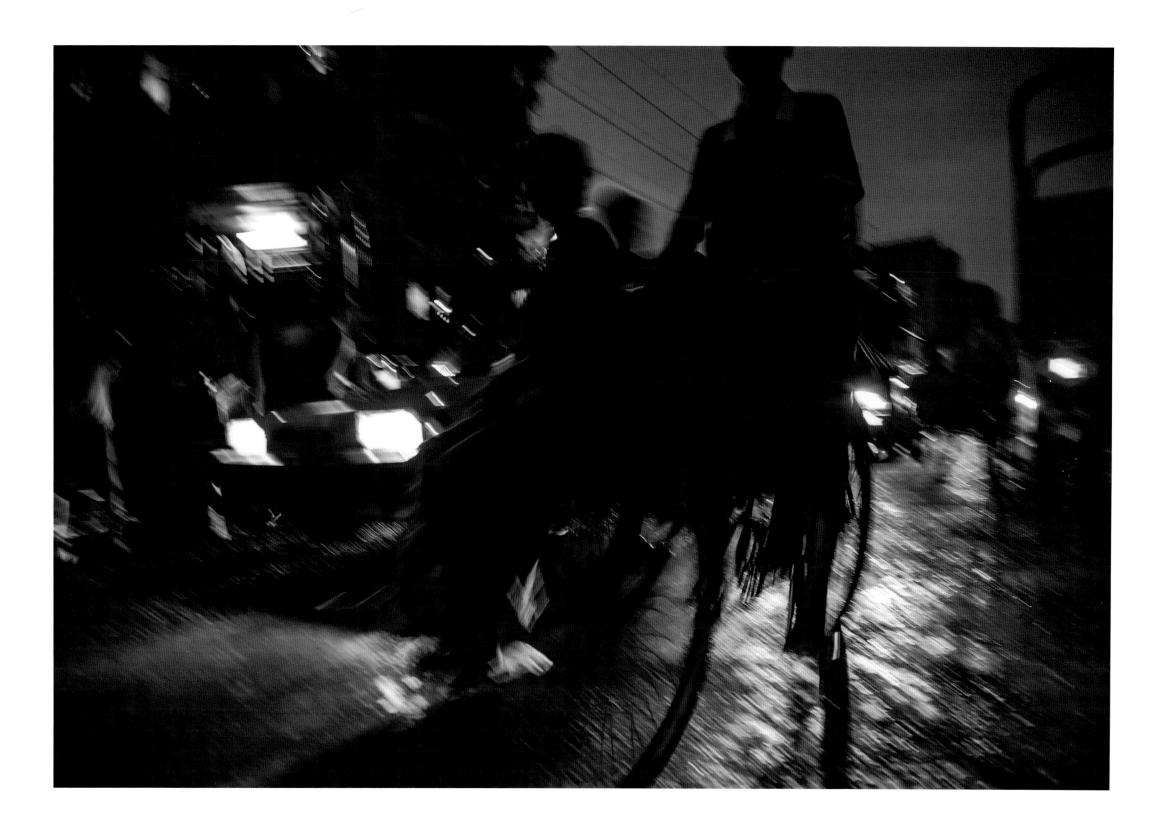

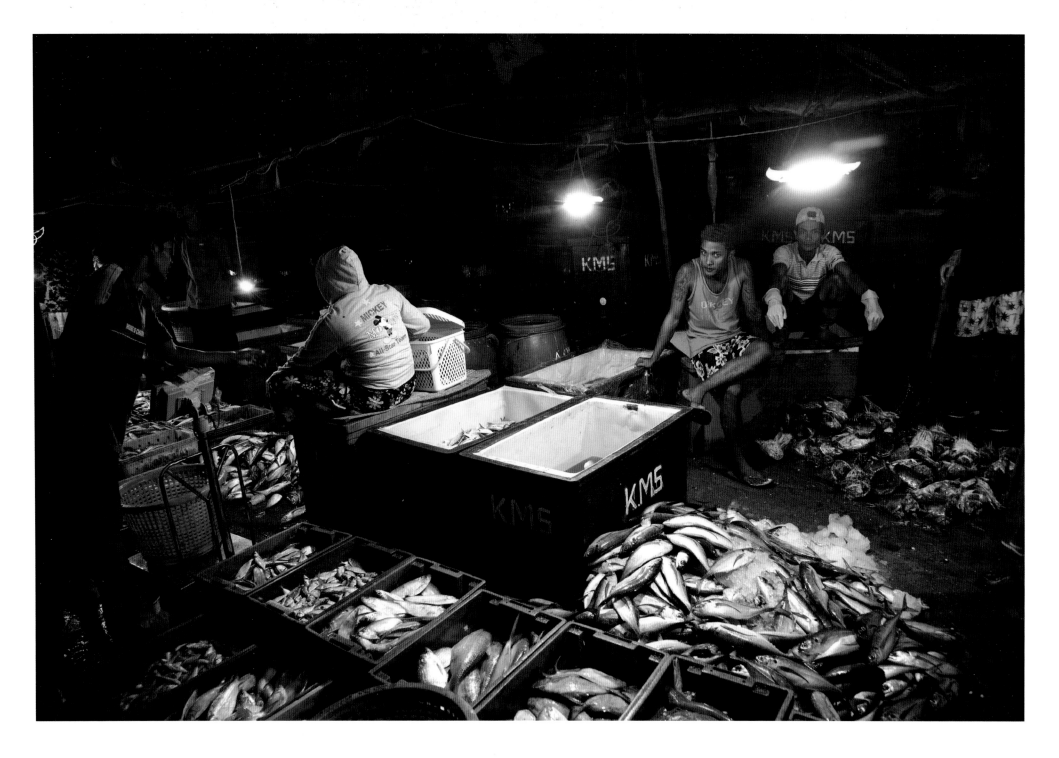

Long before sunrise, the local fish markets thrive with the nonstop motion of
workers preparing for the new day. Tons of fish are unloaded from local boats.
People flock to the markets as the fish is sorted and laid out for sale.

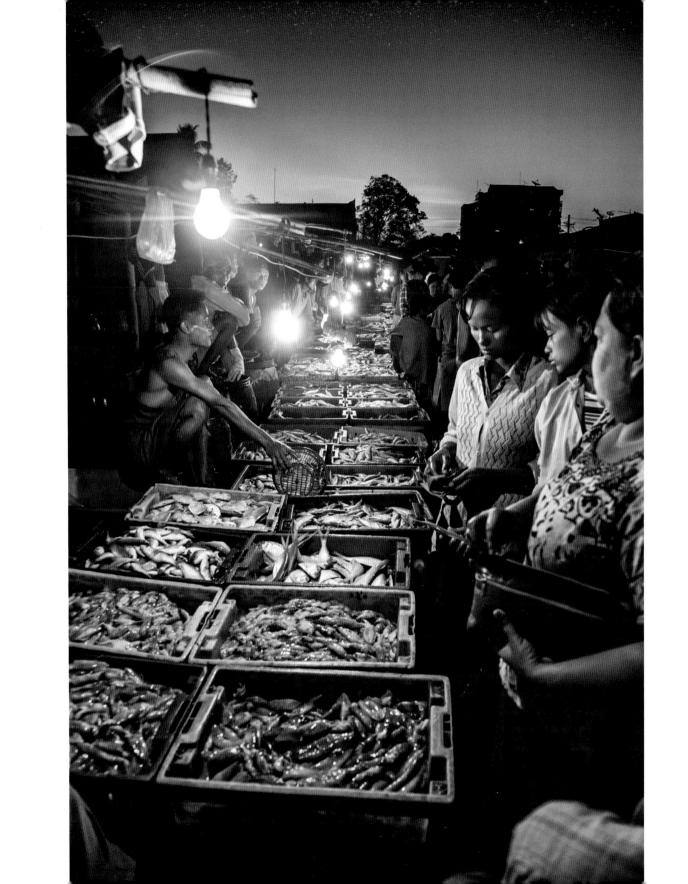

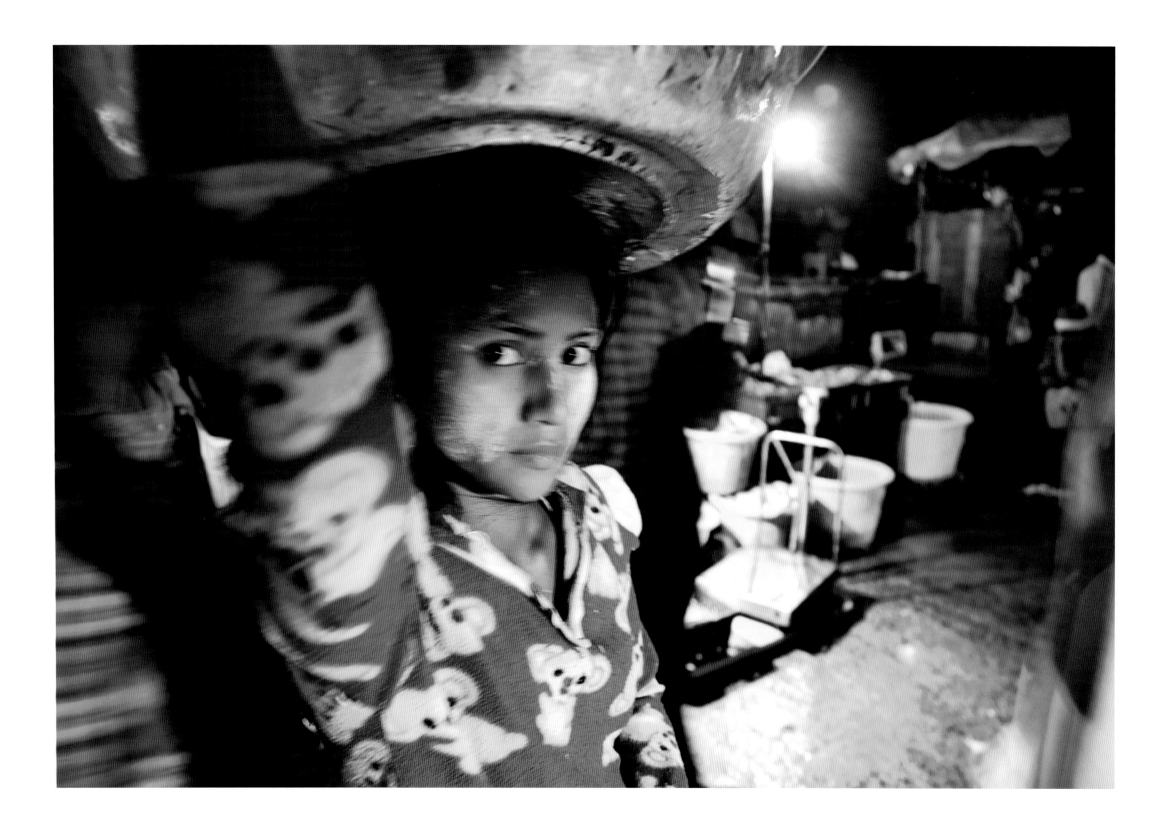

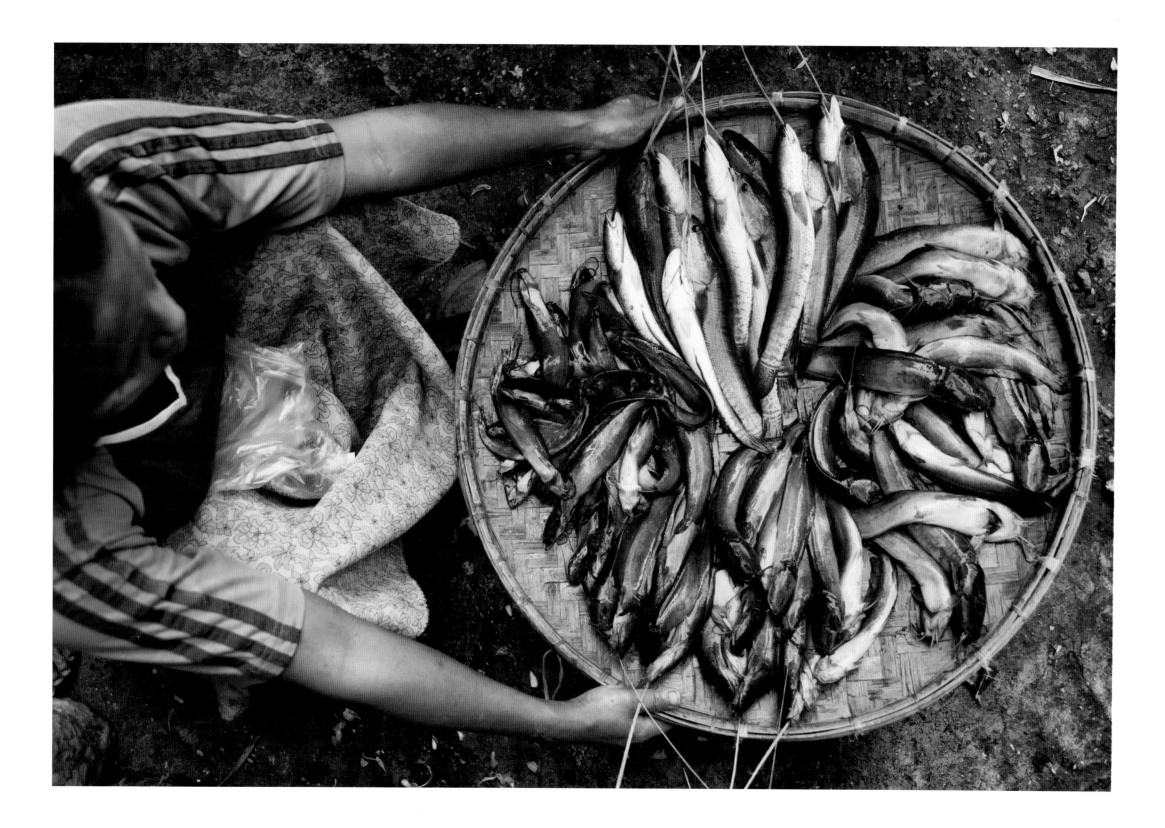

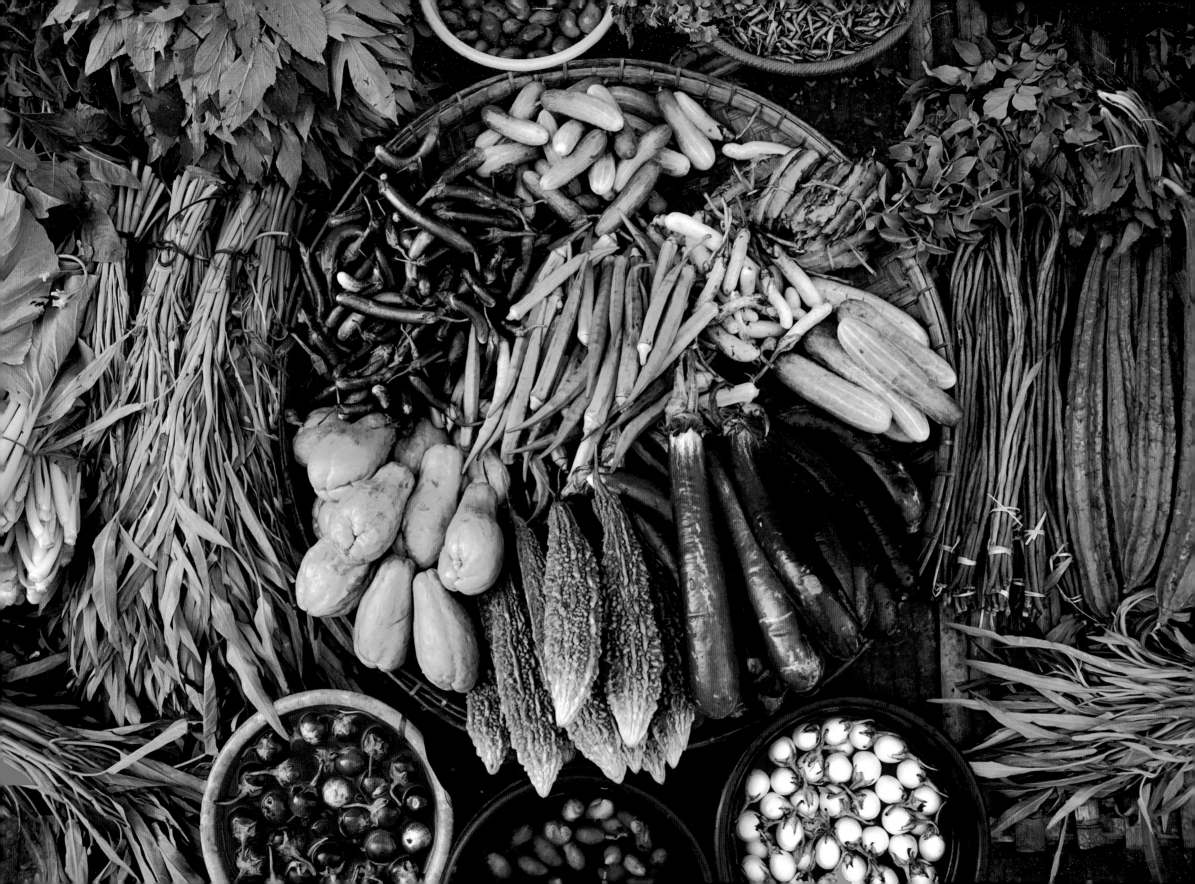

The vegetable markets in Yangon are unlike those found anywhere else. The diversity of food, the freshness of the produce, and the vibrancy of the market itself create photographic opportunities in every direction.

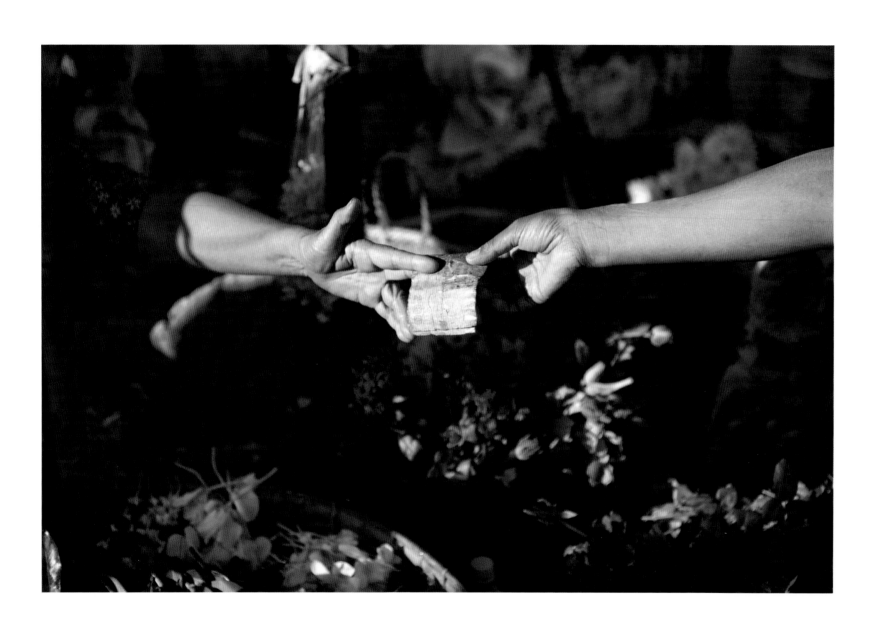

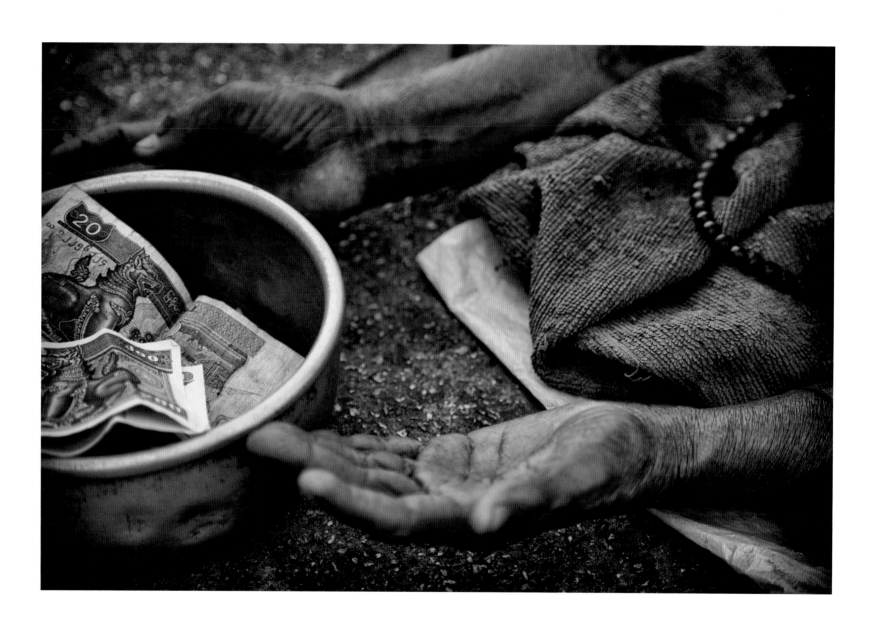

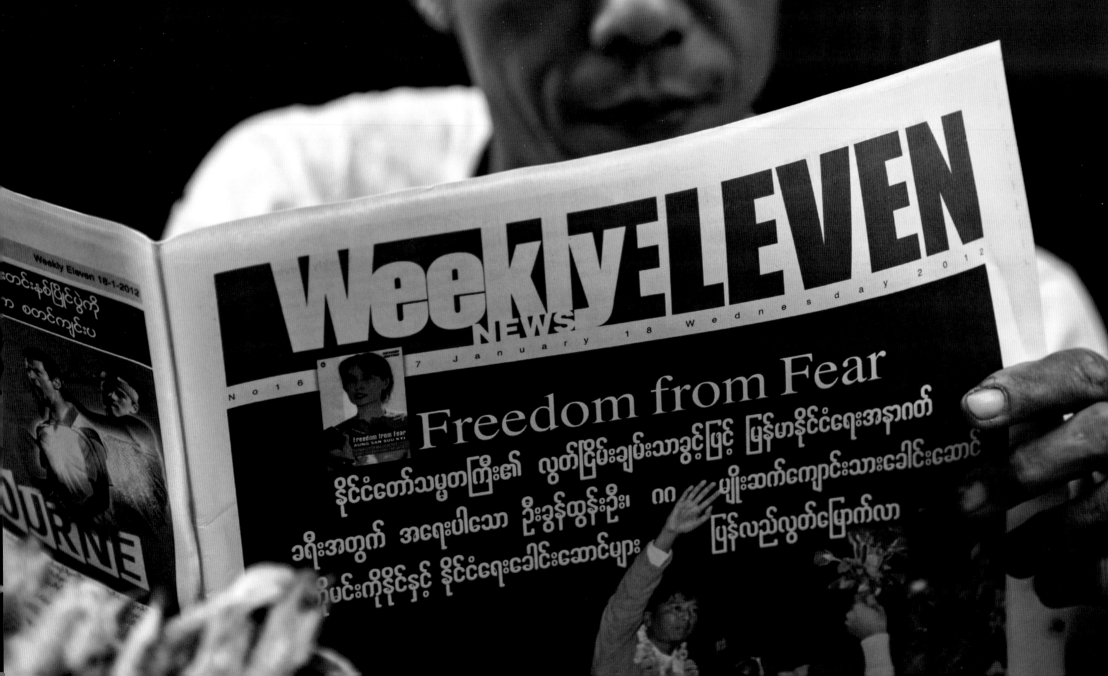

In 2008, the country's name was changed from "the Union of Myanmar" to "the Republic of the Union of Myanmar." Since its beginnings at the dawn of human time, the country has gone through a series of political and military upheavals that have shaped it as a state. In many cases, violence broke out between the military and the country's Buddhist monks, and while some unrest continues today, there is now hope for a long-term peace.

Outspoken politician Aung San Suu Kyi was finally released from twenty years of house arrest, and she has taken an active role in the reforms of the country, which include liberalization, reformed labor laws, and a thawing of the relationship between the government and the press. Time will tell whether things will continue to improve, but the long-awaited political thaw was a welcome change for most.

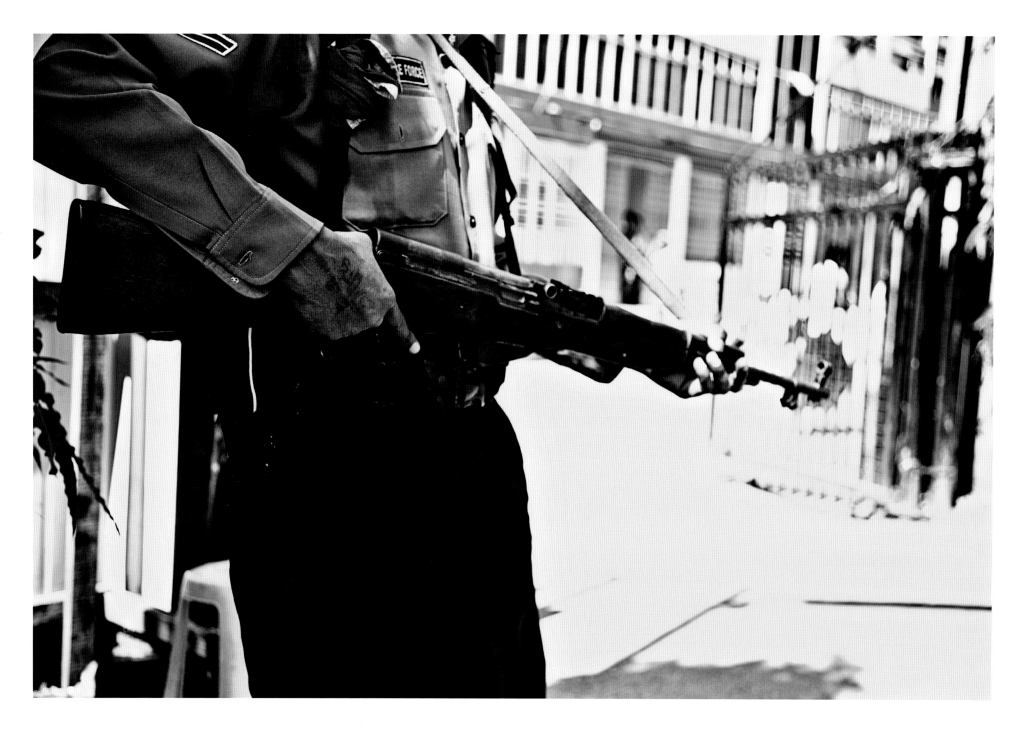

Although change is happening, there are daily reminders of real life in Burma.

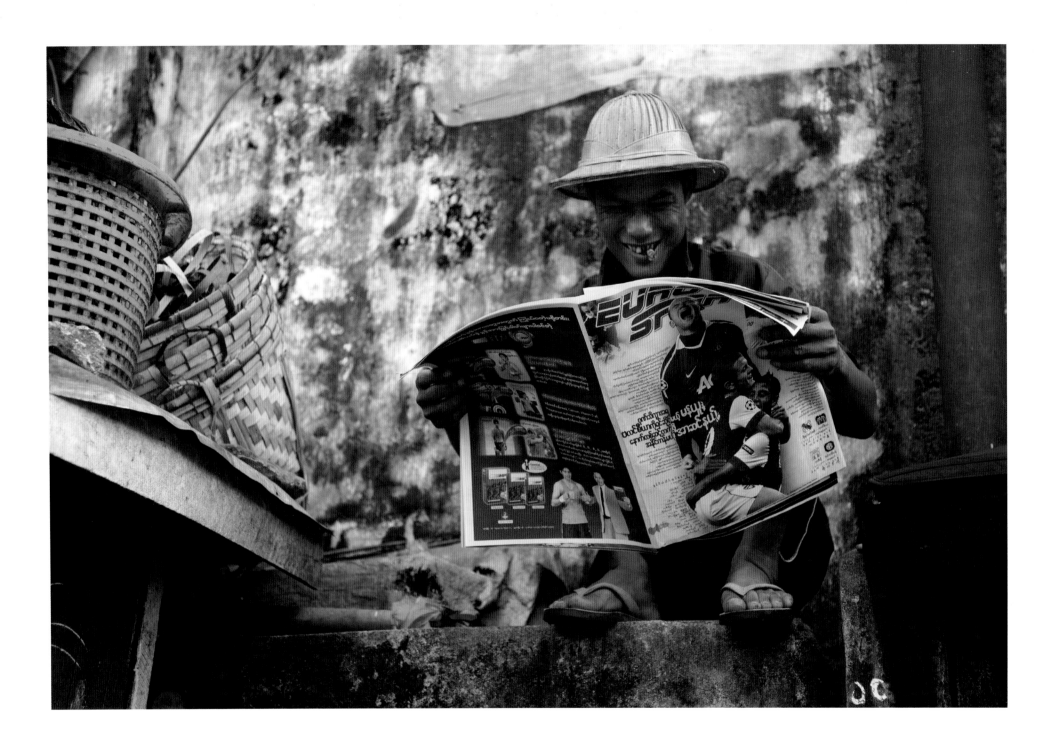

Following sports is a fun, welcome distraction even in a third-world country like Burma.

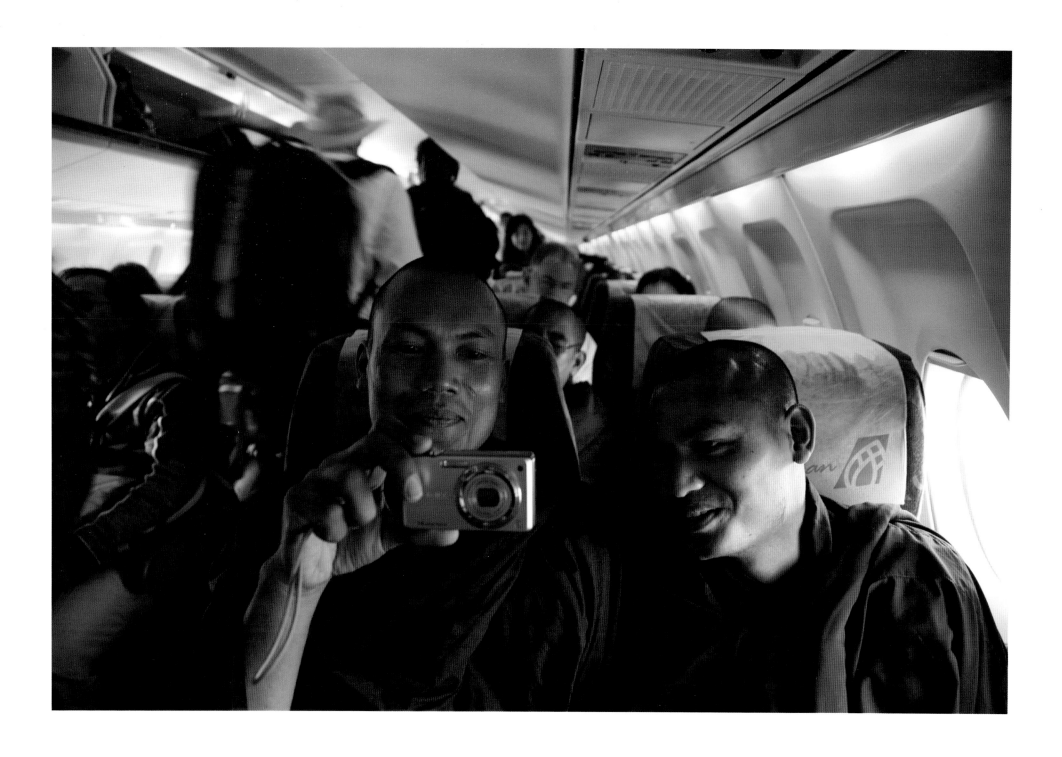

We see evidence of a more modern Burma as these monks view photos from their camera.

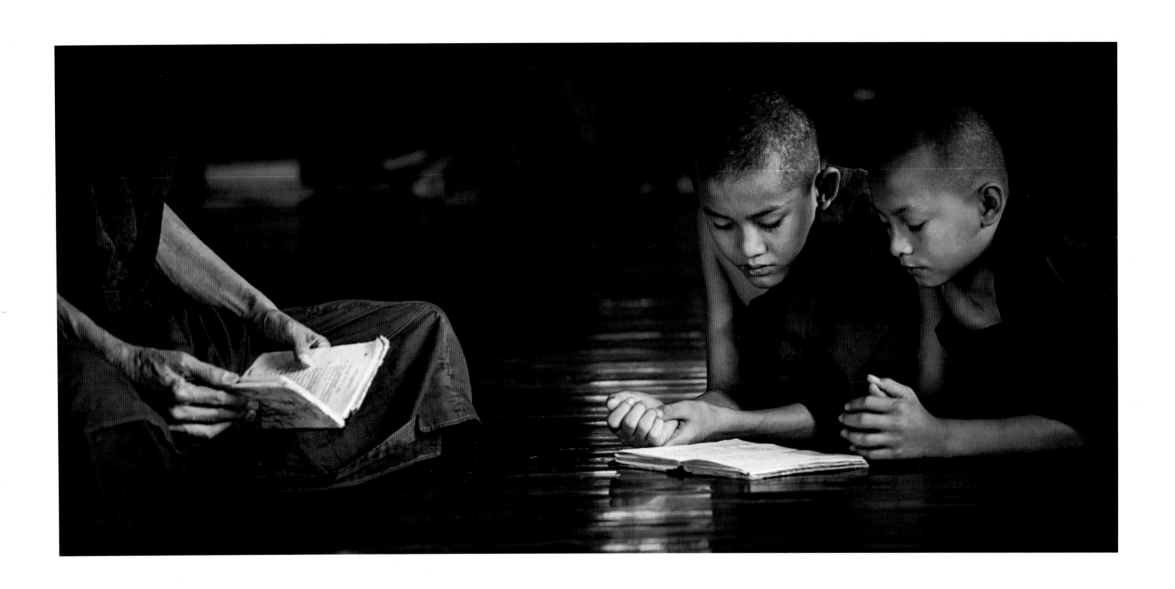

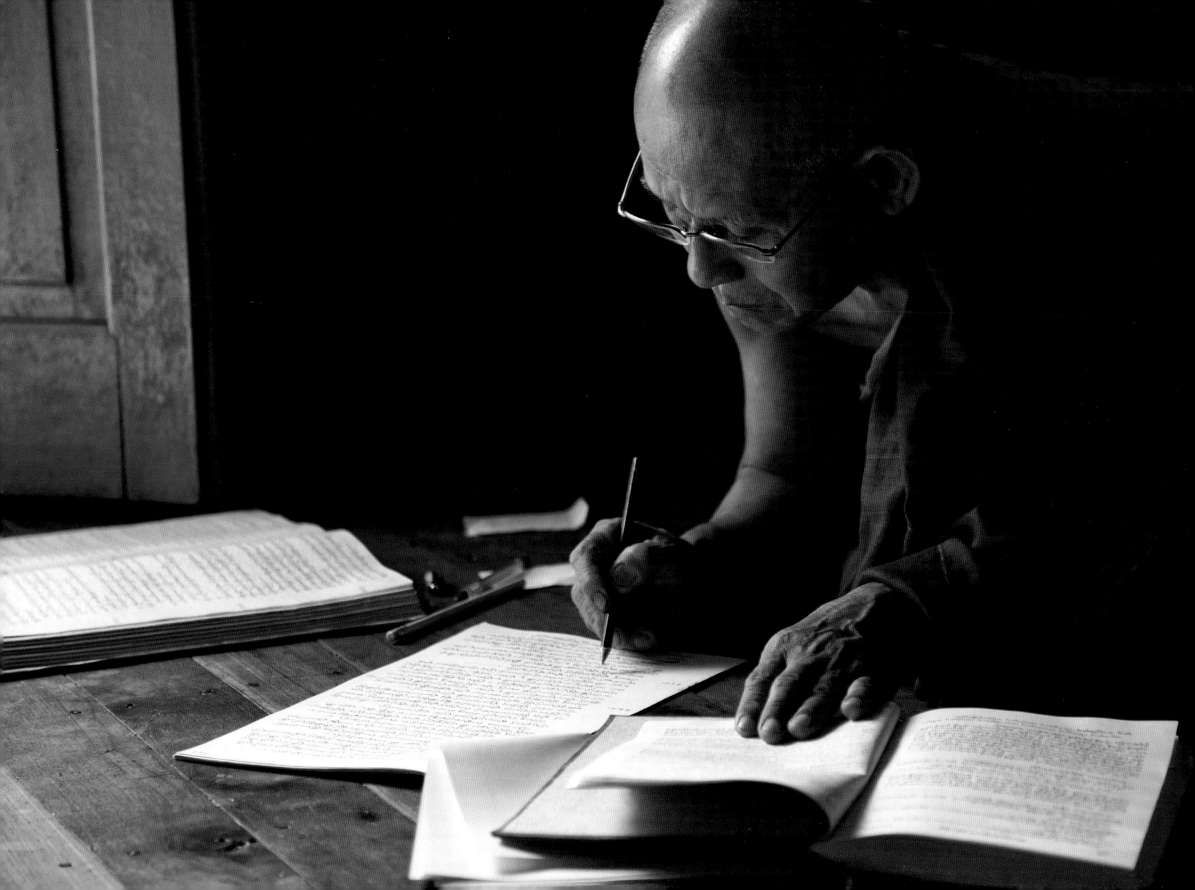

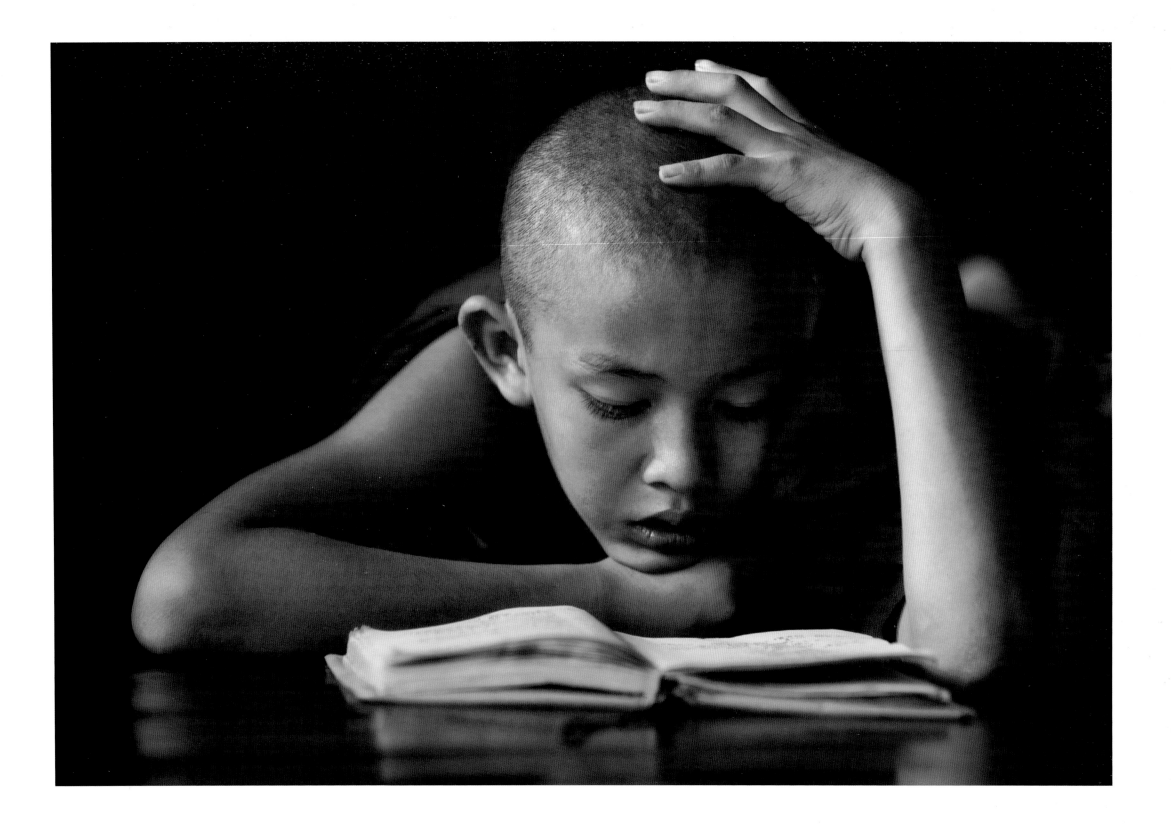

Some of my fondest memories are of the monasteries in Yangon. The monks and monk masters have let me into their lives for years, and their way of life has always intrigued me. They wish for so little but are filled with inner peace.

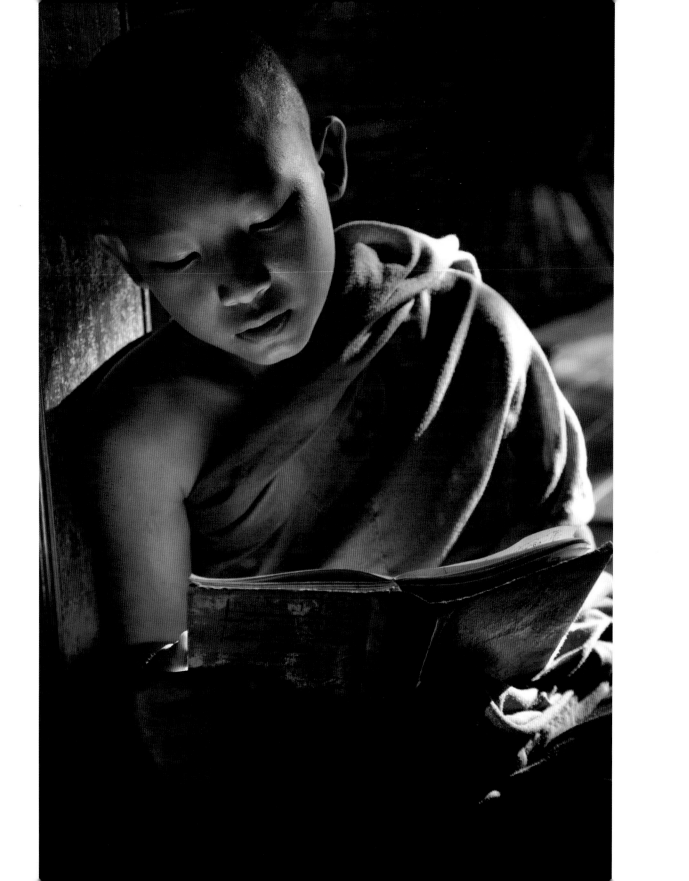

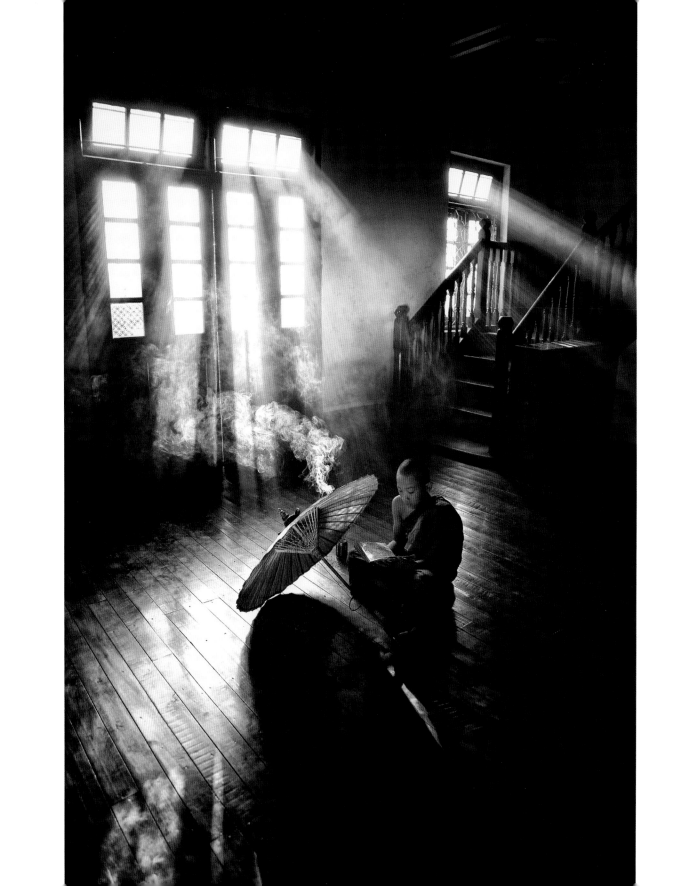

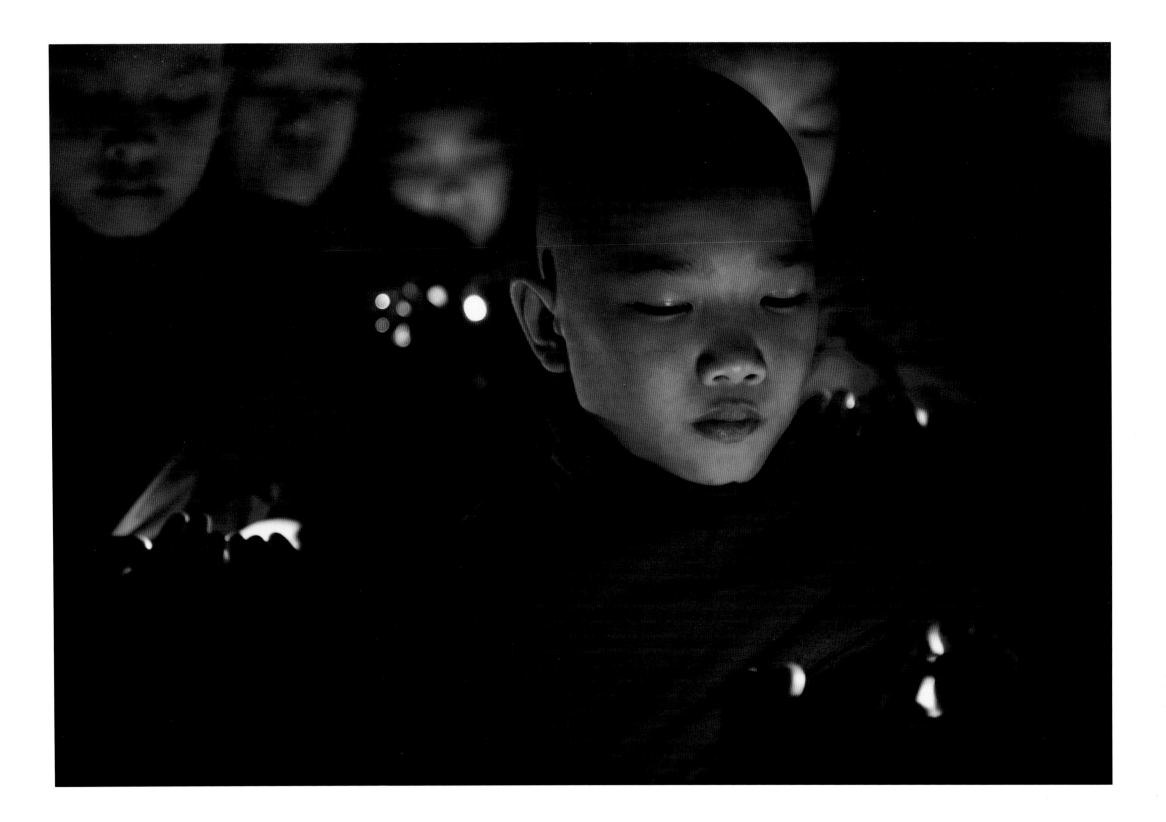

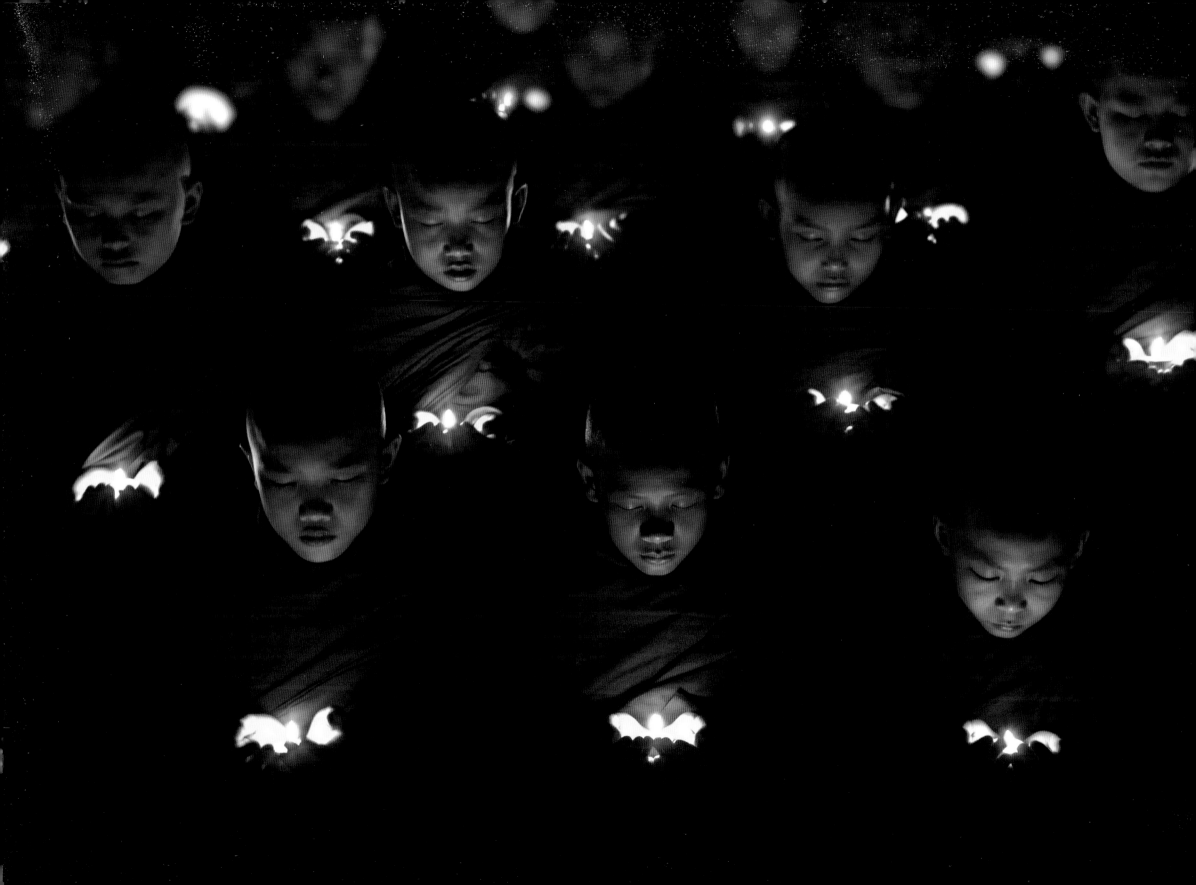

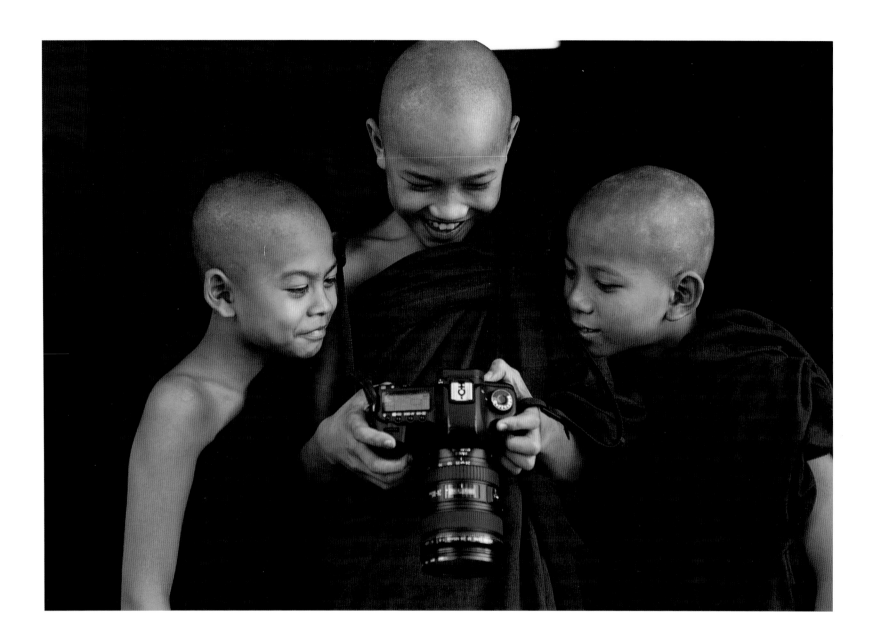

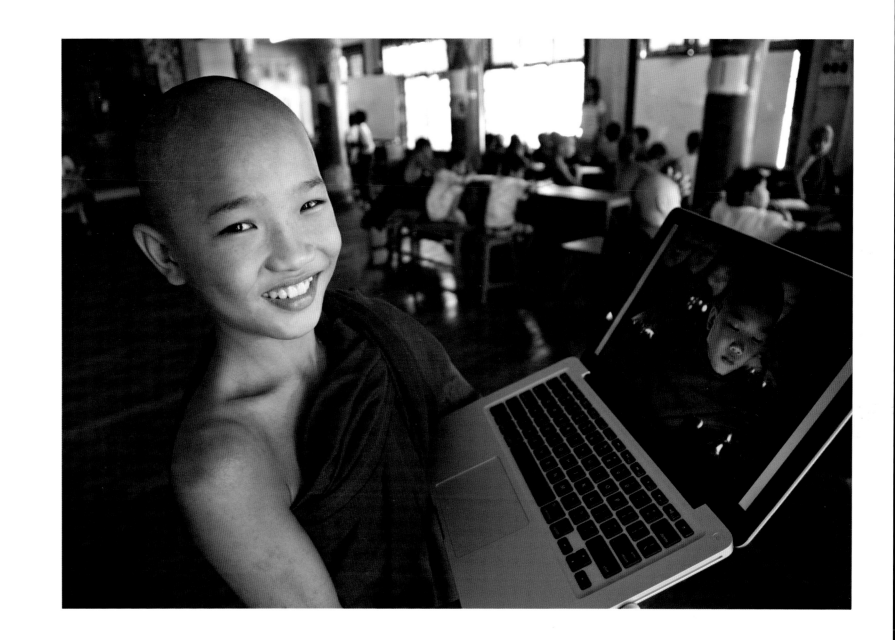

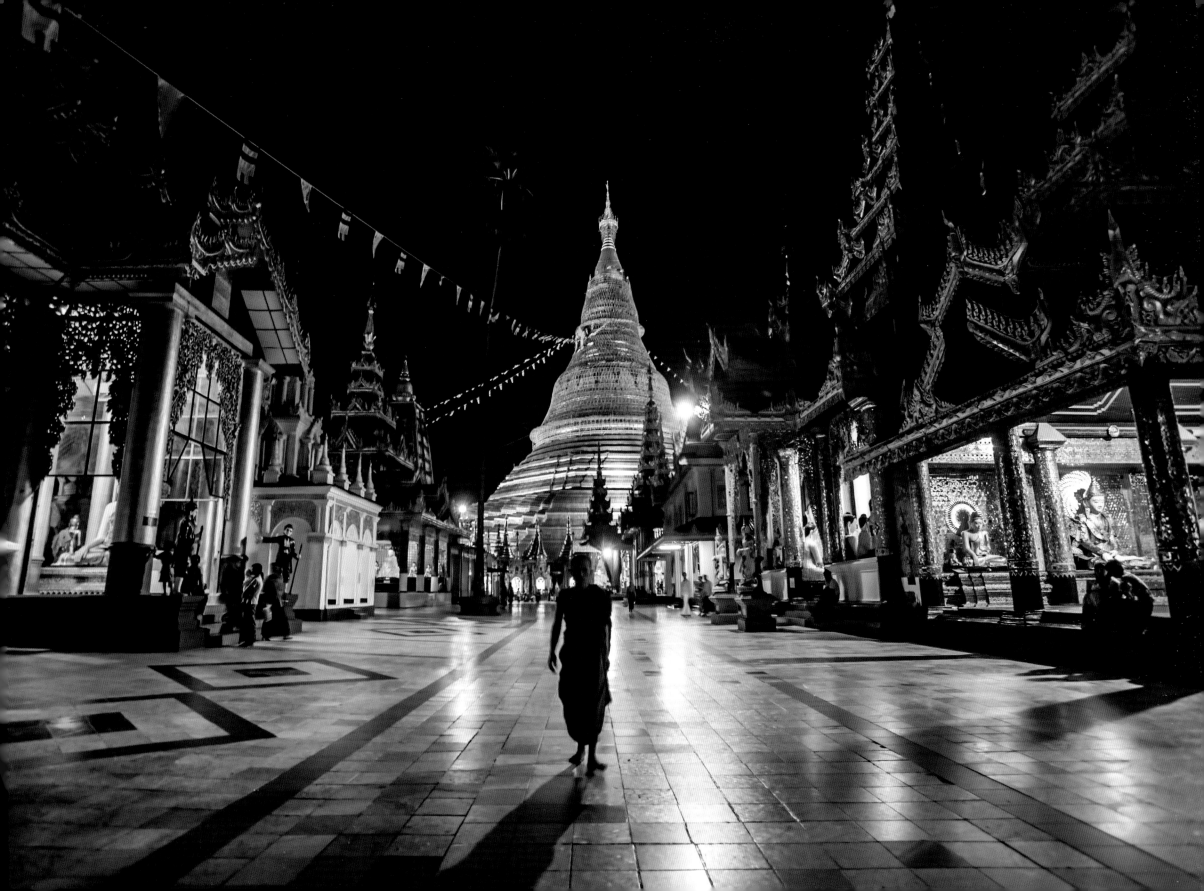

The gold tinge of Shwedagon Pagoda is ever present and makes for one of the most beautiful sights in all of Southeast Asia.

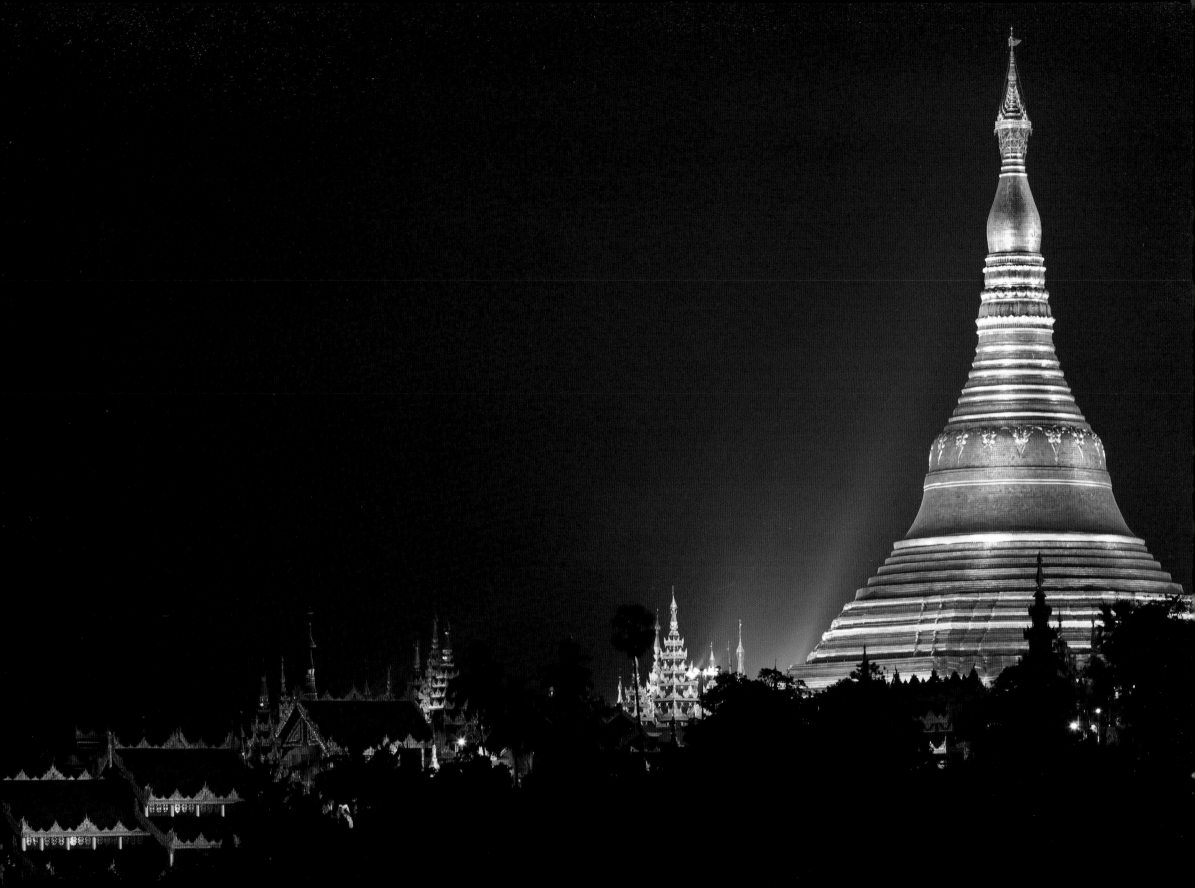

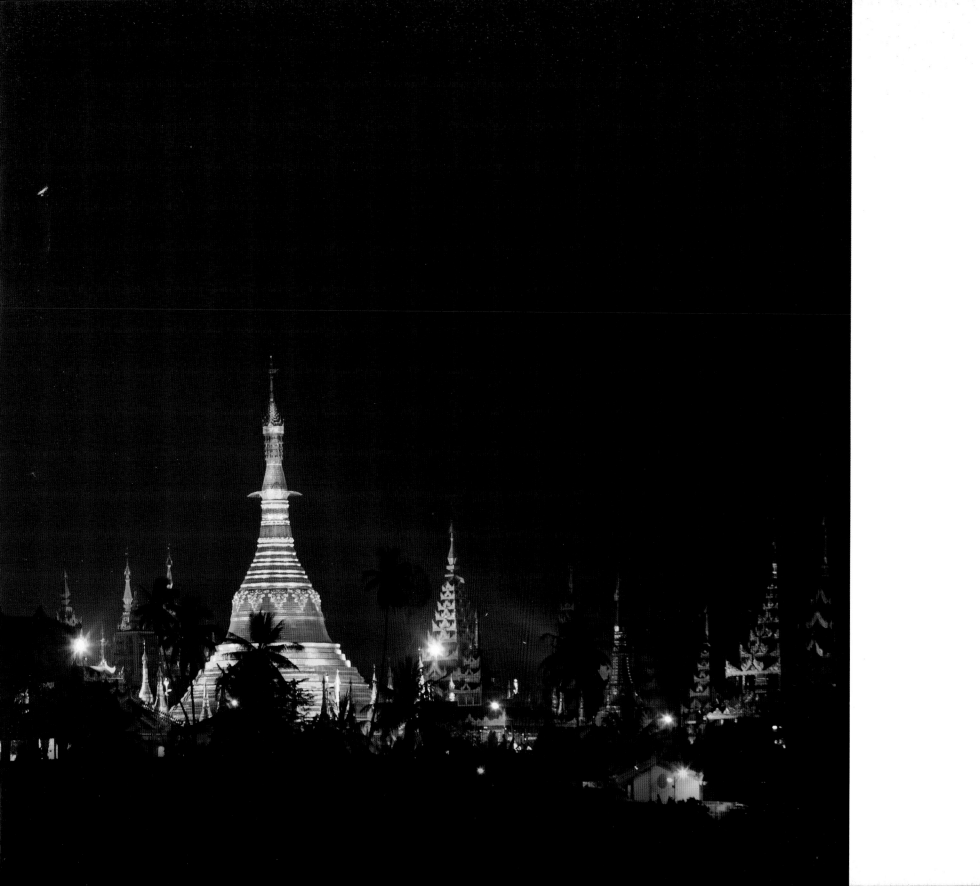

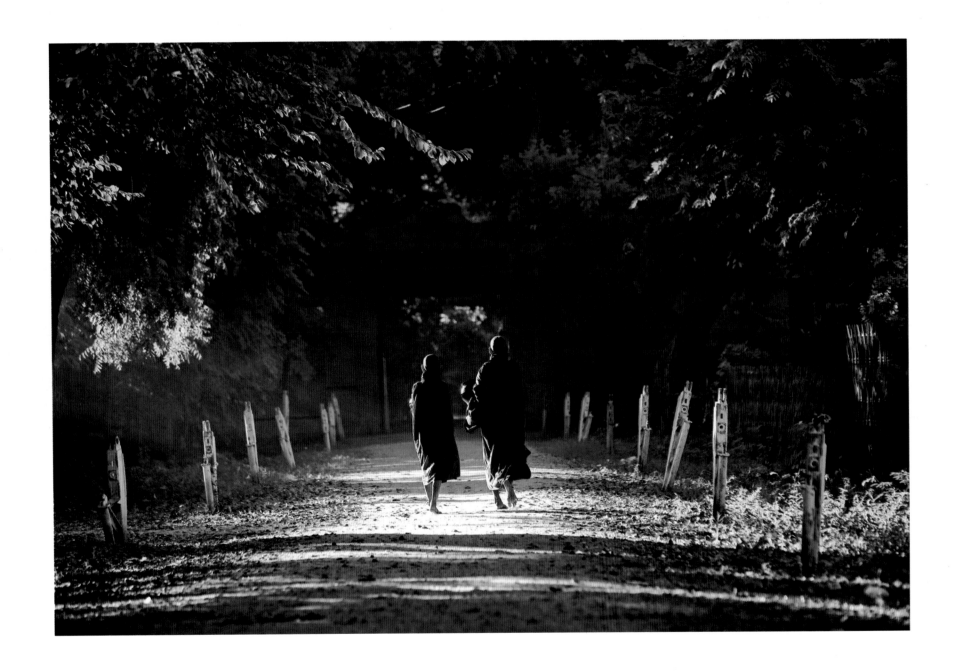

Thank you for taking this journey with me to this very special place.